A Complicated Marriage

A COMPLICATED *Marriage*

MY LIFE WITH CLEMENT GREENBERG

Janice Van Horne

COUNTERPOINT · BERKELEY

For Sarah, Matthew, Clementine, and Roxanna

Copyright © 2012 Janice Van Horne.
All rights reserved under International
and Pan-American Copyright Conventions.

Library of Congress Cataloging-
in-Publication Data is available.

ISBN: 978-1-58243-821-4

COUNTERPOINT • 1919 Fifth Street
Berkeley, CA 94710
www.counterpointpress.com

Distributed by Publishers Group West
Designed and typeset by Gopa & Ted2, Inc.
Cover design by Anna Bauer

10 9 8 7 6 5 4 3 2 1

Clement Greenberg —
Capricorn —
Jan. 16

CONTENTS

part one

Our First Year

Meeting Clem

GREENWICH VILLAGE and the century-old brownstones along West Fourth Street near Eighth Avenue are quiet. The evening is well along. Windows are open to the street to catch the unseasonable Indian-summer warmth of an early-October night. There, at number 32, on the top floor under the eaves, the spill of Miles Davis and Charlie Parker tells us it is 1955 and the symphony of voices tells us that a party is beginning.

Jennifer Gordon, in her impeccable black silk sheath, with her platinum blond hair pulled severely into a chic twist, flutters, high heels clicking, from the front room, with its handkerchief kitchen that used to be a closet, down the narrow hall to the back room, her bedroom. This is her apartment and she is the hostess.

There is a young woman, very young, in fact just twenty-one, seated on the edge of a paisley-draped foam couch in the living room. She crosses and uncrosses her long legs under the midcalf, serviceable gray wool skirt, far too heavy for such a warm night. Made by a local dressmaker and bought at a Bennington College sale for $12, the skirt is so serviceable that for forty-five years it will hang in her closet, rarely if ever worn. Besides the moths, maybe it is her memories it will serve.

She looks down, appraising her sandals, new, from Fred Segal on MacDougal Street, with leather thongs that lace up past her ankles. Too tight, they will leave grooves that will take years to erase, but tonight her only concern is that her exposed feet might look too big, which they are. She smokes a Pall Mall and then another, and holds a glass with a few inches of gin and a dollop of tonic, as if it were her ticket to where the high life might be.

She smiles too much and when she talks, it is of nothing, and when she listens to what is said, she listens not at all. Her nearsighted eyes scan

the room, pretending to see what she well knows she cannot. She does not wear her glasses. One does not wear glasses on special occasions. She is looking for something comforting, but finds nothing. Her New York roommate, Debby, has brought her boyfriend, Norman. They lean against the fireplace on the opposite wall. A couple. She watches them and hates them for their exclusive ease and for the safety net she sees them wrapped in.

She looks down at her hand clenched around an emptying glass and lights another cigarette. Soon she loses sight of Debby and Norman. The room is filling up, smoky and dim; people swooning with booze strain toward each other, confiding, at top shrill, secrets and lies, withholding secrets and truths. She knows this because everyone here knows everyone else, and this is what she suspects sophisticated people do. Whiskey sloshes onto clothes, pooling in the shag rug already busy catching the ashes from a hundred cigarettes.

She looks up toward the hallway. A man enters. He is with a small frenetic woman carrying a small frenetic dog. A dachshund, not a breed the girl fancies. The couple, she assumes they are man and wife, are of an age—old, at least in their forties, maybe older. The dog is what he is. Not long after they arrive, she is startled to see that the man has sat down next to her. As she turns and looks at him there on that paisleyed couch, she falls into the rest of her life.

That is how I envision the party where I met Clem. Those are the images, old and familiar, that have taken root in me over the years. Yet as familiar as the images are, there always seems to be something "other" about them. After all, those two could be any girl and any man meeting at a party. A random collision. All so ordinary. Isn't that how so many people first meet? But of course it wasn't ordinary at all, because the images were of me, me and Clem.

Earlier that evening, three of my college friends and I had gone to an opening of Paul Feeley's paintings at the Tibor de Nagy Gallery on the Upper East Side. Paul taught painting at Bennington, and Jennifer Gordon, a dress designer, was an old friend of his. I was a literature major, but in my senior year, through my dorm neighbor Debby Booth, I began

to hang out with her friends in the art department, among them Nancy Smith and Judy Backer. After graduation we all reconnected in New York, and so it was that in October we four showed up at Paul's opening. And I suppose that because it's always nice to have young girls at parties, we were invited to Jennifer's.

When Clem came over to sit next to me that night, he introduced himself, and before even asking me my name, said, "Plattdeutsch." Seeing my confusion, he explained that, judging from my flat forehead and bridgeless nose—my self-esteem buckled—my heritage was most likely northern German, or Plattdeutsch. I said that all I knew was that I was Dutch for centuries on my father's side and German through and through on my maternal side.

His disappointment at my generalities clearly evident, I then ventured that I thought my grandfather might have come from Emden. He brightened. I had validated my Plattdeutsch-ness. While on the German tack, I mentioned his dog.

"Not my dog," he said.

"But your wife . . . " I countered.

"Not my wife," he said, and explained that the woman he had brought to the party was Busch Meier-Graefe, the widow of an art writer he much admired. *Lord*, I thought, *more German*, and wondered if I should launch into the saga of my uncle, the Nazi, but decided that might be a bit off-putting.

In any case, he hadn't finished analyzing my face. It seemed it was unusually symmetrical, my eyebrows and eyes perfectly spaced and level. He capped it off with an admiring gaze into my apparently perfect eyes and added, "*Blauen augen*." That one, I could figure out. He then asked if I would like a refill. I nodded, and he threaded his way toward the alcove kitchen. As he moved away, I realized he hadn't said a word about himself, but I was curious to know more. I never did see that refill, nor did he return. The party was about to shift gears.

My friend Nancy lost no time taking his place on the couch. "Do you know who that was?"

I shook my head.

As she always did, she told me everything she thought I should know.

"That's Clement Greenberg. He's the most famous, the most important, art critic in the world!" I gave her a blank look. Her eyes dripped with condescension. She would have many occasions to look at me like that. Suddenly we were interrupted by a crash in the kitchen. A big, chubby man—Johnny Meyers, the gallery director, Nancy whispered—ran through the room, waving his arms, screaming in a falsetto, "Clem's crazy! He's crazy! Get him out of here!"

Debby, who was closer to the action, hastened over to tell me that the two guys had gotten into an argument and then the one called Clem had grabbed the other one, shoving him hard against the refrigerator, knocking things over. She said the fat one had been needling Clem about someone called "Helen" and the man she had brought to the party. I instinctively knew who the girl was. The party, maybe like most parties, had a shining center. She was hard to miss. A tall, beautiful magnet of a girl, now with a name—Helen.

The commotion died down. For all the flailing and shouting, no one got thrown out. The party resumed. But it was getting late—we were working girls—and soon my friends and I regrouped to make our departure. It was then that we heard a woman's cries coming from the bedroom. People pushed through the narrow hall to see what was going on. We stayed put but heard Clem's name again, and Helen's. Evidently he had slapped her. Lord, it all seemed an awful lot of goings on in such a short time in such a small apartment.

But this was New York, I thought. Not that these things didn't happen in Rye, no doubt a lot worse. I knew they had happened in my house. But in Rye there was a code of silence and eruptions were muffled by solid walls and acres of well-tended landscaping. It was called privacy. This was drama, like something that might happen in the movies. Truth was, I didn't know what to make of it all. But whatever it was, I was uneasy, and fascinated.

Two things prompted my next move. One, I was having a hard time connecting this drama with the quiet-spoken man who had singled me out earlier, and two, when in doubt I invariably fell back on good manners. After thanking Jennifer Gordon for the "lovely party," and Paul

Feeley for having invited me, I decided to say good-bye to Clem, the only person I had talked to other than my friends.

I maneuvered my way to the back of the apartment. Clem was on one side of the small bedroom; Helen, surrounded by sympathetic friends, huddled on a chair on the other side. I gave him my best party smile, extended my hand to say good-bye, and said it had been very nice talking to him. He said it would be nice to see me again. I then did something that was not in any book of etiquette, something I had never done before: I asked if he would like to have my phone number.

He said yes. He took out a little navy blue leather book and a fountain pen from his breast pocket and wrote it down. Before I made it to the street, I was quaking with every dire scenario I could imagine: *What have I done, what if he actually calls, what if I see him face-to-face, what will I ever say to him?* I had jump-started my own drama.

I was ready for some drama. I had come to New York on Labor Day weekend. My stepfather, Harry, had driven me down from Chatham, Cape Cod, where he and my mother, on their uppers, had moved three years before. We had left at daybreak; Harry was a stickler for "beating the traffic." I had spent the long silent hours in the car—after nine years, Harry and I had perfected the art of having nothing to say to each other—reveling in the romance of my impending adventure.

My anticipation was spiced with just the right sprinkling of anxiety. I had everything I needed to begin my life: $200 in my pocket —I had yet to acquire such a grown-up accessory as a purse; a typewriter; a suitcase; a few books—T. S. Eliot, James Joyce, a binder of every poem I had ever written; bundles of schoolgirl clothes; a mattress, box spring, and frame strapped to the top of the car; and, across the back seat, a sturdy mahogany bench, the only furniture I had ever bought, $10 at a thrift store, that would serve as cocktail table, desk, dining table, foot stool.

We were headed for 8 Morton Street, right off Bleecker in the Village. Debby had found the one-room, one-closet, midget-bathroom, "Pullman"-kitchen, $80-a-month apartment. Ground-floor rear of an old, very old, tenement, it had two rusted iron-barred windows facing

a concrete, trash-filled, treeless "garden," and floors that heaved here and there from whatever unspeakable horror was brewing below, as the peeling gray walls ate up whatever light might filter through the jumbled buildings outside. It was heaven.

Harry, wanting to "beat the rush" back to the Cape, didn't linger, and Debby and I called everyone we knew, walked the Village, and planned a "welcome to New York" party. I bought the Sunday *Times* and scanned the want ads just in case the two "promising contacts" I'd gotten from my ex-mentor at Bennington didn't pan out.

Roger Straus, at Farrar, Straus, was gracious, if a bit lordly, and drop-dead handsome. Was that a cravat he was wearing? He had much advice, which included improving my typing and learning shorthand. Then, after describing all the drawbacks of working in publishing, which was all I had ever imagined myself doing, he finished by saying with a dazzling smile, "Now, young lady, you don't really want to work here, do you?" A superb interview-stopper, at least to me, as unversed in self-salesmanship as I was versed in being a nice girl who never disagreed with her elders. It was only after I hit the street that I realized we had never sat down. Oh, he had read me like a book.

As it happened, I had a social run-in with Roger only three months later, at a party the Strauses threw for Alec Waugh. Heady stuff. Roger didn't remember my interview and, as often as we would be introduced and reintroduced, he would never remember me from one time to the next. I never took it personally. He was so what he was, and had very selective radar. But hadn't escaped my radar. Even as I had stood in his office that day, I had seen it as a life-determining moment. I would wonder whether, if I had started out in publishing, I would have stuck with it and had a "career," rather than an "interesting life." Interesting is fine, but a career would have been a whole lot simpler. And, an even more provocative thought—maybe I wouldn't have been so quick out of the gate to get married.

My second strikeout for a job was at Time-Life. Nothing charming about that interview, though at least we were seated. I had once again girded myself with garter belt, stockings, black pumps, and my all-occasion black dress with white Peter Pan collar—reversible to blue, to

fool people into thinking I had two dresses—topped off with a headband which I thought gave me a suitably "finished" look, though "outsized grade-school girl" might have more accurately described my effect. The woman was polite, I was polite. The interview was short and concluded with, "I don't think you are Time-Life material."

This time I couldn't agree with her more, and sincerely meant it. The endless corridors of windowless cubicles, and was that linoleum on the floor? I left gasping for air, thinking longingly of the sumptuous, heel-swallowing pile of Roger Straus's carpet. A friend told me that I might have stood a better chance if I had worn white gloves and a hat. Good Bennington girl that I was, I was too ashamed to admit that I *had* worn white gloves. But a hat! I hadn't worn a hat since I was confirmed a Presbyterian at age twelve.

My anxiety spiked in the second week; my "contacts" were dust and my money was dwindling fast. I turned to the *New York Times* in earnest. My first, and last, job interview was at *TV Guide*, with a nice distracted man in shirtsleeves with receding hair who sat half-buried behind a chaotic desk in the corner of a small, bare-bones room high up in 30 Rockefeller Center. I knew right away this wasn't going to be a formal interview. I think what got me the job on the spot was that I said I was a poet. That tickled him. I would complete his literary pantheon.

Of the three other editorial assistants, all scruffy guys in their twenties, Arthur was a playwright, Neil a novelist, and Jay a screenwriter. We comprised the New York editorial office. Each major TV market had its own, usually staffed with only two or three people, while the publishing hub was in Radnor, Pennsylvania. As was the norm, the two offices in the back of the room housed the manager types and blocked off the air and light, but I didn't care. This was my style, a bit wacky and off the cuff. I envisioned a day when I might even risk knee-socks and loafers, or, dare I think it, bare legs and sandals.

My daily routine had begun. Up at seven thirty; scrub the night's soot off my face—the rattling windows, open or not, let in whatever detritus was wafting through the courtyard—grab my clothes and, always on the lookout for cockroaches, give them a good shake; followed by bread, jam, and orange juice from the mini-fridge—the only roach-free

zone—while trying not to breathe the smell of gas leaking from the stove; then a swipe at my hair, a smear of lipstick, and I was on my way down Bleecker, up Sixth, to the Waverly movie house and the West Fourth Street station to catch the D train.

It was a breeze. I had somewhere to go and they paid me $45 a week before taxes to go there. Lunch was one of two choices: milk and a cream cheese sandwich without the jelly—five cents extra—at Whelan's lunch counter on the corner of Sixth and Fiftieth, or a hot dog with everything from a vendor at the skating rink. I watched the twirlers and the stumblers and felt very grown-up as I thought of the skating palace at Play Land in Rye, where I had gotten my own white figure skates when I was six, and how I had worn them to bed the first night, slicing the sheets to ribbons. My first, and only, athletic passion.

At night Debby and I hung out with friends, drank cheap gin—Mr. Boston's—cut with grapefruit juice, ate cheese and Ritz crackers, and laughed a lot.

Because I was the new guy, my job revolved around sorting press releases looking for new programming and, most important, the care and feeding of the teletype machine. Huge, black, and belching, the machine took up half the wall ten feet from my desk. Every time a shrill bell sounded, it would go into a frenzy of shaking and clattering and I, like Pavlov's dog, would dash over, push a button to silence the bell, then watch the latest national programming magically appear on a scroll of paper. Like a player piano's, the keys had a life of their own. I'd tear off the paper and cut it into strips to pass on to the other editors.

Daytime TV—what little there was of it— was my turf. I would condense the chunks into two lines of type and wait for the next jolt of the bell. One day the routine was briefly interrupted when some bigwigs in suits from Radnor burst in. They announced that the magazine, in only two years, had hit a million circulation, and that in January we would be moving to a new location. With that, they poured champagne into the water cooler and beat a retreat. The trickle-down effect would be that I would be blessedly unleashed from the teletype machine, get a small raise, and . . .

After Jennifer's party, two days passed before Clem called. And when he did, it wasn't at all what I expected. It was late, around ten. Did I want to meet him for a drink? No one had ever asked me to meet him for a drink. What was that about? Of course I said yes. He told me to meet him nearby at Delaney's bar, at the foot of Sheridan Square.

Delaney's was an old-time Village bar, big and quiet and dark; best of all, it had high wooden booths. It was probably a blessing for my sanity that I didn't have time to worry about what I would wear or say or . . . I came as I was, and things just took their course. Not that it was easy. This was the first time I'd talked one-on-one with a non-Bennington, non-family, older man.

There must have been the usual preliminaries, but very soon they gave way to real talk. He told me about his five-year relationship with Helen—she now had a last name, Frankenthaler—that they had never lived together, and that, essentially, it had been over for some time. Was it that night he told me about his mental breakdown the previous spring, that he was seeing an analyst, that for too many years he had been seeing people he didn't like but was now living in a period of grace, with a new clarity about who was okay for him and who wasn't, that in his twenties he had been married for six months and had a grown son, Danny? Could he possibly have talked about all that that first night?

I do know that he told me that since Jennifer's party, he had sent Helen telegrams asking her to marry him. Not because he wanted her to, but because he felt he owed that to her after so many years. He also said he knew she wouldn't accept, because she would have been too concerned about losing face after the incident at Jennifer's party.

I'm sure I didn't absorb much of what he was saying, but I was startled by his openness. I also thought he was telling me these things because he wanted me to know them up front. Very Clem-like, as I would come to know. A trait sometimes reassuring, sometimes painful. Most of all, I was taken by his confessional tone. So personal, so intimate, him to me.

And what did I say to him that night? Besides the utterly forgettable, two moments were decidedly memorable. At one point, Clem came back from getting cigarettes and started to sit down next to me in the booth, rather than across from me. I told him I would prefer that he didn't,

which spoke to how unbearably uncomfortable I was. I felt way over my head. And Clem? He took it in stride. I think he was rather amused.

The other moment was when, perhaps spurred by his confessional tone, I told him that I was a virgin. Not without much fluster and fuss. To confide such a thing to a man was certainly a first, but I knew it was important. It was clear to me that he expected sex sooner rather than later, and I was definitely not okay with that. At the same time, I was ashamed of my virginity and didn't want it to come as a surprise somewhere down the road, if there was going to be a road.

Convinced that my flat-footed disclosure warranted some cushioning, I must have told him about my high-school boyfriend of two years, just to reassure him that I wasn't irrevocably inexperienced. Did I mention that I hadn't really dated since my sophomore year in college? Or vapor on about my mother's hushed urgency as she intoned her oft-repeated incantations against sex, from the obvious, "Men only want one thing" to her more fanciful, "Letting a man touch you 'down there' can make you pregnant, and your life will be over."

Did I tell Clem how she had balanced all that with wistful, honeyed references to "the sanctity of marriage," "the beauty of intimacy with the one you love," and the wedded bliss of "happily ever after"? I hope I didn't tell him her tale of how she had known when her love was true because she had heard a nightingale sing. But I might have. Clem had set the disclosure bar rather high.

One thing for sure: I know that once the virginity declaration was made, I capped it off with a Hester Prynne reference when I told him I often felt I had a capital *V* on my forehead. I had sensed that Clem wasn't exactly thrilled by the idea of my virginity, that he was probably just looking for a quick walk in the park without any long, drawn-out, push-and-pull skirmishes. And I figured humor would soften the blow. I was right. He laughed long and loud. Somehow, in the throes of my earnest blushes, I thought it was all pretty funny, too. And so, with my cards on Delaney's table, I glimpsed that it might be okay, might even be fun, to hang out for a while. We were an unlikely pair, but the timing that night was right. Each in our own way, we had suggested that we might be ready for a change.

And then he didn't call for two weeks. But this time he called a day in advance. This time he called to ask me to meet him at a painter's studio. This time it was like an honest-to-God date.

After work I walked up Sixth Avenue to Central Park South, then into a building and into an elevator. It wasn't much, nothing special, just an elevator, going up in an elevator. A very small cage, gilt and cherry wood and a tiny red plush seat tucked into a corner in case one felt faint. Just an elevator in a narrow, twelve-story studio building tucked between two hulking apartment houses. I was expected. I liked who I was that evening: a girl on her first date with a "real" man, a girl who was starting out on the next phase of her adventure. I also hated who I was that evening: a girl terrified of starting anything, much less an adventure. Maybe I *would* faint.

I towered over the miniature elevator man, in his maroon uniform with matching hat and white gloves. He was so much better turned out than I in my standby Peter Pan number. For this occasion, I had added my grandmother's single strand of cultured pearls. Maybe cultured, maybe not. One couldn't be too sure about that grandmother on my father's side, with her gin-drinking, chain-smoking, card-playing ways and a husband who had dropped dead of a heart attack at a suspiciously young age. No, one could never be too sure of Ruby—*grandmother* was a word forbidden in her presence. Such were my thoughts that evening in the elevator on my way up.

René Bouché's studio was on the top floor. I had never been to a studio before. Was I breathing, smiling, shivering, happy, scared? Yes. The elevator man pulled open the brass gate and released the outer door, and I stepped directly into a small hallway that, in turn, opened into a sitting room overpowered by a vaulted ceiling and an immense domed window that confronted the length of Central Park. Its vastness astonished me. Even though I had grown up only thirty minutes north of the city and had now been living in New York for two months, most of the time I had no idea where I was at all. No one was in sight, but I heard voices, and soon Clem came toward me and drew me into an adjacent room, a cluttered, paint-filled, strange-smelling room. So this was a studio.

Clem introduced me to Mr. Bouché, and to Paul Wiener and his wife,

Ingeborg ten Haeff, who stood by yet another immense window. They nodded, drinks in hand, and turned back to themselves and the view. Clem showed me the portrait of himself that, still incomplete, was on the easel. I couldn't tell whether he was pleased with it or not. In the large rectangular picture, he sat at a table, contemplative, holding a book in three-quarter profile, his head tilted, resting in his other hand. When I looked closely, I saw a shadow of sadness in his face—not deep, but there.

Overall, the picture was pretty, pastel-ish, sketchy, the paint brushed on delicately. This, I would come to know, was the Bouché style. Clem was wearing a pink shirt that diffused a soft glow. There was a gentleness, a sweetness, about his face, about the whole picture. I liked it, although, little as I knew Clem, I thought the tone an odd choice. I said nothing. I also thought Clem looked wonderful in the pink shirt. I wanted to reach out and touch his arm as he handed me a drink. I didn't.

As Clem and René talked, I watched the couple by the window. How beautiful they looked, framed in that window against the backdrop of the darkening park, both very tall and thin, with the posture of gods. Her hair was everything, shining gold, so rich and thick that, even coiled around her head, it framed her face, her remarkable defiant face, the features large and chiseled, the planes sharply defined. A face painted with high color, the eyes huge and black rimmed, fringed with thick lashes. A face that startled. I suspected that she wasn't particularly nice. Her clothes were like drapery, layers of exotic colors that flowed around her and served as a deeply vibrant canvas for a pair of pendulous earrings, set with cascading beads and stones that reached to her shoulders, and an enormous necklace of claws and teeth and unfathomable objects that almost reached her waist, the bones clanking as she turned toward me. Paul was impeccably turned out, polished and buffed, elegantly thin, pin-striped, with a remarkable shock of abundant white hair exquisitely pompadoured, and when he smiled, which I imagined he rarely did, he flashed a similarly remarkable mouthful of outsized teeth. A perfect companion piece for Ingeborg.

That night may have been my first date with Clem, but the night really belonged to Ingeborg. She was the first woman I'd ever seen who

so profoundly defined herself, who so clearly presented to the world the self she knew herself to be. Watching Ingeborg, I glimpsed that, as grown-up as I might ever come to be, I would never be so clear, so defined, so sure of who I was that I would dare to expose the fullness of my self to others. I also knew for sure that I would never wear bones and clank with arrogant confidence as I strode toward the world, nor would I cloak myself in the arcane textures of pagan colors, or paint myself as the goddess of my secret desires. That night I had entered a new world, in which Ingeborg would always stand as the priestess at the gate. A world whose code I would never decipher. And even if I did, I suspected that I would never know how to make it my own.

After Clem and I left the headiness of René's studio, our date proceeded on a more mundane course. We had dinner nearby at La Potinière. Not fancy, but very French and nice. And then we went back to Clem's place at 90 Bank Street, not too far from Morton Street. I surprised myself—the girl who hadn't let the man sit down next to her in the booth two weeks earlier had now agreed to go to his apartment.

As I entered the living room from the small entryway, the first thing I saw, silhouetted in a rosy glow coming through the windows, was an easel, a thick, wooden easel almost six feet high. Startling, lifelike, a man astride. Clem turned on his green glass desk lamp, and the room revealed itself. Near the easel was a card table weighted with a palette, tubes of paint, turpentine, and a large wooden paint box overflowing with more paints, brushes, rags, and lord knows what. While Clem got drinks, I looked out one of the two windows fronting Hudson Street from the second floor, and there, just to the right, was the source of the rosy light. Jutting out from the building was a long, narrow, perpendicular neon sign: LIQUOR. It didn't flash, but to cast its spell over the room, it didn't need to.

I followed Clem into the kitchen, where he was refilling the ice tray at a sink supported in front by two legs in the old-fashioned way. Long and narrow, the near part of the kitchen was lined with bookcases on one side and rolls of canvas and paintings of all sizes stacked on the other. His paintings, he told me. At the end was a window onto a fire escape. When Clem opened the refrigerator, I saw that it was empty except for

a bottle of orange juice, a can of Maxwell House, a box of cigars, and a jar of suppositories.

Back in the living room, I sat in the only upholstered chair and he turned his Windsor chair around from his desk, a few feet away, to face me. Next to the desk was a small metal typing table topped by a high, office-size typewriter. It made me nervous, those spindly legs thinking they could support that oversized machine. Behind me was a wall of more bookcases. I liked that—a bit of warmth, grounded, substantial. Otherwise, the room struck me as stark and uncomfortable. Not as stark as the contents of the refrigerator, nor as quixotic, but I wondered that someone had lived there for ten years. That I lived in a quasi-basement hellhole didn't count—I was just passing through. Particularly foreign to me were the paintings that covered the walls, haphazard, small, large, everywhere I looked. "Not painted by me," he said, painted by others. But then he pointed to the biggest picture—like most of the others, abstract— and added, "Except that one. I painted that one." I wondered if I should say something about it, but thought better of it. I didn't know what I thought of those pictures at all, what I could see of them, in the shadows cast by Clem's green glass lamp.

That night we didn't talk about anything dramatic or memorable, like mental breakdowns or the *V* on my forehead. But we sat there in the rosy glow of LIQUOR until very late. We must have had something to say. And we kissed. And then he walked me home. And at my door we kissed again. I do remember that the next morning, when I opened my eyes to the familiar, sooty grayness of Morton Street, I had liked all that kissing.

Kissing or no kissing, again it was more than two weeks before Clem called again. To my shame and misery, this time I quickly reverted to being a moony teenager hovering over the telephone at *TV Guide*, wait- ing for him to whisk me off into the unknown. Those weeks were endless to an impatient girl who saw a kiss as a promise.

Eventually he did call, and after that the pattern shifted. To my relief, there would be no more waiting. We were soon seeing each other almost every evening, and I was indeed whisked into a life unknown, much less imagined. Dates, a phone that rang, fancy places to meet, parties,

restaurants galore . . . Which is not to say that much of the time my mother's daughter didn't cringe; what would I wear, was I too tall, too fat, would I be enough?

We never did just one thing. An evening was like a fan that slowly opened. Drinks hinged to dinner, hinged to a movie, an opening, a party or, if we were with a group, especially out-of-towners, hinged to the Cedar Bar or the Five Spot. And always, for me, the next day, *TV Guide*. For a particularly chock-full evening, I referred to Clem's small leather daybook, the same one in which he had noted my phone number a month earlier. The entry for the evening of November 8: "The Savoy Plaza to fetch Nika Hulton (wife of British publisher Sir Edward Hulton), with Jennie [*sic*] and her to Whitney Museum opening, Martha Jackson's, Gallery 'G,' dinner with Paul Jenkins (painter), Ken Sawyer (art writer), Jean Garrigue (poet), 10:30 Cedar."

The social diet soon sorted itself out; all evenings were not equal. There were good times, okay times, and bad times, usually depending on where we went and sometimes with whom. Very low on my hit parade was any evening that ended at the Cedar Bar.

Ah, the Cedar. Whether in a city, a neighborhood, a restaurant, a party, a school, an apartment building, I didn't like being any place that was homogenous. That was the Cedar—wall-to-wall artists. For me, I might as well have been a vegetarian walking into a union meeting of meat packers. For me, it meant washing the smoke out of my hair and brushing the stubborn bits of sawdust off my shoes the next morning.

We would slowly thread our way past the bar jammed with the regulars and the girls who wanted to hook up with the regulars. Pollock, Kline, de Kooning, Smith, Guston, Held, Cherry, Tworkov, Leslie, Goldberg, Marca-Relli . . . any roster of artists would do. Those who would become big names, and a lot who wouldn't, they were all at the Cedar one night or another.

Finally making it to a booth, I would inevitably find myself squeezed into an inside spot. The drinks would arrive, the cigarettes would be lit, and the talk, talk, talk would go on as people drifted by, drawing up chairs, leaning over the seats, then drifting off, only to be replaced by others, everyone half in the bag and bleary, as I smeared condensation

from my glass, making endless designs in the ashes on the tabletop, thinking, *When can we leave, when can we leave?*

We were also going to a lot of gallery openings. One night, at the Stable Gallery, Clem spotted Helen with her current boyfriend. Words were exchanged, and next thing I knew Clem had pushed the man over a bench. For me, it was a replay of the night we had met. Except then it had been strange and interesting. Now I was with Clem and had begun to meet some of these people, if vaguely, and it was awful. People circling, commotion. I instinctively moved away and stood at the far end of the gallery, clutching my fragile self-esteem. Why was I there at all? Damn Helen! Obviously I meant nothing to Clem. How could he put me in such a position? Suddenly, there was Bob Motherwell, whom I barely knew, standing next to me. He handed me a drink, said soothing things, and gave me a handkerchief for the tears that his kindness had set to flowing.

Not long after, Clem and I were on the street. Still fraught, I vented my "how could yous." He stopped and said, "You're only worried about your face. Someday you'll get it that what other people think is bubkes. I've learned more from making a fool of myself than by being right." I never forgot Clem's life lesson or the kindness of the tall, blond acquaintance, but that night on the street I knew it was the kindness that had gotten me through.

And then there was dancing, another sure hit for my self-esteem. Clem was partial to a club called Winston's. He loved to dance. He would jazz it up with lots of fancy footwork, a sort of homegrown swing/jitterbug. I felt inadequate, always had. Dancing rekindled the wallflower mortification of my teens and exacerbated my self-consciousness about my height, the two afflictions hopelessly intertwined. Our forays on the dance floor would invariably end with his muttering that I was trying to lead, and I would mutter that it was just that I was taller—at six feet with shoes, I had two inches on him—and he would mutter, no, it was because I didn't follow properly . . . I blessed the day when rock and roll and the twist put an end to all the muttering and we could each move to our own drummer.

On the flip side, some of the best times for me were the nights we

would hang out with my friends. Clem enjoyed it, too, and I liked that he liked it. Sometimes he would invite everyone along to an opening or to a party. Sometimes we would double-date with Debby and Norman and go out to dinner or a nightclub. And often, best of all, we were on our own: movies, dinner, usually ending up at his place, talking, and kissing a lot. Then he would walk me across the street to Abington Square to put me into a taxi, always pressing a few dollars in my hand. A block or two away I would tell the driver to let me out, and then walk the rest of the way home. I would defray the twinges of guilt by thinking of the leeway the extra money would afford me the next day.

But far and away my favorite late-night destination was Bon Soir, a basement nightclub—no dancing, thank God—dark and dank, deep in a catacomb under the madness that was Eighth Street. There, Clem introduced me to stingers on the rocks and the best singers and comics around: Kaye Ballard, Larry Storch, Mabel Mercer, Felicia Sanders, Phil Leeds, Ethel Waters, and the club's anchor, Tiger Haynes and his combo, who always gave the regulars, like us, a wave and a grin.

It was Felicia Sanders who knocked us out when she introduced us to "Fly Me to the Moon." And Phil Leeds who one night told a joke that had Clem laughing so hard he choked. It went like this: "A father comes into the living room and sees his son reading a comic book. 'What do you think you're doing? Why don't you get a job?'

"The boy looks up. 'But Pop, I'm only twelve.'

"The father sneers, 'When I was your age, I was sixteen.'"

It became Clem's all-time favorite joke, and it was one of the few times I saw him—never one for more than a chuckle or two, at best—give over to all-out, gut-splitting laughter. The only other guy who made Clem laugh like that was Lenny Bruce. He was too far out for Bon Soir, so we would head to the Village Gate, the Vanguard, or wherever we could find him—one night it was a lesbian club in a basement off Seventh Avenue. We'd sit through show after show, leaving only when he did. And even then, reluctantly. He made me blush and feel like a grown-up, all at the same time.

Always the standout singer for us at Bon Soir was Barbra Streisand, a mere eighteen when we first saw her, and even then as extraordinary

as she would ever become, sitting in a skirt and blouse like a schoolgirl on that stool, singing "Sleeping Bee." Clem whispered, "She's got something." In Clem-talk, high praise. A clumsy girl, tripping on the mic cord—part of her act? And endearing, because she couldn't seem to get anything right until she was on that stool, in a pin spot, singing. We felt that we had discovered her.

That was the way it was at Bon Soir. I was enthralled. Ever since I had seen *Carousel* on my eleventh birthday, I had harbored a secret yearning to be a singer. After hearing Barbra, I found the courage to go through the curtain leading behind the small stage. To a man standing there, I said I wanted to talk to her. He said no, and that he was her manager. I said I wanted to sing, and who was her teacher? He said, no teacher, she just knew. I retreated. Somehow I wasn't surprised by what he said. Years later I heard her say, when asked about how she achieved her amazing sound, that if she could hear the sound in her mind, she could sing it. By then I had achieved my dream, and I almost cried because she had put into such simple words what I had instinctively come to believe was true.

Bon Soir was not a place where an entertainer stood elegantly in front of a mic, delivering some patter or a song, like at the Blue Angel, or #1 Fifth Avenue, or the uptown hotel nightspots. At Bon Soir the audience felt like insiders, performers ribbed each other and us, it was theater, it was family.

And then, during those first months, there were a few unforgettable parties. Like the one at André Emmerich's apartment-gallery on the parlor floor of a brownstone in the East Seventies. At that time André was a private art dealer, handling mostly pre-Columbian work. The main room was large and packed with a crowd that even I could recognize as the usual assortment of artists and collectors. But there, dead center, feet away from me, were Janet Leigh and Tony Curtis. This was my first movie-star-in-the-flesh moment. How perfect. And young—well, within a decade of me—in the full blush of their power couple-ness. And here was André introducing them to us, as if they were real people. Clem hadn't a clue who they were, but I was a junkie.

That night I might as well have been twelve, cutting out pictures of

Rory Calhoun and Guy Madison from *Photoplay* and Scotch-taping them to the wall next to my bed. For some reason, right there with the hunks was the prince of the snarly bad boys, Richard Widmark, who never got a girl to kiss but who I thought was sex walking. And the girls? Jane Powell and Debbie Reynolds, because I wanted to sing and dance and be five feet tall and, like Nancy Drew, have dead mothers and adoring fathers who were handsome and doting, thus fulfilling my Electra dreams. But that night at André's I was thrilled to make do with the movie stars at hand. Quite content to have no conversation, I just stared and stared at Tony's curly black hair and headlight teeth and at Janet's enormous breasts and tiny waist. They were perfection in miniature. Clem would gauge the world by me. "She's even taller than Jenny," he would say, not that the opportunity came up often. The stars would already be divorced in a few years, but, blissfully ignorant of the reality ahead, I feasted on the fantasy at hand until I'd had my fill.

Later that evening, I confessed to Clem how ashamed I was for being such a starstruck idiot. And he told me that he had had his own starstruck moment when he was in his twenties. He had been in Hollywood for a job interview and one night had gone to the Pasadena Playhouse. During intermission he found himself standing near Marlene Dietrich. As she pulled out a cigarette, he leaned toward her with a match. As she exhaled, she looked at him with those eyes and said, "Thank you, darling," with that voice. He said his knees had buckled. "Not the kind of thing you forget." I felt warm all over and no longer like an idiot.

Most of the big parties had a way of clashing with reality. The glamour soon wore thin, as thin as my meager wardrobe and Alice in Wonderland headband. Most awkward for me were the big fancy Upper East Side parties in the big fancy townhouses. Whether at the "Skinny" Iselins', so upper-drawer—with that name, how could they not be?—where even Clem didn't know that many people. Or at the Alex Libermans', who gave huge parties for the downtown art crowd that Clem found tedious because he knew everyone and their cousins—the Libermans didn't believe in cross-fertilizing their circles. Or at the Bernard Reises', the artists' accountant of the day, who amassed a large collection in lieu of fees and who, like the Libermans, also believed in giving what Clem

called "A-list" and "B-list" parties. Or perhaps at Mary Lasker's, where people of every nationality and color stood about, no one seeming to know anyone else, all silhouetted in her all-white house, from the walls, floors, and furniture to the smallest petal on the smallest flower, and where I drank vodka lest I spill a drop, and never dared sit down on the pillows plumped just so. Those were the high-life times that had a way of promising so much and would end by turning my insides to stone.

That fall was a time of having nothing to say and of routinely being asked, "Do you paint?" I would stand by Clem's side after being introduced to whomever and try to listen to what was being said, and wonder if I would ever have something to add. But the conversations were about people, places, and things I had never heard of. On the rare occasion that someone expressed curiosity about me and what I did, I would venture a few words about being interested in poetry, perhaps mentioning Bennington or that I worked at *TV Guide*. No, I hadn't published anything. Yes, Bennington was an interesting college. Yes, the most expensive in the country, quickly adding that I had had a small scholarship. And what was *TV Guide*? they would ask. A new magazine that started up two years ago. How interesting, and what do you do there? I write some of the blurbs that tell about what shows are on. I was definitely not moving in a television crowd. Most people, including Clem and me, didn't have sets, and those that did, claimed they didn't watch them. I soon dropped *TV Guide* from my already impoverished repertoire.

And there was always the top-ten favorite: How did you and Clem meet? By this time I could swear I could hear the underlying incredulity, more like: How on earth did you two ever meet? We met at a party for Paul Feeley. Who? Paul Feeley, the painter. Poor Paul—he wasn't then, nor would he ever become, a household name, even in the small art-world household of the fifties. Very soon I dropped Paul from the how-we-met story, and the severely truncated version that I stuck with for decades became a shrug accompanied by, "Oh, at a party." What was I going to say? "We met at a party. You must have heard about it. The party where Clem slugged Johnny Meyers and slapped Helen. But it was hunky-dory for me, because he told me I had *blauen augen*."

All to say, these few attempts to find a conversational bridge quickly

petered out. There was never a connection. I had entered Clem's world without knowing the language and without any credentials. The people and places slipped through me so fast, and most I never saw again.

Then one night in early December, there was that first party at Helen's. I hadn't wanted to go/I was dying to go. So curious to see Clem's long-time girlfriend up close, where she lived, who her friends were . . . One thought that never occurred to me was that she might be curious about me, or be pissed at Clem's new girlfriend. Why would she give a thought to the nobody from nowhere who was going out with her dumped ex on the rebound?

That evening I ran headlong into the trap of comparing myself with her. Helen wasn't an Ingeborg or a Janet Leigh or a Nika Hulton, women whose lives and looks were light-years from anything within my realm of comparison. But here was Helen—young, a graduate from Bennington five years before me, and, even though she was beautiful, rich, and a talented painter, she was vaguely on my planet. And accessible enough that I could indulge in envy and self-pity and tears.

When we arrived, did she greet us and immediately turn to Clem in her intense, focused way and engage him in talk of things and people I knew nothing about? Was her exclusion of me intentional? I hope not. Did I, out of my own insecurity, read into her behavior more than was there? Maybe so. Whatever, the start was rocky, and got rockier when, later, she put on dance music. Sinatra, her favorite. Clem and I danced, I more self-conscious and awkward than usual. Then Helen danced, beautifully danced, with Clem. That did it. I notched up from envy to envy and jealousy. Dancing! She would never know what a nerve she had struck. I just made it to the bathroom before the tears flowed. When I did return, my insides like a soft mango, I stiff-upper-lipped it through the rest of the party. Even that night I knew that this was not going to be a rare occasion, that our paths would continue to cross.

Two months after we had met, Clem called and asked if I wanted to have lunch. Another first. Clem, who worked half days at *Commentary* as an editor, was a breakfast-and-dinner guy. But for whatever reason he had decided to take the day off. He suggested we meet at Louis XIV, just across the rink from 30 Rock. There were a lot of "kingly" restaurants

in New York in those days, and the higher the Roman numerals, the more posh. And what a place it was: huge, creamy and beige, carpeted and chandeliered, and so quiet I could hear myself chew. Through the large window we looked out on the tree lights and all the pizzazz of pre-Christmas Rockefeller Center. We had a drink, probably two, and soon, habituated to my Whelan's routine, I was lightheaded and delighted as a child to see that every time I blinked the lights on the tree fused into a wall of color.

As we sat there, somehow, sometime, the subject of Christmas came up. And a present, and . . . All I know for certain is that after lunch we strolled west on Forty-seventh Street, headlong into the diamond district, and into a hole-in-the-wall store. We looked at the rings in the cases. I tried a few on. We asked the prices, which I'm sure didn't exceed $100, or else I, and no doubt Clem, would have fled. My clearest recall was of the small dingy store and the bored dingy salesman, who, when the purchase was finalized, disappeared behind a curtain with the small diamond ring to "polish" it. He returned, I put the ring on, and we left. Outside, I took my first real look at it and wondered why it didn't look shinier. I figured maybe the guy had pulled some sort of switcheroo on us. And what kind of yokels had we been to think we were buying a diamond for $100, fortune though that was? As we walked arm in arm down the street, the thoughts disappeared. I felt as if I'd landed on the moon. Clem walked me back to my office and then headed down to *Commentary*.

Giddy, I displayed the ring to my cohorts, until everyone knew a hundred times over that I was "engaged!" Oh, that word! Probably a dazed hour passed before the thought struck me: But does Clem know? I called him at the magazine and without preamble blurted out, "Does this mean we're engaged?" Silence. And then Clem said something in the vague direction of a yes. Did I dare to breathe? I said, "Really yes?" And he said, "Yes." And I breathed. That evening Clem said, as he would say often as the years passed, that when I asked that question he had felt a warm glow inside and there was no doubt in his mind. I thought of Delaney's and his talking about his breakdown or, as he now called it, his "breakthrough" to clarity and to his instincts about who and what were right for him. A state of grace.

But the engagement day was not over. That night was another of those multi-tiered evenings: a party, a late dinner, and then, very late, Bon Soir, a stinger, or two, on the rocks, and just us. One of our favorite acts was on, Tony and Eddie, two comics who lip-synched songs, parodying the lyrics until the audience went limp with laughter. Their star turn was "Hey there, you with the stars in your eyes," from *The Pajama Game*. The swish camp of them. We loved it. We sang it to each other as Clem walked me home, and it became our song. A few weeks later, as a Christmas present joke, I gave Clem a picture of me at age three, wide-eyed in a garden, holding the ears of a stuffed bunny. I inscribed it with the song's opening line. He kept it in his middle desk drawer until he died.

Over the next days, we talked a bit, a tiny bit, about getting married. There wasn't really much to talk about. Clem's scenario was very clear: no big deal, roll out of bed one morning, a civil ceremony, and that was that. Considering we had never been to bed together, I found that rolling-out-of-bed part a bit off-putting. But for the rest, I had never been the kind of girl who mooned over wedding fantasies, and the notion of Clem in a rented tuxedo in front of an altar seemed rather far-fetched. In fact, we both laughed at the notion.

At some point he moved on to the future: "As long as nothing changes." The remark was so vague that, if it registered at all, I would have thought, *Yeah, right*. After all, change was exactly what I had in mind. What could be more changing than being married? In fact, Clem's words were by way of being a preface to his next, rather offhand remark that our marriage should be an "open marriage." Did that mean what I thought it meant? Christ, we were back to sex again. Clem went on to talk about having lived his whole life as a free agent, and realistically he didn't see that changing, and how a good marriage was one where two people who loved each other would also be free to make choices . . .

I heard, but didn't hear. I was too busy sweeping the notion into a far corner of my mind. Whatever an open marriage really meant, it would never happen to us. After all, he would have me. So much for that December's communication and miscommunication. Anyway, much more top of mind for me was the more immediate sex thing. I didn't have a precise timetable for losing the scarlet *V* on my forehead, but I knew I had better

get a diaphragm, because it wouldn't be long before I tumbled into Clem's double bed. Christmas was coming, maybe . . .

There is another elevator, similar to the one at René Bouché's. The paneling is as fruited, the velvet bench to catch me when I might faint is as red, and the elevator man is as short and immaculately uniformed and white gloved. However, this elevator is at 1155 Park Avenue at Ninety-first Street, and I will ascend only as far as the fourth floor. This time I know very well where I am. I have been riding in this elevator since I was in my mother's womb. This is where my aunt Elfrida, my mother's younger sister, my uncle Rolf, and my two cousins, Fred (Manfred), two years older, and Marlene, three years younger than I, live.

I hadn't planned to be in that elevator, but my aunt had called me twice that day to please, please come. When my aunt wanted her way, which was always, she would screw up her face and squeak like a baby badly in need of a good swat. She layered on the honey along with the misery I would cause our "Darling Betty," how much she would miss her "Sweet Jenny." Like my paternal grandmother, this grandmother didn't acknowledge the word *grandmother* either. And what about "Poor Lolly," aka my mother, Vera? Poor Lolly was always said as one word, always crooned with crocodile sympathy. "Poor Lolly, all the way from Cape Cod, and without her Jenny for Christmas Eve," and on and on.

I said I could come but I couldn't stay long, an hour at most. I had someplace to be. A home of my own (well, not quite, but almost), a man who waited for me (delectable thought), and two fancy parties to go to, I didn't say. I was too nice a girl.

The door is opened by my perfumed and taffeta-ed aunt, with my mother behind her, a shadowy second. Elfrida is tall and very fleshy. Always too-too, she dresses to stun—too flouncy, too tight, too low cut, skirts too short, heels too high. Alternately boisterous and coy, she drinks too much. She writes songs and doggerel poetry, and volunteers at a hospital as a nurses' aide. She has an appetite for life that approaches gluttony and is never sated. I always liked that about her. Unless it spilled over into empty promises made to me about sweet-sixteen parties at the Plaza, or a trip

to Europe . . . someday. She carried herself away on her own promises, and until I eventually knew better, she carried me away, too.

Elfrida kisses me noisily, hugs me fiercely, and bustles me into the den, a room rarely used except as a repository for coats and such. I once spent a squeamish night there on the daybed tucked into its dimmest corner. Shrouded and be-pillowed for decades in heavy rugs and tapestries that spoke of Africa and Turkey and Persia—when Persia was Persia—that bed, and the room in general, would be forever redolent with decades of dust and mildew, mixed with the exotic musk of Eastern bazaars and camel dung.

The room is also the repository of all things foreign. Nothing is functional. Everything is decorative. From tiny carved jade and ivory doodads to the leopard-skin rug, its mouth a travesty of mortal ferocity that now could frighten only small children, its cracked teeth yellow and cobwebbed. Curio cabinets crammed with trinkets of beads and shells and ivory, and mother-of-pearl fans, and boxes of filigree and cloisonné smelling of ambergris and musk and cedar, and necklaces and bracelets and amulets of animal teeth and horn and topaz and shells and tiger-eyes. The walls are lined with elephant tusks, and prayer rugs of velvet and silk, fading and shredding day by day, and staffs carved with totems, and weapons of all kinds—spears, machetes, and daggers—and a world of masks, painted and beaded and feathered to fend off bad spirits, enemies within and without, and to put the fear of God in me.

Also sprinkled on the walls and on every surface are the faded photos of the man responsible for all the contraband and trophies of the hunt, my maternal grandfather, Hermann Norden, the long-dead adventurer, trust fund provider—for my brother, not me, I hadn't been born when he died—and the progenitor of the Plattdeutsch genes that Clem had bulls-eyed the night we met.

That Christmas Eve, I never make it out of the den. I never make it to a chair. I am never offered a drink, though I do think I take my coat off. While my aunt, with murmurs of something we need to talk about, scurries off to get the others, my mother and I stand waiting in that den, lit only by a few small lamps jerry-rigged out of bronzed animals and snakes and ivory cupids with faces eroded and veined, all shaded with red moiré.

My uncle Rolf enters. Rolf, with the mouth that only knows how to turn down. Pomaded black hair slicked back. With overpoweringly bad breath. My mother always said it was because, as a child in Germany after the Great War, he had had nothing to eat but turnips. Clem would always say bad breath was a sign of bad character. Either way, Rolf is stuck with it. He clicks his heels through life as he orders his dominion at home and in a travel agency—an occupation neither vaunted nor bruited about by the family. With his heavy brass ruler always prominent on his desk, always at the ready, always an intimidation. How many times had it cracked down on his children's hands or backsides? I never wanted to know.

I did know that during World War II he had hung a map of Europe over his desk and moved pins of different colors to track the Nazi offensives. And it was whispered that at that time he had attended Bund meetings around the corner. This area was New York's Germantown, after all. No conversation had ever occurred between us, but two remarks from Christmas Eves past still stung.

I was a young teen in my prized red velvet dress, daringly scoop-necked and with a flared, scalloped skirt. For a rare moment, as I had looked in the mirror, I had dared to drink in my dazzling beauty. Soon after we arrived, Rolf said to my mother, "Isn't it time she lost her baby fat?" Followed by, "At the rate she's growing, she'll be too tall for a girl." He had skewered me where I hurt most.

For years I had slept in a tight ball, lest I grow in the night, when my guard was down, and I had never ever dared stretch in the morning. All to no avail. I grew and grew. I had perfected the art of compression by sticking out my pelvis, standing with my weight on one leg, and jutting my head forward. As for shoes, by wearing ballet shoes—fortunately, "in" at the time—and ripping the heels off my penny loafers, I could reduce my problem by half an inch. Now, in a flash, Rolf had turned "dazzling" into fat and gawky.

The following year, once again in my red velvet dress, I wore my ballet shoes. This time Rolf pronounced to my mother, "Those bedroom slippers make her legs look fat. Proper girls wear proper shoes with proper heels." I couldn't win. I wasn't meant to. The message was: Our

lives were a mess, while their lives ran like the clocks Rolf collected that ticked and gonged in unison.

This Christmas Eve, there is still no conversation. Rolf speaks. I listen. His communication, delivered in a guttural accent, still thick after decades in America, is to the point: "I hear you are planning to marry someone by the name of Greenberg." There follows a list of reasons why that cannot happen: the shame I would bring upon my family and myself; I would not be accepted in respectable homes, or clubs, or resorts or . . . He is on a roll. At some point Fred enters the room and stands at attention beside his father.

As a boy, Fred had socked me and broken my nose. I was four and had beaten him to the front seat of our car. When I was five, he proposed to me while we were fooling around on my bed. That pretty much ended our conviviality. He soon joined my brother, Norden—yes, named after the aforementioned White Hunter—in tormenting me, whenever and wherever. Fred and tears, that became the drill.

However, he sank to his nadir when I was in college and he asked me to set him up with my friends. The first turned out to be a feckless mischief-maker who, after he dumped her and moved on to number two, wrote him that he ought to know I was a lesbian. Fred told his mother, who, naturally, rushed the news to Poor Lolly, no doubt ending with, "What do you expect when you send your daughter to Bennington?" My brother, designated as the preserver of family virtue, dutifully confronted me during his next visit home and told me that such behavior would irredeemably destroy my reputation and chances for the future. He was terse and performed his task well. In shock, I stammered my innocence. No more was said.

Now, two years later, Fred socks it to me once again, this time for heterosexual waywardness. Like a good foot soldier, he echoes his father in detailing the life of estrangement and shame I can look forward to, not to mention the shame I will bring to the family. Lesbian or marrying a Jew, the verbiage is pretty much the same as Norden's, differing only in its vehemence.

The blood is awash in my head. I want air. I want out. I want to kill them. Smash their heads. Spill blood. At the least, wreak havoc on that

killing field of a room. My mother droops beside me, silent and stricken. Elfrida begins to play the contrapuntal good cop. "Jenny won't do anything foolish. She would never do anything to hurt Poor Lolly and her Darling Betty." Then, as the scene reaches its denouement, an off-stage chorus of one is heard. The Bund has fully convened.

Marlene, perhaps fearing contagion, never enters the den. From the living room she screams hysterically about the sin I am committing. She uncages the proverbial elephant by introducing sex and a smattering of Christ into the mix.

Since I had moved to New York that fall, Marlene and I had spent our first "grown-up" time together. I had shown her around the Village, new territory for the cloistered uptown Spence girl. She had bought a pair of sandals like mine that her father forbade her to wear. We had talked about boys and dating—the blind leading the blind. At eighteen, having never hung out with boys, she had gotten a vicarious thrill out of my virginal tales. But tonight, no doubt fueled by her family, our girlie talks have taken on a new reality: marriage plus sex plus Jew. Images she can't handle. She has gone over the edge and can't come back.

I rush for the door. How long have I been in that den? Fifteen minutes? More? The elevator takes years to come. I am imprisoned in that small hallway between two apartment doors. The Nazi—my name for him then, and forevermore—stands guard at his gate, white with rage, still ranting about my obscenity. My grandmother, who has arrived only moments before, stands in the foyer, bewildered, in her fur jacket and feathered hat, supported by my mother's arm. Behind them, Marlene, violently pushing her mother away, fires another volley: "Our grandfather is turning in his grave!"

That is my last look at my family as a group. But the Nazi has the last word. As the elevator door finally slides open and I step into its sanctum, haunted by someone's *arpège*, his voice thunders down the airshaft. "If you dare use our name in a wedding announcement, we will sue you."

The blur of Christmas lights ushered me down Park Avenue. I was a victim. I was a raging warrior. I was a martyr. I was omnipotent. I was powerless. I was all-knowing. I knew nothing.

Only a year earlier, there had been another taxi ride down Park from 1155. A senior at Bennington, I was going to meet my mentor, Stanley Hyman, for drinks at the Algonquin, the Mecca of the literati. I no longer needed a red velvet dress. I was beautiful, radiating with the power of being me. I spread myself across the backseat, arms outstretched, my feet propped up on the jump seats across from me. I told the driver I was going to a party, that I was a poet and had just published my first book and the party was for me. He said that was swell. And I said, "I know." I soared down the avenue. None of it was true, but what did that matter?

Tonight there would be no chat, no soaring. I wrapped my wounds with vitriol. Why wasn't my mother with me in the taxi? She who had said nothing. What was she thinking about? Was the Nazi reenacting the annual charade of Santa's arrival—thump! thump!—before sliding open the dining-room doors to reveal the ceiling-high tree ablaze with real candles, in the German way, a bucket of sand at the ready, just in case. Were they singing a rousing chorus of "Tannenbaum" as they entered? I could see the table sagging under the weight of silver: candelabra, bells, birds, reindeer, and cornucopias. Oversize glockenspiels spinning their chimes. Dishes of red cabbage, heaps of mashed potatoes, applesauce, gravy boats thick with innards, and chestnut stuffing, and lord knows what else. And there, set before the Nazi honing his knife, the carcass of the goose, who had laid its last egg.

Later, they would surely ooh and ahh over the blue flames of the plum pudding, and smack their lips over the *schlag* and crack their teeth on the marzipan and unforgiving German cookies. And then the presents, opened one at a time, with disparaging smirks at those not up to par. And Elfrida, would she cap off the ceremony with a spirited rendering of her annual family poem, which highlighted our doings in dum-de-dum rhymed couplets? My stanza excised.

At long last the candles would be snuffed and the glockenspiel angels halted mid-flight. Was it a Christmas like any other? Or would Betty shed a tear, then take a tiny compact from her tiny purse and powder her tiny nose until it was caked with powder and her lovely *blauen augen* were cloudier than usual? Would my aunt get more "tipsy" than usual

and slur and sashay to the kitchen and back, too gay and laughing too much? After dinner, would she sit at the piano and croon an after-dinner song, her face moist with feeling? And Marlene, was she stewing in sullenness, her father-mouth turned down more than usual? Was Manfred shadowing his father, keeping the troops in line?

And my mother, what did she do? I liked to imagine that five minutes after I left she drew herself up, squared her shoulders, said, "Enough is enough," and marched herself out. Or at least before the plum pudding. Whenever she left, she would take a taxi to 125th Street, then a train to the Manor Inn, where she would join her husband Harry, who had always known better than to set foot in 1155 on Christmas Eve. But no solace would await her there. He, a Jew hater, would say, no doubt had already said, "I never want to meet that man. She made her bed . . . " And she would shed more tears, silently in the bathroom, before crawling into the bed she had made to wonder how such a thing could have ever happened to her. What had she done wrong? And then she would do what she always had done when life went sour. She would sugar it up. They hadn't really meant all those nasty things. Surely tomorrow was another day and things would be better. And I hoped her dreams were of Tara.

Those were my thoughts as I headed downtown to Bank Street. Yes, I had someplace to be. Yes, a man waited for me. The catalyst of all those people's rage. The man none of them had ever met. But when I arrived, truth was, the man wasn't waiting for me. Oh, Clem was there, reading at his desk under his treasured green-glass lamp, but had he even noticed my absence or remembered where I had been going? I sat in the armchair and cried out my story, and he did put his book down and he did listen. Then he made me a drink, his panacea for all things distressing, and, before I had time to blow my nose, made it clear how relieved he was. Having severed connections with much of his family over the years, he now would be spared having to deal with mine. "Besides," he said, "those people are obviously barbarians. You're well rid of them."

And with that, the lid slammed shut on my feelings. They fled into the cracks and crannies of me. Easy as that. My mother had taught me well. I washed my face, glued myself together, and off we went to the parties.

Dinner with the Whitmans at Chambord—no goose on the menu—then on to a Christmas party at the "Skinny" Iselins'. Very fancy.

What I hadn't foreseen was an attack of such virulence. No one screamed in my family; violence happened sideways and sotto voce. I had struck a mother lode of bigotry that had been mostly hidden but was startlingly close to the surface. Marriage! The gloves came off. Jews were perceived as "foreign," "other," and by association, I was tainted. Yet, even so, I hadn't foreseen that I mattered so little that they would throw me away. Bigotry vs. Jenny: I hadn't stood a chance. I could even understand how they would have been able to eat hearty and rest easy that night. They had disowned me, wiped their hands clean of me. The irony would surface a few years later, when a family tree revealed that the hallowed Plattdeutsch patriarch's mother was Jewish. From Bohemia, she had brought her fortune and her Biedermeier into the family. Her descendents had selective awareness and memories.

As for bigotry itself, of course I knew about that. I had grown up in a hotbed of anti-Semitism. In most of Westchester County's suburbs, and especially in Rye, schools, neighborhoods, country clubs, and social activities were "restricted." The big, fancy house I grew up in until I was eight was in an area called Green Haven that prohibited owners from selling to Jews. My mother, on her descent into the marginal middle class after her disastrous second marriage, to the Con Man, was one of the first to break the covenant. Not out of principle, but out of need. My high school, Rye Country Day School, under financial pressure, had grudgingly opened its doors to a small quota of Jews. My best friend there was Jewish. My mother suggested that I not see so much of her, because I couldn't "reciprocate." Reciprocate what, I didn't say. Even then, I knew the limits of my mother's imagination. My friend continued to be my best friend.

Whatever had gone before, I had been set up that Christmas Eve. Certainly by the Augustins, but by my mother? I suppose it was possible that she knew, to some extent. But, like me, she could not possibly have foreseen the brutal turn the "conversation with Jenny" would take. I had never learned how to defend myself, other than to duck and run. One aftermath was that, overnight, I became super-sensitive to anti-Semitism,

sniffing it out whenever I came within shooting distance. And I have done a lot of shooting. As for that Christmas Eve, the event was soon eclipsed by more compelling experiences.

On Christmas day I went to bed with Clem for the first time. Wounded from the family wars, I very much needed the closeness with him. But it wasn't easy. Though I hated to admit it, sex still carried a "bad girl" stigma. Having never been rebellious, my early exploration had been confined to a furtive kiss with my best friend Cissy when I was ten. But oh, how I wondered about it. I had wondered since David, the handsomest boy in my whole thirteen-year-old universe, had kissed me behind the garbage cans at my friend's country house and told me I had the most beautiful lips he had ever seen and set my stomach lurching for weeks. Thereafter, stomach lurching would be associated with love.

At least until the day of the "posture pictures." The ninth-grade girls were taken one by one to a room in the basement of Rye County Day School, and I was told to take off my clothes. I stood on a platform under a bright light while a man took pictures, front and profile. I never saw the pictures, but the feelings lingered: Nakedness = shame = sex. A year later, I did what teenagers did and fell in love with my boyfriend Doug and made much ado about not "doing it." We necked and petted in the backseat of his best friend's car until I had orgasms without knowing what they were—all, of course, without going "below the waist."

I stood there in front of Clem. My nakedness made me feel ugly. Shame welled up in the depths of me. I wanted to hide. *A lover? How do I do it?* Here was a new, bad-girl role that I wasn't sure I wanted to play. But I touched his arm, the silk of his arm. This was Clem; this was the real thing. Then I was on the bed, giggly with nerves, wishing "it" would be over as soon as possible. No surprise, I experienced little pleasure and much pain. So much for my mother's "beautiful moment with the man you love."

After the deed was done, I lay on the far side of Clem's sheets, now stained with lord knows what, but what I romantically thought of as "my girlhood." My face to the air shaft, the thought that I would ever have to have sex again scared the hell out of me. But as I was learning, real life had a way of smoothing out the wrinkles of my mind, and gradually,

during the next month, that night was followed by another and another, until it wasn't frightening at all.

As a young girl with every reason to be wary of what each day might bring, I had found it comforting to think that if I could truly picture myself in some place, or with some person, then that would show me my path. In January 1956, I was confused. Although engaged to Clem, I still had no picture, none at all, of where I would be after Morton Street. But there were circumstances.

Debby had already started to move out some of her things to Norman's, in preparation for sailing to Greece with our friend Judy, and I couldn't afford to keep the place. Most of my other college friends—at least those who preferred men—had already married, or were engaged to up-and-coming banker- and lawyer-type guys who still had their hair. Growing up, I had always imagined he would be in my picture. In high school I'd married every boy I met, combining our initials, writing endless variations of our names, and doing numerology to see if we were compatible, as if compatibility mattered. We would go to country club dances on Saturday nights, live in a white colonial with a circular drive, have a station wagon, and make lots of babies. All the things that would make up for being a have-not in a town of haves.

It had been only four years since I had written in my Rye Country Day School yearbook that my life's ambition was "to be a model wife." Lord! But there it was, among the other eleven girls' aspirations of journalist, doctor, teacher . . . Fortunately, the seeds that Bennington subsequently planted about finding and fulfilling an "original" life wiped out my years of suburban brainwashing.

Yet even in the few months since my entry into the real world, the empowerment of those college years often seemed like an aberration. Oh, I knew my confusion wasn't really about suburbs and country clubs. It was more about wanting to opt out of the hardscrabble workaday life. I knew *TV Guide* wasn't in my picture, $8 raise or not, yet I had lost any aspiration for something better. It didn't help that in Clem's world, surrounded by impassioned people, I felt increasingly out of my depth and passionless.

But to hell with aspirations and girlish pictures of my future. Here was

Clem, a real man, a man with his own world. The most interesting man I had ever met. He found me attractive. He focused on me, listened to me, seemed to enjoy what I said and how I saw the world. He lit up in my presence. A man I could trust, who I could give my love to and know it would be returned. Compelling stuff for the fatherless girl summarily dumped at age five. And all firsts. Our relationship had evolved as if on an assembly line: We met, we got to know each other, we got engaged, we had sex. Now I was on the cusp of moving in with him. Then the giant leap: marriage. That would solve everything. Wouldn't it?

But didn't Clem challenge all the norms? I would be marrying strange. Twice my age, not much money or much of a job, and no interest in either. Yes, Clem was interesting. But why did I foresee loss? Loss of the girl who wrote rivers of poems, had even published a few in obscure magazines, and who loved her army-navy-store clothes. If I lived in Clem's world I would always be at the bottom of a ladder I didn't want to climb, a know-nothing in a world of know-it-alls. And so the seesaw went on.

Then, as if on cue, the requisite deus ex machina cut through the dithering. In mid-February, Morton Street was robbed while we were at work. The take was paltry—a small stash of jewelry accumulated from my grandmother, and a few things of Debby's. I called Clem, who told me to call the police and that he would be right over. The underwhelming event, at least by police standards, was duly recorded and that was that. Debby was staying over at Norman's and, unwilling to spend the night alone, my move into Clem's place began that night. After all, what was a girl to do?

This justification that I had no choice was very important to me. I clung to it. And why not? I was painfully aware that my unmarried college friends were either living with roommates or with their parents. And here I was "shacking up" with a guy, "living in sin." As titillating as the thought was, it didn't make me feel good. But then, as if to make sure I leaped off the cliff, the robber returned the next day and stripped us of whatever was left, including the chocolate cake in the mini-fridge.

A week later, feeling just fine and very grown-up about it, I moved into 90 Bank Street with my table, my typewriter—scorned by the discriminating thief—and my clothes. A few weeks later, with no ballyhoo

and no regrets, I quit my job. I would be a Mrs., a jobless Mrs. Wasn't that the way of the world?

From the outset, Clem's implicit acceptance of our living together surprised me. He could so easily have felt my presence as an intrusion. After all, he had never really set up housekeeping with anyone before. Even when, at twenty-five, when he had had the six-month marriage in California, they had lived in hotel rooms or with her mother. Yet here he was, taking it in stride.

As for me, more than surprised, I was astonished. Suddenly there was a man in my bed, there was a man sharing the small space, the bathroom, bureau drawers, all the day-in-day-out intimacies of life. And it was much easier than I had dreamed. Most astonishing of all, now that I was attached to someone, I felt free. It was that freedom that, at least for the moment, allowed me to indulge in floods of feeling: pleasure, misgivings, second-guessing, the delicious drama of it all. And I was the star. No longer a hostage to confusion, I now loved wallowing in all the reasons I shouldn't marry, while inside me, safe and snug, were all the reasons I most certainly would.

Floating on these delicious thoughts, two weeks later, right before my twenty-second birthday, I decided to visit my father in Chicago and my brother in Denver.

My father, David, stepmother, Marge, and their young son, Pieter—Dutch-ness will out—lived in an apartment on the Near North Side that was a testament to Marge's passion for all things purple. I didn't know any of them well. After the divorce, when I was five, I hadn't seen my father again for six years. Thereafter, I would make excruciating two-week visits each summer. As withdrawn and tongue-tied as I was with him, so he was with me. On the other hand, Marge was a loud, frightening force of nature housed in a large, bosomy body that she thrust into the world like the prow of a ship. I kept my distance. Pieter was a loving oasis, so proud to have a sister. Now, after almost ten years, I had reached a comfortable middle ground with the family. Or so I thought.

Cocktail hour, the evening ritual, begins soon after I arrive. As usual, there is the enormous platter (purple, of course), heaped with crackers

laden and soggy with braunschweiger and minced ham and cheddar, and celery stuffed with cream cheese and pimentos, and bowls of sugared pecans, and jumbo green olives. Restraint is not allowed in Marge's domain. Or in David's, at least in his delegated domains, the carving of roasts and the mixing of drinks. I had never called him Father or Dad. They were words that would never pass my lips; my brain just wouldn't wrap around them. Marge had often urged me to do so, saying how hurt he was that I called him David. Knowing I couldn't, I had done second best—I called him nothing.

He now holds sway over the large pitcher of iced gin. He deftly taps in a few drops of Noilly Prat, before he swirls the mixture briskly and fills to the brim the chilled martini glasses, each anchored with an olive. Do I on this occasion mention my preference for a twist? I like to think so, given my almost-married adult status.

Two martinis or more later, we move to the dinner table. Surely, that night there was a roast, with my father fulfilling his other manly function. And mountains of mashed potatoes and peas drowning in lakes of butter, and oceans of gravy, and Parker House rolls—this is Chicago, after all—crowned by a warm gushing pie. As always, there is a large cut-glass jar of hard sauce to ladle onto the pie. "I know how much you love hard sauce," Marge would say, and I would dutifully dollop it on. That would be the last time I ever had hard sauce.

Later that evening—I trust Pieter had gone to bed—talk turns to my marriage plans. I don't know how far I get into my story. Probably not an inch. I know I am never asked the obvious questions, such as how Clem and I met, what he does for a living . . . Within minutes, my usually passive father, who never, to my knowledge, has had anything to say about anything in heaven or on earth, leans forward and starts to tell a joke about a Jew and a priest. And then another and another. No one laughs but him. His Scotch shivers in his glass. Soon he is talking about "Them." "They're all alike." He has to deal with them in business, but he has never had one of them in his house. As with the Augustins, that he has never met Clem matters not at all.

I sit on the lavender couch, wedged between Marge's oversized purple pillows, as a lifetime of anti-Semitism pours over me. He is now on his

feet. His mouth won't stop. Jews have ruined the country, now they're out to ruin his family. All punctuated with, "dirty Jew" this, and "goddamned kike" that. *Where am I? Why am I here? Who is this man who looks like me and is so vile?* Somehow I find my voice. "Stop! If you don't stop, I'll leave. And I'll never come back." He doesn't stop. I escape to my room off the kitchen.

No grand exit. No slamming door. Unlike Christmas Eve, there is no elevator down to the street. No taxi to Clem and the rest of my life. I'm stuck until morning with my rage and humiliation. Once again I am deemed to be of no value; bigotry has won out. If possible, my father's tirade is more virulent than my uncle's. If possible, I feel even more jumped in the dark and punched out. The silent cipher has sprung to life, like a monster in a horror movie. Above all, that night in Chicago the stakes have been higher, and sadder. This is my father who has now thrown me away. Twice.

That first time. He must have left in the dark. He must have; otherwise, I would have heard him go out the front door. Did he carry a suitcase? He must have, at least one. My mother must have packed the rest, the suits and ties and underwear. Those things must have all left the house while I was at kindergarten at Mademoiselle Hupert's house, two roads away and around many bends. His things must have left quickly, because they left no smell or even a mote of dust. Not a stray sock.

My mother must have cried as she packed up the Adulterer's things. She must have lingered over this shirt or that monogrammed handkerchief. She must have sat down now and then, overcome by shock, and bewilderment, and terrible pain. I knew nothing. I was never told anything. Not even that he had gone. But I knew he must have left in the dark. And, like the obedient child that I was, I erased all images of him from my mind. My memories of him had been tucked into those suitcases, and I never saw them again.

The next morning, Marge corrals me for a tête-à-tête, reeling off a *Ladies' Home Journal* list of reasons to think twice: cultural differences, children raised in a different faith, when you're forty he'll be sixty-five, he'll die when you're still young . . . I look at her blankly, at her flat, pan face. The outlandish image of Clem in a yarmulke drifts across the room.

She hasn't a clue about who I am, who Clem is. And it doesn't matter. My father is a no-show. No good-byes. Once again, no good-byes. How could there be? There has never been anything "good" between us.

In Denver, things ran true to form. I knew my brother: hail-fellow, cocky, always with his eye on the next big deal, happiest with a rifle or fishing rod in hand, and tight with a buck. There was no racist rant from Norden. But no commiseration with me over my Chicago tale, either. In fact, he was taken aback by my mass alienation of our family. That they were the ones who had alienated themselves from me never penetrated. In his fatherly/brotherly way, he offered his advice. The gist, to mix platitudes: Sit on the fence, and you'll never burn your bridges. And, consistent as always, he didn't burn his bridge with me. That would happen a year later, when he and Clem met. They quickly developed, on their own personal terms, a mutual dislike that deepened over time and that in turn intensified my own, already hefty dossier of resentments toward my brother.

On that visit, though Norden didn't provide the huggy, warm reassurance that I craved, he did his best and I enjoyed my time with him. He threw a birthday party for me. We went skiing—well, let's say I tried. I met and liked his girlfriend, Lou, whom he would soon marry. And one day, armed with leftover cans of house paint and fat brushes, I painted an abstract mural in his basement rec room. My way of thumbing my nose at all the full-of-themselves artists I was meeting—*hell, anyone can do this!*—even as I danced with exhilaration at the sheer fun of it. I don't think I told Clem. It was a one-shot and it was all mine. I even spent a snowed-in night in a mountain lodge with a forgettable friend of Norden's. I had an irrepressible urge to see, just once, what another penis looked like before I disappeared forever into monogamy. I didn't tell Clem about that, either.

I flew home the next day. I had visited the two men I had been dealt at birth. Though both had fallen short in demonstrating their love in the past, I had harbored the wish that they would have stepped up now. Perhaps, hearing the final call of Electra, I had wanted them to be jealous of this man who was snatching away their only daughter and sister.

I had wanted to hear the words "Come live with me, I will take care of you." Not that I would have ever done that, but I wanted to hear the words, or something like them, simply because I never had. Instead, in a raging blizzard, Norden waved me a breezy good-bye, and I flew to LaGuardia, landing after midnight in yet another blizzard. I spent the night in the airport, before a bus made it through and took me to New York, and Bank Street, and Clem.

To celebrate my return and, belatedly, my birthday, Clem had gotten tickets for *The Pajama Game* for the following night. He had also, in an adorable spurt of domesticity, bought new sheets at Gimbels. The die was cast. And to the buoyant strains of "Hey there, you with the stars in your eyes"—our official favorite song—I assumed my new role: Wedding Planner.

MARRIED

THE HOW AND WHERE we would get married mattered little to me. But the when, that was important. Somehow, May struck me as the perfect month, neither too soon nor too far off. And the fourth, the first Friday, would be the ideal weekday, workaday kind of day to suit Clem's no-big-deal parameters. And so it would be.

Meanwhile, our social life of drop-ins—whoever called during the day would be invited to come by for a drink around six—and parties rolled on much as before. On everyone's schedule were the gallery prowls, usually the first Tuesday night of the month for openings and Saturday afternoons for seeing everything else. We would start on Fifty-seventh Street, then wander north on Madison, winding up at, say, Tibor de Nagy or Martha Jackson's, who could be counted on to be serving drinks. These nights were like parties, meeting, as one did, friends along the way and ending up around large tables at some low-end bar or restaurant. More often than not, we would then head back downtown to the Five Spot or the Cedar.

In a matter of months, the pace seemed to speed up. More galleries, more openings, more painters from abroad, more new faces passing through our eighteen-by-eighteen-foot living room. Artists who weren't selling at their galleries now sneered louder at other artists who they said were "selling out" to the newly roused media. For years, Jackson Pollock had been the prime whipping boy, ever since his spread in *Life*, which, as skeptical as the tenor of the piece was, had turned a national spotlight on him and the "new" abstract expressionist painting. Now, everyone was fair game. In unison, artists took to task the Johnny-come-lately museum directors and craven collectors who were limping warily onto the belatedly perceived bandwagon, buying a bit of this and that

43

on spec, before hastily retreating uptown in their big cars with uniforms at the wheel.

While I was still swooning over movie star sightings, celebrities were beginning to swoon over the artists. In 1956, the flamboyantly rich Ben Sonnenberg, the so-called "father of public relations," had heard the bandwagon loud and clear and contacted Clem. There were drinks, a few lunches, sometimes including me, sometimes not, always unsparingly charming. One day Clem and I were walking down Madison Avenue, when a Rolls-Royce touring car from the thirties pulled up. Of course it was Ben, inviting us to join him. In a castle on wheels, we seemed to float high above the street, the crystal flower vases by the windows, a rose in each. When Ben got out at his destination, he told the driver to take us home. I held Clem's hand and resisted waving at the peasants as we sailed down Fifth Avenue. Surely it was the most exotic and grandest of all the rich people's cars that ever had or ever would pull up outside 90 Bank Street.

Soon Ben began inviting us to his lavish parties in his mansion on the south side of Gramercy Park. Number 19 comprised two elegant townhouses melded into one. Oh, that house, with its seductive excess, replete with circular staircase, ballroom, art of the Masters, and plushness of the rich. And brass, Ben's signature touch, was everywhere, as art or decoration. As he did with all his passions, he indulged in brass beyond measure, all floors fairly ablaze with it and polished by a special "brass polisher," as if to vie with the sun, as if to put gold to shame.

For all his worldly persona, Ben was an ardent family man, oozing with gemütlichkeit. It took a few intimate visits to get to see that his heart belonged to his wife, Hilda, whom I met only twice and who rarely attended the parties. It was in the midst of one of those soirees that Ben asked if Clem would go have a chat with his son and gave us directions to his room. The sounds of the party faded as we passed through a labyrinth of dark corridors, eventually knocking at a door of a small room dominated by a tall young man who, though shy, seemed to take our visit in stride. Clem drew him out about his interests. They talked of art and writing. Not a chip off the old block, he might as well have been a student in a garret in the Village. I thought, *Like mother, like son.* I knew

that Hilda, too, had chosen to absent herself from Ben's world and spent most of her time in their house in Provincetown. The notion of Hilda and Ben's marriage of intimate distance intrigued me. It was new to me. I wondered if Clem's world would ever get so big that it would take forty rooms to hold us in harmony.

Ben understood that the fun of a party was in the collision of worlds. Nothing random, everything about Ben was contrived. Most people were there because they were interesting, beautiful, very rich, or famous. In my fanciest duds—I had now graduated from Peter Pan to an off-the-shoulder black number—I devoured from afar the likes of Kirk Douglas, Montgomery Clift, and Maureen O'Hara.

One night, Clem and I found ourselves pressed close to Janet Gaynor and her husband, Adrian, the fabled costume designer of the thirties. By now, I had come to accept the diminutiveness of movie folk, but those two were the tweeniest of them all, and between the din and their soft-spokenness, I almost had to squat to hear them. They were way before my time, but I was slightly reassured when Ben whispered that Gaynor had won the first Academy Award in 1928. Then suddenly the star blazed with excitement as she cried out, "It's him. It's really him!" I turned, expecting Jesus, and saw only Bill de Kooning coming toward us. We introduced them and left them to their twittering awe.

I was even more taken aback when, at another party, a few months later, this one given by theatrical lawyer Bill Feitelson, I watched Rosalind Russell and Gloria Swanson close in on Clem, foot-long eyelashes fluttering as they cooed about art. I wondered what planet I was on. I think Clem wondered, too.

The art rush was on. The cash registers were beginning to *ka-ching*. As bemused as I was by the fervor of it all, I was also aware of how long it had been in coming. I knew that since the late thirties, Clem had been writing about abstract expressionism and these artists, heralding their work as the best new art being produced anywhere. Here, Paris, anywhere. What was it about his lovely hazel eyes that they were able to see what others couldn't?

That art scene was becoming mine, at least insofar as that was where I spent most of my time. If someone had made a movie about that world,

I would have been a nameless bit player, the girl who stood off to the side of one of the leads. As the novelty wore off, I grew accustomed to that bit part and, not knowing how to change it, succumbed to it. More unsettling were my behind-the-scenes, unstructured days. There had always been school, a job. Now, for hours, I read and thought about poems that I would never write. I hadn't the words. Soon I stopped thinking about it.

I was amazed by how insular the art world was. Not that I knew anything about culture "worlds," but I figured it was because the New York scene was so relatively new and small. I was particularly disappointed that there was so little interaction between artists and writers. Clem, associated with all the avant-garde magazines, from his *Partisan Review* days on, had always moved in both circles, but, unfortunately for me, the literary people had turned out to be the social casualties after his breakdown. As he had told me that first night at Delaney's, he had pretty much made a clean sweep. True to his word, there would be only a few forays into the literary crowd, during our first months together, and then none.

Yet even as I prepared myself for total art immersion, an exception presented itself, a party at Lionel and Diana Trilling's where I met Mary McCarthy. She outranked any movie star, thanks to her sexy, cut-to-the-chase short stories in *The Company She Keeps*, which I had gobbled up at school. Fabulously beautiful, with her pale delicacy, she had all the litheness of a swan and, with her gleaming dark hair, all the sly sleekness of a panther. I even managed an exchange with Jessica Mitford, who so flustered me with her cool British-ness that while gushing and blushing about how much I loved her books I made a senseless hash of titles and characters, none of which she had written. She rewarded me with a smile of ill-disguised pity for which I was abjectly grateful.

More sustaining were the parties given by Oscar Williams, the poet and anthologist, and his poet wife, Gene Derwood. Oscar, almost leaping out of his shoes with the joy of life. I was glad he had escaped Clem's clean sweep. Oscar lived on top of a small industrial building on Water Street near the fish market. Dark, not a soul to be seen except the poets climbing those rickety steps to the promise of spending an evening with

writers who wrote. One night, I stood on the roof next to Saul Bellow, looking at Brooklyn and its beloved bridge. We talked about the Dodgers and I told him how, as a child, my older brother, a fanatic Giants fan, had for years made me memorize all the Giant lineups in order to impress his friends. Saul smiled and said, "Not a bad thing to know." I remember thinking, *This is a moment.*

And then there was a quintessential New York moment. Rush hour, pouring rain, no umbrella, not a bus in sight. I had just come out of Macy's, having had a lousy haircut on the cheap, when a taxi from nowhere appeared. As I reached for the handle, another hand covered mine. She smiled fiercely and growled, "Mind if we share?" Somehow, between 34th Street and Bank Street, we warmed to each other, exchanged names, and I almost fainted. My new best friend was Jean Stafford, the woman who couldn't write a bad short story if her life depended on it and whose novels *The Boston Adventure* and *The Catherine Wheel* had opened my eyes to what it might be like to write from the inside out.

I gushed compliments and then, overcome by sheer abandon, I blurted out that I had just moved in with Clem, who I figured she probably knew. She did, and I asked her up for a drink. She accepted, and the three of us hung out drinking for an hour or so. I was delirious—finally, a conversation I could bathe in. Then, too soon, my new best friend dashed off into the night and out of my life forever. Well, except for an occasional wave across some vast bar or restaurant. She, by then married to A. J. Liebling, I, by then married to Clem, we were evidently not destined to be a foursome. All for reasons, past and not forgotten, such as happen in a social enclave too close for comfort, and such that I could not begin to unravel.

Yes, there were a few time-outs, but for the most part life was art, art, and more art. My days, unstructured as they were, slipped into the semblance of a routine. Usually, having been out late, we would sleep until ten o'clock or so in the sanctuary of our air-shaft bedroom, which would turn into bedlam on weekends, when the building's weekend drunks would get it on, loud and violent, the women, to my surprise, outlasting and outcussing the men. I'd make breakfast for Clem: orange juice or half a grapefruit, one fried egg sunny side up, yolk runny but not too

runny, two strips of well-done bacon, one piece of rye toast, and one cup of coffee, half with the egg and half after. Me? I was more of a corn flakes and orange juice sort. Then Clem would go off to *Commentary*, just like the husband in my "picture." Well, with a few tweaks here and there. And I would busy myself with what I thought a wife-to-be would do—I nested.

My new nest came with a new neighborhood. Ninety Bank Street marks the spot where Hudson Street becomes Eighth Avenue as it continues to Central Park. Then, as always, it was a major truck route northward through the city. Problem was, Hudson Street was still paved with cobblestones. Day and night, starting around 4:00 AM, the trucks would *ker-thump* past our second-floor apartment. The bigger the trucks, the more our windows rattled.

Across Hudson, on the corner of Bleecker, was the last public toilet and watering hole for horses in the city. An elegant Greco-Roman octagonal structure, it could easily have passed for a monument to the heroes of a forgotten war. I never saw anyone, living *or* dead, enter. Directly across from us was a storage facility with blind windows, and to our north, a massive GE warehouse. All of which provided us absolute privacy; no shades ever need shroud our windows. A block north, Abingdon Square, established in 1836, sat as a gateway to the smooth macadam of Eighth Avenue. For all its high-tone name, it was in fact a small woebegone triangle with a few splintery benches and a forbidding statue of a war-weary soldier dedicated to the neighborhood casualties of the Great War. No one, except an insouciant pigeon or two, ever sat or played inside the park's iron fence. A pall lay over it, and I fantasized about what dreadful thing might have once happened there.

Of course, on the ground floor of our five-story building was the Imperial Liquor Store with its neon sign, which on warm spring nights hummed and sizzled. Al, its owner, was like family, except better. He cashed checks and stocked Tanqueray for Clem, an exotic brand of gin in 1956, and a big step up from the $2-a-quart Mr. Boston's from my college days. Also under us on the corner was an appliance store with air conditioners and television sets that sang siren songs to me as I walked by. Within the year, I would talk Clem into buying both. The TV in time

for the World Series. The air conditioner was a harder sell to someone who had lived his whole life in New York without one. But like so much that I introduced Clem to—like having a Christmas tree—he took to it. Especially the TV.

Unlike me, Clem never watched indiscriminately; it had to be funny or real. In particular, Imogene Coca and Sid Caesar, and the fights. We would each score rounds to see who made the best call. He was chagrined that I usually had him beat. On Sunday afternoons the set would be on to whatever game was on, with Clem wandering between his desk and the bedroom, a drink in one hand, a book in the other. Somehow, he never missed a big play. But the best was when we curled up for late nights with Jack Paar. He was right up our psychological alley. For five years, from eleven thirty to one fifteen, it was like watching a striptease of the man's id, ego, and superego. It was such a New York show, so hometown.

I may have assumed a new role, but I didn't have the props. A cook with no pots, a housekeeper with no vacuum. One Saturday afternoon, on the way to a movie at the Greenwich, we went to a hardware store and bought two Revere Ware pots and a frying pan. I foresaw that this might well be a one-time shot at domestic togetherness. And I was right. But that day Clem was as exacting as if he were looking at paintings. The pots must be the precise size to suit our needs, and they should last for millenniums. To me, a pot was a pot. Then, as if on cue, a salesman arrived at our door, selling vacuums. I wasn't home, but to my amazement, Clem bought one. He was very proud of that major purchase. To me, it was better than diamonds. I was now a bona fide housewife, and as such, I began to gussy up the bare bones of my domain.

At a fabric store on West Fourteenth Street I bought a nubby, mold-green remnant of mysterious origin for a dollar to re-cover our upholstered chair. Also a curved needle, edging, and fabric glue, all recommended by a motherly saleslady. On the chair's weary frame I cut and draped and sewed and pasted, then stood back to admire my handiwork. If I squinted it looked fine, except for the bilious color and the springs poking up that hardly showed at all. Next, with a scrap of shiny white cloth with large gold dots, a piece of string as a curtain rod, and thumbtacks, I fashioned a curtain for the tiny window in the bathroom. For my finale, I painted

the bedroom a dark rose, with grim results. Terrified ever after of wall color, I would never again venture beyond white.

Then, once more, as if on cue, another salesman appeared—probably a relative of the vacuum guy—and sold us a rug off his truck for the bedroom. Puce, which effectively transformed grim to grimmer. The rug shed and smelled iffy, but we hadn't expected too much for $15. I took on the entry into the kitchen, stacking and restacking Clem's paintings that were stored there, hoping each time to further compress them. I needed the space because I wanted to put away Clem's paints, card table, and easel. I wanted a living room.

Clem turned a disinterested eye on all these "improvements." Except for the rug. Being a barefoot guy, he relished its softness and in later years became addicted to wall-to-wall carpeting. While relieved that he didn't criticize my efforts, I was disappointed that as much as I puttered and pasted, no one really cared but me. That was on gloomy days. Most days I suspected Clem got a kick out of it all. And I knew he loved the eggs and bacon.

On rare occasions, we would invite four people for dinner, that was my limit. I would set up our two card tables and, to disguise their different heights, cover them with the damask tablecloth my mother had given me. I would serve my only dish, beef Stroganoff and mashed potatoes from the *Good Housekeeping* cookbook, a present from my college friend Nancy Spraker. One night, right before Esther and Adolph (Gottlieb) and Ileana and Leo (Castelli) arrived, Clem made some remark about the potatoes and I threw them at him. He laughed, I cried. Though I was secretly thrilled by my audacity.

Any criticism was agony, but with cooking I was most vulnerable. I had never learned how. Helping in the kitchen as a child had meant mashing an orange pellet of food coloring into a pound of lard to make "butter" during the war rationing years. My mother was a hamburger, hot dogs, Jell-O, and open-a-can kind of cook. Best times were when we would go across the Boston Post Road from our apartment house to the diner. A real diner, silver on the outside, with porthole windows grimy with steam and torn-up red booths. Turkey with soggy dressing and bright yellow

gravy and soft rolls topped off with gelatinous cherry pie. Heaven. Our hair would frizz from the steam. And my mother wasn't tight-lipped and cranky from having to do something she loathed.

Unfortunately, I followed my mother's ways and ever after felt alienated in the kitchen. When I cooked for people, it was not with love but with trepidation. Coupled with that, my taste for food remained that of a child, a diner child. Before college I had never tasted anything as exotic as lasagna or pizza. An analyst would tell me one day that food hadn't been "validated" for me—my first encounter with psychobabble—which I found marvelously funny. It was also true.

About once a month, Clem and I would give a party. Unlike our drop-in gatherings, these were the real thing, where we actually called and invited people. "Spit backs," Clem would call them. Cheese, chopped liver, and some nuts would suffice. And no A and B list; uptown, downtown, and sideways, we invited everyone who had recently invited us, plus close friends and anyone who happened to be passing through. In fact, parties were often prompted by out-of-towners, usually young artists who Clem thought should meet as many locals as he could round up. He believed strongly that artists should get to know each other, talk about art, see what was going on in New York up close and personal.

One such evening was a particularly large party for Pierre Soulages, in from Paris. There was the usual throng of Bennington girls and art types, among them Lee and Jackson. By now, I had gotten to know them a bit. We had been out to their place in Springs for a few weekends. Uncomfortable times, for me. Things were easier in New York when they would sometimes come by on Jackson's weekly trip to town to see his analyst. Such was that occasion.

Mid-party, mid-crush, Jackson pinned me against the stacked paintings in the kitchen and started in on all the reasons why Clem and I shouldn't get married. Clem was too old, I was too young. Why would he want to marry me? Fucking was one thing, but you don't have to get married. What the hell did I think I was going to get of it? On and on, ending with the inevitable coup de grâce, "If you think it'll last, you're crazy." Nothing new, except for the language, from the garbage I'd already heard

from my family and even ex-teachers at Bennington. But this was the first, and only time, anyone close to Clem had confronted me, and the only time I was the bitch who was out to hog-tie Clem.

Not to say that over the years there wouldn't be critics of my performance as Clem's wife. My reviews would trickle in and were often harsh, but they were never said to my face. But to Jackson that night I was a nobody who had crashed the good-old-boy party. I wasn't shocked by his words; I had grown up with a raging drunk. But I was hurt and bewildered. Who was this angry guy breathing Scotch all over me? Why did he care so much? Was he afraid I would break up his buddy times with Clem? As if I ever could, or would. But I never had the chance to say a word. I was trapped. Tears were welling, and Jackson backed off.

I probably told Clem the gist of what Jackson had said. And he probably replied, "Fuck'm, he's drunk," or some such. Jackson soon left to continue his own party and no doubt forgot all about it. I would have to do the same. It was painfully clear to me that other people were never going to get Clem and me right. Also clear was that Clem was an old hand at not giving a damn about what others thought. I was going to have to learn fast how to toughen up. And then we all went out to dinner at El Faro, the cheap Spanish hole across the street on Bleecker, and that was that.

The post-party drill was always the same. After dinner, depending on the crowd, we might wind up going back to Bank Street for a nightcap and more art talk. Sometimes Clem would put Fats Domino on the portable record player and we'd get it on to the thrills of "Blueberry Hill," or Bill Haley's "Rock Around the Clock," and we'd dance. But most often, dinner would be followed by a walk down Hudson to the White Horse for drinks in the back room, or the Half Note for jazz. That was always the destination if artists David (Smith) or Ken (Noland) were along, or if the out-of-towners were from abroad. To them, jazz was the big thing. So American, after all. So like abstract expressionism, they would say. With that, they would segue into rhapsodies about the American West, cowboys, and, for some reason, San Francisco. Clem would shrug and call that kind of thinking a bunch of crap picked up from second-rate writers in American art magazines. A trip west? A waste of time. Just

look at the art, all of it, he would say. Go to studios, see what's going on here, where it's happening.

And for happening jazz there was the Half Note, the Five Spot on Cooper Square, the Vanguard—those were the places. We heard Thelonious Monk, Ornette Coleman, John Coltrane, and so many others. For me, it was all Thelonious, though it would be an acquired taste. Ever since the days when my high-school boyfriend and I and a bunch of friends would drive into the city to Eddie Condon's, the girls in their crinolines primly tapping their feet, smoking, drinking Horse's Necks, feeling sophisticated, listening to music we couldn't dance to, couldn't sing along to, I had found the sounds discordant, jarring, and boring. My heart was still with Patti Page and "The Tennessee Waltz." But Thelonious now broke through to me. "Blue Monk," "Round Midnight" . . . I didn't know all the names, but whatever he played, he and the music were one. I could let go and not think about what I was listening to. Being there was all. A new experience. I couldn't listen to jazz on the radio or on a record. Canned, congealed versions of the real thing. I needed the darkness, the smell of booze and smoke, and the sweat and passion. What came out of them was raw. I never could accept that what I heard had names or had been put on paper.

Some weeknights at the Five Spot there were now poetry readings. Among the dreadful were a sprinkling of stars: Kenneth Koch, Kenneth Rexroth, Allen Ginsberg—who would later knock our socks off, and everyone else's, with his *Howl*—and all the Beats, who would soon be packing them in. And the capper for me was that the jazz clubs weren't the Cedar Bar.

There were also the quiet evenings with Clem's closest friends, one of whom was the painter Friedel Dzubas. Wiry, dark, a lingering German accent that on Friedel, even to my German-phobic ears, sounded charming. A dedicated womanizer, he seemed to be wrapped around a different dazzler every week. I liked him. He was fun and lively.

Clem's other close friend was Sidney Phillips. Clem had met him in 1938 within weeks of moving into the city from Brooklyn, where Clem had been living with his family. Thanks to a $30-a-week government job at the Customs House, he had finally been able to afford a place of his

own, a room with a bath down the hall for $25 a month. Sidney was in publishing, first at Scribner's, then at Dial, and by the time I met him, he and his wife, Gertrude, had founded Criterion Books. We saw them often, usually for dinner at their place. Talk was about books, a relief for me, and sometimes we would dance to Belafonte records. For Clem, Sidney was that soul-mate confidant, that touchstone of common sense who was always there for him. They were a perfect choice to be witnesses at our wedding. In turn, they asked if we would like a party afterward. Yes. And if we would like to use their farmhouse in Great Meadows, New Jersey, for a weekend honeymoon. Yes, again. They even offered the use of their car.

My new geography was now sliced into two parts. Downtown was jazz, poetry, artists, studios, seedy bars, cheap restaurants, Bon Soir, hot singers and comics, Levi's, sandals, and tatty sweaters. Uptown was openings, sedate bars, cocktail parties, restaurants with soft lighting and softer carpeting, my black dress, pearls, pumps, and purse. The division was unequivocal, as if the Great Wall of China had sprung up across Fourteenth Street. Actually, Fourteenth Street itself was still on the "right side." Hofmann, Kline, and Gottlieb, among others, lived or had studios there.

The demarcation was brought home to me one day when a high-school friend called—that very friend behind whose country house I had first been kissed. Not having been in touch since we'd gone off to college, I was excited to hear from her and suggested she come visit me. "I never go below Fourteenth Street," she said. I could feel the ice pass through the wire. She didn't come, and I never saw her again. Not because she was a snob, though she was a bit, but because she had a point. I had "crossed over." It was as finite as that.

Even with my college friends, lines were being drawn, though of a different kind. It became a time of gradual sorting out and diminution. I had imagined that now that I was an almost-wife of leisure, I would have "lunches with the girls." I tried. One friend now lived with her new husband in an apartment on lower Fifth Avenue and, though she was downtown, the doorman, fancy building, and talk of redecorating and babies in the imminent future soon squeezed our friendship dry.

I really hit bottom with another friend. I knew her well. We had both gone to Rye Country Day School, as well as Bennington. She now lived in Forest Hills and had recently had a baby. She sat with jars of baby food and the TV tuned to soap operas while she complained about her young banker husband, who left too early and came home too late. Her tale was as dull and drab as her surroundings, the air oppressed. In high school, from afar, I had wanted to be her, even more than Debbie Reynolds. She was the brightest light, the "most likely to" girl, wherever she was, was where I wanted to be. In college I had adored her as we sat under a tree, she reading Baudelaire in her flawlessly accented French. Now, pushing her carriage as she walked me to the subway, we passed through streets that screamed "suburbia" and "Rye" while she talked of what she was going to make the banker for dinner.

I was dismayed that she had fallen into the very sinkhole we had so recently rejoiced at escaping. I said nothing. Her lights had gone out. Her quick wit and sense of irony had shut down, and I knew we wouldn't be able to share the joke of it all. Her sadness tracked me home, lifting only when I got below Fourteenth Street. She and her handsome husband came to Bank Street a few weeks later and we went to dinner and the Five Spot. Afterward, Clem summed her up as "dowdy" and mentioned her bad breath. There was no follow-up, and I didn't see her again. In her forties, she would asphyxiate herself in the garage of the Westchester house they had moved to as her husband got richer and, I guess, she got sadder.

My attempts to keep my friends came up empty, with the exception of my tried-and-true Village cronies. The rest were tourists, while I had become a tourist in their worlds. I didn't know how to talk to any of them anymore, to confide in them. How could they possibly understand how scared I was that in Clem's world I might forever feel like a fish out of water, how scared I was of the feelings of boredom and deadness that would sometimes wash through me? How dare I complain about my new life, which seemed to them to be so interesting, even glamorous? Besides, wasn't I supposed to be happy because I was getting married? Sadly, I was closing the door at the time when I most needed to be close to girlfriends who could remind me of who the real Jenny was. Changes

were happening so fast, no matter what Clem had said that day of our engagement.

It turned out Clem had a wish list. First, I should be his barber. Reluctantly, I gave it a try. He was bald on top. How hard could it be? Shears in hand, I gingerly picked up bits of his superfine, silky hair and trimmed around the bottom of the fringe, while Clem grumbled that, like a real barber, I should use a comb rather than my fingers. I became defensive in my "take it or leave it" way. And he, being wary, no doubt, of a temperamental barber wielding a sharper instrument than mashed potatoes, suppressed further criticism. Layering the hair on the sides was trickier, and I invariably exposed a spot or two of scalp. But on the whole I rather enjoyed the process, the intimacy of it, and I thought I was pretty good at it. Clem was overjoyed; he'd always wanted to be shaved with a straightedge. He had seen Carole Lombard shave her husband in some thirties movie and, I guess, had found it a turn-on. I said no, with a look that brooked no argument.

Clem's second wish was that I would be, in effect, his amanuensis. In addition to typing, he wanted me to read what he wrote and tell him what I thought. Though I could touch-type, which was what had impressed him initially, I was slow and inaccurate when under scrutiny. Fact was, with his own, half-assed method, he had me beat. As well, he was an exacting writer, paring and refining, subjecting each word and comma to repeated editing until he was satisfied that each piece conveyed his precise intent in the least possible words. Over the years, Clem would lecture far and wide. Invariably, during the Q & A period, some hapless person would attempt to paraphrase something he had written. Clem's response: "If you had read more carefully, you would know that what I said was . . . "

Letter writing, though much less painstaking, presented a different hazard. By the time I had erased and corrected the original and the carbon, the letter could have been halfway to Mars. His dream that I would relieve him of his onerous chores was gradually laid to rest. A few years later I would take speedwriting classes—shorthand for dummies—again in an attempt to be a helpmate. I enjoyed it, and it would serve me well over the years. As for being an in-house reader of his pieces, it was an

appealing idea but obviously impossible in practice. In any case, Clem's writing was Clem's writing, and, whether letters or manuscripts, it stayed his own, from first draft to last, exactly as it was meant to be.

His third wish, that I should be his banker, was easier. I loved numbers, had even entered college as a math major. I paid bills as they arrived and balanced the checkbook. New to me, I'd never had a bank account. And so simple: rent, utilities, that was about it. Until the windfall.

One afternoon, on the way to some MGM extravaganza at Loew's Sheridan, I picked up the mail. In the dark I opened a letter from my rarely glimpsed Philadelphia aunt, my father's sister. Out fell a check for what I thought was $25 but that, on closer look, turned out to be $250. A bloody fortune, and mine. A wedding present. Someone in my family had at last done the right thing.

When I got home I proudly waved the check at Clem. He grunted, stowed it in the checkbook and, before returning to his book, mentioned that Danny would soon be coming by. Danny was Clem's twenty-year-old son. He was at Georgetown University, not his first or last college, and I had barely seen him since first hearing about him at Delaney's bar. Tall and thin, his bones jutted through his clothes. Ashen skin stretched taut across the sharp planes of his face. He walked with small, urgent steps, hunched forward like an old and desperate man. His hair, already receding from his high forehead, was thin and light brown, his eyes a blazing blue. He chain-smoked, his body never still, no eye contact. He spoke in a monotone, rat-a-tat, fast and angry, an incessant bark. He couldn't listen; he could only challenge. When he did come over, he came for money. He came for much more from his father than that, but there was no bridge, never had been. The other times I had seen him there had been other people over, and he had managed to squeak by socially. But that afternoon the gloves were off.

As the light faded, we sat in semidarkness. Danny needled and goaded Clem until they fell to shouting and almost came to blows. I was frightened. I had never seen or heard anything like it. I wanted to shut them up, throw Danny out, scream at them, cry for them, all at once. I pitied Danny. I wanted to mother him, make him whole, make him smile. I wanted him to like me. I wanted to like him. But he made it impossible.

Just as he always slammed doors instead of shutting them, early on he had slammed the door on me.

Eventually, somehow, they calmed down, and Clem reached for the checkbook. Checks to Danny, whether mailed or by hand, he always wrote out himself. He then turned to me and, holding out my aunt's check, asked me to endorse it over to Danny. I froze. Did I say something like, "But it's mine," or did my face say it all? Either way, Clem said very quietly, very simply, "There is no me-um, tu-um between us." The lesson was swift and harsh. I'm sure there were tears as I signed. There I was, like a ten-year-old, crying over the check, knowing that I wanted it both ways: to be taken care of and to keep the bounty that had fallen into my lap. Fortunately, later that night, the quasi-adult in me surfaced and the rightness of what Clem had said and its real import became clear. We were partners. The thought had never occurred to me.

Money was a hot zone for me. I had grown up feeling the pinch that had started after my mother's two-year marriage to the Con Man when I was six. He had stripped her of all available assets and, thereafter, my mother lived on the income of a trust fund set up by her father. Not large to begin with, its value diminished over the years. There was no alimony from the Adulterer; child support was $50 a month.

I first felt the squeeze at Christmas time. Later, the effects became more pervasive. My mother would take us to doctors down back alleys in New Rochelle and to an ancient orthodontist, who never did get my brother's or my teeth straight. Rock bottom for me was when, instead of buying clothes, she would take me to a dressmaker, an old woman who didn't speak much English and who lived in an apartment building that smelled so bad I held my breath. The woman made me school dresses out of scratchy fabrics that didn't fit right and looked too old for me. I would stand before her mirror, she on her knees with pins in her mouth, and when she looked up at me, I tried to smile. I felt so sorry for her that I could never say anything. Even when she concocted her worst, a maroon wool number with pleated skirt and "bolero" jacket. I looked like a blood sausage, and my stomach would turn when I saw it in the closet.

Never would my mother explain the reason for her economies or what I could and could not expect. And knowing what to expect—after two

fathers and four schools before the fifth grade—was a gift I most yearned for. Further skewing my financial perspective, my brother had been left a large bequest that he would inherit at twenty-one. I had been born after The Great White Hunter's death, and my mother had reinforced her son's sole entitlement as the man-child. Girls, as she would always say, would marry—an eventuality that, to her mind, also eliminated the necessity of such things as reading books, learning to drive, and going to college. Meanwhile, as we slipped down the financial ladder, she would always say with a forbearing smile, "Money doesn't grow on trees, dear." And I would always want to kick her and tell her to hurry up and figure out where it did grow.

Now I was going to marry, and thanks to Clem I was in a "partnership." On some occasions the partnership took a curious turn. There was a vaudeville routine Clem sometimes launched into when people came by for the first time. I was the straight guy, and it went like this. While Clem went to get drinks, the visitor would perhaps remark on the weather, or on the difficulty of finding our place, all the while taking in the art. Soon would come the by-now-familiar "Do you paint?" At this juncture, with perfect comic timing, Clem would re-enter and cheerfully assure the guest, "Jenny has no interest in art." Following it up with, "She loves me for my eyes." He might even hammer it home with, "Jenny doesn't even like art." At which, feeling like a half-wit, I would flush and murmur some protest. Problem was, it was partly true. With all the openings I went to and painters I was meeting, I rarely took in the art. It was still too much and too soon to even think about such things.

But I had a lot of time to think about Clem and me. How had we ever gotten to where we were? And so fast. Just six months earlier, in the flick of an eyelash, I could have been just another girl among the terse entries in his confirmed bachelor's daybook. That would have been the logical outcome. It certainly would have made more sense to all those people who thought our marriage was a bad idea. Yet somehow, all the negativity had opened me up to how much we belonged together. We coexisted in our own sort of harmony. And because the bond kept getting stronger, I knew it was for the long haul.

I thought about how alike we were in the ways that mattered: our

pace—whether walking, eating, or sleeping—our need for talk and silence, our humor, our takes on people . . . Early days, yet we felt comfortable with each other. One night, very late, as I lay waiting for sleep, Clem leaned over and kissed my shoulder. The next morning he mentioned the kiss—only then did I realize he thought I had been asleep—and said he'd never before had the impulse to do that with anyone. And then he said, "You're the best thing that ever happened to me." I thought, *What a small gesture to carry such a magnitude of feeling.* But to Clem, these were breakthroughs. His words that morning made me admit to myself that, to some degree, I still felt like a guest in Clem's house and, by extension, in his life and in his heart. Now I allowed myself to think that just maybe I didn't have to feel that way anymore.

I once made a list of all the things I saw in him. At the top of the list I saw his love of me, which meant more than the world. I saw his appetite for life, for people, for fun, and for good conversation, all fed by his boundless curiosity about all things under heaven and on earth. I was astonished by his ability to immerse himself completely in whatever he did: books, opera, dancing, Schubert *lieder*, gossip, making art, zoos, birds . . . And, of course, the way he lost himself inside art, wherever and whenever, picture by picture, sculpture by sculpture. I loved watching him look at art—the way he would sometimes levitate with pleasure; the way he would annotate catalogs with his special code of checks and plus signs and minus signs and, often his highest praise, question marks. In Clem I saw an ethical, straight-arrow, truth-telling man, such as I had never known. I trusted him with my life. And the negatives? I would have liked him to be a little younger, a little taller, and a little richer.

And I imagined what Clem saw in me. Some things I knew for sure. Besides my eyes and my symmetry, he liked that I had no "culture awe." Better, I had no awe at all. He liked that I wasn't in the art world. He liked that I was intelligent, rather than "bluestocking." He saw a gentle, soft-spoken girl. "I love your presence," he would say. I liked that. Although I wasn't sure what it really meant and whether, in time, it would be enough. On the negative side, I thought he would have liked me to be a little older, a little shorter, and a little richer. Also a bit bustier. And I was damn sure he didn't think marrying a shiksa was God's gift.

And then *Commentary* did a very nice thing—they threw a party for us. I was excited about what was the first, and only, official acknowledgment of our engagement. And I enjoyed seeing Clem at a loss, for a change, and a bit grumpy about the hoopla. The event gave a rather belated jump start to our wedding plans. Clem arranged for a State Supreme Court judge, Harvey Breitel, to marry us on May 4 at noon. I had no idea what their connection was, if any. The party that would follow that evening was in Gertrude's capable hands, and I gave her an invitation list of everyone we knew, or at least everyone we knew who we liked.

A few weeks to go. It was time to get serious. What to wear? Clouds of white tulle and a veil were obviously out, but something white would be nice, even for a shacked-up girl. And it had to be simple, everyday-ish. That, and our money constraints, limited the field drastically. I worked my way down Fifth Avenue from Bonwit's to Saks to Best's to Russeks and found nothing. Then, across from Lord & Taylor, I spotted Peck & Peck. I had gone to high school with the daughter of the owners and had liked her, and her clothes, a lot. A good omen. Besides, I knew it was a young-suburban-matron, Peter Pan–collar kind of store.

At first glance I struck out, but there in the back I saw a blur of white. Golf dresses. Just the thing. A white linen sleeveless sheath, straight skirt to just below the knee. And cheap. So cheap that I bought a white cardigan with "pearls" on the collar to wear over it. Next door I found a $6 pair of white flats to finish my "ensemble." Only $32 poorer, I was set to go. And all without a fairy godmother.

But I did have a real mother. She came to town a few days before the big day. On the few occasions when they had met, my mother had related to Clem through a fluttery fog of bewilderment mixed with flirtation. My mother was a consummate flirt, in her demure way. She would tilt her head down, then gaze up at the man from the bottom of her eyes. I'd seen the look—"bedroom eyes," they called it—in the old Joan Crawford and Bette Davis movies that I had devoured on our first TV the summer before I went to college. Alone, with the twelve-inch screen on late summer nights, I'd sit in the sunroom and think I'd gone to heaven watching the glamorous thirties unreel on *Million Dollar Movie*, with its "Syncopated

Clock" theme song. She once asked me if I didn't think Harry looked like Herbert Marshall. I thought she had a point, though it wasn't saying much. She then leaned closer and in her hush-hush way confided that she had often been told she looked like Joan Crawford. There, I wasn't so sure. But whatever she had, she was one of those women whose whole body and voice would shift gears when a man entered the room. As mortified by her behavior as I had been growing up, I was sad that it had never paid off for her. Oh, she caught the men—it was just that she threw the good ones back.

Now, here she was, sitting on Clem's and my double bed in our puce bedroom, primed to give her daughter premarital advice. In brief, it covered three salient points: First, marrying someone older can work out very well; you'll be able to wrap him around your little finger. Second, Jews are very good to their wives, everyone says so. And third, don't forget, if things don't work out, you can always come home.

As she elaborated, my attention wandered. My mother always spoke at length, and always in the clichés of a bygone soap opera. The absurdity of the "finger-wrapping" bit made me think of Clem's caveat to our marriage—"as long as nothing changes"—with its postscript about an "open marriage." Funny, on the one hand, it sounded so wholesome, while on the other so ominous. But Clem would never . . . Of course he would never . . . And just as I had suppressed his words before, I quickly suppressed again. And where in hell had my mother gotten that bit about Jews? I hated to think. And why did everyone keep jamming Jews into a "they" box? As for running home to Mommy, I had heard that one before, when she had dropped me off at college. Except that day she had been crying. Today, she just looked foreboding.

For her finale, she presented me with her diamond and sapphire Tiffany bracelet. She repeated the oft-told story of how her father had given it to her right before he walked her down the aisle to David, all the while telling her all the reasons he disapproved of the match, summing it up with, "That man never has been, and never will be, good enough for my beautiful girl." My mother loved that story. I didn't, for a moment, think she was sending a similar message to me. Not wittingly. Despite

her weakness for melodrama, she was an abundantly loving person and mother. Yes, she had let me down on Christmas Eve, but in a few days she would be standing up with me when I married, when it really counted. She wasn't a fighter, and I could well imagine what she had been putting up with from Harry and her family. I loved her for that. And I loved the bracelet. That night I stowed it, in its little suede pouch, behind De Quincey's *Confessions of an English Opium-Eater.* I knew I'd never forget where it was.

The next day, the day before the wedding, more jewelry. Clem and I went to Cartier and bought a gold beveled ring. No engraving; I would always know it was mine and who had given it to me. I liked it. Right in line with my golf dress. Next stop: Tiffany's. I wanted to send out wedding announcements. The saleslady, very chignoned and high-toned, suggested that "at-home cards" should be included so people would know where to send gifts. I'd never thought about that. Presents! I couldn't tell her, "Oh, we don't know the kind of people who do that. Besides, they know where we are; we've been living in sin for four months." And, wanting to do the right thing by the saleslady, I ordered the cards: "Mr. and Mrs. Greenberg will be at home at 90 Bank Street . . ." The absurdity of it made me cringe. Clem, as usual, said nothing.

That night, our wedding eve, was just as Clem had ordained, a night like any other. We went to the Blue Mill on Commerce Street, one of our favorites, which served martinis straight up with a "bonus" in a small carafe. Then to bed—books to be read, sleep to be slept, until it was time to roll out of bed and get married.

Me in my golf ensemble and pearls, too early in the day for diamonds. Clem in his only suit, his "funeral gray," he called it, with white shirt, tie, gleaming shoes—he treasured his shoe-polishing gear—and gray hat. How fine we looked. How fine the day looked, sunny and warm. Amazing, considering that I hadn't been able to get anything right. The face that couldn't decide whether to be blotchy red or white as chalk. The ornery hair that couldn't decide whether it was straight or curly and that had sprouted a cowlick I had never seen before. And as the coffee pot boiled over, I burned the eggs. Omens everywhere—I was drowning

in omens. Clem kept to his day-as-usual schedule; reading at his desk, finishing his second half-cup of coffee, lighting up his first cigarette of the day . . . until I thought I would scream.

Without a minute to spare, we were in a taxi heading up Eighth Avenue. We weren't going far, just to Madison Square and the chambers of Judge Breitel. I flashed on the Emerald City, the Wizard who was to marry us at noon emerging from behind a curtain of smoke and mirrors, if the tornado didn't hit before then. Suddenly Clem had the driver pull over, and he dashed into a florist. I leaned out of the window and yelled, "Wrist!" Regular corsages were what wallflowers wore as they hovered in cloak rooms, gardenias staining their bedraggled taffeta. With any luck, today I would break the curse. Back Clem came with an orchid, which he tied to my wrist. Lovely.

Our small wedding party had gathered: my mother; Clem's father, Joe, and brothers, Marty and Sol; Sidney and Gertrude; Friedel Dzubas and his two young children, Hanni and Morgan; and my friend Nancy Spraker. The groom was well attended, the bride's side of the church rather sparse. The judge was forgettable, the ceremony forgettable, though the large corner room with the sun pouring in was extravagantly leathered and carpeted, as befitted his State Supreme Court almightiness. The words were said and the ring slipped on, before I even had time to think, *Oh my God, I'm getting married*! Before I had the time to press the moment into my memory book.

We all taxied up to the Vanderbilt Hotel, where Clem's father was taking us to lunch. I had met Joe only once in the preceding months. Clem saw him rarely, but it had seemed fitting that we should drop by for introductions. He and Clem's stepmother, Fan—Clem's mother had died when he was sixteen—lived at Ninety-sixth Street and Central Park West. Clem never talked much about the past. I knew only that he disliked Fan, that he had been "on the outs" with his father for some time, and that I could expect Joe to turn on the charm, as was his wont when it came to the ladies.

Our brief visit was stiff and uncomfortable on everybody's part. Father and son exchanged a few jibes that were meant to be good-natured but weren't. I could tell I wasn't making much of an impression. I was a shiksa

without even a notable family or money to recommend me. I wasn't too surprised. Clem had told me that his father still couldn't figure out why he hadn't married Helen, who had been blessed with all of life's advantages and, to ice the cake, came from a German Jewish family. Clem had shrugged it off, adding that this was also the man who had never stopped telling him it was time he made something of himself and got a real job. Joe would live to ninety-six and never did change his tune.

The visit ended none too soon for all concerned, and though Joe had been cordial, his reputed charm never did beam my way. But here he was, standing up with us, as were Clem's brothers, and, more, he was hosting a lunch. I recognized clearly that day that the Greenbergs, unlike the feckless bunch I sprang from, did the right thing. More than recognize it, I marveled at it.

The Vanderbilt was at Thirty-fourth Street and Park Avenue. As we left the bright warmth of the spring day behind us, I could feel the chill of a place whose grandeur was a thing of the past. We made our way into the bowels of the hotel, where we gathered around a long table, Clem at one end, I at the other, marooned in a decor that was more a bastion than a restaurant. Vast and stone and echoing, a space whose dimensions had outlived their function. Only a few tables were occupied.

Drinks and food were ordered. Toasts were made. Later, more drinks as some split off to go back to their jobs. I went to the ladies' room. I stared into the gilded full-length mirror. I thought I would see that I was more, or at least different, like the girl who looks in the mirror after having sex for the first time. I hadn't done that, but this was the big deal, the life-altering, life-determining moment. I said my new name out loud for the first time: "Jenny Greenberg. Mrs. Clement Greenberg." I liked the sound of it. My name had changed, but all I saw in the mirror was a young girl, as pale as her dress, with a big bite taken out of her. The attrition had started. I wondered what would fill up the emptying spaces.

After lunch, my "husband" and I ambled uptown to Radio City, where from the smoking section in the loge we looked down across the plush red fields of near-empty seats at *The Swan*, with Grace Kelly, Louis Jourdan, and Alec Guinness, all about royalty and marriage. Vaguely apt, but god-awful and as romantic as a chewed-up bone. The Rockettes were the

Rockettes. But I had been drawn there by the memory of *National Velvet* and Christmas shows past. No déjà vu that day, though. Poor Grace Kelly—even her luminous beauty could barely reach the first row.

But then, the movie wasn't really the point that day. We were passing time, doing uptown things, the kinds of things we knew we would never do again. So it was that we went around the corner to the Rainbow Room for tea and a drink. All those months at *TV Guide*, and I'd never made it to the roof. Now I sat by the window, holding hands with my husband. We talked of things to come. In two weeks we were going to Minneapolis, where Clem was to jury a show and give a talk at the fledgling Walker Art Center. A long weekend of dinners and studio visits. Our first trip, our first hotel together, my first experience of Clem as a "figure" in a world outside our milieu. And my first trip in a Stratocruiser, the pioneering luxe plane, a double-decker with cocktail lounges in its huge belly. That would be the real honeymoon.

Entranced, I stared at the city and the Chrysler Building aflame in the fading sun. Yet I couldn't shake the chill of the Vanderbilt. I wondered if it had been as dismal as I'd thought, if we had really been in a basement, if there had been flowers on the table, what people had said in their toasts. I couldn't even remember if there had been champagne. I knew nothing. Somehow I had missed it all. Like Christmas mornings after the presents were torn open and laid bare. The moment was over. Now what? Expectation was the fun. This was all I had wished for. This was a wonderful day. Yes, all that, but . . . And there, on top of the rainbow, I swore to God that I would never, ever get married again.

Evening had come. We headed downtown to Peter's Backyard to have dinner with Nancy Smith, my other Nancy from college, and young friends of Clem's, Bob Staub and Sylvia, his stunning fiancée from India. She had once painted my eyes with kohl and told me how beautiful I looked. Immediately I had bought myself a black eye pencil, but, as hard as I tried, I could never achieve exotic. I asked her if she would do my eyes again.

In the cramped ladies' room she applied her magic and added lipstick and rouge and brushed my hair. Her hands were soft and loving. She restored me. I took off the orchid, now wilted. Flowers don't like to be

worn, but there would be no stains on my dress tonight. I hoped some-
one would look at the orchid by the sink and wonder about the woman
who had left it.

When we got to the Phillipses' apartment in Murray Hill, people had
started to arrive. The place looked beautiful, like it might be a wedding
party; the Pollocks had sent masses of white flowers that Gertrude had
arranged everywhere. Music, champagne, food, and a genuine, honest-to-
God wedding cake. So what if there was no Lester Lanin playing "Hey,
There" for the bride and groom's first dance? So what if there had been
no father to give the bride away? Hell, he had already done that. It was
that cake that sealed the deal for me. I finally believed it. I was really
married. And this was a wedding party. And it was for me. Well, yes, for
Clem, too. But it was really for me, because I had been the first to leap
off the cliff that day at lunch overlooking Rockefeller Plaza. And then
again, when I moved into 90 Bank Street. And today we had leapt off
the cliff together when we said, "I do."

East Hampton

FRIEDEL TURNED from the refrigerator and said, "There's no jam." Everyone looked up briefly and then went back to eating, smoking, drinking coffee, and reading the Sunday *Times*. I stared at him, skinny in his jeans and T-shirt, with his bare feet and stubbly chin. He stared back, his dark eyes glinting: "There's no jam!"

I could hear the scream before I felt it. High and full. It lifted my body out of the chair and across the room and to the stairs and to the window between the eaves, where it shot into the hazy heat of the morning sky. The sound was song. The song was singing me.

Clem looked down at me in the chair in front of the table in front of the window and touched my shoulder. He said, "I wish I could do that." I wondered why I was upstairs sitting in that chair. I had traveled far and returned. And then I cried for a long time. Clem moved me to the bed. I was so tired and empty and peaceful.

I didn't go downstairs until late in the afternoon, when I heard the lawn mower. Clem loved the exertion, the smell of the cut grass under his bare feet, the sweat running down his back. I went out and sat on the front steps. Clem stopped mowing and sat next to me. He was tentative. I thought, *He thinks I'm breakable.*

He said, "You're so strong."

That, too.

Friedel came from around the side of the house with Marisol. He said he was sorry if he had upset me. I laughed. I couldn't look at him. Marisol said nothing.

That was the middle of July. After the recurrence of an eating disorder, the end of a friendship, the crash of a marriage, the mashed finger, and the dog attack, and after I had read half of Edith Wharton. And that

69

was before the paranoid breakdown, the fall in the bathroom, Jackson, the death, the murder, and the funeral, and before I polished off Edith Wharton.

"Everybody gets out of the city in the summer. Everybody knows that." All the while knowing nothing of the sort about what New Yorkers did, or didn't do, about anything. But so it was that I talked Clem into spending our first summer in East Hampton in a house too small, too stuffed with too many people. Even though he knew better.

There were five of us sharing the house in East Hampton. Besides us, there was my college friend Nancy (Spraker), who worked as an assistant to an assistant in the feminine ghetto of *Good Housekeeping* and was desperate for men and a change of scene. And Clem's friend Friedel, who agreed as long as it would be cheap and he could bring his current girlfriend, Marisol (Escobar), an aspiring artist who sculpted very large penises. She was inscrutable in a forbidding way. I knew little about her except that she was Venezuelan, beautiful, with gobs of money and gobs of black hair that she wore as a veil, and a sly—or was it cruel?—smile. And when she deigned to speak she growled single, heavily accented words, usually repeated twice. The sheer rarity of her utterances always brought conversation to a halt. "Hungry" was a favorite. All in all, not quite strangers, but certainly a mixed bag. *Fine*, I thought. *How bad could it be?*

Nancy and I went to East Hampton and rented a dollhouse in the shadow of the windmill at the far end of town. Three hundred dollars for the season, it had two small bedrooms and a bath upstairs, one bedroom and bath down, a living room too tiny for human use, and an eat-in kitchen, the only communal room. No porch or outdoor furniture conducive to an alfresco summer. Stretched thin three ways, we could all just manage the rent. The elderly landlords were surly folk, leery of the city aliens. A bit off-putting, given they would be squatting in a bungalow a veritable stone's throw behind us. The good news: Helen Frankenthaler was going to Europe and lent us her convertible.

Two weeks before we took possession, I went into a second-guessing frenzy. I blamed Clem. If only he had said no to the whole venture, and

meant it. It then came home to me. As convenient as Clem's passivity about decisions usually had been for me, it also meant that in the future it would be a good idea if I knew what I was doing. At the outset he had clearly said that he had never been away for the summer before and didn't see why he should start now. But then he had shrugged and, as with so many things, I knew he really didn't give a damn one way or the other. The result of his diffidence was double-edged; though I would never get a reassuring pat on the head and an "Everything will be fine," I would never be slapped down with an "I told you so" if my plans failed. Yet another addition to my growing dossier of life-with-Clem lessons.

Nancy, Clem, and I drove out on in mid-June, the car jammed with a summer's worth of this and that, and, most important, Clem's books, my portable typewriter, which he would use while there, a few bottles of booze to get us started, and a radio. I did the driving, as I had when we had gone to the Phillipses' farm for our mini-honeymoon. Clem preferred being a passenger, he could read, and I was happy with the job, much less boring. Besides, he was a terrible driver, unengaged and erratic. Thus died yet another of my mother's treasured myths: "The man always does the driving."

Upon our arrival, the landlords scuttled over to greet us with a list of dos and don'ts, while pointing to the hand mower for the lawn, which must be tended to weekly. They gave dire warnings about the sensitive nature of the antique washing machine with a mangle attachment, and then, handing over the keys reluctantly, they retreated to their lookout post. We had a celebratory drink, got into our suits, and headed off to the Coast Guard Beach, *the* beach. Our summer had begun.

Our routine was in stone. Monday to Friday nights I was on my own, until August, when Clem would come out full-time. The first four days I would hole up with sandwiches and Fig Newtons and Edith Wharton from the local library, starting with *The Age of Innocence* and working my way downhill. Fridays, with a jolt, I sprang into guilty housewifery. I marketed, cleaned, shaved my legs, and did the laundry, before meeting the evening train for the arrivals. Weekends were nonstop—Coast Guard, followed by whatever parties were happening. Late nights we often ended up at the Elm Tree Inn, a down-home roadhouse on

the Montauk Highway—the Cedar away from home, where everyone stopped by of an evening. Not so much the year-rounders, but for the New York transients it was a good way to end the day. On slow nights there was always a movie on Main Street. Most of the time, wherever we went, we would see the same people we saw in the city, except for the clothes and the sunglasses. For eating out, there wasn't a lot to choose from. Either the upscale Spring Close House and Chez Labatt or, if we found ourselves west of town, Out of This World, where Clem would invariably remark, "It should be Out of *the* World. Don't they know there's only one world?" That was my adorable pedant, who even proof-read the back of my cereal boxes.

For those homesick for a bit of drama, things could sometimes heat up at the Elm Tree. One night the power went out and for some reason two guys started to yell and shove and shove back and in a flash we could hear punches landing and people crashing into tables. Scary stuff in the dark. We headed for the parking lot, where everyone hung around quarterbacking over who had said what to whom and who had thrown the first punch. No one wanted to go home, so someone turned on a car radio at full blast and in the glare of the headlights people danced. A lively free-for-all that got livelier when the cops pulled up. That night, the Elm Tree had the Cedar beat, hands-down.

East Hampton housed a small, very small, art colony. The artists who had year-round houses were spread out, from Montauk in one direction to Watermill in the other. They had migrated slowly after the war, looking for a cheap place to live and work while still being near the city. Even in summer, it was a workaday place. During the week the Coast Guard was nearly deserted. And even when the art circle expanded a bit on weekends and there were more blankets on the beach and a few parties sprang up, the sense of family was a constant. Vacationers like us, who came for the whole summer, were few.

As for the parties, it was always the same gang and the same rhythm: gossip, a lot of grousing, plenty of drinking, a slow build to a climax with a verbal and/or physical slap-and-tickle skirmish, followed by a denoue-ment accompanied by the chorus venting their two cents.

The town itself was a sleepy place with a stodgy, old-time Yankee smell to it. Nothing touristy. Artists were on the fringes, tolerated but not assimilated. Judging by all the mansions lining the road to the beach, East Hampton was unquestionably a town of the rich, a "them" and "us" sort of town. And, like Rye, no cross-pollination. I didn't realize just how small the art community was in East Hampton until, in summers to come, Clem and I would go to Provincetown to stay with Hans and Miz Hofmann over Labor Day weekends. As distant as the Cape was from New York, it was clear that that was where most artists were. Provincetown was an industry town—art, art, every which way art—and had been for years. Not so East Hampton.

Only two weeks passed and we had our first houseguest, Nancy Smith, who wanted to come for the weekend. With nowhere to put her up, I bought a folding canvas cot in the hardware store. That plus a bamboo screen from the living room would have to do. The kitchen now had a sleeping alcove. I figured that the accommodations would effectively discourage people from overstaying their welcomes. No such luck. Nancy could be great fun but she could also wreak havoc, and during her week's stay she managed to disturb our fragile peace. She had taken to drinking more in recent months and wasn't an easy drunk. Loud, belligerent, she hacked away at anyone in her path, but I was her most frequent target. I withdrew but couldn't bring myself to throw her out. Nancy was why I had gone to Jennifer's party and met Clem, why I was in East Hampton at all. And so much more.

As small as Bennington was, students usually didn't drift from one discipline to another. After bowing under the weight of calculus, I had burrowed single-mindedly into literature. Under the tutelage of Howard Nemerov, Francis Golffing, and Stanley Hyman, I was soon up to my eyeballs in the modernists and writing a poem a day. It took me three years to discover that the interesting people were in the art department. I soon drifted away from the girls who thought and looked like me and toward the "others." I felt as if I had been swept into a hurricane. Dirty feet, sandals, hair down to the ass—this was what Bennington was created for. Soon, getting changed to go wait on table at dinner meant maybe

a clean T-shirt and my hair brushed if it was lucky. A far cry from when my mother had first deposited me at the school with my prim pageboy and saddle shoes.

Nancy Smith was the ringleader and I became a groupie. She knew everything. I had never been to a museum, and my only memorable pictures had hung over my nursery bed: a print of *Blue Boy* and, in a small carved frame, Jesus in flowing robes, hands clasped, looking heavenward. Nancy thought it was time someone introduced me to art, and New York. She took me to the Museum of Modern Art, where I walked up the main stairs headlong into *Guernica* and the impressionists, cubists, and surrealists. Nancy reeled off the artists' names and the movements and what had led into what. All too much. But I had seen things I didn't know existed, never dreaming that they would become old friends.

I knew she was a lesbian and that she loved me. But without a word spoken, we had early on settled into a comfortable friendship. Now, since my marriage, that friendship had become less comfortable for her, and in East Hampton it reached the breaking point. She showed every sign of settling in on that kitchen cot. It wouldn't do. Then one evening, as we all sat around the table before heading off to some do or other, she threw her drink in my face. That was that. The next day she called her analyst, who had a place in Amagansett, the psychiatrist ghetto, and I dropped her off there. I saw her a few more times, before gradually cutting her off. Not long after, she moved to the West Coast and I didn't see her for thirty years.

I lost a friend when I could least afford to. My friends in the city had dwindled to a precious few, but in East Hampton, for the first time, I was awash in isolation. I knew no one well enough to call during the week, and if I did spot someone at the beach, I was too shy to approach them. Even in the house I felt vulnerable, ever since I had come downstairs one day to find the landlady poking around, probably because I had already rendered the washing machine a casualty.

There was one unexpected respite. At a party at Paul and Mimi Brach's, I met the painter Perle Fine, a straight talker who seemed interested in what I had to say. Before she left, she asked if I would like to come by for lunch during the week. Yes. I wondered what it would be like to spend

time with a painter who was about Clem's age, just her and me. So far, I'd had nothing I could really call a conversation with anyone I had met.

Perle was in her big, homey kitchen when I arrived, expertly chopping piles of vegetables, cold cuts, and cheeses. She hoped I liked chef salad. I nodded, not quite sure what that was. I warmed to her as she poured wine and set me to chopping. She talked of her studio and her recent move to Springs with her husband, and then asked me about myself. Things went along fine, but I was getting anxious about the chef salad, all those chunks of raw vegetables in particular.

During the previous weeks, my throat had started closing up while I was eating. I was okay by myself or with Clem, but in restaurants, or with others, I would sometimes gag on food. This wasn't new. It had started at age eight when I was in Fort Lauderdale with my mother for her divorce from the Con Man. For three months we lived in a motel and ate mostly in restaurants. One day I choked, the food not going up or down, and my mother pounded my back until I spat it out. Much commotion. I was scared and embarrassed.

The problem continued over the years, sometimes not at all for long stretches, other times coming on acutely. This was promising to be an acute phase, the first in years. Fortunately, that day at Perle's I managed to make it through lunch without incident. The visit ended with a tour of the house and studio. Perle spoke about her work as if I might know what she was talking about. Altogether, a good day, a grown-up day, and a welcome break from Edith Wharton.

On weekends we were seeing a lot of the Pollocks. Often we would pick them up to go to the beach. Clem and Jackson loved the water. Lee, too. A good thing, because she and I, though we had spent a lot of time together, had never found a lot to chat about. I sat on the blanket and watched them. Since I had married, I had become fearful. Not just the choking; there were new fears. The first had surfaced on the Stratocruiser to Minneapolis two weeks after the wedding. I had experienced such stomach-clenching panic that I wouldn't fly again for five years. This, after having flown routinely to Chicago by myself since age twelve to visit my father. Now, in East Hampton, the ocean that had always been my friend became a threat. I yearned for the abandon I had felt as a child

at the Jersey shore when I would go beyond the breakers and swim and float until my face and shoulders fried. As fast as I was moving forward, I was losing ground. Sometimes during those summer months, I didn't think I was coming out even.

After the beach we would head back to the Pollocks' to hang out, often staying for dinner and TV. They would talk through most of the TV, but I ate up the shows. There was more tension than usual in the house. Jackson was off the wagon, though still clinging to the slippery slope that could lead to all-out bingeing. And there was now talk of a woman he was spending time with. It wasn't unusual for him to make crude passes if he was drinking, but if his bluff was called, he would bolt in the opposite direction. This was something else—a woman who held his interest. Lee was on the fence between war and peace, and for three weekends the détente held. And then it didn't. Jackson had crossed the line. He had thrown the woman in Lee's face by bringing her to his studio for the night while Lee was in the house. The next day Lee went to New York, where she hashed and rehashed the incident with Clem. She tried to let it go, but in the end, couldn't. She sailed for Europe the week after the Fourth of July for an open-ended stay. The next day the woman, Ruth Kligman, moved into the house. Our weekend routine with Jackson continued, though with less frequency, and now with a new cast member.

I was hit hard by the whole ugly mess. I wanted to repaint the picture, to dress it up in dainty platitudes: *It's just a fling, Jackson made a mistake and now he'll do the right thing, they'll make up and everything will be fine.* I knew these thoughts were pathetically naive, but the recent turn of events had rekindled the five-year-old in me. When I was a young teenager, my mother had told me about the "other woman" who had precipitated her divorce. Evidently, a registered nurse my father had been seeing on the sly for some time had left a slipper at the hotel where they had spent the night. The next day the hotel called our house to say that they had found "Mrs. Van Horne's" slipper. On a silver platter, my mother had been handed the evidence of adultery and the grounds for divorce, and I had been saddled with Marge, the Nurse, for a stepmother.

I equated the "forgotten" slipper at the hotel with Ruth's eagerness

to cooperate in the ugly scene on Lee's doorstep. I was proud of Lee for having the courage to leave, but wished she had had the courage to stay. I was angry at Jackson for blowing the roof off his household, yet at the same time wished I could just once see him happy. But the "other woman." That was still too much for me. I resented her for reconnecting me to that five-year-old who had felt the house tremble under the weight of anger and guilt and sadness.

On a more realistic level, I don't think I took Jackson and Ruth's relationship very seriously. After all, this was Jackson. I knew well that drunks did willfully stupid things. I also knew how passive they could be and how strong the ties were between an acute alcoholic and his caretaker, and vice versa. Surely this would blow over. The question was when. And Europe was awfully far away.

The switcheroo had been so astonishingly quick and so complete. Abracadabra, behold the polar opposite of Lee: Ruth, only a few years older than I was, dark haired, voluptuous—Elizabeth Taylor, in a faux sort of way, which she played to the hilt—and touchy-feely, a come-hither, good-time girl with brains that didn't show. Lee was none of the above: no-nonsense, combative, smart. Though far from being a beauty in the usual sense, she was fired with an energy that gave her an attractiveness. She was that rare woman who seemed not to care about her looks. As in most things, Lee defied the rules.

Though Ruth and Lee had little in common, they shared two qualities—both were willful and ballsy. As for me vis-à-vis Ruth? Well, we were both young women with older men. There was that. Could Jackson have been "inspired" by Clem's hooking up with me? Lord, I hoped not. And I'm sure I compared myself with Ruth in terms of looks and sexiness, coming up short on both counts. But when it came to behavior, as hard as Ruth tried, she could never get it right.

Now Lee was only a shadow in the kitchen. Ruth, the lady of the house, sat across the table. I couldn't shake the feeling that overnight Ruth and Jackson had both become interlopers in Lee's house. I never would have thought I would have missed Lee's gruff sourness, but I did. All their "for show" cuddling and canoodling brought out the prissy, righteous, "just married" matron in me. A new self-image that made my

skin crawl, but I was stuck with it. The worst, for me, were Ruth's efforts to impose domestic normalcy on such a profoundly shipwrecked household. She brought a let's-pretend wifely bustle into the house, despite the fact that she was cooking for someone who couldn't/wouldn't eat and smiling at someone who had forgotten how. So like my mother with her alcoholic. Again I was torn. Part of me wanted to throttle them, all the women who didn't get the futility of it all. Part of me wanted to hug them for trying. I also empathized with Ruth's nesting impulses. How could I not? I was knee-deep in them myself.

Hard as it was to cozy up to Ruth, I did my "well-mannered" best, hoping to coast along in the wake of her cheery ways. Sadly, when I looked at Jackson for any reflection of her lusty sparkle, he was as morose and moody as ever. Worse, he was drinking more.

Sometimes we would join up to go to the beach, ending up at Jackson's or our place, where I would make a spaghetti-and-meatball dinner for them and our houseful. Ruth always cooked more elaborately, especially for a group. As usual, the men talked and the women listened. Jackson had met Ruth at the Cedar Bar. A girl with art aspirations, of course she listened. I drifted. One night, when it was just the four of us, Clem asked Jackson if he had any plans concerning Lee and her return. Jackson hung his head, Ruth got mad. That ended that evening.

I knew what had prompted Clem's question. While deploring the course of events, he had stood by both his friends. His efforts to reconcile them may have failed, but he saw Lee's departure as temporary, as she herself did. He saw Jackson's provocation of Lee as an aberration, something that would blow over in time and could be rectified. In the meantime, "A friend doesn't take sides," he would say. He supported them both, them and their decisions. And however it worked out, he would continue to support them. To my mind, that was well and good for the long term, but for the day-to-day, I thought the whole situation stank.

If Jackson had been a plumber, a lawyer, or even a really bad painter, I could have given Ruth some wiggle room. But he wasn't and I couldn't. Why was she there? To be in the spotlight, for the high life? There was none of that. Did she think she would be the one to turn his life around, save the genius? Or, equally far-fetched, did she believe that Jackson

was in any physical or emotional condition to leave Lee and marry her? She seemed to have no idea of the bond between those two amazing painters, who had stuck it out and grown up together, in a sense. To me and, I think, most people, Ruth was there only because Jackson was big-time. But Ruth, as valiantly as she tried to single-handedly liven up the party, surely must have noticed that the party was over. Oh, there was one exception.

One warm night, with the moon full, we all broke loose. Jackson, Ruth, Friedel, Nancy, Clem, and I went skinny-dipping in the bay at Barnes Hole. A lot of giggling and horseplay and some modesty. Nancy and I kept our underpants on. A few weeks later, I sometimes thought I must have dreamt that midsummer night's romp at Barnes Hole.

With high summer now upon us, disturbances in our own household started piling up. Danny came out every other weekend after Nancy vacated the cot. Previous experience put me on alert. He carried terrible burdens that he could never set down, as if they defined him and he might disappear without them. Unfortunately, the inner discord spilled out every which way. I never saw him walk with a light step or speak in a modulated voice. I tiptoed around him, waiting for the dam to break. Not when others were around, but when it was just us, he would rant and bait until he and his father went at it.

As usual, the kitchen was the arena for everything that went down that summer. I was surprised that only once did the situation with Danny escalate to combat. A few glasses broke, chairs were knocked over, a lot of shoving, and a few wild punches from Danny before it petered out. The visit over, Clem drove him to the evening train. Clem was angry and sad. I hated everything about it and despaired of its ever changing.

And then there was pain of a different sort. First, Clem's thumb got mashed when Nancy Spraker slammed the car door on it. We screamed more than Clem did. He was blessed with a high pain threshold. That, and ice and gin, got him through. Though it turned black and ugly, he didn't lose the nail and it wasn't broken. It also gave him the opportunity to brag about his astonishing healing powers.

A few weeks later, he had another opportunity to brag. As we were leaving the Coast Guard, there was a dogfight in full swing in the parking

lot. Big dog vs. little dog tearing into each other, a lot of barking and blood. People were standing around at a loss, when, against time-honored wisdom, Clem waded in and tried to break it up. The big dog turned on him and bit his thigh. Badly. Wrapping his leg in towels, we rushed home. But it was beyond disinfectant and a Band-Aid. Marisol kept bleating a barely decipherable, "Lock jaw. Lock jaw." For once she had a point, and we took him to the clinic. As usual, Clem was the least disturbed and sat reading a book through several stitches and a tetanus shot. He then insisted we continue with our evening plans. Word had gotten out about Clem's exploit. Reactions were mixed. Most came down against his intervention. In effect, "How could you have been so stupid as to . . . ?" Clem shrugged. "You can't just do nothing." I liked that. It spoke volumes.

And then, the first week in August, it was Friedel's turn. He woke up one night in agony. By morning he thought he was dying, and Clem drove him to the South Hampton Hospital. He was diagnosed with kidney stones. He stayed a week and was a difficult patient. Heavily medicated, he quickly developed an unremitting paranoia. He swung from euphoric tales of having seen God, who had shown him how to create the greatest masterpiece of all time, to being persecuted by everyone in the hospital. He would call in the middle of the night; he was being poisoned, gar-roted, guillotined . . . Clem visited every day. I went only once, to reassure myself that he really was insane. And he was, his dark eyes popping out of his head, restless, talking of God, who was now appearing to him as Matisse. The more they sedated him, the loonier he got. Eventually the stones passed. Clem brought him home and Marisol returned from the city to help restore him. But it was slow going. He may have left the stones at the hospital, but the emotional volatility lingered. To complete the effect, he sported a grizzled beard that he would neither tame nor shave for the rest of the summer.

One late afternoon, while Friedel was still in the hospital, Nancy Smith dropped by. I was alone. She seemed to be in a mellow mood, but none-theless I wondered if Edith Wharton wouldn't be better company. We were sitting on the front steps, when Jackson pulled up. He was at loose ends. Ruth, after three weeks of residency, had gone to New York for a

breather. She would be back on the weekend. I brought out some beers and we sat around in an end-of-the-day kind of way. How the subject of toenails came up, I have no idea, but next thing I knew we had carried kitchen chairs out to a patch of grass by the side of the house. There, shadowed by unruly hedges, armed with a few more beers, Clem's nail clippers, and my barber shears, Nancy and I were poised to clip, trim, and prune Jackson.

On his chair, a towel around his neck, he looked as delighted as any pasha on a throne, surrounded by his harem. I was worried about only two things: the long-eyed landlady and whether I would be up to the job. I warned him that I was a novice barber with only one client. But he didn't care; what was good enough for Clem was good enough for him. I figured less was more, and cautiously trimmed the shaggy edges, staying clear of an all-over cut. It wasn't so hard. He and Clem had the same top-of-the-head baldness, though Clem's was more advanced. And Jackson's hair was coarser, easier to handle. Nancy proceeded with her nail clipping. It was peaceful there in the hot stillness, with only the sound of scissors and the whirr of insects. I moved on to his ears and eyebrows, and as a final touch, I neatened up his beard. When I had done my best and had brushed him off, I stretched out on the grass to admire my handiwork. I watched Nancy as she tried to art-talk him, and wished she would shut up.

Later we went to the Coast Guard for a stroll and a look at the ocean, then back to Jackson's favorite bar in town, near the station. We sat in a booth and he talked about the impressionists and how important Monet was to him, and as he talked, I watched the interplay of excitement and sadness on his face. That evening, for the first time, I liked his face, the sound of his voice. Maybe because he seemed at ease. I knew for sure it was the first time I had felt at ease in his presence. His drunken prophecy of my doomed marriage-to-be at the Bank Street party faded. I was happy that what I thought of as a "connection" had been made. We lingered awhile, then I drove him back to his car and off he went.

August 11 was a Saturday. Everyone in the household was in situ for the weekend, Danny as well. We all spent the afternoon at the beach, except for Friedel, who was still too weak. After dinner, Nancy went off

on a date and Clem and I geared up for a benefit piano concert at the Creeks, the estate of the painter-collector Alfonso Ossorio. In the late afternoon, Jackson started calling. Yes, he would meet us at Alfonso's. Then no, he didn't want to go. No surprise. Big splashy gatherings weren't much of a draw for him those days, or any day. Then the third call—yes, he would see us there. I figured Ruth had cajoled him into an outing.

That night, Danny and Friedel stayed home, and with Marisol in tow, we arrived at Alfonso's around nine. A clear, balmy night, most of the people we knew, and then some, were gathered in the rosy glow of Japanese lanterns on the terrace and lawn that stretched to the moon-sliced water of Georgica Pond. This was definitely not the usual East Hampton art party. It was all very classy, everyone on their best behavior and dressed to the nines.

A far cry from a few weeks earlier when Alfonso and his partner Ted Dragon had invited Clem, Jackson, and me for dinner. A small group: just us, Betty Parsons—Jackson's ex–art dealer—and her girlfriend. As we walked into the grand entrance hall, Betty and her friend were arguing loudly and tussling at the top of the curved staircase, and down they tumbled, landing in a heap. They got up, greeted us, and the evening proceeded without a word, as if nothing had happened. In fact, I was probably the only one who even remembered it by the time we had downed the first drink. I figured the time would come when I, too, would stop noticing and remembering. Maybe when I grew more accustomed to this world, where the unexpected was all part of life as usual.

Now, here we all were, paragons of civility, strolling in the light of the moon to chairs sprinkled across the grass. Jackson hadn't shown up. He must have changed his mind once again. Clem and I sat under a whispering tree, the piano music, the flicker of fireflies, floating around us. Through the window, I could see Jackson's *Lavender Mist*—the sublime *Lavender Mist*—illuminated by candles. I reached for Clem's hand and slipped into a reverie. The moment, so complete, so utterly beautiful. A time of peace such as I could never have imagined.

At intermission I reluctantly rejoined the world. We made our way to the terrace for a drink. A few minutes later, maybe not even that long, Alfonso hurried over to Clem, drew him aside, and quietly told him that

Conrad Marca-Relli—the painter, and neighbor of Jackson—had called. Jackson was dead in a car accident on Fireplace Road not far from his house.

Alfonso, Clem, Marisol, and I drove immediately to the site. The road was blocked off. Lights flashed from police cars and an ambulance. People were milling around. We pulled up a short distance away and walked down the road. Before reaching the police cars I stopped, saying I would wait there. I didn't know what there was to be seen, but I knew that whatever it was, I didn't want to see it. I don't know how long I stood there. I was a stone. I thought that the ambulance might mean that he was alive after all. I don't know if I thought about Ruth. At some point I returned to our car. I watched the people silhouetted in the streams of lights. I wondered why there wasn't more noise. Shouldn't there be shouts and screams? I had never known anyone who had died.

Eventually, Clem and Marisol came back. I turned the car around and we headed back to our place. He said that Jackson had been thrown from the open convertible and had hit a tree and had died instantly. He said that Ruth, too, had been thrown but was okay; they were taking her to the hospital. And then he said there had been a second girl and she had clung to the car and had been pinned under it and was dead.

We got to the house. Marisol went to the bedroom to tell Friedel, and Clem immediately left again to go to the Pollock house to make sure it was secure for the night. When he got back he called Sande, the brother Jackson was closest to and who lived the nearest. He wasn't home. He then called Charles, another brother. They talked at length, and Charles said he would call his three brothers. They agreed that Stella, Jackson's mother, who lived with Sande, shouldn't be told until the morning.

Locating Lee would prove to be difficult. Clem had thought he would be able to reach her at Peggy Guggenheim's in Venice, where Lee had been going to see the Biennale. Peggy explained that she had changed her mind about putting Lee up, and, unable to book a hotel room, Lee had decided not to come to Venice. Just another of the peevish hassles that seemed to abound in the backbiting art family. Peggy would call later to fully explain "her side" of the incident, as well as to vent at length her caustic thoughts on Jackson's death.

But the question remained, where was Lee? Clem knew that she had planned to look up the painter Paul Jenkins, who was then living in Paris; maybe he knew something. But first Friedel needed calming down. He had been awakened from a drug-induced sleep and was now up and roaming the house, wild-eyed and wailing about the hand of God. While Clem tried to get him back to bed, I took on the task of putting in a call to Paul in Paris. The comedy began. Somewhere between my pathetic French pronunciation, the overseas operator, and the Paris operator, the phone number prefix *LEC* became *Elysées*. And so it went, with waits in between.

Finally, somewhere in the middle of the Atlantic, a lightbulb went off, and so it was that around three o'clock in the morning I heard Paul's voice. I shouted for Clem. He told Paul what had happened, and, miracle of miracles, Lee was right there. She had been staying with them for a few days, and at last the person who most needed to know knew.

We never did sleep that night. The phone kept ringing. I thought about Lee. Clem had said he could hear her hysterically laughing and screaming before he had even told Paul what had happened. It made sense to me. She knew. In some way she had been waiting.

Late the next morning our exhausted group huddled around the kitchen table. Nancy had gone into town for the Sunday *Times*. There was the story, on the front page. I glanced at it but couldn't read it. I was struck by the inanity of reading about what I already knew; I wasn't ready for the secondhand-ness of those deaths. Marisol's eyes lit up, "Peectures? Peectures?" She, who had stood transfixed over the body, now wanted pictures. I wanted to stuff the paper down her throat.

Soon after, Clem and I headed over to the Pollock house. Sande had arrived. A few people had come by and were walking around, talking and shaking their heads at each other. Like an intruder, I crept upstairs to join some of Lee's women friends, who were gathering up Ruth's belongings. With great care they combed the bedroom, guestroom, bathroom, and Lee's studio. Everything must be exactly as it had been when Lee left. The women were like mothering birds cleaning the nest, hovering, sanitizing. Until Ruth never existed. I grasped the importance of what they were doing, but wondered if anything could ease Lee's reentry into

this house that she had left under such painful duress. And that bed. Would she sleep in that bed? The women were smoothing on fresh linens as if for a bride, not a widow. I couldn't even look at that bed, much less touch it. I quickly left and went the few steps down the hall to the guestroom to help Charlotte Brooks, who had started to pack up Edith Metzger's things. That was her name, Edith Metzger, the girl crushed to death under the car.

And then, in the top drawer of the small bureau, I saw the diaphragm case. I was flooded with anger. The expectations. She had come hoping. For what? An adventure, a party, maybe a man, maybe even a painter, maybe the chance to show off a new dress, to go to the beach, to get some sun? All reasonable hopes for an August weekend in East Hampton. And her anticipation must have been building on the early-morning train ride out with her friend Ruth, who would have fired her up with talk about her lover, the great painter who would meet them at the station. *Yeah, some adventure.* The little room was hot and stuffy. I couldn't get the window open. And there on the bureau was the damn diaphragm, pale and powdered in its case. I had looked. Just like that, I had looked. I disgusted myself. My prying was prurient and ugly. But there was no taking it back.

I tried to imagine what Edith had looked like, what she was like as a person, this person who had so carefully sprinkled powder on her diaphragm, something I never bothered to do. Was she beautiful? Other than her name, all I knew that afternoon was that only a few hours before she had been an innocent bystander, a victim, and that she had died screaming. She had to have been screaming in fear, because Clem had told me that she had been the only one who had clung to the car when it had flipped over.

I may not have known Edith, but I knew what her last day must have been like. I had spent enough time in that house, holed up around that scarred kitchen table. But at least then there had been Lee to spark the energy and mask the emptiness. Yesterday there would have been only Jackson, holding on, if barely, and two girls waiting for him to say, "C'mon, let's get the fuck outta here," or to say anything at all. From the years with my stepfather, I knew what it was like to watch a drunk

get drunk. Clem had told me about the time he had gone to a bullfight in Spain. He said he had never before experienced such an excruciating combination of boredom and fear as when he had watched men repeatedly invite their own deaths. He never went to a bullfight again. To me, watching Jackson during those weekends in Springs had seemed awfully similar.

Sparse details about Edith Metzger surfaced in the following weeks, and they varied. Was she a receptionist or a manicurist; was she a petite blond or brunette; one article spells her name with an *s*; was she twenty-four or twenty-five; did she come from Queens or the Bronx? I wished she had been a rocket scientist. Maybe then people would have been paying more attention to who this hopeful, fastidious, fearful girl was, other than the nobody with the cracked spine in the great painter's car. But, things being what they were, the spotlight was quickly sucked up by the superstar, the grieving widow, and the miraculously surviving mistress. Ruth would become known as "the girl in the death car," as if there had been only one girl.

I heard later that Edith's family hired a lawyer to get compensation for her death. Evidently not a very good lawyer, because he came to the Pollock house and left with nothing, except perhaps an experience to talk about. Later, a civil case was brought, and Edith's family and Ruth were each awarded the token sum of $10,000 from the widow. Ruth testified that Jackson had not been drunk and had driven slowly on the way home. She also said that Edith had not been screaming. Why would she say those things? Why would she whitewash the tragedy? Whatever her reason, she sold her friend out.

I was amazed at the heat of my emotions and at how they stayed with me. I knew I was identifying with Edith and her expectations of a good time, fueled, no doubt, by my own disappointment with what I had hoped would be a happy honeymoon summer with Clem. Edith and I had both wanted some high life and some time by the seashore. But at least Clem and I would have a lot of years to fumble around, trying to get things right. Edith had run out of chances.

The weight of Edith's death lay heavily on Clem, as well. Those first

days, *killed* was the word he used. Not *the girl who died*. Or he would say, when he could bear to utter the words, "the girl Jackson murdered." Clem was so angry at Jackson, not just for having succumbed to his demons but for having taken someone else with him.

But for Lee, the waiting and watching were over. She came home a little more than twenty-four hours after the phone call. All business, she immediately took control and swung into action: the body, autopsy, funeral arrangements, gravesite, newspapers, the will, who would put up the imminently arriving family members—all the subtexts of death. Lee dispatched them with dazzling proficiency and speed. She knew exactly what she wanted and got it. With one exception: the eulogy.

Clem saw her briefly the day she got home, and she mentioned the eulogy. She took for granted that Clem would give it. No discussion. She said only that she would call the following morning to go over the details. She then moved on to the next pressing item on her agenda. That evening, Clem started to compose his thoughts. The clearer they became, the more disturbed he was. He knew what he had to do. When Lee called the next day, he said that yes, he would speak about Jackson. Then he added that she should know up front that he would be mentioning Edith Metzger's death. She must have objected quickly and loudly, because the next thing I heard Clem say was that it was the right thing, the ethical thing, to do. And then again, after Lee's response, he repeated with finality that, ethically, he could not speak about Jackson's life without referring to Edith's death. Over her escalating protests, he suggested other speakers: Barney Newman and Tony Smith. Lee, being Lee, told him that there would be no eulogy and hung up abruptly. *So much for Edith Metzger's moment in the sun*, I thought but didn't say. I didn't think Clem would appreciate my black humor that morning.

The funeral was held on Wednesday afternoon. It was a beautiful day, and we went to the beach for a few hours. When we got to the small church, it was jammed to overflowing. It must have been 120 degrees. I had never been to a funeral and I was shaken by the sight of the coffin, stark and alone up front. I had already buried Jackson, and now there he was. The tears came. No sobs, nothing dramatic, just a steady flow down

my face. The ceremony was short: prayers, some music, and a minister who drily summarized the highlights of Jackson's life. We then went to a nearby cemetery where, the day before, Lee had bought plots for Jackson and herself. A few more rote words, Lee dry-eyed, stoic. There would be no drama or catharsis that day. It seemed like only minutes before we were back in the car, headed for a gathering at the house. Such a rubber-stamp finale for a marriage, for such a passionate, unpredictable spirit, and for the best painter America had ever produced, or so Clem had written over the years.

After a subdued start, the party was soon in full swing. Everybody said there had never been such a wonderful party there. There was an abundance of food and drink. People spilled out into the yard. I heard grumblings about the lackluster funeral, the minister who knew nothing about Jackson, who had never even met him, how somebody should have said something, how it didn't seem right. Of course, I had thought the same things, but now I wondered if anything would have satisfied people's needs, and thought it had probably been best the way it was. The myth machine had already started rumbling. "The great painter who lived in violence died in violence" sort of garbage. As for the people at the house, I think we were still in shock. The word *inevitable* kept coming up, but I had learned that week that inevitability doesn't lessen the shock of death.

Sure, I knew that drunks were drawn to cars and to speeding. My mother always hid the car keys from my stepfather at the first sign of a binge. Thwarted, Harry would run down the street, sometimes naked. He wanted out, out of the house, out of his skin, just out. If he did find the keys—drunks are canny—he would speed off and my mother would call the cops. One time, when maybe he didn't have any yen for speed left in him, he closed the garage doors and turned on the ignition. The garage was under my bedroom and I heard the motor running. Foiled again. Until the next time.

Jackson's large family had come for the funeral. Throughout the party, his mother, Stella, sat on an upright chair in front of the TV. I approached her to offer my condolences. She nodded. I asked if I could get her anything to eat. She said she was fine. Her eyes barely strayed from the

Democratic convention, a shoo-in for Eisenhower's second term. Yet how engrossed she was. She was stolid, like a stop sign. I brought a plate of food and set it down near her, just in case.

A more lively attraction at the party was Sande's five-year-old, Jay. Adorable and outgoing, he and I tossed a ball around. Later, when Sande asked if I would take Jay to the beach the next day, I was thrilled, if a bit aflutter, having never been around a child before. The family stayed for three more days, and each morning I picked Jay up and off we went to the Coast Guard and our world of sand castles. I loved our times together and loved driving through town with the top down and him next to me. I hoped people would think I was his mother. It was probably good they left when they did; my fantasies were running amok.

In the days and weeks that followed, Clem's focus was on Lee. Her pace had slowed. She now made a mountain out of every decision. She talked endlessly to everyone in her circle about the ins and outs, the pros and cons, all the while knowing full well what her course of action would be. Her emotional state was something else. As fiercely strong and pragmatic as she appeared to be, she was also fiercely needy, especially at night, when her to-do list wasn't an option. Unfortunately for me, Clem was her number one confidant. Her tantrum over the eulogy had flared and quickly fizzled, as her need for Clem superseded her grudge. He was at her house sometimes twice during the day and then again in the evening. Several times he spent the night there. Feeling very woe-is-me, I pouted and sulked. To no avail. The new bride didn't stand a chance against the grieving widow.

Clem was stretched thin. He, who prided himself on never getting sick and never having had a doctor, caught cold. And then one night he got up to go to the bathroom and I heard a thud. I ran in and there he was, out cold. My first thought was that my stepmother, Marge, had been right; Clem would die long before me. But not this soon! A few splashes of water and a lot of yelling brought him around. He got up and returned to bed.

I was frantic. "What happened?!"

A shrug. "Must be my thyroid is low."

Clem had a theory—on those rare occasions when his body felt a

bit "off," he blamed his thyroid and would down one of my thyroid boosters. Of course, being his own best, and only, doctor, he had never been diagnosed. He then turned over and went to sleep. I lay there like a zombie, my brain clattering for hours as it spiraled through sudden-death scenarios and funerals, the freshly minted bride turned widow weeping into the grave.

Not helping my frame of mind during those last weeks in August was Friedel's latest obsession. Since the night of Jackson's death, he believed Jackson's spirit had taken up residence in him. He *was* Jackson. Given Friedel's unstable physical and emotional state, Clem had tried to dissuade him from going to the funeral. But of course Friedel had insisted. He had managed the church without incident, but at the cemetery, with the ghoulish Marisol at his side, he had stood so close to the edge of the grave, sobbing, staring down at the coffin, that I was sure he was going to jump in. What a pair. He took to hanging around the cemetery and several times drove down to visit Ruth at the scene of his recent tortures, the South Hampton Hospital. Naturally, whether he was inhabited by God, Matisse, or Jackson, the scraggly beard remained.

Within a week or so, life in East Hampton flattened to a hum. As if the tidal wave that had engulfed us all had subsided and would not strike the town again. At least that summer. The out-of-towners returned to where they had come from. Parties were held, beach life continued, late nights of drinking and dancing at the dives, all that. But with a subdued air. Also in the air was the smell of Labor Day, and with it my release from the blissful summer I had imagined, the summer that had gone so terribly wrong. Self-protection led me to endow East Hampton with all the troubles that had eddied around us. That way, I could believe that, as we packed up and headed back to New York, the bad times wouldn't be following us home.

part two

Artists & Wives & a Trip

HANS AND MIZ HOFMANN

IT WAS LATE Friday afternoon of Labor Day weekend in 1957 when I passed for the first time through the front gate of Hans and Miz's house in Provincetown. As usual, when venturing off with Clem, I had no idea what to expect.

We had come a long way. The Cape Codder train to Woods Hole, then the long bus ride to the farthest tip of Cape Cod, and finally a taxi to the Hofmanns' house near the end of Commercial Street, the town's main drag. At first sight, it was like no artist's house I could have imagined—a white colonial fronted by a picket fence with a brick path that invited us to the front door through a garden ablaze with flowers. But then we crossed the threshold. I thought I had stepped into Hofmann's body and soul. The floors, the furniture, the stairs, everything, painted in his signature vibrant, primary colors. A high-gloss Technicolor toyland. Upstairs, in the large square guest room, the same. Here the late-afternoon light bounced off the sea and danced with the rainbow colors of the room. Never before had I been in a place that made me so happy to be alive.

The Hofmanns had spent twenty years of summers there by that time. There was an inherent stability in that house such as I had never known. My family had never lived anywhere longer than a few years. From place to place we carted our things, shedding bits and pieces along the way, but we never called the walls that contained them "home." This was a home, one of impeccable order, run by Miz with precision and love. I sensed that Miz and Hans moved through those rooms on harmonious, parallel paths—Hans also had his own path, which led from the back of the house to his studio—each endowing their domains with complementary skill and passion.

The Hofmanns were then in their late seventies, my grandmother's

age, but there the similarity ended. That weekend I would learn that who we are is a reflection of the life we live on any given day, not the mere sum of the years we have lived. My grandmother lived the daily life of a sheltered, timid old lady and had done so for most of her life. The Hofmanns had the exuberance and self-assurance of people who knew how to enjoy life to its fullest. Each morning we were there, we would all go out to Race Point to swim in the ocean, which, thankfully, was calm enough even for me. I had never seen my grandmother swim, much less wear a bathing suit. And I had never had a grandfather. For generations the women in my family had managed at a young age to lose their husbands one way or another.

And then there was the German-ness. Again, so different from my family, who even as second-generationers still lived in an insular community and filtered their sensibilities, their views of people and the world around them, through their German-ness. The Hofmanns, in this country for only twenty-five years, kept their door always open. That weekend people streamed in and out—artists to have a chat, students to say good-bye to their teacher. The Hofmanns' accents, still dripping of Munich, had at first put my supersensitized ears on red alert. But it didn't take long to be seduced by the gemütlichkeit and Miz's cooking.

That first evening, Miz and I engaged in a long talk about food. She probably asked me whether I liked to cook and whether, having grown up with German heritage, I had any favorite foods. I would have told her that no, I had never learned to cook, that my mother didn't like to cook, and that my favorite dinner had been hot dogs, canned peas, and soggy rice. She no doubt would have noted the knockwurst connection, before adding that long-cooked rice was a wonderful German breakfast cereal, a dish she remembered fondly from her own childhood. I chimed in with my own memories of *zucker butterbrot*, a treat I loved when I was little. The next morning, there was the large pot of stewing rice on the stove. She ladled it out for me with dollops of butter and brown sugar, and, sure enough, slices of bread slathered with butter and sugar. Children together, we sat down and ate our porridge.

Hans had an extraordinary presence. His big, round, open-as-the-sun face still shines in my mind. And his feet, in the sandals of summer, large

and square, the big toes raised up, as if ready to spring into action. For a thick-set man, his movements were unexpectedly agile and quick. There was a heat coming off him, a furnace at full blast. Even in repose, the fires burned. At times I saw him sitting alone in the backyard, plunged so deep inside himself that I wondered if he would be able to find his way back.

I had come to take for granted that artists took up all the available space and filled up the air with their single-minded passion for their work. Though I admired that passion, it didn't make them particularly accessible. Sometimes I would try to discern the difference between self-absorption, which I could understand, and coldness, which I deplored. A fine line, and often I wondered if I was misreading the two. The distinction mattered, because in those days I was concerned about whether I liked those people and, more important to me, whether they liked me.

Many times I heard artists described by women as teddy bears, usually the burly types, like David Smith, Rothko, Hofmann, and even Pollock. Let me say that I never met an artist who was a teddy bear. All too often, the heat within did not spill over into warmth toward others. Hans was a hard call. As compelling as I found his robust energy, it was tamped down by an impenetrable layer of detachment. As if he were saying, *What doesn't serve my art doesn't serve me.* On the other hand, Clem, who never, to my knowledge, had been called anything even faintly resembling a teddy bear, and despite his relentless passion for art, was an outspoken believer in life before art. And how grateful I was for it.

Hans may have been uninterested in general conversation or, heaven forbid, small talk, but he was known as the greatest communicator. Just as his energy lit up his art and any space he was in, for his twenty-five years as a teacher it lit up all the artists who were fortunate enough to walk into his schoolyard, or be present at the renowned lectures he delivered in the late thirties. Clem had just moved into the city from Brooklyn and had begun to mix and mingle with the downtown artists. He heard some of those lectures and often spoke of the influence they had had on his perception of art. I could imagine Hans's voice, guttural and booming—perhaps more booming by the time I met him, because by then he was quite deaf. Miz would often signal him to put in his hearing

aids, signals he would usually ignore. Around Clem, he was interested in a dialogue and he would put them in. Around many others, not so, and at parties, never.

Hans was the first and most important star in my small, though rapidly expanding, firmament of painters. He and I shared a bond no one knew about, including him. In 1955, shortly before my college graduation, he had introduced me to art.

One night my new circle of art friends commandeered me into helping them prepare for the installation of some pictures by a painter called Hans Hofmann. I didn't need coercing; I was in the middle of a brain-numbing attempt to index *Finnegan's Wake* à la Kenneth Burke, an exercise that I would soon look back on as the absurdist dead end of the modernist spiral. My friends' project would be an all-nighter in the Carriage Barn, the multipurpose arts space at that time. We unpacked the pictures, flipped them facedown, attached screw eyes and measured and strung wires, retacked stripping, and finally flipped them over again and stood them around the main floor of the barn.

Then came the good part. We broke open a quart of Mr. Boston's gin and Ritz crackers, and talked through what remained of the night. And we played with the art. Moved the paintings around. What looked good next to what, and why. And which ones we liked more than others, and why. And in the process, I looked at art for the first time. I touched the paint, the textures of art, for the first time. With Hans, I learned how to handle pictures—with respect but not awe, carefully but not timidly. How to look at a picture separately and next to others. I learned that they had fronts and backs, that they were man-made, by someone who had something to say. And I had fun with art. Such was my night with Hans.

Now here I was two years later, sleeping in his house in Provincetown, being mothered by his wife. I hadn't attended the opening reception of that Bennington retrospective. I would have considered myself too cool for that sort of formal folderol. Hell, I would have had to brush my hair. Clem would have been there. Hans and Miz, too, no doubt. Would Clem have fallen in love with my *blauen augen* across the crowded room? Unlikely. Everything in its own time.

That weekend on the Cape we lived moment to moment. During those last days of summer, Provincetown was a moveable party town. Oh, we had our quiet times with the Hofmanns on the beach or sitting around the kitchen table. Sometimes Hans and Clem would wander off to the studio while Miz and I hung out on the porch. But other times, Clem and I would stroll down Commerce Street, running into everyone we knew and then some, joining up and going back to this one's studio or that one's deck for a drink, then moving on, eating a bit here and there, parties forming on the spot—invitational parties were rare and never as much fun—and maybe ending the evening dancing at the Flagship or the Pilgrim Club, or wherever there was music, which was everywhere.

Oh, it was free and easy. People flirting the night away. Like New York, it never slept. A few men even flirted with me. Well, at least a little. Something that never happened in the city. The only time someone did make a pass at me was during an opening at Martha Jackson's gallery. A young guy had crashed what he thought was a party, gotten drunk, and maneuvered me into a corner. He was quickly ushered out. I always figured I was off limits. After all, a wife was a wife, or at least Clem's wife was Clem's wife. Whatever. But that night confirmed what a small, tight-knit family I had married into. Another lesson learned: There were insiders and outsiders.

And how nice to be an insider in Provincetown. All the same people one saw in the city, but not the same at all. Everyone so laid back and glad-handing. Maybe because it was like a small-town neighborhood where people walked, everything and everybody just a shout away. I think of Milton Avery in front of his house, waving hello and inviting us in. He sat backlit by the sea. Pipe at hand. Sally nearby. Another soul-mated pair, like the Hofmanns. I was always on the alert for what a life partnership might look like. Were there clues I could learn from? If it was possible for others, maybe it would be possible for us.

Milton asked if I would like to have a go at chess. I demurred, saying I barely knew how the pieces moved—not quite true—all the while kicking myself for the timidity that kept me from sharing a few moments with that kind, gentle man whom I wished I could know better. I, who adored

games of all kinds, had early on backed off chess as being beyond me. After all, it was a man's game and therefore veiled in arcane practices and complexities inaccessible to females. And Milton smiled and said, "Perhaps another time."

And I think of Adolph Gottlieb, his skin so dark and weathered from sailing. Who would've thought? An artist who routinely won racing trophies against the pros. A sportsman, not the suit-and-tie artist we hung out with in the city. Either way, I particularly liked Adolph and Esther, he soft-spoken and thoughtful, she more forthcoming and interested in what I called "real" conversation than most artists' wives. We would now and then have dinner at their place in the East Village or they would come to eat with us, usually ending the evening by heading a few blocks south to the White Horse, where, crushed in the back room over drinks, Adolph and Clem would dig deep into art talk and I would try to listen over the din. Eventually my mind would glaze and I would sit back and let myself drift, thinking of how young all the kids seemed who jammed the tables sloshing their beers, even younger than I was, and that if Dylan Thomas were slouched over the bar maybe he would remember me as the girl who had recently sat at his feet after his reading at Bennington—that is, if he weren't already dead. Later I would lay my head on my pillow and smell the cigarette smoke and beer on my hair and think, *I must be in the real world now*, all the while wondering why it wasn't more fun. In Provincetown we all smelled of the ocean.

On our last day, my mother drove up from her place in Falmouth at the other end of the Cape to pick us up. She had recently taken up painting and was studying with an ex-student of Hofmann's, John Grillo. In her swishy print dress, white pumps, and sun hat she was gussied up and at her coquettish best that day. As I had since I was a child, I cringed at her enactment of the coy temptress, to my eyes so blatantly affected. Hans, however, seemed to be taken with her, judging from his smiles and the way he leaned into her. And, needing no signal from Miz, he put in his hearing aids.

After an alfresco lunch, Hans led her to a bench farther from the porch and I could hear the murmuring of German through the kitchen window as I helped Miz with the dishes. I wondered what they were conspiring

about in that dreaded language of whispers and secrets. But that day the sun was shining, I had a cool vodka and tonic near at hand, and I stopped cringing. I saw the sweetness of the scene, and another side of Hans.

Clem and I would return to the Hofmanns' in 1958 and again in 1960. By 1961 our life had assumed a stepped-up momentum of its own. The spontaneous days and nights were over. We continued to exchange visits in the city, and Clem would visit Hans at his studio. And we invariably saw them at the small dinners Sam and Jane Kootz would give for the "boys," as Sam called the artists in his gallery. Too formal by far, the Kootzes lived high; they always employed a "couple" and lived on Park or Fifth Avenue in their cutting-edge world of Henry Miller and Georg Jensen. I would put on my fanciest dress and dangly rhinestones. I don't know why, but with the Kootzes one just did dress up, even the artists, even Clem.

After an elaborately endless dinner, conversation tautly anchored by our hosts, we would adjourn to the living room for Napoleon brandy and liqueurs, demitasse, and cigars while Jane and Sam reclined in their matching white Eames chairs. The overall effect was chrome and crystal, chill and leather. I, in a low-slung Mies chair, my dress too tight, my head muzzy with too much booze, waited for the first hammer blows of a Kootz headache. No matter who was there on any given evening, I never got to know anyone better, no hair was ever let down, nothing personal was exchanged. I always felt the artists were there as hostages. Heaven knows why we were there, except that in those days all too often we simply went where we were invited.

When I next looked around, or so it seemed, I was at Miz's funeral in 1963. And by 1966 Hans, too, was gone. My affinity for the Hofmanns was connected primarily to my times with them in Provincetown. It was there that I had endowed them with so much. I wonder what they would have thought if they had known that they were the German family I wished I'd had. That feeling no doubt accounted for the strong sense of loss I felt when they were gone. And it also contributed to the pleasure I got from the superb "slab" painting Hans gave us as a wedding present. As the decades passed, it became necessary to occasionally ask an art dealer to sell a painting for us. The Hofmann would be one of those. It was the only picture I truly missed.

I like to think of the Hofmann house as still being there, much as it was during their decades there. However, I am told that it has changed hands several times, and while the house and studio behind are indeed still there, they appear shabbier, the garden is untended, and a large modern house was built across the street. There would no longer be a rainbow dancing on the bedroom ceiling upstairs. Of course, the only testament to the greatness of an artist is the work he leaves behind. Their houses and sundry accoutrements are only so much fuel for the mythmakers. However, the house will always be preserved by me, not only as the place that embodies the greatness of the artist who worked and taught there, but, most important, as the place that speaks to the solidity and harmony of the two lives that lived there.

Hans's passionate spirit touched me once again when I found these two handwritten letters he wrote to Clem four years after my first visit to Provincetown. Clem had tucked them away among the Hofmann catalogs on his bookshelf, a filing system he was partial to. I include them here, as written.

February 17, 1961

Dear Clemm—

I thank you sincerely for the enormous work you did with your book on me [*Hofmann*, Editions Georges Fall, 1961]. I go basicaly almost completely with it—almost but not completely.

The reason: I never paint a bad picture.

I may not always paint a successful one. As a juror which I quite often was I always resented to function in the roll as a critic. I resented it because whoever criticieses himself. The work criticieses back.

And as a teacher I was constantely aware that one must never be a schoolmaster by entangle oneself in enormous or academic steril problems that anihilate the vital approach to creation. The vital approach to creation is deep rooted in the

faculty of the mind to sense and recognize the inherent qual-
ity of the medium of expression to bring the qualities into
appropriate relation to each other for the creation of a higher,
of a new and complete independant, quality which the means
of expression have met in themselves but which transcent the
spirit of creation.

Only this to me is Art. In following this principle it is impos-
sible to paint a bad picture.

Most affectionate yours

<div align="right">Hans Hofmann</div>

July 22, 1961.

Dear Clement—

Your book [*Art and Culture*, Beacon Press, 1961]—your great
book—its arrival with dedication a great and most pleasant
surprise to me—how could it be otherwise. [Hans must be
referring to Clem's personal inscription to him. The book is
dedicated to Margaret Marshall, arts editor of the *Nation*.]
It mirrors in my opinion a span of great revolutionary time
in the realms of all the Arts in which we have all participated
creatively in one way or the other. It analyses all events most
profoundely and in greatest honesty. What I most admire is
the courage of attack from a polemic point of view that will
connect much of the historical blunders so far falsely build up
about this events.

I congratulate you—your book will make its mark on his-
tory as it is full of wisdom—its destination will be to sustain
and accelerate creation on its highest level.

I am so deeply enwraped in my work that almost nothing
exsists any more for me outside my work. It is the reason for
this "belated" letter. Excuse me therefor and accept please my
simple "I thank you!"

<div align="right">Love to you both
Hans Hofmann</div>

BARNETT AND ANNALEE NEWMAN

I ACCOMPANIED CLEM to Barney's studio for the first time on a December afternoon in 1956. We took a subway to the southern tip of Manhattan and walked across the deserted weekend streets of the financial district to the East River. I had met Barney and Annalee before, across dinner tables or at openings or parties, but I had never seen or heard talk about his paintings.

As I walked through the studio door in that crumbling Front Street building, I was startled, disoriented, by what I saw. Pictures everywhere, some hanging, some propped up along the floor. Two of them were the biggest pictures I had ever seen—one all red, with a few ragged stripes, the other an improbable combination of a bluish-green and ochre. They were beyond my comprehension. As I moved among them, they advanced on me, surrounded me. Not that they were hospitable, or accessible. On the contrary, they offered no footing, no grounding point to hold on to, no concept, nothing I could name. Were they paintings at all? I felt threatened by the proximity of so much that couldn't be named, defied definition.

Annalee, of course, was there—wherever Barney was, Annalee was—and also the artist Tony Smith, an old friend of Barney's. I was the only innocent; the others had known Barney's work for years. William Vandivert arrived later, and it was he who took a photo of Barney and me posed self-consciously as we gazed at one of his pictures. At a distance, Clem is also in the photo, looking at a different painting. I manage to appear as if I have a clue about what I'm looking at, that this is just another ho-hum day on the art circuit. Had it only been a year, or was it a century, since my first studio visit, when I had gone to Rene Bouche's to meet Clem for our first date? No red velvet and mahogany elevator

here, no vista of Central Park, no elegant guests sipping martinis. Nor, at the far end of the studio spectrum, was this Pollock's rough-hewn, step-at-your-own-risk barn. This was like a generic space. There was little sign of the making of art or of the person who had created it. I wouldn't have been surprised if the place had been wiped clean of fingerprints. No buckets of paint—or even the faintest whiff of it—no piles of rags, no old shoes kicked into a corner. There was only the art, as if it had arrived there full-sprung.

Over time, as well as I got to know Barney, I never could imagine him knee-deep in the creation of art. Part of if was that he was a dapper man. Like an actor, he strutted and posed, always dressed to the nines with his bow ties and monocle or pince-nez. But a painter? No. He enjoyed the smoke and mirrors, challenging the expected. In that sense he and his art were one: *Who am I? Are my pictures art?*

Impressions aside, the fact was that Barney, in some respect, was a painter who didn't paint. At least at times. Not long after the studio visit I learned that following his shows at Betty Parsons's gallery in the mid-forties, Barney had refused to show his work for years. He had withdrawn "on principle," not that anyone was clamoring. During that time, he painted only intermittently. When he did show his work again, in the late fifties, dates were fudged to close some of the more glaring gaps. Evidently, that was not an unusual maneuver for artists.

That day we sat around with his pictures for several hours. I was still in a daze from the initial impact they had had on me. I had been taken unawares. I had never dreamed that art could exert such power, such full sensory power. Barney's pictures made me realize that the only certainty was that there were no rules. And if I learned to open my eyes wide and get my mind out of my own way, art would just happen to me. No wonder I was in a daze. I knew that what I was seeing that day would change forever the way I looked at art.

The afternoon wore on and ended, as many days do, on a more mundane note. A lot of drinks later, we all made our way through the darkness along the river to have dinner at Sweet's across from the Fulton Fish Market, a restaurant so venerable that even I had heard of it. Only later did Clem tell me how rare that viewing was. Unlike the studios of most

artists, who were more casual about opening the doors of their studios, Barney's door was locked and sealed.

Month after month we four would meet at Bank Street and go to the usual cramped, dim restaurants, where I would listen to Barney's relentless, droning voice, nasal, wheedling. Oh, that voice. Hours stretched to light-years as I grew wizened and gnarled, rooted to the floor, as Annalee hummed, dark in a dark room, as Barney talked on and on about "issues," his touchstone word. The world according to Barney was comprised of issues. He had his own criteria for what an issue was; anything that didn't fit was of no consequence.

Barney would launch into a riff slowly, drawing out the words as if he were about to reveal the secrets of the universe. "The . . . um . . . issue . . . ahh . . . is . . . " He spoke in immense pauses punctuated by odd little snorts from somewhere between his throat and sinuses. I was always waiting for the toaster to pop. And by the time it did, I didn't give a damn.

A polemicist, he would niggle about everything from semantics to the spelling of *goulash* on a menu, as his hand chopped the air, affixed to the cigarette or cigar that spewed its vapor. The same went for art talk, until I would want to lean across the table and shake him: *Isn't it enough to know something and just do it? Why must you always explain everything?* But, of course, that was exactly what he needed to do. Barney's way of speaking might have been slow and painstaking—and why not? He was that way in his art—but, unfortunately, it was also nonstop. He talked like a teacher, which he sometimes was; like a philosopher, his major at City College; and like the socialist he was when he ran for mayor of New York as a young man. Those were the engines that propelled his art talk, because of course he talked about art most of all.

For about five years we saw the Newmans regularly for dinner. No one else was invited along to divert; no Five Spot or Cedar Bar would cap off the evening and mix up the drill. And always, Barney's voice would trail me home and invade my dreams. Needless to say, double-dating with the Newmans was not high on my hit parade. However, as much as my heart would sink, I hadn't yet learned how to beg off, nor had I even considered the possibility of doing such a thing. Instead, as I so often did

when the onslaught of information that surged around me became too much, I retreated behind my defensive shield. Not directed at me, or of any practical use to me, that information was peripheral and it dispersed as quickly as the smoke from Barney's cigarettes.

Barney actually had a reputation for being witty. But invariably I found myself waiting in vain for a spontaneous moment of lightness, of humor. Oh, he could come up with a witticism now and again, but I felt that even they were hard come by and were delivered more as well-polished aphorisms. Two, in particular, would seep into Newman's lore: "I paint so that I'll have something to look at" and "Aesthetics is for the artist as ornithology is for the birds." As much as Barney enjoyed discoursing on the subject of humor, for me, he succeeded only in de-humorizing it. In this respect, he joined the crowd. By and large, I had always thought of artists as humorless. I saw it this way. Drunks aren't funny, artists drunk aren't funny. Impoverished, fearful, driven artists aren't funny. And that pretty much covered the artists I knew.

Clem was another one. He rarely laughed—a full-out *ha-ha* laugh— except when someone told a good joke. He despaired that he had no gift as a raconteur and admired inordinately those who could pull it off. He loved wit, bitchiness, and gossip, especially when packaged in the repartee of his gay friends. Most of all, he loved Jewish humor and nightclub comedians. As for me, I was a deplorable joke teller, though I was thought to have some wit and a good overall sense of humor. Somehow, I don't think of myself as having done much laughing in those early years. But a lot of the situations were funny. Not to mention the entire square-peg-round-hole predicament my marriage had landed me in.

One scorching summer weekend, Barney, Clem, and I took a long bus ride to Camp Tamiment in the Poconos. Barney sat in the seat in front of Clem, his head swiveled around as he talked ceaselessly, cigars and cigarettes going, the windows open, hot air gusting against my closed eyes. The "issues" were as heavy as the heat: politics and the murder of socialism. And why not? Tamiment was founded in the twenties by labor unions and the radical Left as a getaway for their members and families. Like any camp, it was on a lake in the mountains and had a plethora of Jewish comedians passing through. But this was no Catskill pleasure

dome, like Grossinger's. Tamiment, true to its socialist roots, was plain pipe rack. And what really set it apart was that it believed in serving up culture along with its light entertainment. It took both very seriously.

So it was that later that night the sparkling duo of Greenberg and Newman performed as the warm-up act for a Sid Caesar wannabe. In that environment it turned out not to be as lopsided as one might have thought. Culture drew a hefty crowd, even without the laughs. And Barney and Clem played off each other like old pros. They were enjoying themselves; Barney the Ponderous revealed astonishing comedic timing, and Clem, as he never had and never would again, actually played to the audience. They were rewarded with a roar of applause, and both were rather pleased with themselves.

The next morning passed rather uneventfully; the "stars" were corralled into various impromptu confabs to debate art vis-à-vis politics, as I lay on the raft in the sun, listening to the screams of euphoric children. I thought about this strange place that had transformed Clem and Barney into adorable boys. A Jewish place, where Yiddish and English merged and the food tasted different. On the ride back, I relinquished my wifely seat to Barney and listened contentedly to the murmur of their polemics as we returned to a more familiar world.

Despite his dazzling duet at Tamiment, Barney stood alone, a hard-nosed hard-liner. There was only one right way, and that was his way. Yes, that could be said of most artists, but Barney . . . I see him astride the battlements of a fortress, wielding lightning bolts of ego. Inevitably, Barney's oldest friendships had faltered along the way—notably, those with Rothko, Reinhardt, and Still, with all of whom he had once shared many of the same views about art and the art scene. Temperamentally, Barney came close to being like Still, the iconoclast of all iconoclasts, with his grudges and righteousness. But, thankfully, Barney stopped short of Still's extreme posturing. He had been blessed with humanity and an appetite for the world. And when I could cut through the oratory I could even glimpse a sweetness and a bad-boy charm, but rarely enough for me to hang on to through those long hours in those dark restaurants.

Clem's relationship with Barney began to fray after he curated Barney's first retrospective at Bennington in 1958. But what pushed it to the

limit was when Clem became an advisor at French & Company's new contemporary gallery and arranged for Barney to have the opening show. Barney's demands and micromanaging knew no bounds. I watched him on Madison Avenue and Seventy-sixth Street, orchestrating the crane as it hoisted his eighteen-foot pictures to the penthouse gallery. Barney was in his element. And the icing: The *Times* ran a picture of the traffic-stopping "event."

Clem would say that the beauty of the show in no way made up for the strain of being forced into running interference between Barney, with his high-handed demands and threats, and the gallery directors, who were used to dealing with dead artists. It was all more than Clem had signed on for. And even though the artists that followed—Gottlieb, Smith, Louis, Noland, Olitski, among others—were a breeze in comparison, Clem's heart wasn't in it. He had soured on the project, which had originally seemed like a fine idea, and after the inaugural season, he quit and never did curate another show.

The one time we went to the Newmans' apartment, I saw a photograph of Annalee and Barney posed against the New York skyline. They were newlyweds, she camera coy, a vivid brightness about her, he cocky and proud. How winsome and pretty she was as a young woman with her dashing Barney. In the camera's eye, they were complete, joyously ready for an unordinary life together.

There was no doubt in my mind that if Barney and I had met when we were young and starting out, we would both have run screaming in opposite directions. But after I saw that picture of Annalee, I felt that we would have connected. At least we would have stood a chance. I was sure that rather than being swathed in her usual black, she would have worn the colors of new love and adventure to match her glowing face. And I was sure she hadn't been a hummer when she was young. When I say "hummer," I don't mean just now and then; I mean a lot, and loud enough to be heard, loud enough for me to know that there would be no conversation because she was someplace else.

But there was rarely conversation between any of the artists' wives and me. That was part of their earnestness, the wary listening to every word that passed between their husbands and Clem, the deciphering of codes,

the reading of glances, and the committing of it all to memory, perhaps in order to play it back later. How could there be space for casual girl talk between us? After all, the wives were hardly a frivolous, frolicking bunch. And if there were close friendships among the wives themselves, I saw little sign of that. At least among the wives who, like Annalee, had full-time jobs as well as the full-time nurturing of needy husbands.

Then, too, as the stakes grew higher in the late fifties, perhaps there was too much competition and volatility in the air. Over time I became accustomed to the lack of give-and-take, although I still yearned for it. I had always enjoyed the company of women and, for the most part, found them more interesting than men to talk to. As for Annalee and me, the might-have-been connection never happened.

I would have to read Annalee's obituary to learn that she went to graduate school at Columbia and the University of Nancy, where she earned a degree in French; that she was an expert in shorthand and taught high-school secretarial studies; and that she was a lecturer at the Baruch School of City College. I wish you had told me about all that, Annalee; at least it would have been a starting point. But that humming. Was she as bored as I was? Was it simply an occupational hazard of her many years as a schoolteacher? Or maybe it had started decades earlier during the long evenings with her Barney, who talked enough for two. Whatever, my mind still resonates with that talk and that humming. Just as I can still hear Annalee saying *Barney*. She sang it with a wide-open *a*, held two full notes, with a lilt between the syllables, rather like *Swa-a-a-nee*. (The rest of that song's lyrics would work just fine, too.)

The devotion was mutual, but I always thought the weight of it was on Annalee and her financial and emotional caretaking of Barney's art, aspirations, and convictions—no small undertaking with that dogged warrior as he carved out his place in art history. A friend, the painter Yvonne Thomas, once told me a story that, as I saw it, epitomized Annalee's dedication to Barney. Many years before, she had run into Annalee, who was on her way to work. In the course of things Yvonne had asked, "And what's Barney up to these days?" "He's thinking," Annalee had replied, not missing a beat. On that occasion my friend had noticed a loose button on the front of her coat. "That wasn't so strange," she

continued, "but when I saw her a year or so later the button was still loose, now hanging by a thread." My friend and I laughed and agreed that Annalee had taken spousal selflessness to a new level.

Not to suggest that Annalee was put upon or passive. I thought of her more as a sergeant at arms, happy and comfortable with her chosen path. When Barney had a heart attack in 1957, I saw in her the combination of palpable fear and street fighter as she hovered by his hospital bed. What a terrible shock it was for her, for all of us. He was only fifty-two. No mute wife then. How fierce she was in her concern lest Clem would get him stirred up with art talk. But even in the hospital, flat on his back, on oxygen, monitors beeping, Barney would do his own stirring up. After all, there were always far-flung "issues" to expound on, even if his voice was weak. And when Annalee left the room for a moment, there was talk on a different issue, one that really got my attention. With his usual deadpan delivery, he launched into an analysis of the nurses and their perfect breasts, and did Clem have any theories on why, on average, nurses had better breasts than other women? One thought led to another and eventually he was satisfied to conclude that their breasts must simply be a gift from God, because at the rate he was having erections, he knew he wasn't going to die anytime soon. The admixture of Barney, sex, and his over-the-top narcissism had me bursting with laughter. But this was no joke to Barney, who silenced the flibbertigibbet with the lift of one eyebrow.

True to his prediction in the hospital, Barney didn't die at fifty-two. He lived another thirteen years and died in 1970. Annalee would survive her soul mate by thirty years. I liked thinking of her as being the tiger she had been by his hospital bed. I was reassured when, in 1987, Annalee refused permission to the Albright-Knox Museum to include Newman in its show of geometric painters. Barney had long battled the inclination of curators and critics to label him as geometric. He had characteristically refused to be labeled as anything, which left his work up for grabs, and it wasn't long before the minimalists tried to claim him as one of their own. A closer match. To the end of his life, Barney had continued to enjoy swatting away at the "issue" brushfires, and it was nice to know that Annalee was still bearing the standard.

I was also happy to hear that in her later years Annalee moved to the posh River House, to an apartment with a marble entrance hall. How grand. The last time our paths almost crossed was in 1992 at the Museum of Modern Art, on a special viewing day of the Matisse retrospective. Across several adjoining galleries, I espied her standing in profile in the middle of a room, alone, gazing fixedly at a picture out of my view. Even at that distance, she was unmistakable, still dressed in head-to-toe black, her bearing unchanged, though she had a cane. I moved forward, eager to greet her after so many years, but by the time I reached the gallery she was gone.

JACK AND MABEL BUSH

WE FIRST MET Jack and Mabel in 1957, when a group of painters in Toronto, known as Painters Eleven, banded together to invite Clem up for a week to look at their work, one-on-one. Because the decision had not been unanimous, for this visit the group would be, in fact, Painters Nine. Canadian artists seemed to have had a predilection for numbering their like-minded posses; besides Painters Eleven, others included the Group of Seven and the Regina Five.

That was my first trip to Canada—in fact, to any "foreign" country, and over the years Clem and I would return often. On this occasion, the Bushes had been designated as our hosts. Jack, in his tweeds, looking for all the world like a British country gentleman, picked us up at the train station. Our overnight trip from New York had taken fourteen hours. Since our "honeymoon" trip to Minneapolis, I was still afraid to fly, and would be until 1963.

To my surprise, Jack pulled up in front of a white colonial in the suburban rim of Toronto. As surprised as I had been upon first seeing the Hofmanns' Provincetown house, I couldn't believe this could be an artist's house. Toronto, being a large city, had made me envision some sort of loft. Instead, I walked into the house I had always wanted to live in as a kid. Nothing grand or over the top, it was done up in a cozy, chintzy way. And there was a big backyard that showed years of loving care, where we had drinks and mountains of fancy hors d'oeuvres that first evening.

Mabel was a tall, pretty brunette, so welcoming and warm. She wore a summery pastel dress with a very full skirt and a wide white patent-leather belt that showed off her figure, and I wondered if I had brought

something nice I could change into, though I knew I hadn't. In any case, what would have been the use? I despaired of ever developing a waist. At twenty-four, I was getting a bit long in the tooth to ascribe the problem to "baby fat," as Clem fondly called it. To me it was the hex put on me those many Christmases ago by my snarling Nazi uncle: "Isn't it time she lost her baby fat?" But while I waited for the day that would never come, belts were for the Mabels of the world.

As the sun set, the Bushes talked about their three boys with love and pride. Though their sons were nearly grown, Mabel and Jack would always refer to them as "boys." Jack talked about the art in Toronto, the feelings of provincialism there, and his concerns about the future. Mabel appeared to me to be the perfect wife and mother. I thought in those terms. I was still looking for role models, my own family having left me at a loss in so many ways.

After dinner Jack and their two younger sons, Terry and Rob, played music—Jack proficient on the piano, the boys equally so on drums and guitar. Jack was mad for jazz, but Clem was equally mad for dancing and, as usual, protested that you couldn't dance to jazz. With some reluctance he made a concession in honor of the visitors, and that night, as Mabel, Clem, and I threw ourselves around, the beat of Buddy Holly and Elvis shook the small room. The Bushes and the Greenbergs had clicked.

During the next few days, as Jack became more and more excited by all the art talk and hearing about what was happening in New York, Mabel retreated. I could tell that the talk made her anxious. Even then, years before Jack's art career ignited, I glimpsed their fears about what lay ahead. They were in their late forties, Jack an established commercial artist in advertising, Mabel a homemaker. By the time our visit was over, it had become clear that Jack yearned to break the mold of his life. At the same time, he was fearful that his talent as a painter might not be sufficient to justify making the leap from secure, well-paid work to the precarious future of a full-time artist. On her part, Mabel wanted to shine and polish their life as it was, keep it safe. She had sought out, found, and fallen in love with the traditional man of her dreams. That he happened to like to paint had no doubt just added a bit of zest. Her fear was that maybe he would take that leap and she would be left behind

and the boat would sink. She knew how to be an executive's wife and a mother and hostess. How did one "be" an artist's wife?

I empathized with Mabel. I hadn't begun to figure out what my role was in Clem's world. I dog-paddled my way around in a pool of artists' wives who seemed to me to be accomplished, happy campers. Although it was still early days for me, somehow I already suspected that I would never get the hang of it. At least Mabel had the domestic, wifely role down pat; she not only owned it, but gloried in it. To my mind, I was striking out on both counts. As ungrounded as I felt in the art world, I was also unclear about how to "be" a wife. Oh, I did what I called "nesting" and I puttered, but I certainly never gloried in it, nor felt accomplished at it. Sometimes I thought it wasn't in my nature, that I must be missing a link. Other times I hoped maybe in time . . . And every day I managed as best I could. And I watched the art wives and hoped that what they seemed to do so well might rub off on me.

After our visit, the Bushes came often to New York. They would burst in like a gust of fresh air at the end of the afternoon, sinking gratefully into our big couch, elated after a day of galleries interspersed with shopping sprees. For them it was as if every adventure were like Christmas morning. Infectious. Clem would shake up the martinis—he was not a stirrer—and I would produce my far-from-fancy best effort at nibbles, invariably chopped liver from Barney Greengrass on Amsterdam Avenue, saltines, and a dish of canned ripe olives. Jack would effervesce to Clem about this artist, that picture, tentatively venturing his "takes" and why he thought this worked and that didn't. Mabel would gush to me about the stores they had gone to and what they had bought for themselves and for the boys, and where they had had lunch and how she had asked for the recipes for this or that dish. It was a rare dip into girl talk with my pipeline into "real" married life. More than a pipeline, Mabel was my first artist's-wife friend.

Sometimes she and I would talk fondly about Jack and Clem, so alike in the fundamental ways: same age, same height, both smoked Camels, a lot, both drank, a lot—though we agreed that Clem could handle it better—both had strong ethical and moral standards and were sticklers for good manners, and both could talk about art until hell froze over. And

they had both had emotional breakdowns—Jack when he was thirty-eight, Clem at forty-six. Their conversations about life and relationships were filtered through their experiences and fascination with the process of analysis.

As for differences, they were mostly a matter of appearance. Jack, with his shining pink complexion, neatly trimmed mustache, thick mane of slicked-back graying hair, and snappy clothes, always looked as if he had just stepped out of *GQ*. Clem, three-quarters bald, his skin a pale white, was a "comfort first, to hell with appearance" kind of dresser, a "take me as I am" sort of guy.

As for the give-and-take about art between Jack and Clem, it was not always fifty-fifty. That would develop only as their rapport deepened. Jack, by nature a sweet guy, found it difficult to be tough even when it came to his opinions about art. It was as if he were still playing catch-up and was unsure of his footing. Clem would sometimes get impatient and push him to disagree with him, to look harder, more critically, at what he saw. I was used to the hammer-on-the-nail precision of Clem's opinions about art and people. And I was used to it from others; for most people in the art world, judgments were their daily bread. But Jack. Sometimes even I wanted to shake him, shake him until all the dregs of anger and revolt, that underbelly of feelings that I was sure was in everyone, spilled out. Jack was certainly the only artist who ever made me wonder if someone could be too nice. Without that critical edge, would he ever be able to make it as a painter? But voicing strong opinions in our living room about his likes and dislikes of artists and their work, especially if there were other people around, which was often the case, well, it never happened.

The martinis drunk, the chopped liver eaten, and the olive pits piled on the plate, we would then set off on the town. With the Bushes that always meant jazz and Max's. And sometimes, if we "girls" held sway, we would head for a nightclub, somewhere fancy where Mabel could sport her new clothes and we could watch a show and the music would be divinely danceable.

How little I understood during those early visits about Jack's process as a painter. I, with my burgeoning list of absolute opinions about this

and that. Opinions, of course, that were rarely voiced among the big talkers that filled the airspace; at least I had learned that much from the wives.

But by the time we next went to Toronto and saw Jack's new work, I got what he was about. Jack's way was to sop it all up, everything he saw and heard in New York, and then, once he had internalized it, he would sort through what he liked and didn't like. I could look at his pictures and see how he worked. He painted his insides out. And in that he was like all the other good painters. His pictures said everything his reticence kept him from expressing in our living room. His pictures were an open book, an honest book. He felt deeply and painted deeply. Lord knows, he didn't need me or anybody else to shake the sludge out.

Gradually over the next years, Jack did take the life-altering leap and the boat did not sink—far from it—but in some ways Mabel was left behind. Not that she didn't support and even encourage his decisions— after all, she loved Jack—but there were also those deer-in-the-headlights moments, when I could see how uncomfortable she was in Jack's new world. Mabel could not have possibly foreseen that, far from being a Sunday painter, Jack would become internationally heralded as one of the preeminent contemporary artists to come out of Canada. When the time came for her to march forward into Jack's new world, I could see that their redirected life was too much for her to take on. As he joyfully threw open the door to his art and took over more and more of the house for his painting, she, in effect, closed her door with a resentful *click*.

Those were the toxic years. Her whole body revolted against Jack's art. She suffocated on the fumes of his paint media until her face swelled, her eyes closed, and she broke out in rashes. Did Jack resolve the problem? Indeed, he did his best, and as he soared creatively, he was eventually able to move his work into a large studio downtown. And as his pictures got bigger, so did his life.

Yes, they kept the house. And because guilt and resentment have a way of running through marriages like a river, Jack assumed the mantle of guilt for having put Mabel through such difficult changes. He was already known for his self-effacing, modest ways, and these traits became only more pronounced as time passed, almost as if he needed to balance the

bliss and passion he was experiencing in his art, lest those newly released emotions overwhelm him and others. But there were social occasions, especially after a few drinks, when his joy about painting would break through unbridled and his whole being would quiver with it.

Those were the breakthrough years for Jack, as the paintings avalanched out of him and he began to show in New York. Mabel continued to accompany him on his visits, but, although she slowly adjusted to their new lifestyle, it seemed to me that she stopped being as spontaneous and took a step back from being a full participant at Jack's side.

Jack was an art-world anomaly, a painter who flowered in middle age after years of juggling an increasingly incompatible day job. And so was Mabel an anomaly, an artist's wife who found herself thrust into a life she didn't want or understand. Jack grew up fast in those years. He enjoyed his recognition and success. It seemed that each time I saw him he was more confident and at ease. Why not? He was finally living the life he was meant to live. And then, in 1977, at sixty-eight, he died suddenly of a heart attack. As with many other artists' wives, in due time Mabel assumed a new role as Jack's widow. I was happy for her. With her characteristic grace and beauty, she represented him well and seemed to enjoy taking on the tasks and functions associated with his art. Perhaps she saw herself as a redefined homemaker, this time of Jack's posthumous career.

I once told the Bushes that I thought we four were like the Ricardos and the Mertzes. They laughed and we argued about who was who. Clem was miffed because he didn't know what we were talking about. And we laughed all the more, telling him he was probably the only person on earth who had never heard of *I Love Lucy*. But I was serious. Of all the people Clem and I hung out with, the Bushes were the only couple who had ever made me feel that I was part of a foursome. Compatibility times four.

Clyfford and Pat Still

At night our living room was as dim as a cave, even with two table lamps, a standing lamp, and Clem's green-glass desk lamp. As small as the room was, there was never enough light to fill its veiled corners. Perhaps it was the high ceilings. Perhaps it was the dingy white walls that every day got dingier with the grime of Hudson Street that seeped through the old window frames. The walls were jammed with small paintings and one large one, a six-foot square abstract that Clem painted, dusky rose shapes billowing around a vortex highlighted with gold. Along one wall was a row of bookcases painted white. A few small sculptures perched along the top, while sprinkled in front of the books were an assortment of highly- polished silver candy dishes and the like, that cast a glimmer or two. They were the small fruits of our wedding that I had hoped would spiff up the place. They didn't. Instead they made the room look incongruously fussy. On every surface was a much treasured ashtray, small white china ones, swiped by Clem from bistros during his European trips in 1939 and 1954. Add to that a tattered and frayed Oriental of diminished reds and yellows, two small tables, two upholstered chairs, two weary Windsor chairs, and Clem's desk, and that was that.

I had not met Clyfford Still before, but that winter evening in 1958 he had come to our Bank Street apartment, a rare house call for this reputed recluse, who had moved to Baltimore. With him were his wife and one of his two daughters.

He sat in one of the armchairs—the bilious green one with the springs that poked through. Whenever anyone sat in that chair, I watched them wince. As bony as Still was, he didn't. Maybe he was invincible. He

was very tall, with luxuriant white hair. His face was expressionless and gaunt. His friends—did he have friends?—called him Clyff. Tonight, Clem called him that, his wife called him Still; I called him nothing. On his right, on a Windsor chair, sat his wife, a small dark ramrod, barely leaning back, barely sitting at all. The daughter sat near the door on the other wooden chair, huddled. Across from the Still family, Clem was by his desk; I was in the other small armchair, faded orange, a hand-me-down from my mother. There they were, lined up, in Puritan grays and blacks. We were as we were.

As I looked at Still, I wondered if I was seeing him or the self-devised myth that preceded him. I had heard that he would set himself up as the supreme moral arbiter and pass out judgments from on high. His way was white, "their" way black. I imagined that the darkness he saw "out there" was as dark as his towering paintings, with their spires that clawed at the sky. He had recently walked into the painter-collector Alfonso Ossorio's house in East Hampton and "reclaimed" one of his paintings. He had cut it out of its stretcher, rolled it up, and taken it home. The reason? He didn't approve of Ossorio's having sold a Pollock from his collection, and was protecting his picture from a similar fate. And although Ossorio owned the purloined picture, he did not protest.

Still's astonishing work empowered him to hold curators, dealers, and collectors hostage. Having shown in the forties with Peggy Guggenheim and Betty Parsons, he had had no regular dealer for years and personally controlled every aspect of his marketplace. Purportedly, no collector ever chose a painting to buy. Still vetted the collector, selected the picture he would be permitted to buy, and set the price. And Still's reputation, prices, and myth grew. And the more he tested people, the more they sucked up, and the more they sucked up, the more he held them in contempt.

Had Still visited Clem before? I thought it unlikely. In an early review he'd written in the forties, Clem had marginalized Still as being "slack," "undisciplined." It wasn't until 1953 that Clem had had an epiphany and made his reversal official in 1955 in "American-Type Painting," saying he was ". . . impressed as never before by how estranging and upsetting genuine originality can be . . . " and called Still the " . . . most important

and original painter of our time." When I met Clem, he was reveling in his mistake. That was Clem's way. Still would always be Clem's touchstone when he talked about how important it was to look hard at art and even harder at the art you didn't take to at first. Now the touchstone was in the living room.

Still joined Clem in another drink. The wife and daughter drank nothing. I didn't know why they were here. It was obvious to me that this was not a social call. I somehow knew not to pull out my scant repertoire of social amenities and smiles. The occasion had taken on all the earmarks of a summit meeting where the agenda remains obscure. The men spoke. Still spoke a lot, using complex words to embellish simple opinions. The wife, being the wife, leaned in, drinking in each word. That was her way. She was the tape recorder, the note-taker. What was the daughter's way? Perhaps to be as unobtrusive as possible. I knew how to do that, too. I leaned back and tried to remove myself from this company, tried to think of anything but what was going on.

The Stills did not look at the art. They did not look at me. None of them spoke to me. They were as one. Finally, I ventured a word to the wife. I ventured a word to the daughter. There was no response, lest a word that passed between the men be missed. Nothing unusual, but never before to this chilling degree.

The voices went on—no banter, no chat. Still talked of polemics and issues and enemies. He reminded me of Barney Newman, that other painter of big pictures with big talk that could also numb my brain, but this man made Barney sound like a pussycat. I watched the women watching Still. Like chameleons, they had absorbed his coloration.

And then the conversation took a jolting turn to the personal. Now I, too, straightened in my chair and leaned in. Still was describing their living situation in Baltimore, his studio and their living quarters, his daughter's "room," separated from theirs by a curtain. He was proud of this austerity. I learned that the daughter was his, one of two, and that his wife was their stepmother.

I looked at the girl, noticing for the first time that she was not really

a "girl," but rather a young woman. Could she have been close to my age? I was twenty-four. They were so strange to me, this family. How did she manage with only a curtain between her and her father and her stepmother? I thought of my own stepmother and quaked. Before I could stop, I was in the anger of my own past. How had I ever managed to live in the same room as my brother when I was eight and he was thirteen? And when I was ten, how had I managed to share a room with my mother for the next three years? And I hadn't even had a curtain.

My self-pity disgusted me, and so I tried to refocus on these people in the room. It was difficult. I didn't want to identify with this daughter, but I did. I didn't want to hear this talk, but I did. I could see the curtain. It was not thick enough. It was rough homespun, but it was too thin. I looked at Still and he became a righteous crusader flailing at injustice, all the while mowing down those closest to him.

They had arrived at five and would stay until seven. They left on the dot, as if the time had been prearranged. I was surprised that they had even stayed that long. They rose as one. They didn't say good-bye to me. I don't think they knew my name. Nor did I know the women's names.

Later that night Clem and I went out with David Smith, a girlfriend, and Bill de Kooning. We hit the Five Spot to listen to jazz and met up with more people and then headed off to some parties. Bill drifted off, probably to the Cedar. We four wound up the night at the Chelsea Hotel, where David often stayed when he was in town from Bolton Landing. This time he had one of the penthouse rooms, huge and shabbily grand, and on an oversize low table, in a bowl as big as a salad bowl, was grass. Clem and I were new to all that, but we gave it a try—I more scared than excited, Clem ready to try anything new.

David made a production of rolling a joint. I was fascinated by his big beefy hands, hands that could weld monuments of soaring steel, now so deft at such a delicate task. He lit up and earnestly demonstrated how to inhale. We passed the joint to one another. I liked that ritual. It bonded us. I felt close to David that night. I had not been able to feel that way about him before. The more I inhaled, the more I swore over and over that I felt nothing. Everyone laughed, so I laughed, too. The more Clem inhaled, the more he muttered over and over that booze was better. Everyone laughed.

Clem was miffed. I sank back into the couch and drifted into thoughts of the couch I would have if we could afford a couch, big as a boat and soft as a bag of marshmallows. And I thought of the room I would live in, big and high and open to the air and to the light of the moon and the sun. It seemed like years later when Clem unearthed me from the couch, and I made my polite goodnights to David and his friend, thanking him for his hospitality. That was my way. Still going on about the grass and how we didn't see what all the fuss was about, we ambled our way home. There in the small foyer of our building was a dead-to-the-world drunk. I got a bit dithery and Clem reassured me that drunks were harmless; it was the junkies you wanted to stay clear of. I laughed. Clem, again, didn't get the joke. I couldn't stop laughing.

Why have I always remembered that? I don't remember David's girlfriend, or what went on at the Five Spot, or the parties, whose or where they were. But I remember the grass. And the drunk. And that it was all part of the same night that the Stills had come to visit, and how they had eaten up what light there was in the room and then left their shadows.

In an old Still catalog, I recently came across a long letter Still had written to Clem in May 1961—the tone dark and ominous. In it, Still dismisses *Art and Culture* as ". . . purveying downright lies, or worse—malevolent ignorance." He later lumps Clem with Barney, writing, "There is something rotten in your impotent souls" that motivates you to tear down ". . . the work and purposes of your betters." He concludes his litany of charges by referring to a dossier he has compiled that he will reveal at his discretion ". . . to correct your pedestrian perversions of the truth.'" The letter was signed by his wife, Pat Still, though for all the world, it would seem to have been written in tongues. Clem had never mentioned the letter to me, perhaps because it didn't surprise him.

Still died in 1980. True to form, his will was, in effect, an audacious challenge couched in stringent and labyrinthine terms. He bequeathed his enormous art estate, numbering some 750 paintings and 1,400 drawings, to the city that would build a museum dedicated solely to his work and maintain it in perpetuity, no deacquisitions permitted. He specified the required size of the museum, a minimum of twenty-five thousand

feet, and even the number of paintings and drawings that must be displayed on a rotating basis. For Still's widow, that patient guardian of the flame, it would take twenty-four years for the right suitor—the city of Denver—to appear and the terms to be met. She died a year later, and it would take another six years for the entombed oeuvre to be finally disinterred. I am sure Still will continue to manipulate the strings from above. With him, things had a way of never running smoothly. But then, he liked it like that.

FRANZ KLINE

FRANZ STAYS WITH ME. Yes, there are those raw, gut-wrenchingly honest paintings that when I first saw them made me gasp, the slashes, like black lightening, sending a shock down my spine. Oh, those pictures. But it is he who stays with me as well. Whenever I see one of his paintings or hear his name, I think of his dark-haired paleness, his deep melodious voice. And his soft brown velvet eyes with a smudge of sadness under a mesmerizing widow's peak. A romantic view. And why not? With his black fedora, thirties movie-star mustache, and flower-in-his-lapel ways, he certainly projected that image.

Franz's beginnings are so stark and bear so little resemblance to the man I knew, not well, but somewhat, from 1955 until his death in 1962. As so often happens, those who people our lives have stories we never hear until they are long gone. Only later would I think of the disparity between the open, fun-loving Franz, the Franz who was wild about dancing and took such bold strides that he took my breath away, and the Franz of the harsh early years. I looked for clues to link the two, but apart from that smudge of sadness, it was as if his past had left no trace. But, of course, that couldn't have been true.

His story rings of the gothic: extreme poverty, the father a dollar-a-day worker on the railroad who committed suicide when Franz was seven, and an orphanage in Philadelphia until he was fifteen. His interest in art started early, and after his mother's remarriage he was able to study at college and in England. While there he married Elizabeth, an elegant dark-haired woman who "dreamed of being a great lady." Arriving in Greenwich Village in 1938, Franz became part of the impoverished artists' world, worked and lived in a small studio underneath Bill de Kooning's, and survived on coffee laced with sugar. Elizabeth, sucked under

by hardship and isolation, withdrew and took to her bed, until, in 1946, Franz had to put her in a state home for the mentally ill for the next fifteen years.

By the time I met Franz in 1955, he had already been for several years with another dark-haired woman, Betsy Zogbaum, the ex-wife of fellow artist Wilfred Zogbaum. Lively, strong, beautiful, she became his life partner. And in 1950, at age forty, Franz achieved "overnight success." Evidently, one day he said to Betsy, "I've got it." He had started his series of black and white paintings. He is also purported to have said, "I don't know what to make of them."

Clem had played a pivotal part in Franz's career when, in 1950, he included him in the first show he ever curated. He and Meyer Shapiro picked up-and-coming artists for a show called "Talent" at the Kootz Gallery. This first showing of a Kline black and white picture garnered a lot of attention and got him his first uptown gallery, the Egan Gallery, where he had his first one-man show in 1951. In a rare gesture, Clem contributed a blurb for the show that dubbed Kline the "most striking new painter in the last three years." He was also acclaimed by his fellow artists.

However, Franz, like all first-rate artists, would have to wait a while for most critics, museum people, and collectors to catch up with his work. Another critic of stern stuff who was not won over was Kline's mother. Evidently, upon seeing the show, she said to him, "Black and white—you always did choose the easy way."

Whether from the establishment or from one's mother, acceptance was hard won in those decades. The better, the more honest, the work, the higher the wall of head-shaking skepticism. That came to be the standard. And the reverse was also true. Early in his career, I recall Ken Noland after an opening of one of his shows at Tibor de Nagy as he walked down the street, downcast because people had liked the pictures; he had concluded that the work wasn't very good. How soon that would all change when the art scene moved into a time of newness for new-ness' sake. No more time delay as collectors, afraid lest they miss the next "star," paid top dollar. Wonderful for artists, but thoughts of Kline

and his slow but sure success at age forty made me hanker for a more discriminating time.

Clem's earlier familiarity with Kline's work might have suggested a more than casual relationship between them, but if that had been the case, it was no longer so by the time I came around. Not that Franz and Clem didn't get along—everyone got along with Franz. But, as with many artists, I was content with liking him from afar as our paths crossed and recrossed. That said, there would be a few exceptions.

The most unforgettable was in 1958, at a late-night gathering at his studio on East Tenth Street. The night had started at Barney's studio, where Annalee had arranged a viewing party, followed by dinner with Lee Krasner, then on to the Five Spot to hear Kenneth Koch read. It was the third time that week for us. We loved his poetry and kept taking whoever we were seeing on any given night to share the experience. De Kooning, also a fan of the Beats, was there and we joined up. After the reading, we all went over to Franz's place nearby. And there, to my astonishment, was Hedy Lamarr.

I was enraptured. Most of my memory of Franz and my surroundings was eclipsed by Hedy's dazzling presence as visions of "Samson and Delilah" danced in my head. Where was Betsy? Were Hedy and Franz having a thing? My mind boggled at the thought: a lowly painter—to my mind, all painters were pretty lowly—and a movie queen. I had no answers. I could only wonder how on earth a painter had snagged a movie star. Not any star, but the penultimate dark-haired beauty. A rather pedestrian explanation surfaced later that reversed my scenario. It seemed that Hedy had bought a picture of Franz's and written him a fan letter, and one thing had led to another. But still, as often as I saw evidence to the contrary, my imagination never would allow for the possibility that Hollywood might find the New York art scene glamorous.

Franz and Hedy must have continued to see each other, because there was an addendum to that evening a few months later, when we were invited to a small party at Franz's place and once again the movie star was there. That night I was a bit more alert. The room was large, very high ceilings, haphazard. The only place to sit was a long low sofa—more

likely a couple of mattresses piled up—along one wall. It was there that I sank down next to Hedy, smelled her perfume, and listened to the soft murmur of her foreignness, so familiar from the front row in the loge of the Rye movie house. I mused about Franz's attraction to luminous brunettes. It was Hedy who confirmed what I had always suspected: that all truly breathtaking beauties were brunettes. She was nice. She asked about my "husband," a word I realized I never heard or used much. But I couldn't ask her about hers, because I couldn't remember who all she had been married to. Instead I told her that I had never seen Franz so happy. Her whole face lit up. It was true, and that night Franz was an exuberant host, smiling as if his face would burst. Adding to my fun was that I was hanging out with a whole new gaggle of art types, the Tenth Street guys. And we all danced, and drank and drank. Hedy, too.

The following year we saw Franz in Provincetown, where he and Betsy had bought a house/studio. We were on one of our Labor Day visits to the Hofmanns'. How I treasured those few days in a place where all the spits and spats of the New York scene were swept clean by sea air. Where artists were like real people who just wanted to have a good time. More and more, the air in the city seemed to have gotten thick with competition and divisiveness among the artists. There was uneasiness; times were changing. Provincetown was like eternal adolescence, living in a neighborhood with a bunch of kids always at arm's reach, ready for the next adventure. The kind of fun I had known only in a hit-or-miss way, when my mother's ever-changing finances would land us in a "hang out on the street" kind of neighborhood: low-end/low-rent depression for her, bliss for me.

There was one particular day in Provincetown that centered on Franz. It started on New Beach, where we went with the Hofmanns each morning for a swim. It was there that we met up with Franz, Betsy, and David Smith. I had just gotten a camera and I took pictures of them all. Beach pictures were the best, especially when you took a bunch of indoorsy urbanites and plunked them in the sand and water. A "who would've thought?" innocence took over.

Later we went back to Franz and Betsy's, where the drinking began. As the afternoon drew on to evening, Mel and Mark Rothko, Sam Francis,

and others dropped by, and I helped Betsy miraculously improvise something to eat. Then it was on to Fritz and Jean Bultman's, where at one point a fiercely drunken and competitive game of charades took on a life of its own. Only art-related clues allowed, as one might expect. I was on Franz's team; Bob Motherwell headed up the other. How is it possible that I still recall one of my charades, Delacroix's *Horses Coming Out of the Sea*? Probably because I can still feel my panic. Who the hell was Delacroix? Had I ever seen a painting of his? I also remember the charade because Franz guessed it quickly and made me feel quite clever about my swimming-horse performance. Later, we all went to the Madeira House for dancing, followed by, as Clem would note in his daybook, "sundry parties." And so it was.

As I got to know more artists and became more familiar with their work, I was always fascinated when I heard of their "aha!" moments, such as Kline's "This is it!" That heart-stopping breakthrough that comes unbeknownst, followed by the recognition that this is the first step over the next creative cliff. In every instance of discovery there had to have been that first seminal painting or sculpture that stepped into new territory. That supremely private moment between the creator and his art. For me, those hard-earned epiphanies linked the artist to his passion to his work in a new way; it made their process real to me and humanized the art.

Of course, I didn't know Kline when he found his black and white path, or Pollock when he painted his first all-over picture, but I do remember a particular Friday dinner at Esther and Adolph Gottlieb's in 1956. I know it was a Friday because I was introduced that night to the delectable treat of my first challah bread. At dinner, Adolph, a usually placid man, was almost shaking, too excited to eat. Later, in his studio, he showed us his first "burst" picture. Like Kline, he also said he didn't know what to make of it, that it had just "happened" late one night, and that the picture had "frightened" him. The images of the burst pictures would be at the core of his work for the rest of his life.

And then there was Morris Louis and his large "veils" of translucent luminous paint, rivers of cascading color poured onto unsized canvas. On this visit in 1958, one among many, to his suburban Washington, D.C.,

house-studio these pictures were simply and stunningly there, rolls and rolls of them. And just as simply, he seemed to know, *This is it.* He had his own pragmatic way of dealing with the breakthrough. He had gone on a painting frenzy. For an already obsessively prolific painter, that meant producing a staggering number of veils, over 125 in the next year.

On that day of our visit, one after another after another of the big canvases were unrolled in his small living room, often with me holding one side and a helper the other. Overwhelmed with their beauty, I was also overwhelmed with acrylic fumes. Eventually I had to go outside for air and just made it to the porch before I threw up.

Also in 1958, our good friend Ken Noland arrived one night from Washington, D.C., and walked into Bank Street with a roll of pictures under his arm. Nothing new. Ken often drove up to cruise the galleries, usually bringing a few new pictures to show Clem. On this visit he was edgy as he unrolled one, then another, of the three-foot square canvases, until they carpeted the floor. He seemed to know they were special, and, at the same time, he was unsure. He was still raw with the experience of having painted them. As Clem and I looked at them, Ken looked at them, too, but with wonder, as if he hadn't seen them before. Clem nodded and said, "Yeah." And Ken exhaled. They had a shorthand. They were his first circle pictures, his "targets." Ken had already had shows at Tibor de Nagy, but it was the targets that would eventually thrust him into the big time.

When it came to artists' breakthroughs, there seemed to be a common ground. They struck fiercely, and what happened in their aftermath? Well, that varied, but in some cases they could take a toll. Betsy Zogbaum would complain that Franz was surrounded by people wanting a piece of him—a not unusual woman's plaint as her mate's star rises. But also undoubtedly true, as I knew from my own experiences with Clem over the years. The delicious one-liner of Franz's chum Bill de Kooning, suggests a variation: "Franz and I had some success, and then we became a couple of drunks."

In the years to come, whenever I saw Franz he was front and center in his unassuming way. A guileless magnet. Maybe that's how Hedy had found herself swept into him. Always in the middle of things: an opening,

a party, leaning on the long bar as you walked into the Cedar, standing with a group on the street, smoking, hat on, talking about whatever needed talking about . . . The beach day and the evenings with Hedy were different, special, because I could focus on his niceness and maybe he, for a moment, focused on me.

Kline would go on to have a ten-year run. He died of heart disease at fifty-one, asking from his hospital bed, "Will I ever paint again?"

JACKSON POLLOCK AND LEE KRASNER

CLEM NEVER REALLY enjoyed staying with people, but visiting Lee and Jackson was different. Clem felt at home there. From the time I met Clem until Jackson died, about once a month we would go out by train to their place in Springs. The weekends were predictable, each much the same as another. Jackson would pick us up at the station and we would head back to the house, often—depending on whether Jackson was on or off the booze—stopping for a drink at the locals' bar in town.

Once we arrived at the house, the routine was set in stone. No hi-how-are-you, no formalities of any kind. We would sit down around the small, beat-up kitchen table a few feet from the back door where we had entered. And that was that. Conversation would pick up as if the time lapse had been three minutes, rather than weeks. Coffee and gossip wrapped in cigarette smoke. Who was doing what, which shows were good and which bad, which paintings worked and which didn't and why, which reviews and reviewers passed muster and which were full of shit, who had sold what, for how much and to whom, who said what about who, who was being fucked over by their dealer and who was just plain fucking who. Business as usual. All the stuff that artists have probably talked about since the first cave painting. But in that house, with Lee at the helm, no matter how mundane, there was always an impending drama to be hashed over.

Lee was a master at fanning the flames of injustice, either art-political or personal, either real or perceived. Injustices all. The art scene may have been small, but there always seemed to be plenty of grist for the griping mill. For me the grist would go in one ear and out the other. I had learned early on to mentally detach. In the sixties, it would be called

"astral projection," and I would laugh and say, "Hell, I've been doing that for years."

I see Jackson white-knuckling his coffee mug, kept full to the brim by Lee, both stalling minute by minute the switch to beer and then, if it is one of those days, eventually to the hard stuff. During our visits that winter and spring, Jackson never tips into a full-out binge. Lee is taut, at high voltage, her eyes darting, animated, and compelling despite themselves. I try to measure her appearance by ordinary standards but fail. And her lack of vanity confuses me. I care too much about what people think of me and am envious of her "fuck everyone" arrogance. I am envious, too, of the passion that animates her: her love of art, and her commitment to the genius of "Pollock." She always refers to Jackson as Pollock, whether he is across the table or on the moon. She is never in repose. Arms spread out on the table, she stretches into the conversation, thirsting for it as if she has been through a drought. She always thrusts herself into the action, into the talk.

Jackson slumps back, alert but at a remove. He never says much around that table—alone with Clem, that was something else. When Jackson speaks, it is in the muted mumble of a sober Jackson. His voice reminds me of David Smith's, both so surprisingly soft-spoken for such über-men in the studio. I never say anything at all.

Clem and Lee bat the ball back and forth for what seems like hours. Do I hear Lee laugh? No, there is never laughter. Lee is a loaded shotgun armed with black and white opinions—she doesn't believe in gray—all delivered in her inimitable gruff New York–ese. I hear her riffing on some affront, usually one that has been perpetrated against Pollock. Later, I will still hear her from the guest room where I lie half-dozing into the night, her voice growling up the stairs, interspersed with the contrapuntal murmur of men's voices. Life is scrutinized, carved up, chewed and digested, or spat out in anger, and that takes energy, all the energy of the day. No scraps go undissected.

One morning, we four again in our familiar positions around the table, Lee wants to talk about a dream she had the week before. She was in an old house reminiscent of a childhood house. She was looking for

something and went downstairs to the cellar. In the gloomy shadows she saw something move. She was terrified but moved closer. And then she saw it: a faceless, formless monster, not human, not animal. She couldn't move or scream. Then she woke up, panicked and so fearful she couldn't return to sleep.

Clem speaks often of his dreams, and she of hers. They offer these conduits from the subconscious with pride, as if they are trophies. Nightmares get the gold star. Lee and Jackson are both in analysis, but Jackson keeps his dreams to himself. Lee says it wasn't the first time she had had this dream, but this has been the most vivid and frightening version. She and Clem gnaw at its ramifications. Clem observes that the "monster" no doubt represents the concealed part of her— concealed not just from others but from herself—that had finally revealed itself. He saw it as a breakthrough dream, one to be excited and pleased about. She avidly drinks in what he says, considers it, then spits it out. If the dream is a breakthrough, she believes it to be a warning dream alerting her to danger around her. Clem shrugs. They both know they are right.

I find Clem's interpretation upsetting. I think of my own subconscious monsters waiting to reveal themselves and privately concur with Lee.

After lunch, Jackson and Clem cross the driveway to the studio. That is where the switch from coffee to the stronger stuff often takes place. If invited, I tag along. Usually, I am not. When I am alone with Lee, conversation stops. She busies herself with this or that, and I wander around or pick up a book. The silence in the house is thick. It never occurs to me to go outside. No one ever does. It is as if the house is an island.

From the moment I had first entered that house, there had been no question in my mind that an alcoholic lived there. An alcoholic and an alcoholic's wife. There was that tension, that desperate wariness. The alcoholic sunken into himself with defeat, his body warring between restlessness and inertia. The tiger in his cage, always the dead center of attention, making the room seem too small.

Of course I knew. Less than a year had passed since I had left home for good. While growing up, I had learned that drunks came in different varieties. There was the daily drinker, like my runaway father. Though I

saw him only occasionally, I knew him as a chug-a-lug, three-martinis-before-dinner drinker, disengaged, taciturn, his Arrow-shirt handsomeness glazed with apathy.

When I met Clem, I discovered a variation on the daily drinker: the end-of-the-day, slow-and-steady drinker whose appearance and behavior never changed and whose appetite for life remained undiminished, at least until the end of his long life. So it was that, early on, I decided that although Clem was a drinker, he was a drinker I could live with.

At the low end of the spectrum, there was the binger. One drink could send the binger off into a spiral of out-of-control days or weeks of occasional violent, delusional, even suicidal behavior. A frightening drunk. When sober he would become a so-called "dry drunk": demanding, self-pitying, despondent, physically and emotionally shaking with remorse and debilitation from his ordeal. A sad drunk.

My stepfather Harry was a binger. I had known him since my mother first brought him around when I was twelve and had lived with him and his daughter Judy since I was fifteen. A "sometimes sister," she was away at boarding school and camp most of the year. I never chose to live with Harry. I had pleaded and raged against that marriage, against that man who had more than once passed out in his vomit on our living-room rug. "Harry's not feeling well," my mother would say, as I watched her clean it up and try to get him to his feet. But the inevitable happened. Over the years, Harry's abrupt and unpredictable swings left me on guard, my feelings frozen. One week I might be pushing my bureau in front of my bedroom door, just in case, listening to the muffled voices and, worse, the silence that masked possible violence. The next week I would stay out as much as I could, before tiptoeing back, hoping not to confront the sobered man riddled with self-hate and guilt. Sometimes he would say he was sorry. I probably said, "That's okay," before fleeing from his remorse that stank up the house worse than whiskey. Through the next week I would watch him struggle back, his hands relaxing on the ever-present coffee cup as he tried to reengage with my mother and me. I recall only a handful of times when he and I were alone together. We had nothing, and everything, to say. We didn't know how.

Sometimes during the hard times, my mother would wake me in the

middle of the night and say we should go to the Manor Inn in Larchmont, her refuge of choice ever since I could remember, when she was embroiled with men too difficult to handle. Now I was a teenager, and my heart would leap with hope as she wept her woes and apologies to me. But when she would say, as she invariably did, that she had done it all for me—to give me the things she couldn't give me, to give me a father—my heart would boil and I would want to smash her face in.

Inevitably, she would subside into hopelessness and the late-night huddle would end, until the next time. Only once did we actually get into the car. We only got as far as Mamaroneck, two towns away, before she turned back. Those were the nights I would have liked to talk to Judy, someone saner than my mother. Even though I often resented her for being shielded from the truth, while I navigated solo through her father's storm.

Despite all that, my feelings toward Harry were ambivalent, swinging as he would swing. Sometimes I wished he would get better at committing suicide and get it over with. Once in a great while, I wanted to reach out and touch him in some way. I never did.

So it was that, like Clem, I felt at home at the Pollocks', or at least on familiar ground. Not that the personalities were the same. Lee and my mother couldn't have been more different, one a combat-ready commando, the other a soft-hearted pushover. But they shared the daily grind of life with a binger. Jackson and Harry shared alcoholism and early death. Jackson died at forty-four. A year later, Harry died slowly of cirrhosis at fifty-seven. Harry's alcoholism, never spoken of, was kept a shameful secret to the end. Jackson died quickly and violently in a scandalous, public splash—no secrets there—and was mythologized as a doomed, self-immolating genius. One, a nice guy who worked at an ad agency; the other, the rising star of American art. Whatever the differences, for me they remain linked in their despair and isolation.

I've often been asked, "Did you know Jackson?" I know they want to hear any sort of inside tidbits about the Great Man. Usually I just answer, "No." Because I didn't know him, not really, and probably wouldn't have even if he had lived longer. The few personal moments I had with Jackson have stayed with me, not because of any particularly noteworthy

content but because I'm surprised they ever happened at all, given what a private man he was, and given the tight circle Lee, Jackson, and Clem drew around themselves and the intensity of their focus on each other.

I knew Clem and Lee had been confidants for many years, and Jackson, too, in his quiet way. Clem had told me how understanding Jackson had been during his breakdown. When he was still fragile, Clem would visit the Pollocks and he would talk to Jackson about what had happened to him, and about his new feelings and insights, and how he wanted to change his life for the better. Clem said how helpful Jackson had been, how deeply he had listened and how thoughtfully he had responded. One afternoon in our living room, Jackson thanked Clem and told him that no one had ever confided in him that way before. Which is not to say that, as heartfelt as these exchanges were, there weren't times at the Cedar when we would all duck down in the booth when we saw Jackson coming in drunk.

Clem had once told me about the time he had first met Jackson, in 1941. He had known Lee for several years, and one day he ran into her on the street in the Village. With her was her new boyfriend, Jackson. Clem used words like *well-mannered*—manners were high on Clem's list of assets—*unassuming, good-looking.* And he went on and on about the hat Jackson was wearing, a fine, brown felt hat. I don't know why he honed in so specifically on the hat, after all, most men at that time wore them. I loved the image of the young, outrageously handsome Jackson in that felt hat.

But that was then. When I knew him, Jackson's life was so very small. It stretched from the kitchen table, across the few steps to his studio, or into his green convertible pulled up between the two. It extended to trips to New York, by train, or sometimes by car, with the inevitable pit stop along the way, then to his analyst on the Upper West Side, maybe to Sidney Janis, his dealer, maybe to a few galleries to see shows, and finally, if he was in drinking mode, to the Cedar, before ending up at the fleabag Earle Hotel nearby, then home again. And then he was gone.

And that is where Lee's story really began. Her life would go on almost three more decades. And her life got very big. Lee raised the bar for art widows. Being one of those women who could have successfully run

any large enterprise, she ran the Pollock estate to perfection. A widow, sought after, wooed, she wheeled and dealed with the best of the masters of the art trade. A tough bunch, but they met their match in Lee. Yes, she bought the minks, but nothing lavish. And yes, though she took an apartment on New York's Upper East Side, it was strictly functional. She had more important things to do.

Once again Lee became a full-time painter and soon took over Jackson's studio. Her work flourished. Within a year she had a show at the Stable Gallery and her career continued to gain momentum. As for Jackson, he would eventually capture the gold ring as the foremost American painter of the twentieth century. No one would again think of using that mingy equivocation *arguably*. Clem would often say that "quality will out," and certainly in determining Jackson's place in art history that was so. But in the short run, the role of the estate manager could not be underestimated. In 1956 Jackson's future wasn't certified and Lee wasn't taking any chances. Unlike most women, she had no trouble asking for what she wanted. The patriarchy of the art world, far from daunting her, made her stronger.

One of her first decisions was to quadruple Jackson's prices at Janis—notwithstanding that sales, even at the lower prices, though they had been increasing, were still infrequent—while imposing strict controls over which pictures and how many could be shown, could be sold, and to whom. With restrained deliberation she turned what had been a slow ground swell into what in time became a tidal wave, culminated by the 1972 sale of *Blue Poles* to Australia for $2,000,000, a record-breaking sale for any contemporary American painting. Ironically, it was a picture Clem had never particularly liked.

But the first major approbation of Jackson's work was closer to home. In December 1956, the Museum of Modern Art mounted a Pollock retrospective, the first such conferred on an abstract expressionist. On the night of the opening, as we wandered through the galleries, Alfred Barr took Clem aside and said, "You were right." There was a brief, but warm, exchange. One that had been a long time in coming. The museum had been slow to pick up on the excitement fomenting in its own backyard. Barr's allegiance had been rooted in European art and, as with so many

other informed people, it was difficult to imagine that America could ever be a major contender.

Lee, at the vortex of the Pollock whirl, was living at full throttle. Listening to her, I would think, *It's as if she's now living for two.* And when we would go out to Springs, it always seemed as if Jackson hadn't left any empty space behind. She had filled it up so quickly, the house and the studio and the emotional air. Control must have felt good. No more was her extraordinary energy drained by the volatile alcoholic, no more being second-guessed; she was free to focus on what she knew best, the making and marketing of art. She had a steady stream of new "best friends," some lasting longer than others. Lee was adept at the womanly ploy of coming on as a frail in need of men's advice about her dilemma of the moment, and she could spin them out like Scheherazade. Whatever the manly advice, she of course would proceed to do exactly as she thought best. Maybe a few old friends hung in, but I wonder.

For the first year or two after Jackson died, Clem continued to play a role in her decision making, continued to be a confidant. Lee didn't role-play with Clem. They would hammer out pros and cons much as before. But not for long. The wheels of the art world in general were moving faster, and around Jackson even more so. Increasingly Lee's circle included the rich and powerful, and though she now spent a good deal of time in the city, we saw less of her.

The denouement came in the spring of 1959, after Clem became an advisor at French & Company's new gallery. He had lined up a stellar roster of painters for them to show. Lee wanted to be included. We went out to Springs for the weekend so that Lee could show Clem her new work. They spent a long afternoon in the studio, and when they came back, all seemed as usual except that, for the first time I could remember, they didn't talk about art.

Later, a new friend of Lee's came by for drinks and dinner. Another change—we sat outside, enjoying the warm evening. No more kitchen table. Lee made dinner and she let me help her. She was a good cook. After her friend left, Lee and I did the dishes. I was feeling closer to Lee than ever before. Always in the past she had tersely turned down my can-I-help-yous, leaving me to feel neither part of the girls' team nor the

boys'. But then, whether impelled by the wine or by the camaraderie, I made some critical remark about her friend. In a flash Lee turned on me. "Who the hell do you think you are to . . . ?"

Her response, like a cobra's, was so fast, so sharp, that the blood went to my head and I was shaking. I blustered my apologies. I knew I had been in the wrong. But Lee was having none of it. She continued her harangue. I escaped into the living room, a few feet away, where Clem had been reading. For once, he had put his book down. My anger was now on the rise. Yelling as loudly as Lee, I told him we had to leave immediately. Of course there were no trains at that hour; I said I didn't care, that I'd rather sit in the station all night.

And so it went. At one point, I grabbed a phone book to look for a taxi company. My outrage, Lee's outrage, and Clem in the middle. His equilibrium prevailed. Especially when he said, "We don't leave this house in anger." I heard that. And as much as I hated to admit it, I understood it. I had come from a family of slammed doors—not literally of course; we were too "genteel" for such things—but slammed nonetheless with brutal finality.

I agreed to a compromise: We would leave first thing in the morning. And with that, I crept up to bed. I felt guilty, humiliated, and as angry as I could remember. A painful combination. And once again, like the child listening to the grown-ups downstairs, I heard their voices until I fell asleep. Lee drove us to the morning train. Icy civility prevailed. Relief that I would never again have to spend time in that house or be around Lee's glowering acidity, that would come later. And only much later would I realize what a rare gift that moment had been. I had never before allowed my anger to rise up and spill out, allowed myself to confront someone else's anger with my own. And to my amazement, the world had not come to an end.

On the train home, Clem filled me in on what had gone on in the studio. He said that Lee wouldn't be showing at French & Company. She had been very prolific recently, and they had spent a long time going through her work, picture by picture, as he always did. I could imagine the familiar push and pull between them. Lee was particularly interested in having a show of a group of pictures she had put to one side. About

those, he had told her he had "reservations," that she was "pulling her punches"—in effect, that there was too much from Jackson in them and not enough from her. She stood by her pictures. And Clem assured her that what she showed would be her choice. He told her that, whatever his personal take on those pictures, he would never refuse her a show at French. She hadn't responded right away, but during their late-night talk she had refused the show. Hearing all this, I had a new source of resentment. The way I saw it, my whole damn run-in with Lee hadn't even been about me. I had just been the hapless victim of someone wounded, armed, and looking for blood.

There was no question Lee would have been wounded. Beyond her personal relationship with Clem was their relationship in the studio. Clem had always been a staunch supporter of her earlier work. It was Lee who had told Clem about Jackson, the painter she was living with, and the good work he was doing and that Clem should take a look. Clem did look and he also saw Lee's latest pictures. He was much more impressed by Lee's work than by Jackson's. Later, Clem would always say that, at that time, Lee was the better painter. He would also say that Lee had the best "eye" around. For Clem, the highest praise of all.

By the time that day came in Springs, Clem and Lee had shared twenty years in the studio, either Lee's or Jackson's. Clem had told her flat out what he thought of her recent pictures, as he always did in any studio with any painter. Now that Clem was in a position to offer her a show, there had been special treatment in deference to their history. But for Clem there would never be special treatment when it came to looking at art. Clem called it the way he saw it, always. Of all people, Lee knew that; she had always counted on it. That was their bond. Problem was, Clem had put her on the horns of a dilemma that day: While she may have found herself trusting Clem's judgment, in no way could she accept it, or his terms.

Over the years, Lee would reconnect with Clem for his advice about this or that, or to look at her work when she needed a hit of his straight talk and "eye" in the studio. On only one such occasion was I present, or, I should say, tangentially present. Our paths crossed at a dinner party.

A memorable evening on two fronts—it was the last time I went to Lee's East Seventy-second Street apartment and the only time I had the misfortune of having a close encounter with Louise Nevelson. The dinner party was quite Park Avenue and quite large, the guests dispersed around small tables scattered throughout the rooms. I had been seated with Miss Nevelson and a few others. I had seen her now and then, but always from a distance. Close up, and decked out as she was for the occasion, she took me aback. She was a colossus, swathed in layers of black and festooned with elaborate necklaces that clanked with the teeth and claws of man-eating creatures. Above, her dark, molten eyes—awning-ed with immense fake eyelashes, askew and about to plunge into her curry—pierced me from the chalky maquillage of her face. In a clawed hand she clutched a long ivory cigarette holder, ashes scattering, smoke from her blood-red lips befogging the table. Was she wearing a turban?

As startled as I was by the look of her, I was completely unprepared for the sharpness of her tongue, which she proceeded to hone on me as the meal progressed. I had hoped that I had slipped under her radar, but she knew who I was and prodded me with questions about Clem, myself, and art. I didn't hold up well on any score, and at some personal jab or other over dessert, I felt my eyes start to tear. I excused myself, sweet tooth notwithstanding, and escaped into the bathroom, never to return to the table.

Lee had been talking to Clem and said she would like to have a tête-à-tête—some new drama, no doubt. So, without much ado, we left the party and went back to Lee's place. With us was Lee's nephew, Ronnie. Lee and Clem went up the few stairs to her bedroom off the living room while Ronnie and I perched on a window seat, the room lit only by a street lamp. We had little to say. He was strumming a guitar. It all seemed like a stage set where all the action was offstage, with the audience's attention drawn to the sliver of light coming from the open door. The only sound was the steady flow of voices, on and on, accompanied downstage by the soft sounds of the guitar. I was torn between waiting and taking a cab home, but I was overcome with inertia. Maybe it was exhaustion. Two divas in one night.

That was my last interlude with Lee. Other than the inevitable casual acknowledgments in crowded places, we never spoke again. Lee died in 1984, at age seventy-five. Though her last years had been difficult, plagued as she was by severe arthritis, she had achieved success as an artist.

DAVID SMITH

I HEAR his graveled voice that at times could be so honeyed and soft that it sounded ingratiating, even condescending. When he talked about art he talked straight out. And when he got angry, the gravel thundered and grated. I see his big ears that, once I noticed them, were hard to avoid staring at. I feel his dark bushy mustache that was harsh, too harsh, against my skin when we would greet or part from each other. I see his large head and the bulk of his torso, which made people think he was a towering man, much bigger than he actually was. At a distance he would seem to loom, but face-to-face we were about the same height. But that heft was mighty. When he arrived at Bank Street, he filled the doorway side to side.

We saw a lot of David when he would come into town for a hit of the city after his long periods of seclusion upstate. In the early forties he had built his house and studio in Bolton Landing near Lake George and had lived and worked there ever since. David and his wife, Jeanne, whom I had met in New York a few times and liked a lot, had recently separated. She had taken their two baby girls and moved back to Washington, D.C., her hometown. Now he lived in Bolton Landing alone. When he would come down from his mountain, there he would be at our door, tweedy, rough-hewn, smelling of cigars, and ready for an art infusion and some high life. A hardy man, homespun. At least, that was how he appeared. Sometimes, if David went overboard on the woodsman talk, Clem would remind him he was just a middle-class city boy from the Midwest.

We would hang out, go to galleries and openings, and always ended up at the Five Spot or the Half Note. Like most artists, David loved jazz, traveling in troops. He was all go-go, do-do. That was how it was in New York. Bolton Landing was something else. And it was there,

after I had been married about two years, that I first got to know David one-on-one.

It was fall, and as we drove north it got darker and colder. I had never been to Lake George. There was someone else with us. I don't remember who, but it was someone with a car, because we couldn't have afforded to rent one. The smell of the impending wilderness seeped through the windows. Driving through the night, I wondered if this was the farthest north I had ever been. But no, there was an earlier time when in 1942 my mother, my brother, Norden, and I drove to Saranac Lake. Behind the wheel that day was her current boyfriend, who had the implausible and unforgettable name Colby Dam. He himself would be utterly forgettable and, like so many of his predecessors, would soon be out of our lives.

It was my eighth summer, and for two weeks we stayed on the lake in a log cabin with a forbidding outhouse and a scratchy wooden seat. Afraid to sit, I would hover over it, terrified of what might come up through that black hole to nowhere. Colby and my brother fished— girls not allowed—while I wrote stories about being eaten by wolves and bears and snakes and, of course, fish. I illustrated the stories, bound them together with yarn, and called them books. Meanwhile, my mother swatted and whacked at all the crawling, flying creatures and smeared us head to toe with calamine.

After dark, she and Colby would tear off to whatever nightlife there was to be found and I would lie in bed, rigid, listening to the caterwauling of nature on a hot summer's night, a sentry armed against the fearsome hordes that were massing to storm the cabin. I would wait for my mother and the man to return, wait for the whispers and laughter to die down, wait for their silence before I slept.

Clem pointed out Lake George on our left, but it was too dark and I saw nothing except motels, mostly closed, it being off-season. The winding road continued for miles. I kept expecting to see a town; there had to be a town. But it was not to be. We turned up a hill, away from the lake, up a steep rutted road off of which was David's place marked with his sign, TERMINAL IRON WORKS. *Ominous*, I thought. And indeed, the house was not welcoming, built as it was of exposed cinder blocks, raw to the eye and touch inside and out. My spirits sank. The main room

was rough and ready, like David. The place seemed full of musty, dim corners, the furniture unyielding. I saw no sign of a woman's touch. I was surprised. How could Jeanne have been so quickly and completely erased? This was a man's house, and I didn't know what to do with that. My mind whirled: *Where will I sit, is there any food, where will we sleep?* I was already counting hours until we could leave. But when that would be, I didn't know. The men were happy, pouring the Scotch and lighting up the cigars. I considered the advantages of getting drunk and decided to join in.

At last there was some murmuring about dinner. My stomach rumbled. At least, until I heard David in his mountain-man way going on at length about the deer he recently shot. It had been hanging from a tree and now, suitably bloodless and hacked up, it was to be on tonight's menu. He reminded me of my brother, a hunter of a different sort, who as a small boy with a BB gun quickly graduated to more lethal weapons and bloodier venues than Westchester County. Norden would shoot his way through North America, Africa, and the mountainous reaches of Nepal and Russia, decking the walls of his conservative suburban Denver house with his glassy-eyed trophies. Even before I was a teenager, our freezer was often filled with suspicious hunks of this and that. But, though teased unmercifully for being a sissy, I succeeded in never swallowing a bite.

As David threw the slabs of venison over the fire, I asked if I could help. He gave me some onions and garlic to chop. As I started to peel the garlic, he grabbed the cloves and with a loud *thwack* of his massive fist decimated them and shoveled them into a frying pan of sizzling butter. He suggested I might set the table. Humbled, I beat a retreat, wondering if this time I would be able to avoid swallowing and, more important, whether there would be any bread, a more comforting sop for my hunger. Somehow I did manage, and there was bread. The Scotch helped. And I was grateful to that deer. I had heard the stories about David's pies that he would concoct for guests out of chipmunks, groundhogs, and any other furry critter that might get in the crosshairs of his rifle.

Later, as the men settled in for more talk and cigars, my real job became clear—I was to play the woman's part and clean up. At least I knew how to do that. I was at the sink, washing the dishes, when David suddenly

appeared behind me. He startled me with his closeness and anger. That graveled voice boomed: "Where do you think you are? Have you ever heard of a well? Do you think the world is made of water?" I heard the unspoken message: *You good-for-nothing stupid bitch*! He pushed me aside, turned off the water, grabbed a dishpan out of thin air, slammed it into the sink, and started doing the dishes as he and God intended. He flung me a dishtowel. I wanted to scream, punch him, hang him from a tree. I didn't. I wanted Clem to punch him. He didn't.

David was silent, intent and efficient at his task. I meekly started drying. Soon after, I went to bed. It would be hours before Clem turned in. I curled up in the corner of the bed, facing the concrete blocks. I counted them. I memorized the grainy map of them and stroked their coarse cold surface.

Most of the next day was spent in David's studio, a large structure down the drive from the house. Clem said David could build a complement of tanks there; it was that big and that filled with steel and hoists and welding equipment. I liked the feel of it. It was what a sculpture factory should be like. The possibilities—anything could materialize. The men were so happy there, and now and then we went out into the fields to look at the finished pieces mounted on their concrete slabs.

Everything was warmed and softened with the sunlight. I was at ease. I now knew that we would be leaving today. I also knew that plans didn't always count for much. I saw those steel pieces, some delicately filigreed and soaring, some as hefty as David, soldiering as they caught the sun and threw their shadows across that large field that sloped away from the cinder block house. This morning there were no wolves and even the house looked almost inviting. Could concrete look pink in the sun? This morning I liked where I was.

When we finally left the compound, it was dark again. I never did see the town or the lake. Maybe we stopped at a diner along the way, maybe I ordered the soul food of childhood, meat loaf and mashed potatoes.

The feelings evoked by that visit to David were not unique. During those early years, I invariably felt at a loss when visiting Clem's friends out of town. If I found artists difficult, artists without wives or girlfriends were my nadir. Writers were easier; they enjoyed batting the

conversational ball, had a wider curiosity and laughed more, and enjoyed their creature comforts. But writers were a rarity in Clem's life. And the women? Well, they softened my landings, softened the edges. Sometimes, not always.

Not that I hadn't any experience being in a man's place. After all, Clem had been living alone at Bank Street for some ten years when we met. But there was an important difference between David's or any other artist's place, and Clem's: I was wanted at Clem's. With the others, it wasn't that I was *not* wanted; it was simply that they were indifferent to my presence. Though I was certainly aware that my feelings of inadequacy and unease contributed to the problem, I was as yet unable to resolve them. I also knew that my interactions would have been eased if I had been able to merge the artists with their work that gave me so much pleasure. That would be harder for me to do. The indelible imprint of the men themselves—the sound, smell, feel of them—remained separate from the mastery of their art.

Biographies and documentaries were routinely based on the assumption that the sum of the artist's character lies in his work. Many artists would have agreed. After all, wasn't art the through-line of their life? Some might have even agreed that they had been fated to play out the Faustian drama: The greater their renown, the more difficult their lives. David must have agreed. He was quoted as saying, "Art is a luxury for which the artist pays." He might well have added that those around the artist pay as well.

After that first visit to Bolton Landing, I became familiar with the many facets of David. He was often kind and generous and well-mannered. He adored his little girls. He could also be angry and blusteringly full of himself. At times he was depressed and sad. And he could drink a lot. In other words, he was human. For my part, even though I grew up a bit and gained confidence, I nonetheless knew that David and I weren't a good fit. And though he played an intimate part in our lives and we saw him often both in Bolton and in New York, I kept my emotional distance.

My relationship with David, as well as with other artists, would soon become more relaxed. I stopped asking myself the questions of an insecure child. *Will they accept me, maybe even like me? Will they make me*

cry, or just bore me to tears? Or will they not notice me at all? And I came to accept that, in their insular world, I would have little conversational entrée, at least while Clem was in the room. And I always remained open to the art. Art was everywhere I went. And at home I was surrounded by it, literally tripped over it in the kitchen. It was simply there, the stock in the soup of my life.

As my perceptions slowly expanded, it was inevitable that I would develop preferences between this artist and that, this picture and that. And more and more, I warmed to sculpture. Particularly the living with it. I enjoyed the way it never stopped exerting its presence, unlike paintings, which my eye could in time skim over, unseeing. A piece of sculpture commanded interaction; I would walk around it, bark my shins on it, dust it, and creatively find space for it. And since my first morning at Bolton, I had delighted in the way sculptures hurled their shadows, arrogantly enlarging their turf. I would always place sculptures near windows, and I became convinced that the images cast by David's pieces had been endowed with a spirit of their own. In my heart, David finally did merge with his glorious art. I came to love him for having created those pieces and then for allowing them to become part of my life. But that was later. By then he had died in 1965 as a result of an accident in his truck.

EUROPE 1959

I AM ABLE to be precise about the details of this trip because, starting in 1950, Clem recorded his activities in a pocket-size daybook. Every night, at his desk, with the last drink of the day, he would fill in the day's entry. Scrupulously noting the names of people and places, he would cram those small blue pages with his perversely broad-nibbed Montblanc. He chronicled the facts—no editorializing, ever. What a gift. Order out of the chaos of memory.

I offer an example of a day during our trip to Europe in 1959, this from June 12. We are in Paris:

> Up at 10:30 bkfst in.
> Walked to Cafe Flore. Met Allanah Harper & Amy Smart; then (Adolph) Gottliebs and (Robert) Goldwaters—w. them to lunch at Petit St. Benoit.
> To galleries w. Gottliebs and Trapp of Amherst.
> Spanish show at Museum of Arts Decoratifs.
> To tea on R. Rivoli.
> 6-Jenkins' opening at Galerie Stadler.
> Drinks w. crowd at the Palette on R. Callot off and on till 9.
> 9:30-dinner party by Stadler on R. Gueregaux till 12. To Dome with Paul & Alice, Kimber Smith.
> To bed at 2.

I always thought that because we hadn't gotten divorced after our trip to Europe in 1959, we never would. That I was along on the European journey at all was a fluke. Two years earlier Clem had come home early from *Commentary* one day and announced, "I've been fired." No

surprise, the situation between Elliot Cohen, the editor, and Clem had been oil and water for some time. Clem was jubilant; at last he was free to do whatever he pleased or nothing at all, and he skipped off to the liquor store. My heart shrank as the last picture-book image of married life—where the "little woman" kisses her "hubby" good-bye as he whistles off to work—turned to ashes. Clem returned with the usual bottle of Tanqueray. When I murmured, "Shouldn't we be switching to Seagram?" I learned yet another valuable Clem lesson. "If you expect less, you'll get less. You never pull back, the money will be there."

Of course, the notion that I might get a job never, or hardly ever, crossed my mind. The iconic "breadwinner husband" still hovered over the ashes. And Clem was right. Though we were stretched thin over the next two years, and though my mother's diamond bracelet made several trips to the Century Pawn shop—that Bergdorf Goodman of pawnshops on Eighth Avenue—we scraped through.

Then, in 1959, Clem was hired by the venerable gallery French & Company as an advisor for its new venture into contemporary art. He had already lined up local talent that included Barnett Newman, Adolph Gottlieb, David Smith, Morris Louis, Kenneth Noland, Jules Olitski, and Friedel Dzubas for the 1959–60 opening season. The directors were interested in adding a few Europeans to the mix. The gallery would of course be paying Clem's expenses. However, even though his $100-a-week fee had restored us to solvency, it would never cover a trip for two.

That's when the fluke came our way: The *Saturday Evening Post* asked Clem to write a piece about abstract expressionism for the heart-stopping fee of $1,500, an unheard-of amount for an art writer at that time. It was an amount that would allow me to tag along, as well as allow Clem to extend the trip and see as many treasures from the past as he could possibly see. But the price he paid was high. I watched him struggle with that piece, which would be his first and last for a mainstream magazine. It was also the first time he had to consider the needs of his audience, not explaining too much or too little, all the while staying true to himself. He finally hammered out a middle ground he could live with, but I always thought he would just as soon have seen that article disappear.

We made plans. We would travel by ship, Cunard's *Mauritania*, to our

first stop, England. May 15 was the big send-off. An astonishing number of people jammed the stateroom, spilling into the corridor, everyone from Clem's family to artists to the far-fetched. Perhaps ocean crossings were passé enough to be new again. Maybe they just felt like champagne at noon.

And then we were at sea. A romantic dream. A week of deck chairs, Ping-Pong, "elevenses," teas, dancing, being cosseted. When he wasn't reading or writing, Clem was staring for what seemed hours at the sea, searching the horizon for any storm that would slake his thirst for adventure.

Too soon, we were in South Hampton in our rental car, map in hand, heading west, we hoped, to Cornwall. Clem, clutching the wheel, assuring me that driving on the left could be mastered easily. While I, after a few close calls with bicyclists, leaned half out of the window, yelling, "Watch out! Americans!" Miraculously in one piece, we arrived at Patrick and Delia Heron's house, Eagles Nest, a rambling old pile on a rise commanding views of fields and sea, in Zennor. Patrick had spent his boyhood there and now his daughters ran on that hill, their English blond hair streaming behind them.

The Herons were the nucleus of an enclave of young contemporary artists living in Cornwall, among them Terry Frost, Roger Hilton, John Wells, Peter Lanyon, Adrian Heath, and, perhaps most memorable to me, Bryan Wynter. Memorable because he lived atop Zennor Cairn, a steep hill accessible only by foot, in a house he had built himself, with a generator fueled by the wind, heat supplied by the sun, and, of course, his own well and garden for nourishment. Bryan also happened to be handsome and dashing and, like Lanyon, a glider pilot. Irresistible. The evening we went there for dinner, we stayed until three. It was like that in Zennor. Four days of parties, dancing, sightseeing in Penzance, Lands End, St. Ives, always with long afternoons in studios. And very long nights.

One such night at the Herons', around their long, crowded table, art talk fast and furious, Roger Hilton, the bad-boy cutup of the group, started to bait Clem about this and that. Clem, as usual, took it in stride, not responding in kind. Roger, not getting the reaction he had hoped for, switched targets to the personal, saying something about Clem's having

lost his punch, gone soft, since he had married Jenny. Such a feeble jab, but the tears welled, people made a to-do, and I felt like an idiot child. I thought my skin had finally toughened up, but once again I was taken by surprise, the words quick as a viper's tongue. It shouldn't have been a surprise, but I had been lulled by the days of kindness and inclusiveness, forgetting that where there were artists, studio visits, liquor, and Clem, all too often there was combustion.

Two days later, on our way to London, we crossed the Salisbury Plain on the lookout for Stonehenge. There, between one unremarkable town and another, sitting off the road on a slight rise, was an eruption of stones. No warning, not even a sign, we swerved onto a side road and there we were. No cars, no one but us, the circle of stones, and the setting sun. The brutish power of them, like a vise dragging me back three thousand years. I touched their rough coldness, walked their shadows, wove my steps between them, breathing them in, shaking with awe. I bowed before the mysteries that shrouded the astonishing site. Then, the sun gone, a new moon above, it was time to find a pub and a bed for the night. Evermore I would love stone and rock and the secrets they kept.

The next day we drove into Hyde Park Gate. Quite a different circle, this one of mansions where Virginia Woolf had spent her girlhood, where the sculptor Jacob Epstein now lived, where across the garden I could glimpse the mansard eaves that housed Winston Churchill. At the head of the circle was the grandest of all, Cleve Lodge, the house of Teddy and Nika Hulton—Sir and Lady, of course, in keeping with the neighborhood. This would be our house, too, for the next two weeks. Meyers, white gloved and august, my first butler in the flesh, would be our guide into the quirky Neverland of the superrich.

Upstairs, no grand four-poster awaited; Clem was billeted in eight-year-old Cosmo's bed flanked by toy soldiers, with me adjacent on a lumpy cot in the former nanny's cell. Out of nowhere, a personal maid appeared in the makeshift room to unpack my things and reline my bureau drawers with tissue paper. Lady Diana Cooper had vacated the cell that morning, she explained. Well, who was I to be picky? For the duration of my stay, my clothes would discreetly disappear and reappear, cleaned, ironed, a button tightened, a hem repaired. Another part

of our household regime was Cosmo, darting in and out of our rooms, too early, with schoolboy chatter and curiosity. Clem was grumpy but charmed. The Hultons were abroad the first few days, but Cosmo would remind us that the house was not as empty as it seemed. He introduced us to his ancient tortoise, which roamed the gardens, and he showed us the tennis court, tucked modestly behind some shrubbery. All in the heart of London.

The drawing room awaited, at once cozy and sumptuous in the English way, the sort of room Americans aspire to and never pull off. There we would have drinks and entertain our visitors. Behind closed doors, off the entrance hall, was the formal sitting room, furnished in Louis XV, its gilded delicacy defying human touch, the pale silk walls dotted with Nika's renowned collection of Paul Klee. A room we rarely entered except to behold.

The house came to life with the Hultons' return. Teddy, a small tidy man with quiet, unassuming ways, may have been the ruler of his publishing empire, but Nika was the whirling, radiant center at Cleve Lodge. An erstwhile Russian princess, she was tall and strikingly beautiful, with a cloud of dark hair, magnificent creamy shoulders and breasts displayed in dresses made à la mode for her, all in the same style: off the shoulder, décolletage just so, tight at the waist, shoes to match, open-toed, of course. She knew what worked—why play around? She was also a businesswoman, author, jet-setter, art collector, and society figure whose photo I would trip over in the morning paper. She gave us a party and arrived late. Someone said she sometimes didn't show up at all.

While the hospitality at Cleve Lodge may have been extravagant and on the house, I paid nonetheless. A rare bracelet of large cat's-eyes linked together and set in heavy gold, which my grandfather had had made in Africa for my mother, was stolen off the bureau. I had left it there, and then it was gone. It must have been tantalizing. But still, who would have thought?

Particularly nice was renewing our New York friendship over dinner with the art dealer Victor Waddington and meeting his wife and son, Leslie, who had recently begun to pursue his father's profession. Leslie and John Kasmin would become the two leading dealers of the new

American art. Later that night, Clem and I walked home through Hyde Park. Gentle London. We spent time with art writer Lawrence Alloway and E. J. Powers, who was passionately amassing his enormous collection of contemporary art. We visited the studios of Bill Turnbull and the sculptors Eduardo Paolozzi and Anthony Caro, who, with his wife, Sheila, would become our lifelong friends. We saw Richard Wollheim, the philosopher and art writer, poet W. S. Graham, curator Roland Penrose, and David Gibbs, who became a guide and friend. At the U.S. embassy, we met an exceptionally engaging new friend, Stephan Munsing, who, for decades, would continue to introduce American artists and their work into the capital cities of Europe.

We spent hours over drinks at the Dorchester with Isaiah Berlin, philosopher, critic, political pundit, and an old friend of Clem's. My first highbrow who also knew how to have a good time—besides Clem, that is. And before we left, the gang from Cornwall came up for a few days, and we partied and danced into the morning hours while I pursued my flirtation with Bryan Wynter.

The biggest treat for me was our lunch with author Sybille Bedford. Clem had a soft spot for Sybille because of her connection to Jeanne Connolly, his glamour-girl lover during the war years, when so many Brits lived in New York. He also warned me that Sybille was pretentious, could be a bore, and guzzled white wine, which she pronounced "white *ween.*" We met at the Hyde Park Hotel. Small and round, she was at first barely discernable from the other matrons out on the town for lunch. However, once conversation began, Sybille was anything but matronly. She and Clem quickly settled into fast and furious gossip about their raft of mutual friends, kicking off with tales of the outrageous and hapless Jeanne, who, having succumbed to too much booze and fast living, had died in 1950 at thirty-nine.

I happily sailed through the meal on tales of Auden, Isherwood, Spender, Huxley, Mary McCarthy, Kingsley Amis . . . I fantasized that Sybille, a lesbian, would fall madly in love with me. She didn't. In fact, we exchanged only a few words. But I did grab a moment to gush about how much I had enjoyed her much-acclaimed *Legacy.* Published three years before, when she was forty-five, it was her first novel. Yes, Sybille

was pretentious in that she lived on a shoestring but loved to parade her highborn, snobbish ways. And yes, she did guzzle "white ween," but boring, no. And by 1959 I was an expert on what was boring.

One day, strolling the city, we passed Aquascutum, where Clem spotted a suit in the window that he thought would look nice on me. It was a nauseous green that Clem insisted was an "interesting color," but that made Nika, my new arbiter of taste, blanch. Needless to say, we bought it. Besides making me look like the rear end of a truck, the suit was made of such sturdy wool that I couldn't kill it with a stick. Even the moths took a pass. I am sure that if I hadn't eventually recycled it to a thrift shop, it would have outlived me.

One day we took an excursion up the Thames to Greenwich for a visit with John Bratby. His paintings had been used in the recent movie *The Horse's Mouth*, and he had become something of a celebrity. He lived in a crumbling estate on the edge of nowhere. Cold and damp inside and out, for a while we shivered by a derelict swimming pool, empty except for a few feet of sludge. The house had almost no furniture, and in the distance I now and then glimpsed a large woman with a child on her hip; neither was introduced. Consistent with the ambience, the studio, at one time perhaps a ballroom, was jammed with Bratby's large, dark signature pictures that mirrored all of our nightmares.

On the train back to London, my thoughts ran amok from Brontë to gothic horror movies, with a dash of *Sunset Boulevard*. Arriving late, we went directly from the station to a party at the Alloways', after which I begged off and went home to replay and put to rest the day. I heard the indefatigable Clem come in around three.

The plush Victorian candy box of the boat train to Folkestone, the channel ferry, the gulls that never left us nor cared whether they were English or French, the exchange of the white cliffs of Dover for the cliffs and customs of Calais. Cliffs aside, what really told me I was in France was Clem's appalling transformation to Mr. Hyde in the dining car to Paris. Was it the martini that wasn't right, or the soup he didn't want, or the disdain of the waiter that set him off? I don't know. Whatever it was, a heretofore never seen churl of a Clem erupted. He scowled and barked,

treated the man as if he had committed a heinous crime and was too stupid to live. The waiter, being French, turned on his heel, nose in the air, as dismissive as ever. Clem, smiling like the Cheshire cat, was delighted, with himself and with the waiter. He said it was an involuntary reaction to weeks of living under the thumb of the too-civil, too-buttoned-up British ways—the "ways" that I had found so charming. Now he was free. His venting over, he returned to his easygoing self and the churl disappeared forever.

By 10:00 PM, we were at the Quai Voltaire, at the time a borderline-seedy hotel on the Seine, our headquarters for two weeks. And we were off to a quick start. The Gottliebs and Paul Jenkins had left a message to meet them at a bar on the corner. Openings, studios, parties, the usual drill followed, except that here we spent most of our time in restaurants and cafés. With a few notable exceptions.

Tea at Brion Gysin's. A brief glimpse into the "romantic" Paris. A shabby building on a curlicue street in the Latin Quarter, the tiny garret with shutters open to rooftops of every shade of gray. We were at what was known as the Beat Hotel. Brion, a close friend and collaborator of William Burroughs, had reinvented the dada technique of cut-ups, wherein prose, poetry, and music were cut up and randomly rearranged or recorded. He, in effect, altered reality.

I grasped little of all that, but what I saw and heard that day certainly altered *my* reality. Brion wore a flowing orange silk caftan as he wafted amid immense pillows of glittering stripes and tassels, and walls swathed with exotic fabrics. He had re-created Tangiers, where he had lived for a while. He played tapes on a large machine—I had never seen a tape recorder before—that had the whine of the Casbah, and others that were compositions of cut-ups of everyday sounds and poems. We sipped Moroccan tea and sucked on a hookah of hashish laced with opium. That afternoon would be my closest brush with the expatriate Beats. Brion was a sweet, gentle man, evidently living on a thread of material subsistence, but awash in the creative riches of his mind and senses.

The next evening, we infiltrated a different world. We were invited to tea at Elena Yurievitch's. A small elegantly appointed apartment, a small elegant gathering of guests. The last to arrive, we stood for a moment,

until two more chairs were found and we were squeezed into the already seated circle. As in England, there were no introductions; it was assumed you were either known or not worth knowing. On our spindly needle-point chairs, we balanced cups of tea, lace napkins, and here and there a glass of sherry, while the delectable melody of French conversation played on, not a word of which—despite my high-school French—did I understand. For all the world, I might have been at a meeting of a secret society, or a séance, or a wake. Whatever, there was a set of arcane rules known only to the initiates. And while Clem and I were tolerated, we were not folded in.

Lord Norwich, whom we had met in London, kindly whispered a few names, all Lord or Lady or Princess this or that, intimating that they were known as much for the circles they traveled in as for their achievements. He himself was a viscount, in the diplomatic service, and son of Lady Diana Cooper, who sat across from me and had already caught my eye. So that was my predecessor at Cleve Lodge, she of the discarded tissue paper, she who had lain her fair head on the same pillow, or did she travel with her own?

I stared shamelessly, like a peasant, at the vision in soft green, the supreme beauty of her day. A pale, blond English garden. Silk dress draped just so, shoes to match, and a wide-brimmed hat draped in green tulle that half shaded her powdered porcelain white face. Oh, that hat, the way the green of it reflected on her skin. A green that would have made anyone else look terminal but made her incandescent. She never acknowledged our presence. And she never moved more than a hair's breadth. Before we left, Lord Norwich led us to the window. There below was the garden of the Rodin Museum, the sculpture sprawled so comfort-ably amid the benches in the courtyard. I wondered what *The Thinker* and his confreres would have thought of our stiff circle.

A more disconcerting reality was the Algerian war for independence that was spilling over into the streets of Paris. De Gaulle had been brought out of retirement, and now, after five years of fighting, the French were having a hard time letting go of their colony. The conflict would go on another three years. In the meantime, there were armed soldiers every-where, and we might turn a corner and the street would be blocked off,

sirens and megaphones at full blast. Most frightening was the sound of explosions, random and at any time. People didn't talk about it much, and if they did, it was dismissed as "political unrest" and life went on as usual. But for me it was the unacknowledged elephant that made it all the more unnerving.

There was another battleground that struck closer to home. After the war, many young American artists had chosen to live on the cheap and work in Paris, for centuries the center of the art world. New York was the Lower East Side and those "upstarts" at the Cedar Bar. Paris was ateliers and the Deux Magots and Le Dome, where the past mingled with the new. The only problem: The new art suffered in comparison with what was coming out of New York. Paris was now imitating rather than innovating. Slowly but surely, by the mid-fifties the center of the art world was shifting to America, the least likely place imaginable. As if to hammer the point home, the Museum of Modern Art had put together a show called "The New American Painting" that was now traveling around Europe. French artists seemed to shrug it off; where there was great art, there would always be Paris. But for the expats, this was a bitter pill. They were in the wrong city at the wrong time.

After an opening of Josef Sima at Facchetti's, a large group adjourned to a café. It was crowded, everyone standing around drinking, when a young man came up to Clem and without a word punched him in the face. No great harm was done, and the man was quickly restrained. But the shock. Clem, as usual, shrugged it off as just one of those things. Seems his assailant was one of the American expats. Although he didn't know Clem personally, he knew about him and saw him as the standard bearer for the touted greatness of the new American art. That, and probably too much booze, had been enough to ignite his bitterness.

We spent a particularly long day at Pierre Soulages's studio, where, in a shed out back, I had my first run-in with a hole-in-the-ground latrine with two only boards to stand on. Pierre was a lively, passionate artist, and the afternoon extended to dinner, joined by his wife, Colette, and eventually on to Les Halles, where we ate shellfish until 3:00 AM. On another occasion, the sculptor Robert Jacobsen invited us to his house in Montfermeil for a Sunday with his family. Near Paris, but in another

world, we arrived at an old isolated farmhouse. Lunch under a grape arbor, everyone round-faced and apple-cheeked, filled with warmth. We were welcomed with an abundance of food, wine, and high spirits. Later we played *boules* on the lawn. I had stepped out of time into a France I had only imagined.

One night, the painter Georges Mathieu invited us to dinner. The imposing interior of his historic mansion had been painted a stark white. The effect was startling, more so because, outside of the barest necessities, there was no furniture. Here and there were obscene sculptures of a scale designed to offend. His own art was on the walls. Dinner was formal, served by a butler, again in an otherwise bare room. Mathieu, though elegant and aristocratic in demeanor, loved to shock and had gained notoriety for his method of painting. He preferred to create his works in public, painting his huge canvases on a street, in a park, wherever. All in an hour or two, usually in costume. Many ridiculed, but everyone knew of him. Of course, in a few years such events, or "happenings," would become commonplace, but at the time, Mathieu held the stage. His suave darkness, flashing eyes, and sculpted mustache reminded me of Dalí. But as a person, he was a mild-mannered intellectual who enjoyed a good debate. He and Clem got along well, and he would look us up when he came to New York. Clem chided him for his theatrics, saying his work was too good for that and that in the long run he was getting in his own way.

We also met Jim Fitzsimmons, who lived in Switzerland and was publisher of the new magazine *Art International*. He would become a close friend. And we had dinner with an old colleague of Clem's, George L. K. Morris, from his *Partisan Review* days. On another night, we got together with Marjorie Ferguson, who Clem told me was the only woman he ever considered marrying besides me. I liked her; she was straight-talking, down to earth. Sort of like me, I thought.

With Kimber Smith, another expat painter whom we had known in New York, we went to L'Orangerie, the shrine to Monet's water lilies. I was enveloped and carried away. They were the most ecstatic paintings I had ever beheld; I longed to live beside their serene waters. Later, we went back to Kimber's for dinner. His beautiful wife, Gaby—she had

the smallest waist since Scarlett O'Hara—worked, of course, for Paris *Vogue*. She was also a sublime cook and had prepared a cassoulet that I would never forget. That night, Gaby was uncharacteristically on edge and argumentative during dinner. Later, in the studio, while Clem talked about Kimber's work, Gaby managed, only with some effort, to keep silent.

However, over brandy, when conversation turned to the Paris art scene and to Kimber's plans for showing in the future, she began to rail against galleries, saying that her husband's art was too good to be tossed into a corrupt marketplace, that she would never allow certain pictures out of the studio. Nothing new, I had grown accustomed to outbursts from wifely protectors of their geniuses. But Gaby stretched the parameters of possessiveness, as if she, her husband, and his art had been fused into one and their survival hung in the balance. Why? Like the old saw, was she afraid that a successful husband would leave her? Did she prefer to support the family, thereby keeping control? Kimber, a passive man, chugged brandy and never said a word.

I like to think that Clem let this moment alone, but I have a hunch he said, as I had heard him say in similar situations, "Stop acting like a wife." In any event, the drama was all for naught. After we left, Clem said he hadn't seen anything that would have prompted him to recommend Kimber to French & Company. A disappointment, because Clem liked them both. For me, the whole thing was a mess—well, except for the water lilies and the cassoulet.

One morning early in our stay, Bill Rubin knocked on our door at the Quai Voltaire. He then stayed on and ate and talked through breakfast, lunch, and a long afternoon at the Louvre. In his early thirties, Bill lived in New York, taught art history at Sarah Lawrence, and was an art collector. A Francophile, he spent a good deal of time in Paris, where his brother, Larry, had opened a gallery. He was passionate, obsessive really, about art—the surrealists and now the abstract expressionists. His passions defined him. He ate Clem whole. I was used to people who bit off chunks of him, but with Bill, the pattern was set the moment he stormed our hotel and would continue throughout the years of their friendship.

Bill ate people and food the same way. We would have dinner with him

in New York every few weeks, often at L'Aiglon, a favorite of his and, for me, resonant with memories of long, formal meals with my grandmother. With the face and physique of a chubby boy, Bill had his own method of dieting. He wolfed down enormous quantities of food, all the while rationalizing that he ate only one meal a day. Course after course, he guzzled his way to the post-dessert finale, a large salver of individually wrapped macaroons, L'Aiglon's trademark. Still talking nonstop, he popped them into his mouth like peanuts, the wrappers piling high in front of him, while my tongue was still trying to dislodge the first sticky morsel from my molars.

Yes, I was jealous of Bill's bond with Clem, even that first day in Paris. They never seemed to run out of things to talk and argue about. Until I guess they did, but by then Bill had discovered power: He became curator of painting and sculpture at the Museum of Modern Art in 1969, but by then I had stopped sitting around restaurant tables where art was the only dish on the menu. However grand his titles and position became, when I think of Bill, I will always think of a greedy, self-centered boy eating whatever he needed to fill himself up.

Paris and I didn't get along. Whether it was my language problem or the nonstop art talk, I needed an escape. Hoping to make friends with the city, I would set off alone, map in hand, searching its streets and monuments, any destination that had nothing to do with art. My first stop, the Bastille, which wasn't as much fun as I had hoped, but was no doubt a telling choice. I took a boat ride on the Seine and spent untold hours in cafés, staring at the passing parade. But never did I fall under the spell of the city's renowned charms.

I wondered if my reaction would have been different if I had been visiting as the wife of a shirt manufacturer. I hated being attached to Clem in a place where he was the object of so much ass kissing one minute and animosity the next. It spilled out onto him and, therefore, over me. Feelings never being simple, I also loved being there with him and knowing that I was seeing a part of Paris that shirt manufacturers never saw. Whatever the case, when it was time to go, I was glad to wave good-bye.

We were on our meandering way south in our tiny, tinny, rented

Simca—so tiny that its roof squatted against my frizzy hair, disastrously permed for the European adventure. There was much to see on the way— Chartres, Angoulême, Tours, and, near Montignac, the Lascaux caves.

From above, it looked like not much more than a hole in the ground with a small cluster of people gathered to be shepherded into the deep past. Damp, almost dark, and airless, a narrow passageway slanted into bulges of "rooms" of varied size. The ceiling pressed down. I shivered from the cold, the contrast so abrupt after the hot summer day above. But mostly I shivered from the sensation of standing on the ground where these people had first made their mark twenty thousand years before, give or take a few thousand. In Paris I had been enveloped by water lilies; here I was in the center of a stampede of bulls and bison and deer—their daily bread. The lighting flickered and was so dim that it took a while to take in the complex rendering of the animals and the use of color to shade and contour them. Here and there were a few handprints—the creator marking his turf, making magic. I felt the urge to press my hand into his to absorb his power. Like the child who experiences wonder when she traces her hand for the first time. Or the tourist who stands in the movie stars' footprints at Grauman's Chinese Theatre. I couldn't have known how fortunate I was to have had that glimpse of the caves. Discovered in 1940, they would be closed to the public by 1963, and thereafter could be viewed only in replica at a museum.

That night we stayed at the thirteenth-century Château de Mercuès, near Cahors. We were given a round tower room, and at dinner we had the dining room to ourselves. We looked out across the vast gardens and later strolled there among the roses, where bishops had walked for 1,300 years. A remarkable day of time travel.

The next day we drove on to the Ingres Museum and that of Toulouse-Lautrec before heading to Carcassonne for the night. Like an apparition, the fortified city appeared across the plains on the horizon, its stone walls and ramparts ablaze in the setting sun—a fairy-tale city that we entered through a gate. I liked the idea of a city with gates, as long as they were left open.

We were close to the Mediterranean, and I could barely wait to get my first look. We were on our way to St.-Cyr-sur-Mer, a town far too

small for any map, for a two-day visit with Clem's old friend Busch, the widow of art writer Julius Meier-Graefe, "the lady with the dachshund" whom I had assumed was Clem's wife the night I met him.

High above the town, at the end of a tortuous dirt driveway, sat Busch's doll-size cottage, which overlooked the fabled sea. Charming at first sight, it proved to have a few drawbacks. The ceilings and doorways through which our doll-size hostess gracefully sailed were so low that I felt like Godzilla. After repeatedly concussing myself until I saw stars, I gave up and took to a chair. As kind as Busch was, her connection to Clem was rooted exclusively in people I had never met and places I had never been. I could manage with that, but this was not a dinner with an end in sight, and this was no witty raconteur. Sprinting between French and German, their talk wore on. And wouldn't you know, outdoors was off limits because of a savage scourge of mosquitoes.

Later, Clem and I squeezed into a tiny bed for two, and I finally fell asleep to an ear-splitting lullaby of cicadas, a result of the unusually intense heat that had settled down like a blanket. Even Clem agreed we should cut our stay short, and we fled the next day to the hedonism of a Monte Carlo hotel: dinner on our balcony, with the lights of the Riviera stretching to Spain, or almost, and a toilet of our own, a first since the *Mauritania*.

As we headed for the border, France set off a farewell salvo. As we went through Menton, we heard a series of explosions along the harbor. The earth moved, the Simca trembled, and the sky turned black. Amid murmurs of sabotage, we were told that an oil tanker had caught fire in the harbor and the fire was spreading, that we would do well to leave. Easier said than done—the road was soon backed up with emergency traffic. I had had enough of France and its fireworks.

Sometimes—and this was one of those times—to break the tedium and tension of driving, I would sing. "Bye, Bye, Blackbird" sort of singing. Clem loved that and would always remark on how beautiful my voice was, as if discovering it for the first time. But he never joined in. He said he had no gift for it. But, that said, he would add that his life's dream was to be an opera singer, a tenor.

We crossed northern Italy, stopping at Piacenza and Verona before

tackling the Alps via the Brenner Pass, our hopelessly underpowered Simca huffing through the Dolomites, surrounded by caravans of oil trucks. I thought I must be the only traveler in the world who had been to Italy and never seen Rome, Florence, or Venice, but Clem was eager to get to countries and cities and museums unknown to him. "Besides," he said, "you have plenty of time—you'll see it all." He was right, though it would take me thirty years.

We stopped in Kitzbühel, Austria, where we slept in our first feather-bed, so high that we needed a stool to climb into it, then moved on to Vienna. The Bristol Hotel had a lushness I will always think of as Vien-nese: the room, its upholstery, draperies, and bed dripped with ecru satin, carved mirrors everywhere, ankle-deep carpeting, chandeliers with silk shades—a sumptuous cocoon so dense and hushed I held my breath. All a bit much, considering that the heat wave had followed us and was now breaking records all over Europe. Of course, air-conditioning was a thing of the future.

By nightfall we had met some of the foremost up-and-coming artists and their wives: Josef Mikl, Wolfgang Hollegha, and Rupprecht Gei-ger. After dinner they took us to the Prater, where, from the top of the enormous Ferris wheel, I saw all of Vienna. So incongruous, as if Coney Island had been plunked down in the middle of Central Park. Vienna had hatched a thriving art center, thanks in large part to a contemporary-art gallery around the corner from St. Stephen's and to the support it received from the cathedral's extraordinarily progressive monsignor. Over the next few days, we visited their studios and spent hours in bars as they hammered Clem with questions about what was happening in New York. Clem read German with ease, had even translated a few books as a young man, but speaking was sometimes slow going. Conversation would flow for a few minutes and then abruptly stop as Clem, always a stickler for communicating precisely, searched his dictionary for just the right word.

Our primary guide and companion in Vienna was Kurt List, musician, writer, and another old friend of Clem's. Oozing charm, he was a dashing man with a beautiful blond always on his arm. He drove us everywhere

in his convertible. It had been only four years since the city had been reunified after having been quartered between America, England, France, and the USSR. I became war conscious in Vienna and would remain so for the rest of our trip. My antennae were up, and I couldn't shake the habit of trying to place people we met; were they too old, too young to have been soldiers, had they been Nazis? The hotel staff smiled too much, the people on the street too little. Kurt told us about people he knew who, upon reading about the Nuremberg Trials, claimed to be astonished to learn of the horrors. I cringed. I felt anti-Semitism was alive and well.

When we went to the Kunsthistoriches Museum, its vastness was made even more vast by our inability to find the entrance. Like Laurel and Hardy, we walked the perimeter, the sun blazing, nary a soul in sight to guide us. Finally, we came upon the entrance, not far from where we had started. A man magically appeared, waving a camera. We agreed, and he took our picture and our money and said he would send it to us. He actually did, and for fifty years it has sat in a filigree frame of my mother's on Clem's bookshelf. I look for the wilted stress of our moment in Vienna and see instead a contented, overfed American couple off on an outing, she in her beige drip-dry Dacron dress, he in his drip-dry, short-sleeved shirt and seersucker jacket.

As usual, we spent days in the museum, Clem annotating his catalog in his special code: check marks in ascending scale, often with pluses or minuses, and sometimes with exclamation points or question marks. The latter indicated the more interesting pieces, the ones that had confused his eye, that were perhaps, as he would say, "beyond me." My pace was quicker. Since I had been in Europe, I had developed museum ennui. Airless, I would start yawning and couldn't stop. The cure was simple; I would find a spot where I could read or write in my journal.

Next stop was Munich, a difficult city to visit, having been Hitler's home base and the crucible of the Third Reich. We arrived at night at the large, echoing emptiness of the Hotel Vier Jahreszeiten. The next day, we confronted the devastation around us. We would walk down a commercial avenue and turn a corner, only to find stretches of nothing-ness, as if we were touring a film set of facades. Before lunch we stopped

at a small dark bar. The bartender struck up a conversation, the usual tourist chat, and moved on to some generalities about the war. He then said, "Hitler was a fool."

Clem responded, "No, he was evil."

Unused to having his conciliatory platitudes rejected, the bartender protested. Clem firmly cut him off and in his slow, deliberate German proceeded to define the difference between a foolish man and an evil man.

The next afternoon, we took a taxi to a cathedral in another part of the city. A large structure, it appeared to be even more immense, sitting as it did in the midst of a wasteland, wounded, its stained-glass windows boarded up. Reconstruction was under way, and we roamed the interior, looking at the art to the sound of jackhammers and drills. As we were leaving, a man approached, this time not with a camera but with angry words. "Look at what you've done!" And more of the same.

Clem turned on him. "No. Look at what *you* have done!" And we walked away. I asked Clem if he had wanted to take a swing at him. He shrugged. "It wasn't personal."

After Munich we visited Kassel, Cologne and Düsseldorf. And then we left Germany. Two days later we were in the Netherlands. For the next two weeks we would be tourists. No more artists and studios, but saturated in art nonetheless.

It was in Amsterdam that I felt I was bottoming out. We had been traveling almost three months and it had been gradual, but now it was unmistakeable. It had been the oppressiveness of Germany and its language—for me the family language of secrets and portent—and I was tired of driving. Our entry into the city was the last straw. I went the wrong way on a one-way street and was stopped by a cop. I became hysterical and Clem told me to shut up. I shut up. He took over the wheel and expertly navigated the rest of the way, driving better than he ever had before or ever would again.

For the first time, we had to scrounge for a room, going from one place to another in that overcrowded, underbuilt town. At last we were installed in the attic of a run-down rooming house. I was pleased to note that I wasn't the only one winding down. For once, the mellow,

indefatigable Clem was frayed and exhausted. I found Amsterdam as heavy and leaden as the breakfast tray the landlady brought up the creaking stairs each morning, with its cold meats, cheeses, eggs, fruits, hot cereals, breads . . .

One night at dinner Clem said, "We're not getting along very well." This from someone who had never assessed "us," at least not out loud.

I bit back with, "You can say that again," or some such. My flippancy belied the quaking I felt as I reeled into a dire scenario where I was abandoned on the streets of Amsterdam, panhandling for my fare home. Naturally, I was sure it was all my fault. I didn't measure up. I had fallen short. Problem was, I knew he was right. I wasn't happy as part of Clem's package deal; I wanted to see castles, he wanted museums, and I didn't have the spirit of adventure to pursue an agenda of my own. Oh, I blamed him, but being my mother-the-martyr's daughter, I blamed myself more. A no-win impasse. But our travel routine continued as usual. And I stowed my scenario under my pillow.

I found it hard to find the heart or the rhythm of Amsterdam. Touring by day the old parts of the city, I found it overly precious, too picture-book to be real or intriguing. Then, walking at night through the "New" town, with all its glitz and neon, I found it jarring and tedious. Both were trying too hard and at odds with each other. Perversely, it was the glitz and neon that spoke to me of the effects of the war. They spoke louder than the devastation of Munich. I found I wasn't ready, even fourteen years after the war, to have it blotted out by a second-rate circus.

But there was plenty of art. At least in the museums I could feel the deep roots of the city. We spent several days at the Rijksmuseum where I stood forever in front of Rembrandt's *Night Watch*, which even I had heard of, trying desperately to be moved by it but failing utterly. We went on a day trip to Haarlem to wallow in Hals, until the dour men in black with their white ruffs blurred, until more became less.

On to the Hague, where the noise of traffic in dense narrow streets and the crush of men in dark suits and ties told me this was a city of intrigue and business. Then to Scheveningen, so like a New England beach town with its grand old hotels, except here I dipped my toes in the North Sea. It was the last day of August and the heat had finally broken as the

cold weather swept in, sending tourists to cozier venues. I reveled in the bleakness. Before the sun set, I went out to stroll the "shingle." As the stones dug into my feet, I was happy to be away from the crowds and to once again have a hotel to ourselves. At dinner that night, wrapped in our coats, we watched the approaching storm. Before we left, I once again walked to the sea and sat in the chill morning fog. With an urge to be deep and romantic, I tried to write a poem. But trying does not always make it so.

While we were in Brussels, Clem decided to spend a day in Bruges, while I, in need of a breather from art and togetherness, opted for another beach town, Ostend. At the racetrack I managed to place bets with touts, and lose. And I managed to feel like a grown-up navigating my day and the buses. I realized how childlike I had become after three months dancing in the lockstep of coupledom. Though we were certainly a couple at home, travel was making the dance untenable.

No more dawdling—we headed south to Paris, our only detour, Vimy Ridge. My skin prickled as we drove down a narrow road through a small forest, the sunny day now dimmed and chill. Leaving the car, we found ourselves alone as we walked through what had been minefields, the craters still there. We walked in the trenches where thousands of men had lived, if they'd been lucky, month after month. Then up a hill to the Canadian war memorial, a long wall with the names of the dead, two pylons rising above it, a somber reminder of the sixty-six thousand Canadians who had died in the Great War, many of them there. I couldn't take it all in. I looked at my feet, somehow ashamed to be standing there, young and alive.

Since we had left England, the specters of war had taken up residence in me: the bombs of Paris, the Menton explosion, and the scars of destruction and deprivation, evident or masked, everywhere I looked. I hadn't anticipated that. The war was past; it belonged to my childhood. That unsafe time of too many fathers, moves, and schools, my mother crying as she listened in the dark every night to Gabriel Heater, who brought the news of the war into the room we shared. Crying about the war? Crying about her life? For me it had all gotten mixed together, and I started listening for the bombs that would surely fall on Blind Brook

Lodge. Hadn't I been trained to listen for sirens and hide under my desk at school? Hadn't my brother made me memorize the insignias of warplanes, ours and the dread Messerschmitts, that I should keep an eye out for? But to get retriggered fourteen years later? Oh, how I yearned to outgrow the past.

And soon we were in Paris. We returned the car. Clem retrieved our maps and guidebooks, of course meticulously annotated by his Montblanc. I left behind my tense shoulders, tired eyes, and fear of getting lost. By ten o'clock that night we were on the boat train to London. This time, no gulls, no rhapsodizing about the white cliffs. Instead, a different kind of rhapsody, lying in Clem's arms, in a berth of a train that was rocking on a boat.

The next morning we were on our way to Liverpool, where we boarded the *Corinthian*. To Clem's delight the ship was small, the weather foul. While most of the passengers took to their cabins or crept around looking green, Clem walked the decks glorying in the high seas, heavy winds, and salt spray. I didn't get seasick, but I much preferred the snugness of our cabin, where I spent afternoons writing in my journal, trying to sort through experiences I wanted to remember and tripping over a lot I would just as soon have forgotten.

I was struck with a new theory: that proximity might well cause more divorces than infidelity. I allowed myself to reopen my dire Amsterdam scenario, to wonder about how close we might have come to splitting up. I knew that I had overreacted, though I still swerved abruptly between thinking it was all my fault and thinking what an insensitive bastard Clem could be. Even mid-Atlantic, between here and there, seeing any middle ground was beyond my grasp. One thing I knew for sure—I had shut down after we hit Germany, where I had felt most isolated and inconsequential. I had been spoiled by the English, who hadn't talked through me but *to* me. So civilized that, unlike Americans, they could even make art talk sound like conversation.

I thought about how complicated travel was for me, because on the one hand, some of the best parts of our journey had been the peaceful amblings and small towns, being on our own. At the same time, that unrelenting togetherness was what had eventually worn me down, especially

in the last weeks. Like the horse that nears the barn, I was anxious to get back to the given, the routine and nourishment of home. At least there, there was variety, and whatever was going on between Clem and me, I had escape hatches every which way. In that damned Simca, well . . .

Sick of insights, my thoughts turned to the party at hand, a costume party. I decided at the eleventh hour to jettison Clem's mandated shipboard protocol of isolation and become a joiner. I was sick of pretending we were alone while corralled with 250 strangers. Besides, I had a great idea.

Cunard ships were infamous for their rolls, served morning, noon, and night; beautiful to behold, small, round, and burnished to a light brown, they were impenetrable with tooth or chisel. In vain, people would crack them on the table, hoping for access to their yeasty secrets. I thought it was time to put those culinary rocks to some use. Borrowing knitting needles and some wool from the covey of grandmas in the lounge, and asking the bewildered steward to bring me four dozen rolls, I set to work. I pounded the needles through the rolls with Clem's shoe and strung them together with the yarn, until there were yards and yards of them. Then, after dinner I wound the rolls around my head into a dome-like crown and let the rest hang down my back. The result was stunning, beautiful really, like nothing I had ever seen. Their color and symmetry; this, I thought, was what they had been created for. And the judges must have agreed, because I won first prize and was awarded a brass clock with the insignia of the ship on it. No, the ship didn't instantaneously burst into all-singing, all-dancing Technicolor with me as the star. But at least I had given my shipboard fantasy a shot.

As I tucked the clock into my suitcase, I realized it was the only souvenir I was bringing home. I would put it on our bookshelf in the living room. Maybe it would remind me of what was possible, what I could make happen.

My friends, the two Nancys, met us at customs and eased our reentry. At Bank Street I was dizzy with feelings. It was too small, it was divine. It was dingy, it was ours. I was sad, I was happy. Exhausted and keyed up, I thought of the last three months as a party that had been a disaster,

I thought it had been the party beyond my wildest dreams. Most of all, I thought the party was over and there might never be another.

Friedel and Herman (Cherry) rang the doorbell. They had heard we would be home that day. Clem was in the kitchen, breaking out stale ice cubes, pouring the Tanqueray, Noilly Prat, and single drop of orange bitters into his small dented shaker. The search across Europe for a perfect martini was over. We toasted our homecoming and turned to our friends. "So, what's happened since we left?"

part three

Together/Separate

The Sixties

IN A DAZE of rapture, I sprawled on the bed and drank in the beauty of all I beheld. The windows wide onto a soft spring breeze, the clouds frothing across the bright sky, now and then an airplane darting through them. Late afternoon, a glass of champagne in one hand, the phone receiver in the other, I called everyone I knew to tell them our new phone number. "Imagine, Susquehanna 7—isn't it wonderful?"

Clem was in the next room, henceforth known as his "office," already at his desk, his treasured green-shaded lamp in place, his typewriter table and old Remington upright at the ready. His eyes were torn between the flock of seagulls sunning on the reservoir seventeen floors below and the galleys spread out before him. *Art and Culture*, the book he had been working on sporadically for two years, was about to be published.

That May morning in 1960, we had crossed the great divide of Fourteenth Street and moved our bits of furniture, stacks of paintings, and cartons of books from Bank Street to 275 Central Park West at Eighty-eighth Street. It had happened quickly. Only two months before, Clem had received a windfall from his family that we both realized was a life-changing amount of money. After twenty-five years in the Village, Clem opted for a change of scene on the Upper West Side. His guidelines were few: no fancy building, no more than $225 a month, and as long as he didn't have to do anything. With wings on my feet and visions of light and space and the family that would someday fill it up, I found the apartment that I knew was waiting for us in only two weeks. It faced north and south as far as you could see, with sideways views of the park, two bedrooms, and a dining room that could become whatever it wanted to be.

I needed only a quick look, before dashing home to tell Clem. Sight

unseen, he called the landlord and we went uptown to sign the lease for $220 a month. Giddy with the immensity of what we had undertaken, we headed down Broadway to the Tiptoe Inn and in its midafternoon emptiness toasted our new life with martinis.

Now it was real. Every now and then Clem and I would stroll through our rooms, discovering gifts at every turn: a wall of bookcases in his office, a stall shower, three walk-in closets in our bedroom, a linen closet for our two sets of sheets, and picture moldings to make my curatorial job easy. Neither of us had ever had such abundance. I could see Clem's socialist mind whirring; it was like having more shoes than one could possibly wear. But oh, that view of the birds on the water, and that stall shower of his dreams. I knew he would get used to it.

We stood in the thirty-eight-foot living room—the moving man had paced it out—and laughed at our four chairs, three tables, two lamps, and at the paintings stacked against the walls. And laughed at Clem's easel, a lonely sentinel in the dining room, and at our double bed, so small in the big bedroom, with only a bureau and two little tables to keep it company. That night as we lay there, I listened to the silence broken only by an occasional rumble far away. Clem said it was the subway. No more air shaft with its weekend drunks, no more trucks on the cobblestones of Hudson Street—never forgotten but never missed. The next day I started hanging the paintings. Glorious. Who needed furniture?

On December 21, 1961, our first baby was born, lived a minute, and died. She was full term and was designated anencephalic. The death certificate would simply state that Baby Greenberg was "incompatible with life."

Seven months earlier, Clem and I had been in his office. To the north the windows were opened wide to the warm May night. To the east was the Triborough Bridge, to the northwest the shimmering necklace of the George Washington Bridge near enough to touch, and just beyond beckoned the fantasy lights of Palisades Amusement Park in New Jersey. Clem reading at his desk; I seated on the narrow yellow armchair that had been my grandmother's.

I got his attention and in a small voice told him the news, unsure of his response. I was sure. This was the perfect thing, the perfect time, but

for Clem? Well, that might be something else. He was still for a moment, then, "Do you want to have it?" A blow to the gut. Oh, I knew his resistance to having another child at this stage of his life, resistance that was exacerbated by his guilt for having failed Danny as a father. He was also concerned that I wanted a baby only to fill up my life. On that score he was right. Maybe it was a lousy reason. Maybe I didn't deserve to have a child, but still . . . I couldn't speak.

When Clem went to get another drink, I moved to the window behind his desk chair. With those few words, he had defined the baby as mine, not ours—my sole responsibility. Dire scenarios: The baby would be an unwanted appendage, I would pay for my willfulness . . . Tears wet on my face, I listened to the screams from the Cyclone roller coaster across the river. But he and I both knew my answer to his question was yes.

He had taken a blow to the gut, too. He knew he didn't have a choice, but he wanted me to understand that I did. That sank in and I was able to thaw the chill of those words over the next months, months that turned out to be so happy for both of us. Clem attached himself to me, my belly, and the baby. A new closeness. This was the way it was supposed to be; for once, our life was the way it was in the movies. People told me how beautiful I was, and for the first time I believed it.

With the help of Jennifer Gordon I made a maternity dress, black and quasi-chic. My first encounter with a sewing machine since a disastrous two-month home ec course in seventh grade. Now I had actually made something that I could wear. My mother sent down the old white wicker bassinette that my brother and I had slept and cried in as babies. It was like a boat on large wooden wheels. I sewed a cover for the old mattress and wove white satin ribbons through the wicker so that the baby wouldn't get its fingers stuck. I folded up Clem's card table and easel and put away his paints, which in our first year at Central Park West he had never used. I bought a daybed and a changing table and knitted until my fingers had calluses. Along with the brightest paintings we had, I hung a seven-foot striped Morris Louis where it would be the first thing baby would see. More radiant than any rainbow, it matched my new scenario of our future. We would be a real family.

At noon a few days before Christmas, Clem and I took a taxi to

Doctors Hospital. The baby had been reluctant to come into the world and labor would be induced. We were scared and happy. An hour later, I was alone on a gurney in a white curtained cubicle with the moans and cries of labor around me. Sedated, I neither moaned nor cried. My doctor bustled in. He leaned into me, his breath on my face, not with kindness or caring but because he thought I did not hear him, was not getting the message. But I did get the message: There would be no baby. I heard him through the sirens in my brain that were so loud my eyes squeezed shut and my heart fisted inside itself.

She walks into my hospital room with a heaping bunch of white daisies. She takes charge. Orders a large vase to be brought. Tells me how sorry she is for my loss. Comments favorably on the spacious private room, the view of the East River, and how beautiful the day is: "Unseasonably warm for December," she says. Do I know her? I do, but I have lost her name. She appraises the other flowers. I see her reading the cards, counting the bouquets as she puts a price tag on each. She singles out an overripe white orchid as being "particularly tasteful."

Her words pass through me in icy fragments. I have no appetite for words or much of anything. I take in her tall, lithe frame. She wears clothes as drapery. Her tidiness. Her capped blondness. Skin that betrays no secrets. I wish her dead. I have no body, no hair, no skin. My secrets have been torn out and shredded while I wasn't looking. While I was in the dark they must have crept up and wrenched out my innocence, along with what had been my joy the last nine months. And thrown its bloody pulp into the garbage.

She arranges the daisies one at a time. There are thousands of them. Now and then she steps back to assess her handiwork. Why is she here, this sometime acquaintance? I close myself. She does not exist. When Clem returns, I utter a few words. Angry, in a deep voice that is unfamiliar to me, I say, "Don't tell anyone."

That was the first time I confronted the many faces of acute pain that could be emotional as well as physical. I understood that something painful had happened to me, but I was unable to walk into the underbelly of the pain. That would come much later. Meanwhile, in the weeks that

followed, I experienced a great deal of physical pain. I could barely walk and when I did, I bent forward, my hands clutching my abdomen as if something more might fall out. I was like the old ladies on Broadway who inch by inch threaded their way to the sanctuary of the benches along the strip of green. And I lived and breathed rage. I blamed the intruder who had moved into my body, who had promised me the gift of life and had eaten the heart out of me instead. I blamed the doctor who had ravaged my insides getting rid of the clinging intruder and who had nothing to say to me after his butchery except, "You're young. You'll have another." As if I were a normal twenty-eight-year-old. He didn't see the crone. He didn't see the catatonia. He added, "No sex for six weeks, and don't get pregnant for six months." Sex? Pregnant? I stared at him, as vacant as my body.

My mother, who had come from Cape Cod for the blessed event, said, "You have your whole life ahead of you," in her "think good thoughts and everything will look better in the morning" way. Clem told me later that when the doctor had updated them on what was happening, she had coquettishly said to him, "You must find it all very interesting, in a scientific way." Even the Butcher had been too nonplussed to respond.

As for Clem, he was there, always there. He cried often. And as many times as the doctor told him the cause had been "an accident at conception," Clem insisted it was his fault. He meant his age, but I knew he meant, too, the damning words he had said that hot spring night when the cries from the Cyclone had shuddered in my tears. Soon he stopped talking about it. Me, I had never found the words to talk about it at all. The days, the weeks, passed. We moved forward, parallel mourners in silence.

It seemed to me that my pain had been effectively muffled, as out of sight as the bassinette that had been stowed in the basement of our building. Within two weeks, after a cheerless Christmas and New Year, life resumed its customary social flow and on the fifteenth of January we boarded the Broadway Limited for Chicago, where Clem was to give a talk at the Art Institute. Our ten-day trip would include Buffalo for the dedication of the Knox wing of the Albright Museum, a night at Niagara Falls, then on to Toronto for a few nights with the Bushes.

February disappeared into a fog of parties, some ours, mostly hosted by others, often ending up at a club called Camelot, where we would twist ourselves breathless. I was mad about the twist, which liberated me forever from my self-consciousness with touchy-feely dancing.

One late afternoon, Peggy Guggenheim stopped by. The renowned collector/art dealer was in from Venice on a rare visit. After the first once-over, she ignored me, and she and her old friend Clem flew into a gossip frenzy. Small, cold, brittle, the woman who had been the first to show the abstract expressionist all-stars delivered her final verdict: One and all, they had failed to fulfill whatever promise they might have had. Besides, "They were ungrateful bastards and if I could do it over again, I would never . . . " The artists, the pictures, all ashes in her mouth. Later, we went to the Museum of Modern Art, which drove her to new heights of contempt. I had expected an aura of glamour but found a bitter, combustible woman who made Lee look like a daffodil.

I now look at Clem's daybook and see the staggering array of activities during those months after the baby's death: parties at the Motherwells', the Castellis', Henry Geldzahler's; visitors Robert Jacobsen and Miriam Prevot from Paris, the Piero Dorazios from Rome; a dinner at Bernie and Becky Reis's for Francoise Gillot . . . And I wonder at it, at how the body preens, shows up, joins in revelry night after night, while the mind and the senses sleep. It all happened, but I remembered little except the twist, the fog, and Peggy.

And my introduction to Pilates, the latest exercise discovery of Marion and Bob Wernick. Ex–Time-Life staffers, the Wernicks were extraordinary racanteurs, drank astonishing amounts of booze, and, to Clem's delight, provided an inexhaustible flow of juicy gossip. They were also unique in our repertoire of friends. They were professional guests. Unemployed since Time-Life had slipped from cutting edge in the forties to prosaic in the fifties, the Wernicks had carved out their unusual niche and were evidently much in demand. They were like a vaudeville team with a balancing act, she with her bawdy, husky voice and creamy-skinned amplitude, he with his natty, urbane detachment with just a touch of intellectual repartee, not too much, not too little. Now and then the act

passed through our living room on their way from one exotic locale to another. It was on one of these visits that they talked about Pilates, the panacea that would change my life. They insisted I come with them and give it a try.

Up three flights in a musty derelict building on Eighth Avenue between Fifty-eighth and Fifty-ninth Streets was a drab room with a few padded benches, pulleys, monkey bars in the corner, floor mats, and Joseph and Clara Pilates. We left our coats in an alcove, and I waited for the panacea to work its magic. During the months that I went there twice a week, the routine never varied: much hands-on twisting, pushing, and pulling, and a good deal of bending backward over the benches and pulley stretching. Always, Joseph, with his guttural German accent, would tell me, "You have a fine, strong body. We will develop it." I didn't feel fine or strong as I hung from the monkey bars. I never was able to swing like the monkey they urged me to be, or like Farley Granger, who could swing across and back in a flash. I'd never been a fan of Granger, but for an actor who seemed so slight on the screen, he was a perfect specimen in the flesh.

Soon the Wernicks were off to God knows where, but I stayed on, at least for a while. I liked hearing that old German tell me I had a strong body. Since the baby, I needed reminding that I had a body at all. And I liked it when I would come home and slouch in the yellow chair in Clem's office and hear him tell me that I looked wonderful.

At the end of February, my grandmother Betty died of a heart attack at age eighty-two. It struck suddenly, between the end of dinner, capped off with the applesauce she loved, and the opening hand of canasta with a friend. I went to my first funeral at Campbell's on Madison Avenue, around the corner from her apartment. We then drove across the George Washington Bridge to Englewood, where Betty was buried among all the women she had lived her early life with and their husbands, who had had a habit of dying too young for anyone to have ever talked about them or remembered them much at all.

Then, like magic, our sparsely furnished apartment overflowed with the furniture and bibelots of Betty's life, surprisingly compatible bedfellows with the dazzling colors and shapes of the modernity that decked

our walls. Paintings would come and go, but all that ballast of the lives that preceded mine would remain steadfast.

The fog must have been thickening, because I had my first visit with an analyst after celebrating my twenty-eighth birthday with Bette Davis in *Night of the Iguana*. I still see the first scene, Bette sitting downstage, a few feet from us, wearing a white shirt open to the waist, in full flesh and fervor. As for the analyst, he'd been recommended by the doctor who had seen Clem through his breakdown in 1954. Any trepidation I might have had about opening my brain to some strange man had faded as I helplessly witnessed my drift into inertia, my days like meals where all the food tasted like cream of wheat without the sugar on top.

I showed up at the office of Isaiah "Sy" Rochlin for what he said would be a consultation, after which he would make the appropriate referral to someone else. Uncomfortable, I felt I was being measured, but against what I didn't know, and whatever it was I was sure I would fall short. I relived the panic of my interview with Mr. Snyder, the headmaster of Rye Country Day School, who looked like the Ghost of Christmas Past. At stake was whether I would be accepted into eighth grade after years of public schools. He asked me when Columbus had discovered America and, my mind a black hole, I stuttered 1600-and-whatever. Dripping condescension, he told my cringing mother that I would be tested and most likely held back a grade, that is, if I passed at all. I cried, considered suicide, but hung in. Quaking alone in a classroom on a dripping summer day, I took the test and my life was spared; I was accepted into the eighth grade. Now I was with Sy, the man with the power, asking questions that I answered, trying to hit the right balance between despair and certifiable lunacy. Once again, I must have passed the test, because he decided to take me on as his own patient.

But first there would be a hiatus. Clem and I went on the road again, this time to Florida in a car Ken Noland lent us. The drive was Clem's idea, spurred by an invitation to speak at the Ringling Museum in Sarasota. If we talked about it, I don't remember, probably because it didn't matter to me. Anything that passed the time, got me through another day without thinking, was okay by me. It would be a typical Clem drive. Just as we had on a previous drive from Vancouver to Los Angeles, we

would be traveling only on two-lane roads, until we dead-ended at the wharf in Key West.

We stopped to see our friends Anne and Jim Truitt in their house in Georgetown. They threw a small dinner party where we met several Camelot players, among them the Ben Bradleys (*Newsweek*), Philip and Kay Graham (the *Washington Post*), the Jim Angletons (CIA Counterintelligence), and Mary Meyer, an artist and ex-wife of Cord Meyer, also of the CIA. We had gotten to know Mary when she was seeing Ken Noland and had stayed in touch. She was a mesmerizing blond beauty; I adored her straight-talking ease of being in the world and her style. One day she had arrived with Ken wearing a drop-dead beige corduroy polo coat, and I asked if she would mind if I bought one just like it. She was delighted and I cherished it for decades, as if it endowed me with her beautiful spirit. I also adored Anne, who did it all: wife, mother of three, hostess for her *Newsweek* executive husband, and dedicated artist.

Amid this group of friends, the evening flew by in a whirl of banter and camaraderie. Such a high time in Washington, in the whole country, when it seemed that the promise of a better future would actually become a reality. Impossible to imagine that the next year would bring an end to Jack Kennedy and the idyll that bonded this group. Astonishing, too, was that also within the year this golden circle would be tragically sundered by Philip Graham's suicide and the murder of Mary Meyer. Her violent death soon after the assassination would forever be linked to her long affair with Kennedy, and to the long arm of the CIA. Her murder would remain yet another of the obfuscated mysteries associated with those times.

But that night, in homey conviviality, while Anne's new baby, Sam, slept in his crib upstairs, she and I hung out in the kitchen as she demonstrated her failsafe salad dressing: tons of crushed garlic, pepper, lots of salt, and a few shakes of paprika and dried mustard, madly shaken with oil and vinegar. As she mashed, sprinkled, and poured, she confided, in her simple, precise way, how she, too, had experienced the loss of a baby. Anne wasn't the first. Following our loss, several women had written to me about their similar experiences. However, I was unable to be open in return and was wary about hearing more than I wanted to

know. With Anne, I was grateful for her words, probably because she so tacitly expected none from me. I also knew that when I was ready to talk to anyone, it would be to her.

Three days later, our slow journey got even slower when Clem developed a pain in his left shoulder and I had to do all the driving. I knew that he would never malinger. With a pain threshold as high as Everest, he had never complained about anything whatever, so if he said his arm was "bad," it must have been excruciating. Nonetheless, I came up empty on compassion. I wanted to be a mollycoddled princess, not a damned chauffeur. And I certainly didn't want to be chauffeur to this person, who in between "points of interest" sat there burrowed into Nietzsche while puffing his disgusting cigars.

We stopped at every animal farm, monkey jungle, aquarium, every jerry-rigged roadside stand with a sign out front boasting of snakes, iguanas, monkeys—who pulled my hair until I screamed— tarantulas, crocodiles, or exotic birds and cursing parrots. If it moved and had feathers, fur, or fins, Clem heard its call. To me, walking in the shadow of morbidity, these places were filthy warrens of cages that smelled of slow death. Clem delighted in the infinite variety and checked out each creature with as much intensity as he brought to bear on a piece of art. And he took umbrage with labels that were inadequate or, worse, inaccurate, and would harry the indifferent owners with questions and suggestions for improving the information. A place always got high marks if the creatures had names. After all, if the poor thing had to suffer life in a cage, the least one could do was accord it the dignity of a name. And a dead baby should have a name. And I buried the thought deeper.

After a two-day respite from the animal kingdom, while Clem fulfilled his speaking obligations in Sarasota and we mingled with the museum types and artists in the area, we headed back to Route 1. As we homed in on the Keys, I was jerked out of my lethargy by the sight of an elephant tethered to a post by the side of the road. To hell with Nietzsche—Clem had to make friends with that elephant. There was no one around, just the elephant and us.

Clem wanted a picture and told me to stand in front of it for perspective. I obliged, but when he kept saying, "Closer, get closer" until I could

feel the elephant's breath, I refused to budge. Clem's photos took forever and were invariably disasters because he was mechanically hopeless and had never mastered the art of pushing the button while keeping the camera steady. For some reason, that photo came out clear and true. I don't recognize myself. I am so thin, in a brown pinwale skirt I had worn in the tenth grade and a strange sweater I had bought when we married that was block-printed with smoky flowers so that it looks like a furry tapestry. My hair hangs long and limp. I am a young bare-legged girl with an elephant. I, who always smile too much in photos, am not smiling. That was no Dumbo. I was sure that at any moment I would prove to be his last straw. He would take revenge for every tourist who had ever invaded his turf. I could smell his retribution as he dashed me to the ground and pulverized me into dust. I never showed anyone the picture.

From the moment we crossed the first bridge to the Keys, the water turned to a pale jade green and I felt alive and at peace for the first time in months. The first evening, we stopped at a run-down motel on the gulf side of Islamorada, the name honey on the tongue. After dinner we walked to a deserted dock, where we dangled our feet in the water as the sun set. No talk, no nothing—it seemed as if hours passed. The majesty and languor of the sun. How could it get bigger as it disappeared? It did. And the larger it grew, the closer it came toward us, until I thought it would swallow us whole. I held Clem's hand. Later, Clem wrote in his daybook, "Islamorada. Saw sunset on the gulf." I loved that. For Clem to mention a natural phenomenon came dangerously close to breaking his rule of no editorializing, and reaffirmed how special the moment was.

Most of our trip home slipped by me; evidently, we danced at the Fontainebleau, visited the rocket plant in Cocoa Beach, drove on the beach at Daytona, and, oh yes, visited yet another marine land in St. Augustine. That I do remember. Clem had been searching for a transcendent encounter with a dolphin ever since we had crossed into Florida. Then, at the last opportunity, he hit the jackpot. After the show, Clem stood by the side of the huge tank and willed the dolphins to come to him. And one did. It dove and swam in flirtatious circles but always came back. Their eyes locked again and again. It was love, at least for Clem. He had always adored the water and had briefly been on the swimming team

at Syracuse University, until his ears acted up and he got too busy being highbrow. He had told me that if he could be born as anything else on earth, it would be a dolphin.

In South Carolina we looked up Jasper Johns, who spent part of his time on Edisto Island, outside Charleston. We hung out that day and evening. Clem liked Jasper; I did, too. Besides Jasper's niceness, there was a bond because of their Southernness. About that Southernness, some of the Greenbergs had originally settled in the Norfolk area. Clem would visit them often, spending a month, even a year, there as a child. A keen ear could still pick up a slight accent—words with soft endings, his *g*'s elided altogether. I adored that softness. Yet when I noted that we had spent a day revisiting certain streets familiar to him in Portsmouth and Norfolk, I recalled nothing. It saddened me because he talked so little about his childhood, and I had missed that opportunity. Perhaps I was too distracted by navigating the streets—city driving having been my bête noire since Europe—or perhaps my mind was in New York, and *please, please, let us get there soon.* And indeed, once we abandoned the byways we were home in a blink.

Back to the parties, the apartment we loved, the sadness of Franz Kline's funeral, and my analyst. I quickly fell into the twice-a-week routine of walking to that brownstone on West Ninetieth near Riverside. The room was in the back on the ground floor, dark and quiet, made more so by my depression. Once I had prattled off the anecdotal highlights of my history, what was there to say? He resolutely probed: Did I possibly, just possibly, now, or at any other time in my life, have any interest in pursuing any activity or endeavor known to mankind? Every second week or so I would fork up some desultory morsel, lest he throw me out on my ear as a hopeless case. "Maybe I could learn to cook," or "I suppose I might finally learn French." But usually I would shrug, and he would talk about the cause and effect of depression. Me, I called it living under water. I had noticed that in that room I would lapse into a monotone, barely audible, my words furry. My ears would stop up, my pulse would slow. He talked about catatonia.

One day I sent him a coded message, a dream. Even better, a recurrent dream. There is a big party. It has started without me. The space is like

a ballroom. The men, there are mostly men, wear dark suits and ties. The women wear black cocktail dresses and pumps. The party is in full swing, noisy, almost raucous. I weave through the people. I know some slightly and nod. I know some well and touch their arms. Mostly they are faces without names. There is one man who appears in every dream, square-jawed, swarthy, heavy-browed, but I don't know his name, or if I ever did. As I move deeper into the room, a litany of names streams though my mind that I desperately try to find matches for, but fail. I keep moving faster. Eyes meet in a flicker; we knock against one another. We are the company we keep, and we are trapped.

I told Sy I always woke up with a start. He called it a sexually based dream. I called it a bad dream. Our codes were different. Then, before he had made a dent in my defenses, or observed a flicker of the much-anticipated transference, along came the next hiatus.

Sam and Jane Kootz offered us their country place in Croton for the month of June while they were in Europe. The house was a modern Shangri-La for two, in the hills north of the reservoir. There was a pool and the use of their white Cadillac convertible with white leather uphol-stery. "Yes, thank you, yes." Only drawback: The Kootzes worshipped perfection. For us, who, if we worshipped anything, worshipped comfort, this would be challenging. There I was, with a sterile castle to tend to, an instruction manual the size of *War and Peace*, and a husband who couldn't care less. Add to that the daunting Kootzes, who sat on my shoulder and watched my every move. Sam was wily. He was the guy who right after the war stormed Picasso's inner sanctum by dint of a white Cadillac convertible as a present. Presto! He struck a deal to sell Picassos in New York, and from those acorns grew a mighty gallery. Collectors didn't stand a chance. Bottom line was: *You want that Picasso? Perhaps you might also consider this Hofmann, Gottlieb, Baziotes, . . .* A win-win for everyone.

Me, I never did crack the ice of Jane and Sam. As genial and hospitable as she could be, as lathered with Southern charm and avuncular as he could be, I always felt a chill and retreated behind my own Bird's Eye brand of politeness.

I quickly trained Clem in the art of using coasters and kept an alert

eye on every falling ash, errant Montblanc, and wet towel from the pool. But it was the houseguests that did me in. A first for me. Lord, breakfast, lunch, and dinner. How did normal women do it? Like a queen, I would set off in my white chariot for the supermarket in Yorktown Heights, load up on ingredients I had copied out of an abstruse cookbook, then return to being Cinderella as I pondered what "separate six eggs" meant, or did "clove of garlic" mean the whole thing or just one of those bits inside? For once, Clem was as stupid as I was. My biggest disasters were coq au vin and zabaglione, Clem's favorite. That month put an end to any lingering thought I might have had that cooking anything whatsoever might be enjoyable. Fortunately, most of those weekenders drank like fish and would have settled for dog food. Well, except for the gluttonous Bill Rubin.

The best part was when it was just us. Swimming naked, hanging out at the pool, reading, Clem writing. By the end of our stay Clem had, for the first and only time, grown a full beard and I was pregnant, probably about forty-eight hours' worth. Like the good girl I was, I had waited exactly six months, and bam, there by the pool, two tanned, healthy people created our daughter. This time, there would be no "Do you want to keep it?" questions. No second-guessing. As simple as that.

We must have passed the Kootz test, because a couple of years later, when they pulled up stakes and bought one of those huge piles on Lily Pond Lane in East Hampton, they offered us that Croton house for what Sam called a "basement price" of $100,000. "Thank you, but no." No hesitation. We already were where we needed and wanted to be. Besides, there were three too many zeros in Sam's basement price; $220 a month rent on Central Park West was already stretching our financial imagination.

The Kootz break would be followed by yet another driving trek to Emma Lake in Saskatchewan, where Clem had been invited to lead a two-week artists' workshop. Our trip would extend, as our trips had a way of doing—to a log cabin in the sparsely settled northern reaches of the province, and far enough west for us to hold hands across the line of the Continental Divide between Alberta and British Columbia. We would walk on a glacier and attempt to water-ski, and Clem made a

rare purchase in Calgary—he hated to buy anything—of a pair of brown suede shoes. And I stood alone at dawn by the pale celadon water of Lake Louise, the mist billowing around my legs, and felt blessed.

On our way home, we were in Ottawa, where Clem was giving a talk at the National Gallery, when we heard of Morris Louis's death. He was fifty-nine. He had always seemed old to me, a spare man, dry, with a grayness about him. In our living room he would take up no air, no space, and he would leave no trace of himself, no conversation, not even a dent in the cushion. I never considered any of the artists I knew a happy bunch, but Morris was downright sad. Maybe because, unlike others, he didn't have any passions on the side. Adolph had sailing, Ken had his "toys" and/or women, Jackson and Franz had their drinking, and Barney had the sound of his own voice. But Morris, as if he'd been zapped at birth, was the most dedicated artist I ever knew.

Holed up in his small dining room/studio in the suburbs of Washington, D.C., he was a nine-to-five artist, his workday sacrosanct. He came to New York only once or twice a year, despite Clem's urging that he needed to see what other artists were up to. Grudgingly he would take the train up, check into the Statler Hotel across from Penn Station—he claimed that only the Statler had a mattress firm enough for his back—come up to our place for dinner, make the rounds of the galleries and museums the next day, and go home that night. And who but Morris would casually mention on one of these visits that Dorothy Miller had recently phoned him, she who was Alfred Barr's eyes and ears for the Museum of Modern Art, the diva doyenne whose attention could mean so much to a struggling, unrecognized artist? She had told him she was heading back to New York but would like to stop by and see his work before she left. And who but Morris would have replied, "It's not convenient—I'm working"? He would make it into the pantheon of American artists doing it his way. But not in his lifetime.

And then it was fall and our routine resumed, along with my analysis and expanding waistline. This time I didn't bloom with baby rapture. I was too apprehensive of what lay ahead to even acknowledge the presence of anything that could be snatched away in the flash of a second. Sy kept me as connected as I could be to the pregnancy, and sometimes

sessions turned to the larger matters of jump-starting my life, but for the most part we gentled through the flotsam of day-to-day feelings and moods and "he saids" and "I saids," with the occasional dip into our past and its mossy layers of angers and resentments.

Toward the end of March, Clem grabbed the camera and coerced me across the street into the park. He wanted a picture of very pregnant me. I dutifully turned sideways. He clicked, I smiled. I thought of myself and the elephant in Florida, except this time, sausaged into my winter coat with curly black hair all over it, I was the beast—more like a woolly mammoth. I raged. Not about the way I looked—I raged against everything about that moment, especially Clem's blithe assumption that everything would be just fine. I posed, he clicked. "One more, just in case." *In case what?* I didn't say. *You think I want a picture in case this thing comes out dead?!*

Oh, it wasn't easy being eight months pregnant and pretending nothing was going on, but that was how I was playing it. No plans, no hashing out names, and no preparations. Anyway, wasn't everything stored in the basement, "just in case"?

On April 16, two weeks past my due date, Clem, with his unnerving prescience, brought the bassinette and paraphernalia upstairs, before going to meet Ken Noland at the Guggenheim. Around four o'clock, my back started hurting and by five o'clock, when they came home, Ken pronounced me in labor. With three kids, he was a pro. The pain wasn't much, and the doctor told Clem to come to the hospital in an hour or so. I was surprisingly calm as I sat with Ken at the foot of the bed playing chess, just as we did when we visited him at his house in Vermont. Dear friend—I blessed him, as usual, for putting up with my amateur moves. When it was time, I felt as if I were going to a party, as Ken slowly drove us to the hospital in his open car through the soft April evening.

By midnight, she sat on my stomach like a white moon. Shiny, round, sublime. I breathed through the fire of what they were doing down there to repair her rite of passage. My heat cooled in the placid blue pools of her eyes. She healed me. I knew I would follow her anywhere. How did I get so smart? The next morning, we named her Sarah because we liked

it, and Clem added Dora, the name of his mother, who died when he was sixteen. Sarah Dora Greenberg, as sweet on the tongue as *Islamorada.*

Our first months with Sarah were wonderfully bumbling and happy. For the first time Clem and I were a team, both starting at zero. We quickly learned her language, vocal and physical. Mind reading was another skill we tried to master, Clem tending to the more obvious interpretations, I tending to the more subtle. Sarah was patient and a great teacher. When we were on the wrong track, she promptly steered us back on course. Clem took great pride in his diapering expertise, especially after I discovered the cloth diapers with snaps at Bloomingdale's that eliminated his fear of impaling her with pins.

Clem was also most often in charge of her daily outings, to Barney Greengrass, the bank, the park, she in her carriage, he reading. Proximity was the key. During the day or in the late afternoon, when the visitors would stream through, wherever we were, there she was in her carrier. "She doesn't want to miss anything," the chief mind reader would say. From day one her father had bestowed upon her his highest praise when he had pronounced her "at home in the world." Sitting in the office feeding her at four in the morning, watching for the first glimmers of dawn, I experienced a peacefulness such as I had never known. *How fortunate to have parents like us,* I thought. And she repaid us in kind by slipping gracefully into our lives with a contented smile.

Sy proved to be a wise and skillful analyst. Over the years he provided me with basic parenting tools; he reminded me that I was the grown-up, that a screaming child was a terrified child, to always pick my battles carefully, that there were no winners and losers between her and me, and so much more. Equally important, he doubled his efforts to help me see that I could be a wife, a mother, and also have a life on my own terms. Virginia Woolf knew about the importance of having a room of one's own. And, to my amazement, at twenty-nine I discovered I could have a life of my own, something I had never dared imagine, much less yearned for. Within a year after Sarah joined us, I found myself in the basement of the YMHA on Lexington Avenue and Ninety-second Street.

It is a lackluster room with a raised platform at one end, on which

stands a short, dark-haired woman with a gruff manner and voice to match. This is Ethel Stevens, who gives me, and fifteen or so men and women, a quick run-down of some basic acting exercises and what we will be doing the next few months. I am the baby in the room; everyone else is at least in their forties, on up to doddering. They seem to be old hands at this stuff.

After more than a year of push and pull with Sy, I had finally admitted that at one time I might possibly have been interested in the theater. I told him about my summer at age fifteen at a theater camp, where I was too tall, too awkward, too self-conscious to be cast in anything. Nonetheless, I had the best time of my life. And about having been shot down later by my Bennington counselor, Howard Nemerov, when I whispered that I might like to take a theater class. "Too low-brow, a waste of time," he growled. He was a growler. I blushed in shame and buried the notion. To Sy, who looked like he had swallowed a damn canary, I quickly tried to cover my tracks by adding to my theater camp list of inadequacies, "I'm too old."

Ethel asks everyone to say who they are and why they are here. *Okay, I can do that, I know how to lie.* Funny thing: When I open my mouth, the name that pops out is Jenny Van Horne. That throws me and I fumble around, trying to take it back by saying my real name is Jenny Greenberg, as if I'm either a blithering moron or some sort of self-hating Jew disguised as a shiksa. Blood in my head, sweating—and I am famous for never sweating—I mutter something about wanting to learn how to act. I curse Sy's smug face.

Ethel next asks us, two by two, to do an improvisation where one person wants something and the other is opposed. Big problem—*wanting* is a word I don't recognize, and *confronting*? Well, I'd as soon jump off a roof. My partner is a beautiful, confident older woman who looks like confrontation is her middle name and she has gotten everything she has ever wanted. When it is our turn, all I can think about are her high heels, gold bangles, and January tan, versus my loafers, sweaty wool, and ponytail. We begin: She wants, I apologetically resist, she overcomes. Over and out.

For the finale, Ethel asks each of us to go to the platform and tell about

a meaningful moment. My lights go out. The old men tell funny stories to make us laugh; the women tell about children and grandchildren. I'm still brain-dead when I get up there, but then, from somewhere, out pours the story of the baby that died. Not a tear, not a quaver, just that catatonic voice, like at Sy's. I'm thinking, *Some fucking actress, I can't even cry.* Then something else happens: For a second, I actually raise my eyes from my feet and see the people in those folding chairs, I actually hear my voice. I am speaking and they are listening. I sit down and my body tingles to my toes. I actually have a body. I am awake. Whatever happened, I want more and more and more of it.

That November Helen Frankenthaler and I had lunch at a plush East Side restaurant, Helen-style. A few years after Clem and I married, Helen had married Bob Motherwell, a nice man, someone I had always liked. Over the years Helen and I had become friends, occasional friends, but friends nonetheless. And there had been many parties, with no tears in the bathroom. I discovered that Helen and I had something besides Clem in common; we found the same things riotously funny. That day, after gossiping and laughing our way through lunch, the headwaiter came to the table with the news that the President had been shot. In shock, we went back to her house nearby and watched television and drank brandy. I called Clem, who had already heard the news, and told him I would be home soon. Helen and I sat until the living room was dark. There would be flurries between us over the next decades, missteps—some mine, some hers—and long interruptions now and then, but I had bonded with Helen that day, and remained so.

That fall was the occasion of a lighter, and also memorable, moment when Diana Vreeland, editor of *Vogue*, swept through our apartment the day the magazine was taking photos for a feature about living with art. She was dismayed at the evidence here and there of a baby living on the premises and ordered them removed posthaste. Sarah, six months old, was at the baby sitter's for the day, or I am sure she would have been put in a closet along with the diaper pail.

"Children are tacky," Vreeland proclaimed with an imperious wave of her hand as she swanned out. Oh, Diana, you were marvelously

something, marvelously beyond words. Her minions tried valiantly to spruce up the place with flowers and clever lighting, but the art would have to carry the day. I hated to think what Diana would have said if she had walked into the apartment before the influx of furniture from my grandmother and Altmans.

Clem wrote a short text, but the feature was largely pictorial and went on for pages. On the opening spread was a small, stylized photograph of us. Clem was full face; I was in profile. Not my finest angle. I look dark and severe, one of those *is that really me?* photos. Nonetheless, it is a rare shot of us where I am in the foreground. Who would've thought?

Not long after, I sat across from Diva Vreeland at a dinner party at Helen and Bob's. Riding on some cloud of self-importance and gin, I suggested that her *Vogue* column, "What People Are Talking About," bore no semblance to what the people I knew talked about. Quite a conversation stopper. Maybe it was tit-for-tat for "tacky," but it was certainly rude. And, not for the first time, Bob stepped in with his soft-spoken aplomb and smoothed the waters for me.

If I was becoming a bit cocky, it was because I was off and running. As I turned thirty, Sarah turned one. That summer, as I took my first steps, she took her first steps up at Ken's new place in South Shaftsbury, Vermont, which would become our home away from home. Any fears I'd had about dripping my depression over her as she lay in her crib had evaporated. At the end of the term at the Y, Ethel put on a production of *The Crucible*. I played one of the righteous crones of Salem, out for blood. My debut, and it could only go up from there. But I was proud and I guess Clem was, too, because he and a gaggle of our art buddies came to opening night and were polite enough to sit through it.

The fall of 1964 I took my next step and moved on from the Y to HB Studio on Bank Street, right down the block from where I had begun my life with Clem. There, during the next three years, in the class rooms of Alice Spivak, Bill Hickey, and Steve Strimpel, I worked, learned, and gathered around me a gang of actors to hang out with, my first new friends since college. HB was like a clubhouse, and later, as we moved into the real world of theater, we opened doors for each other. The whole idea that one step could lead to the next was a new concept. Clem's world was

Clem's world, where no door had ever opened to me. And why should it have? But now, the playing field was level, and it was so easy.

A few months after starting at HB, I went to my first audition, at a church on West Seventy-ninth Street. *The Red Badge of Courage* had an all-male cast, plus two token parts for women. They chose me. Okay, so it was for the mother's part, but they chose me. No dressing room, no backstage, needless to say, no money, and, most problematic, no heat. For performances I would dress in the bathroom, then dash to my position behind an upstage curtain, where I would sit on the floor under a bank of drafty windows, waiting for my two one-minute scenes with my soldier son. After shivering through the opening—I had now wised up and invited no one—for the rest of the short run, I huddled in my grandmother's fur coat, slugging down Calvados out of a flask I had splurged on at Dunhill's. Not the Bowery-bum rotgut, but the French Napoleon kind someone had given Clem, the kind that kept my home fires burning while the clashing, blood, and gore of the Civil War spilled across the church altar a few feet away.

What an extraordinary decade to be in New York and in the theater. It wasn't about Broadway anymore: theater was happening uptown, downtown, East Side, West Side; anywhere there was a loft, industrial space, church, storefront, café; anywhere there were a few chairs and a few bucks to pay the light bill. And it all fell under the new catchall of off-off-Broadway. At St. Mark's Church in the East Village, in a protest play by Sam Shepard, I writhed on the floor in the finale as smoke was pumped into the dark space, sending the audience groping in panic for the exit while we held our collective breath and our eyes teared.

Early on, I fell in with a few directors who thought I was God's gift and cast me in everything they did. June Rovenger was the first. Her space, Second Story, was on Seventh Avenue and Twenty-third Street. There, over a bodega, I painted myself green and wailed in widows' weeds for the war dead. Always the Vietnam War nipping at theater's heels. It didn't do a lot for the quality of theater, but it fueled the energy. From there, I was off to postrevolution Russia and a titled young woman who went from posh to politics in a play called *Marya*. June was a pushover for casts of thousands who invariably outnumbered the audience. But no

matter, most nights we ended up swilling tequila at El Quijote under the Chelsea Hotel and telling each other how great we were. Then again for June, an Ann Jellicoe play, *The Sport of My Mad Mother.* I bought two mangy red wigs at Woolworth's and, plastered with white powder and with kohl-rimmed eyes and mostly bare skin, I gave my all as a violent-but-nurturing leader of a London street gang and gave birth onstage.

Clem certainly didn't come to see every play I did; as with all things, he was discriminating. But when he did come, I had trepidations—on the one hand, about what he would think of the play, because, again, as with all things, Clem told it like it was and I wasn't sure I wanted to hear all that. Not that he was ever disparaging about my work. On the contrary, he was happy I had found something I enjoyed so much. But whatever he said, even if it was about the direction or the play itself, I would manage to take it personally. My other concern was that Clem might want to stick around and hang out afterward. At least in the beginning, needing to keep my two lives separate, I guarded my anonymity, my privacy. I wasn't ready to share my fun with Clem. In the natural course of things, that would change as I opened Central Park West to rehearsals and parties where our friends mingled.

So many plays in so many places. One month, a bride run amok in the newly opened Lincoln Center Library Theater, followed by a production of *R.U.R.* at a derelict factory space on Great Jones Street, so decrepit that an actor's leg went through the floor and the show continued. At Caffe Cino, I did a one-act, boy-meets-girl play that was so bad the audience never stopped slugging caffeine and talking.

I had a brief encounter with Joe Chaikin's Open Theater. His ensemble company was at the cutting edge of the growing segment of theater that was moving toward group-created works. My stay was brief because the work was so antiwar-focused that marching around town in protest became part of the communal agenda. Acting was acting and agitprop was agitprop, and I knew which came first for me. Of course, there was more to it than that. I had been initially drawn to the seductive "family" aura of the company. Also seductive: We would be participants in creating our text. Yet there again, I resisted. Acting was still too new and thrilling for me to put text and character work aside. But the real

deal-breaker was that working with any ensemble required a sustained, intense commitment. Too much, when my first commitment was to Clem and Sarah. Besides, I thrived on the variety of new plays, new parts, and new people.

Like Arthur Sherman, another director who took me on when I auditioned for a production at the New Dramatists, a first-class operation dedicated to the development of new plays. I had shown up in a pair of brown-and-white-checked pants. Really disgusting, but he flipped, kept muttering about "legs that never stopped." But the part of a yenta from Brooklyn? "You'll be fine," he assured. "You'll do it in pink plastic rollers." The big theater was jammed, the production a disaster, but the actors had a ball. I worked with Artie again, with equally dim results.

Again at New Dramatists, I did a Richard Foreman ensemble piece, a rat-a-tat dialogue of gibberish wherein actors had to rely on cues memorized by sound and brute luck, and one miscue was like causing a pileup on a highway. The friends I made at New Dramatists were older, more experienced actors. They were also my first connection to Lee Strasberg and the Actors Studio, a connection that would eventually lead me in more new directions.

Meanwhile, performances, rehearsals, classes, and home life all required an intricate schedule and a lot of hustling from one part of the city to another. To ease the crunch, in the fall of 1964, the year the Mustang debuted, we bought our first car. For once, Clem participated. Of course it had to be a convertible, but the color? At the dealership we were taken to an upper level the size of Grand Central, filled with a rainbow of cars, unprecedented at that time, when black, white, and gray ruled. An intoxicating palette for Clem. As I veered toward the blues, Clem stood apart and deliberated, his eye intently scanning tone after tone, until, with absolute surety, he moved to a green car. A medium green tinged with gray, and a dash of yellow, with an innovative metallic sheen that promised to glisten in the sun. Hands down, it was "the" color. Years later I passed some small bronzes at the Met and stopped. Their rich patina, that was it—that was the color.

The Mustang was the first car either of us had ever owned. And oh, my first day in that car. The top down, my hair streaming, Columbus Circle,

and the guy leaning out of his window whistling and yelling, "Mustang Sally." I had started to let my hair grow long—me and the rest of the world—and I highlighted it to look like a tawny mane, or so I liked to think. I had slowly begun to like the way I looked. It may have been a wonderful decade for theater. It was also a wonderful decade to learn to love oneself in.

Setting the pace those years was the Pied Piper throb of rock and roll. On the radio, on the street, in cars and bars and clubs, the city breathed it in, moved faster, and lightened up. Gone was Clem's old record player; we bought a stereo and our first LPs, the Beatles, of course. The night of their first appearance on *The Ed Sullivan Show*, we were at a party at Alex and Tatiana Liberman's to celebrate the invasion of the new cultural phenomenon. TVs had been set up throughout the townhouse, lest any of the polished, perfumed, boozed-up East Side crowd miss the band's debut.

How a few minutes on television could become a "where were you when . . . " moment always amazed me, but since the assassination, that was the way it was. Clem and I may not have grasped that we were hearing the anthems of music's future as we swayed and sloshed martinis to "I Want to Hold Your Hand," "She Loves You," et al., but that night we knew we had heard something new, and we knew we were hooked. It was as if we had been waiting for the galvanizing energy of those cocky boys with their hammering beat.

No more hunching over bars, no more jazz. Dancing was all. Most late nights on the town Clem and I ended up at the Dom on St. Mark's Place. One of the first incarnations of the disco, the Dom was improbably situated in the basement of the erstwhile Polish National Hall. In that sweaty, steamy, smoky, low-ceilinged dance dive that never stopped smelling like the basement it was and that made the old Cedar look like a palace, we would hook up with fellow rock-addict regulars to gyrate the night away. In awe of the black dancers there, Clem soon eased off the gyrating and devoted himself to perfecting "cool." He would barely move; all it took was a twitch this way or that as he worked his way through the Twist, the Mashed Potato, the Swim, the Frug, whatever.

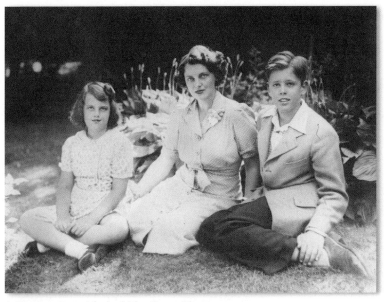

A single mom with the kids, Green Haven, 1941.

Left: With my father,
Green Haven, 1938.

Below: A Bennington
sophomore, 1952.

Jackson Pollock memorial show at MoMA, 1956.

Our first photo,
1955.

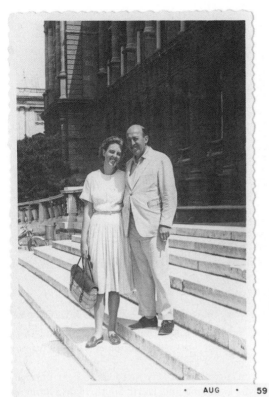

Left: The Kunsthistoriches, Vienna, 1959.

Below: Stonehenge, 1959.

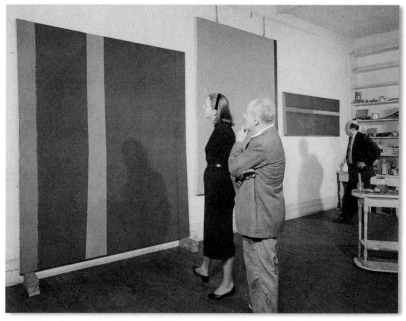

The afternoon at Barnett Newman's studio (Barney in foreground), 1957.
(Photograph by William Vandivert)

Provincetown Labor Day, 1959, (L-R) Fritz Bultman,
Miz Hofmann, me, David Smith, Hans Hofmann.

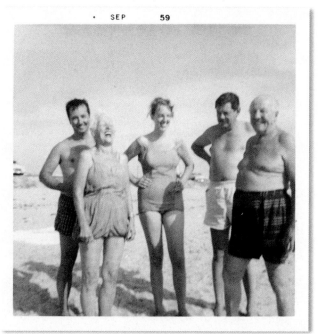

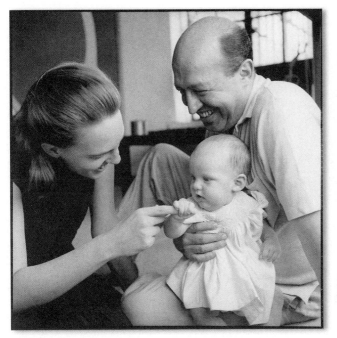

New family, 1963.
(Photograph by Cora Kelley Ward, courtesy of her estate)

On the town with (L-R) Everett Ellin, Karen Rubin, Ken Noland,
Morris Louis, 1961.

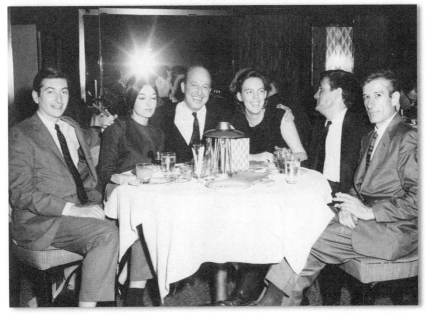

A brief encounter, Florida, 1962.

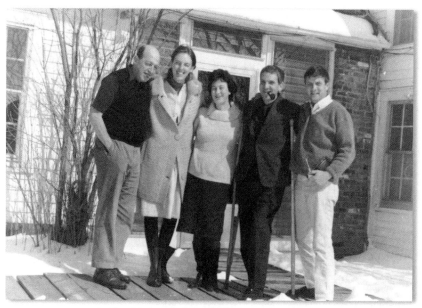

At Ken Noland's farm in Vermont, our home away from home.
With Sheila and Tony Caro, and Ken, 1964. (© Barford Sculptures Ltd.)

Our living room at "275" in *Vogue*, 1964. (Photograph by Hans Namuth, Courtesy Center for Creative Photography, University of Arizona, © 1991 Hans Namuth estate)

A family jaunt to Paradise Island, with Stephanie Noland, 1968.

Above: At opening of Pollock
Retrospective at MoMA, 1967, in
dress by my friend Susanne Moss.
(Photograph by Dan Budnik)

Right: Family outing, 1967.
(Photograph by Esther Brown)

Right: An unwelcome bride in "The Wedding," 1964.

Below: Wearing green paint and widow's weeds for an anti-war play, 1965.
(Photograph by Steve Ruttenberg)

Above: "Under Milk Wood," 1966.

Right: Vera in "Pal Joey," Woodstock Summer Theater, 1969.
(Photograph by William B. Emmons, III)

Mom and daughter backstage at "Troilus and Cressida," 1971.

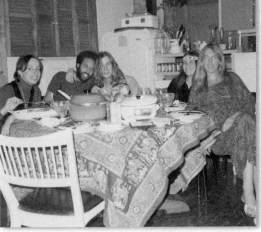

Right: Potluck at loft, (L-R) Beverly Magid, (center) Mark Turnbull, two friends, and me, 1970.

Below: Earlville Opera House "Hernani" rehearsal, Albert Takazauckas at right, 1972. (Photograph by Cora Kelley)

The editor-in-chief of *Madison Avenue Magazine* gets an office of her own, 1974.

With Charlie Mandel, publisher of *Madison Avenue Magazine*, 1975.
(Photograph by Lee Marshall)

"Yet another man's world," ad execs assemble for a *Madison Avenue Magazine* cover, 1978. (Courtesy of Wagner International Photos)

Left: Goodbye Daddy, 1979.

Below: Christmas at "257," 1980. (Photograph by Cora Kelley Ward, courtesy of her estate

Norwich summer, 1981.

"Fine Line," Ensemble Studio Theater, Roxanne Hart, Harris Yulin (director), Jill Eikenberry, and me (the budding playwright), 1984.

In L.A. with Russ Smith, 1982.

The playwright poses for an L.A. production, 1989.

The "kids" revisit Green Haven, 1996.

Above: Our last photo, outside the Pollock house, 1992.
(Photograph by Elaine Grove)

Just a twitch. Me, I was feeling too good to be "cool." I discovered my hips—hell, my whole body. Sadly, the days of the Dom were numbered. Two years later Warhol's Electric Circus opened in the soaring main space of the building, a place where the maestro's extravaganza of pink-strobe, gay, high glitz reigned in the center ring and where dancing was relegated to a sideshow. The disco era was spawning. The Dom whimpered away, leaving the basement to its silence.

The Cedar Bar had also whimpered away. Until the early sixties, people had continued to trek to the Cedar in hopes of seeing the art stars, to hang out where it was happening. Of course, most things had already happened. There would be no more slugging it out between the Pollock and De Kooning camps or about who had fucked who the night before. Age had rolled in and the first-generation "boys" were getting richer and had moved on to great airplane hangar studios in the hills or at the shore, out there somewhere. The up-and-comers found new places to hang out. After the Cedar closed, it was Dillons and then Max's Kansas City, which opened in 1965. But it was different. Max's was huge. It had to be—the art scene had mushroomed into an art world, and up front, five deep along the bar, the artists blew their horns even louder, while having less to toot about. And now no one listened anyway, except maybe the girls, always the girls.

And in the back room at Max's, again jammed into booths, bathed in the fluorescent pall of Dan Flavin's decor, which made us all look like we had just puked, the free-and-easy give-and-take had been replaced by hard-edged wariness. The stakes had gone up; art was changing fast. "What's in, what's out?" "Who do you know?" "How much did you get?" replaced the small-town jibes, the macho who's-fucking-who bravado, and the angst about the day-to-day making of art. The pop-art guys had moved in and merged uptown and downtown, with their zest for high life. Posh was in, and disco and spectacle, making the first and second generations seem staid. The media was courted, not scorned. The new art was sexy. Drugs over booze. Tinsel and high fashion. A far cry from the twenty-four-hour, nickel-and-dime Automat on Eighth Street, the artists' home away from home, where it had all begun in the

thirties and forties. Max's was a sandbox for perpetual children. Bitch and camp. For me, Max's made even the old Cedar smell like a rose. At least it had been real.

Now that we had a car, getaways became more frequent. Most often we headed up to Ken's farmhouse in South Shaftsbury. We had been friends for years, and our bond with Ken had grown even stronger after he had moved to New York and then to Vermont. Though the house was only a short distance from Bennington, Ken never taught at the college. He had chosen the area because his Reichian therapist had deemed it as having the purest air quality in New England. Now, the house, replete with a Reichian orgone box, nestled on the side of a slope at the end of a long dirt driveway. Ken had bought it from the Robert Frost family. It had been Frost who had named it the Gulley, and liked to call it his Gulley Gulch. And, yes, there were groves of birches on the hill out back. Dating from the 1780s, it was very small, one floor and an attic, with slanting wide plank floors, low ceilings, heating that was catch as catch can . . . in other words, rustic and charming. Behind the house was a large barn that Ken had converted into a studio. His "targets" had established him as a major art player. Always a master of color, he was now on a creative roll, painting a river of breathtakingly beautiful pictures. As for the air quality, Ken installed a contraption to measure the ion level on top of the hill, just to be sure he was where he was meant to be. Not that there was really any question.

In the beginning, visitors were mostly close friends, like David Smith, who would drive over from Bolton Landing and Ken's family, but by 1964 the place was jumping. Ken married Stephanie Gordon, recently graduated from Sarah Lawrence, and it was she who brought decor and creature comforts to the Gulley: a finished attic with two more bedrooms, two more bathrooms, and a swimming pool behind the barn.

That year also brought Jules and Andy Olitski, and daughters Eve and Lauren, to Bennington. Also joining the faculty was Tony Caro, the sculptor we had met in London in 1959, his wife, Sheila, and their two boys, Timothy and Paul. It always felt like there was a crowd at Ken's place. If Clem was the New York magnet for visitors from abroad, Ken's place

was the go-to destination out of town. As tiny as the Gulley was, there was always room for one more. And Ken was the ringmaster and game player: cards, backgammon, chess, charades . . . one could always find a game in progress. And invariably a new toy: exotic foreign cars, like his Lotus, which hadn't imported well and sat like decorative sculptures next to the barn; a tractor to roam the fields in; motorbikes; trout for the stream he had dredged, and fishing rods to catch them. Summers by the pool where Sarah, guided by Stephanie, learned to swim and where Clem cavorted like the dolphin he was. And watching Sarah, an only child who had discovered heaven, toddling stalwartly after Bill and Cady Noland, so tantalizing with their mysterious games and languages, while Lyn, being older, preferred the company of adults. And at night, dancing in the barn, Clem and I demonstrating the latest craze at the Dom. Stephanie, the beautiful star.

For me, the nucleus in the mid-sixties was Ken, Tony, Jules, and their wives. That was where the best laughter and friendships were forged. Best of all, they were young, all in their late thirties or early forties. It may have been an art scene, but for once it was a family scene. Who would've thought that just as I was discovering an extended family in the theater, I would find another where I had least expected to? I shouldn't have been surprised. Having plunged into my own life, artists and their art talk weren't as hard to take anymore.

And what about all that sex? It was the sixties. Sex was everywhere, as if it had just been invented. I don't know who jumped first. Well, that's not altogether true. It was Clem who did, but, as shocking as the news was, I so effectively reduced the incident to a non-event that I never did give it much importance. He had taken up with a woman in Los Angeles while on a lecture trip, and there were letters back and forth. That was probably in 1960, right before we moved uptown.

He had mentioned it as casually as he would mention that someone was dropping by for a drink. I was stunned; I hadn't seen it coming. Five years had passed since his talk of "open marriage," a phrase that had faded from my mind. After all, this was the man I called "husband," he would never . . . I could say that I had felt a sickening emptiness as I tried

to suck in everything left in my suddenly diminished world. That I had closed my doors, shut the bolts, and hunkered down, my knees clutched to my chest against the pain of irretrievable loss. I could say that even as I had drawn down the shades of my heart, I knew the worst: This was the start of an altered life and a long journey.

I don't know if I actually thought and did those things. I probably did. I do know that before Clem stopped speaking, I screamed, cried, slammed our door—we had only one—beat his desk with my fists, and hammered him with, "How dare you . . . !" If you loved me, you'd never . . . !" "I hate you, I hate you . . . !" And called him every *bastard, scumbag, dickshit* word in my lexicon.

It was only then, drained of my fervor, that I took to our bedroom cave and began the slow, methodical process of burying the pain. As a child, I had learned how to soothe myself when socked with something too fearful to think about. Now, once again, I shut my eyes and crept under a blanket of darkness until my body was numb and my mind was a blank. After all, California was a long way off. And hadn't Clem, who had been stunned by my fury, assured me that it had nothing to do with "us" or his feelings for me, that I would always be "the most important person" in his life? And I asked myself, *Can I ever have sex with him again? Do I want to be with this man, stay married to him?* And I knew that I could and that I did. And I also knew that if I didn't pick at it, the scar tissue would gradually scab over and mask the wound.

After a few weeks, there was no overt rift between us. And soon it didn't seem to matter at all, as the thrill of our new apartment and the tragedy of our baby's death pushed it off the front page of our lives.

But as things happen, it was just a matter of time—three years in fact—until the next shoe would drop. Sarah was crowing robustly in her highchair, her face smeared with yogurt and spinach, two of her favorite things, when Clem once again casually mentioned that he had had a fling with a woman in Paris. This time I did not slam doors; I walked through the doors of the YMHA. A late bloomer, I had opened up my life.

What happened next had *inevitability* written all over it. It was almost as if sex were an obligation, something I was supposed to experience now that I was growing up. After all, Clem had set up our marital parameters

from day one, and my analyst was certainly encouraging me. So it was, that, while looking over my shoulder for anyone who might disapprove and seeing no one who did, except that slice of me that my mother owned, I tiptoed with little grace or ease into my "starter affair."

I look with affection at the girl/woman as she was swept away by that combustible encounter on a Cape Cod beach at sunset, by the thrill of afternoon trysts in the gorgeous painter's Village studio, by the ardor and attention in those dark eyes that looked so deeply into mine. Afterward, on the way home, my thoughts were like a light switch, flipping between the haze of being the object of a man's desire and the surety that he would never want to see me again. I would paw over every detail: *Did I really say that? How could I have been such an idiot?! What did he mean when he said . . . ?*

By the time I got home, I knew I would never call him again. To hell with him. But, of course, I always did. He wouldn't call me. His rule. Besides his being afraid of Clem's finding out, I knew I certainly wasn't his one and only. The secrecy made me squirm. It felt icky. I vowed that never again would I be in a relationship where that was part of the drill. But, ickiness aside, off I would go once a week after my acting class at HB. My starter affair flared hot for a few months, then sputtered on a month or so, until he broke it off. Seemed he had a wedding to go to—his own.

Overall, I was disappointed with my histrionics, which harkened back to the way I had felt about my boyfriend during the last two years of high school—and we hadn't even had sex. As for the starter sex, it was exciting, but there was no screaming, full-out passion. I was far too nervous and self-conscious. The all-seeing artist painted a small portrait of me during those months. In my hair, he had added a small blue bow, an acknowledgment of my "innocence." The picture was destroyed in a fire, but our friendship would survive.

Early on in analysis, I had discovered that I could want something. Now I knew that I wanted to have it all: to be a wife, a mother, an actress, a lover . . . And that this was the start of what would be a long learning curve. Opportunity was all around me. Whatever theater group or production, there was sex—sometimes a real connection, more often a

run-of-the-play deal. Always with no secrets, no lies between Clem and me. It would have been nice if it had been that simple. Sometimes all that free love was fun. Sometimes it didn't feel so free. And often I wished I was twenty-one again and had only one thought: to be married and be Clem's one and only.

I continued to be adrift in ambivalence. On the one hand I felt hesitant, guilty, about intimacy with another man. And on the other hand I talked myself into believing that the intimacy was linked to love, love being the justifying magnet. I was ashamed to think like such a Virgin Bride product of the fifties and my mother's programming. All that "Men only want one thing," and "Never let a man touch you down there—you'll get pregnant." Now I was answering, *But, Ma, what do women want?* and, *Look, Ma, I've got the Pill.*

However I spun it, the reality was that I had somersaulted from the intimacy of love with Clem to the intimacy of casual sex. And if my doubts surfaced, and they often did, I had my analyst to remind me, "No one person can ever be all things to anyone else." I would nod obediently, even as my thoughts mutinied: *But Clem is my husband, part of me; we live life as one, no matter what you yammer on about.* The analyst would go, lovers would come and go, but, despite my seemingly confident, freewheeling ways, my ambivalence lingered.

I would come to accept that for an open marriage to work at all, it would need to be mutual. To my surprise I found that, with the exception of his first dalliance in California, which had blindsided me, I had never felt "betrayed" by Clem. Without the secrets and lies, the suspicions, the sneaking around, the *Aha! I caught you!*, the word simply didn't apply. And without that deal-breaking word, I would be okay, and so would the marriage. As for my ambivalence and guilt, my acceptance told me it was time to let them go, and I did.

However, there was one instance where I found I had limits. Clem's affairs at the time, like mine, were sporadic and fleeting, and I paid them little mind. However, in the mid-sixties, he began a fraught relationship with a woman in Boston that zigzagged for over two years. Difficult for me because of Clem's angst and drama, which, in the name of openness, spilled out onto me, and because I found her to be a "nasty piece of

work"—as my mother might have said—who darted crafty, smug looks at me when our paths would cross. I learned that the openness in an open marriage can go too far.

After a while, to my horror, Clem began to regale me with vivid accounts of the intimate details and progress of the affair. Once again, after much slamming of doors and my yelling at him to shut the hell up, he finally got the point and I set ground rules. Namely: There are some things better kept to yourself; if you need a confidant, go to an analyst; and keep the bitch at a distance. Sheepishly, he agreed on all points, including that she was a bitch.

Fortunately, my own work and fun provided a balance, which would be enhanced when in 1966 I fell for Jimmy, a fellow actor, and started my own two-year relationship. Clem had balance, too. The art world was at full tilt and Clem with it, writing, lecturing, much in demand. So much to do, we both seemed to be always rushing off somewhere.

For me, there was all that, but at the same time I was doing what mothers do, what wives do: I kept the machinery running; took care of Sarah, her social life, her school life—in 1966 she started nursery school at Manhattan Country School; kept the refrigerator stocked with salami and chopped liver, the ice trays filled, the liquor cabinet full; and did the laundry and sock darning in between. And Clem and I still shared a bed— king-size—and still had sex. And the art world didn't stop just because I had stepped back from it. I still joined in during the gatherings at home or going places with Clem. Just not all the time. It was now a matter of choice, that million-dollar panacea that all analysts prescribed.

As for Sy, I was still seeing him twice a week, and would continue until 1968, when I figured I could steer my own ship. How blithe that sounds. It was, in fact, a wrenching split that had been precipitated by my long-term attachment to Jimmy which Sy viewed as just another excursion into "codependence," a propensity he hoped he had "cured" me of. But there would be no negotiation. I was far too happy. So, not with his blessing, I left. It was messy: Sy sounding like an angry papa; me masking my trepidation with cocksure bravado. I was sorry about that final session. It was the only bad mark I would ever give him.

And there was always the balance of the theater. In 1967 a new director

came on the scene, Albert Takazauckas, and I got a chance to mix it up with a lot of first-class material, such as *A Midsummer Night's Dream*, as a Victorian Helena with a Gibson Girl updo romping through the forest of Riverside Church. Finally something more kid-friendly, and Sarah Dora saw her first play. And there was *Under Milk Wood*, with a chance for me to learn a few chords on a guitar and sing for an audience for the first time—a ditty, only so-so, but it rekindled a passion that had been squelched when I was twelve. I had begged for singing lessons, but my mother had said no, that it was silly to think I would ever be a singer. Poor Ma, she never could just spit it out that we couldn't afford lessons. But, as with acting, passions have a way of resurfacing.

While still at HB, I started studying with Graham Bernard, privately and with a group. Twice a week, for years, I experienced the joy of releasing the fullness of my voice for the first time. Some people could scream. I had rarely been able to. But I could sing. And for many years I did, with groups, with teachers, wherever I might be.

If I ever had a niche, it was Chekhov. I rarely auditioned for a Chekhov part I didn't get, especially if it was for Yelena in *Uncle Vanya* or Masha in *Three Sisters*, each of which I played twice. The drifting, vaporing, fires-burning-deep women who always felt on the fringes of life were comfort food for me. Having never figured out what I was supposed to do in the role of Clem's wife, Yelena's line "As for me, I am just a secondary character" said it all. I would deliver it with a touch of bravado, because Yelena wasn't a secondary character at all, and by then I was learning that I wasn't either, to Clem or to myself.

While in Bill Hickey's class at HB, I added another forte when he pegged me as a comedienne who could do anything Ina Claire could do. I'd never heard of her, but for months I played sophisticated "comedy of manners" scenes. They were fun and easy, but I yearned for the smolder. I think Bill just enjoyed seeing the old material from the thirties that few in the mostly hippie-dippie class could, or were willing to, attempt.

Then came a rare moment. Bill was asked to direct a comedy for Broadway called *The 101-Year-Old Woman*. To rehearse it, he cast students and friends. I was to play the title role, of all inanities. Judd Hirsch was in it; he was wonderful. I was predictably dreadful. Bill was in a show

at the time, so rehearsals would start around 11:00 PM at his apartment on Gramercy Park, and sometimes it would be dawn when Judd would drive some of us home. The play did make it to Broadway—of course not with me, but with Zohra Lampert. It lasted a night, and that was that. But Bill felt he owed me, and one day said, "I've got a present for you." The present was Scott Glenn and a steamy scene from Inge's *A Loss of Roses* that ended with a passionate embrace. Happily, Scott and I rehearsed like mad for weeks. Soon after, I felt I had gotten all I could get from HB. I guess Scott agreed. As he moved on to Hollywood fame, the time had come for me to move on up, uptown to Lee Strasberg's Wednesday classes in the Carnegie Hall studio building.

A smallish space, with windows along the side and the ubiquitous platform at the far end. In the center of the front row was the one comfortable chair, Lee Strasberg's throne. Behind him, every seat was filled; there must have been almost a hundred of us, or so it seemed. Until I figured out the drill, I sat toward the back, among the hunky louts who flocked to those classes. The other generic group were the frails: wilting, pale, young women who wept, onstage and off, more fluently than they spoke. Lee's attention hovered over these two groups. It didn't take me long to realize I fit into neither, which probably wouldn't serve me well.

There was a dominatrix monitor who signed you up to do the basic sensory exercises—taste, smell, heat, cold, touch—in a prescribed progression. There would be a group of actors seated across the stage, each working on whatever exercise they had worked up to. To advance from one to the next meant passing through Lee's needle eye of approval. Other exercises, such as taking on the attributes of an animal or singing a song one extended syllable at a time, or the more advanced exercises, such as "private moments" or "affective memory," were usually done alone. The exercises culminated in improvisation and scene work.

During all the work, whether exercises or scenes, Lee would keep up a steady stream of criticism directed at this one or that, probing, demanding a reality that he didn't see, sometimes softly, sometimes heavy as a fist, usually the fist. He would walk up and down the platform, in and around the chairs, lifting an arm here, a leg there, testing for complete relaxation, which was at the heart of all the work. During scenes, Lee's

procedure was the same; he would critique and walk in and out of the scenes at will. Always, tears signaled breakthroughs, as long as they didn't stop the flow of the work. Authentic, real, were his criteria, and not just in regard to inner experience—he had to be able to see it.

I could smell the damn orange until I salivated, but it was never enough for him. If I moved, it wasn't real. If I didn't, he couldn't see what I was sensing. Lose-lose. I became resistant, angry. He pigeonholed me as an uptight girl determined to keep her vulnerability under a slab and he never changed his original take. For my part, I found him off-putting from the moment I introduced myself. Small, a thin mouth, he seemed to be all head, probably because of his eyes, unblinking, sharp as knives, chillingly cold. He could summon a surface charm, but I never bought it. The result: a massive chip on my shoulder that made it impossible for me to yield. Mutual misfits.

Nonetheless, I stayed for almost two years and kept signing up for the work, as slow as my progress was. Because I was receiving self-satisfaction and approbation from the plays I was doing, the experience was marginally sustainable. But the real draw was, the sessions were compelling. At HB I had explored the nuts and bolts of my so-called "emotional and physical instrument" and had absorbed the basic tools I needed to work on scenes and characters. But in Lee's room the air was emotionally charged; he was a loose cannon. With the others, I squirmed and agonized through the gamut of my sensory life. As much as I instinctively balked at Lee's tactics, in my head I acknowledged that his Method, via Stanislavski, worked. After all, it had broken through the prancing and prating of most actors prior to the forties. I wanted to please him, I wanted to defy him. A father to all—to some a good father, to many a tyrant. The only aspect of Lee I enjoyed was when he turned raconteur and wove stories of great performances, from Duse to Bernhardt to Arthur Rubinstein to Laurette Taylor.

I shared his excitement. I wanted to tell him—as if I ever would or could—about election night in 1956, after Clem and I had left a party at the fancy townhouse of the Tom Hesses. As Eisenhower rolled over on Stevenson, we strolled the deserted Upper East Side streets. Lured by the lights of the Versailles, we headed in for a drink. The club was nearly

empty, a piano thrumming aimlessly. Then, no fanfare, on a dark stage, in a small pool of light, a woman began to sing. She didn't move. A white face, black hair, clothes, everything black except for the fire. I couldn't breathe, a chill went through me, I moved inside her voice, her pain, her passion. As tremulous as a leaf, as mighty as a pillar of steel, Edith Piaf seared herself into my memory. Such a brief moment, such a diminutive woman, yet she was one of those rare creatures who could transport. I, who wasn't in awe of much, was in awe of that.

Being around Strasberg, I often thought about star power. How could I not, with the auras of Brando, Newman, Clift, Dean still in the air? There was a quality that allowed a rare few, by virtue of their very presence, to own the spotlight while others fell into shadow. Reflecting on my experience with Piaf, I wondered if it was their innate gift of transparency that allowed us to see into them and project ourselves onto them. It couldn't be taught.

And right there in Lee's classroom was another harbinger of the past, Anna Sten. Not that she was a Duse or a Piaf, but she had been touched with a smidgeon of that elusive stardust. She had been a brief candle in the Hollywood firmament of the 1930s, after being imported from Sweden by Samuel Goldwyn and dubbed the New Garbo. She fizzled, but thirty years later, every Wednesday in the Carnegie Building, she glittered again as she sat on the right hand of God in the center of the front row, with her tiny, porcelain perfection, sausaged into tight bright colors, breasts thrusting up and out, skirts shorter than mini, towering stilettos strapped onto teensy feet. Buffed and polished and made up to the nth degree, a cloud of platinum topped her off as she fondled her beribboned toy poodle. A Technicolor baby doll amid the rest of us, dressed down in the manner of the day, I because it felt safer in the city I traveled alone in night and day.

It made me wonder how that delectable Anna morsel got two feet down the street without being gobbled up, poodle and all. One day I followed her for a few blocks just to see. Everyone gawked; the guys nudged each other and hooted. She was infectious. Parading down Seventh Avenue, she radiated good cheer. Accessible and untouchable at the same time. I imagined that Marilyn Monroe exuded that same self-delight. But on

the screen Anna lacked Marilyn's ability to turn herself inside out, an ability that would make Marilyn a legend rather than a dim memory. It always seemed to me that in the process Marilyn had given herself away until the cupboard was bare, a fear that no doubt was at the heart of my own self-protectiveness. Anna may not have amounted to much as an actress, but, along with the rest of us, she was in those classes doing her damnedest to break through, break out of her shell. For that, she deserved her seat at the right hand of God.

And then came the transformative day when Peggy Feury substituted for Lee. I had the good fortune to be scheduled to continue work on a boy-girl bit—one did only small bits for Lee—from the scene on top of the Empire State Building from *The Moon Is Blue*. This was my third stab at it; I had already suffered through Lee's slashing commentary and midscene demands for sensory work and even an on-the-spot private moment. I had frozen, but hell, at least that was "real." Now, after we finished our scene, Peggy critiqued our work and then, to me, added, "Be who you are. Let the beauty of your self and your talent come forward." She saw through me and had called on me to come out and play, assuring me that everything would be fine and it was safe to do that. I realized that I was a fearful person in a profession filled with fearful people who, in order to succeed, had to again and again take that leap of faith.

In the month she taught us, I watched Peggy unlock more doors in actors' creativity than I had seen in all my time with Lee. She mined the gold of the Method and then, with her keen insight, helped actors take that leap. Over the years, it never surprised me when, at award podiums, I would hear our finest actors thank Peggy Feury for their success.

As invariably happened, I had started hanging out with a new gang of people I met in the classes. Thanks to Lee's homophobia, most of the actors spinning in his orbit were straight, which added a bit of spice. The bar of choice was Jimmy Ray's, on Eighth Avenue and Forty-sixth Street. Low-end, with beat-up booths, cadaverous lighting, and cheap booze, it reminded me of my nights at the Cedar Bar, except at Jimmy Ray's the seediness felt like velvet and you could get a decent hamburger and fries. But mostly it was about drinking and gossip and talking shop. Oh, there were other places, like Downey's, a few blocks down the street,

high-end, catering to the older theater crowd, with its expensive food and special booths for special people, signed photos on the walls, and an amazingly long bar where we would sometimes stand, beer in hand, when we felt like a change. And there was the upstart, Joe Allen, which started out low-key but soon took a turn toward classy with reservations and guys in suits. No, Jimmy Ray's was home, where everyone talked to everyone and the only status seating was that the old-time dedicated drinkers claimed the end of the bar nearest the door, with the up-and-comers in the middle, and the big booths jammed with nobodies like me. I remember everyone getting pissed when David Mamet staked out a booth up front as his personal turf. He should have gone around the corner to Joe Allen.

Each place had a defining moment. At Downey's there was a tête-à-tête drink in a booth with a sexy actress who had gone from friend to ex-friend when she had seduced a young actor I was seeing. She was desperate to renew our friendship and explained that she had done it only because she was madly in love with me. I can't imagine how I responded to that, but, as soon as possible, I left her there unrequited. She dumped the guy. Well, so did I, and that was that.

At Joe Allen, a sexual encounter of a different sort. This time, lunch with a man who was a big shot in the Shubert organization. He had seen me in something and said he was interested in having me do a play reading. Both of us plied with martinis, he asked if I had ever been in an empty Broadway house. Dim-witted as a kid from Kansas, probably dimmer, I went with him to the Booth Theater, where he tried to get it on with me in one of the boxes. I started laughing, because all I could think of was my grandmother Betty and the plays she had taken me to at the Booth, the only theater she patronized. "Pretty as a jewel," she would say, gazing through her lorgnette. And she would sit only in box seats: "So much cozier," she would say, meaning she didn't have to hobnob with the hoi polloi.

And Jimmy Ray's? There were many moments, but one stands out. Late one night, on the way to the bathroom, I saw Colleen Dewhurst drinking and eating alone at one of the small tables in the back, where no one ever sat. There she was, icon to us all, slumped over, looking so

ordinary and old. Why was she there? And why alone? Where the hell was hubby George C. Scott? I wanted to see her big square smile and hear her big he-man laugh that could fill Madison Square Garden. But she just sat there, on and on, drinking after the food was gone.

I never did audition for the Actors Studio. Good sense and fear prevailed. Nonetheless, I did sneak through its hallowed doors, thanks to a director I had worked with who was a new member of the directors' unit. I did Alma in the last scene of *Summer and Smoke*, a disastrous choice for our mutual debut. The chutzpah: the director taking on Tennessee Williams, me taking on Geraldine Page. There I was in the vast performance space, decked out in a costume with Barbara Baxley's name tag that I had purloined from the changing room. *Imposter, trespasser,* oozed out of every pore.

During the critique, facing Lee and the inquisition, we got hammered. Where Lee led, the minions followed. Until one lone voice dissented. He begged to disagree, he threw me bouquets, until Lee shut him down with a snide remark about his being on the prowl for his next conquest, thus getting the desired snicker out of the crowd. Me, a femme fatale? I was thrilled. Afterward, the actor-director, Allen Garfield, introduced himself and asked me to be in an original scene he was directing. And so again, one thing led to another, and despite Lee's persistent heavy fist, I did several scenes for Allen and even landed a negligible bit in a large period piece staged at the Studio as a fund-raiser.

After a while, I was allowed to audit sessions in the acting unit, but the sameness soon palled, despite the luster of an occasional star turn. I think my finale was the afternoon Elaine Stritch, slurry and plastered, attempted a scene, failed to remember a word of it, and cursed and staggered until she collapsed. What sickened me was Lee's coddling and encouragement of her self-indulgence, and the roars of delight from her fellow actors. Oh, she needed help, all right, but not that kind of help. I knew I had had my fill of Lee's frails and hunks.

Sometime during those heady years of self-discovery and fulfillment, perhaps 1968, I realized that I had nothing to say to my mother. Conversation, like a reservoir in a drought, had slowly dried up. The supply had never been rich or abundant, but now the last drop had been drained.

I don't remember the date when I cut her out of my life. It took only a moment, though it had taken, no doubt, a lifetime to bring about.

Phone calls. Often. Not daily, but too often. Sweetness and light as she valiantly filled the air with tidbits of daily life. The latest outrageous high jinks of her sister, Elfrida; she always chose to forget that I had been banished by my anti-Semitic aunt and had had no contact with her for years. Next, the latest atrocity of her beagle, Beau, a snarling creature who had no use for humanity and who turned vicious around men. I think my mother was pleased by this, having never been able to vent her own resentments against the male species. Her desultory conversation would bottom out with her account of the latest shocker from her soap opera; she always referred to *As the World Turns* as "my soap opera."

Afraid of contamination, I would hold the phone at some distance. And then into the vacuum, the dread, "And what are you . . . and Clem . . . and Sarah . . . doing tonight?"

"Nothing much."

"How is your acting going?" (I heard "your hobby.") "Any exciting parties?"

"Just the usual."

Twelve years old, I would wall up, douse my inner lights, and wait for her to say good-bye.

Those conversations became more and more unmanageable. Each time we labored through the same tired routine. Each time I hated the adolescent in me who was so quick to surface and so difficult to put back into her box. Most of all, I hated the dead, withholding part of myself that made me crawl with shame and guilt. Oh, that *As the World Turns*, a potent guilt trigger, ever reminding me that my mother's world was turning slower as mine accelerated. Each time, between picking up the phone and clicking off, I would careen between the past and the present. I still remembered all too well what it was like to live between two realities. As an adolescent I had my world, and then there was "home," no world at all. I was sick of that. I had my own home and family. I wanted one reality. The one I was creating day by day.

When my analyst, Sy—I hadn't cut the cord yet—suggested that I had a choice, I listened. Our explorations went way beyond the phone

calls, obviously only the proverbial last straw. From my teen years on, I hadn't felt safe in my mother's hands. Odd, because I had always felt loved. But it wasn't her way to acknowledge problems, and therefore she was incapable of solving them. For years my wounds had bled over in my sessions with Sy. I don't recall how long the process took, only that the day came when he broached the ultimate action: *Separate from your mother.* I remember where I sat, where he sat, that morning. No longer in the gloomy brownstone, we were in a sterile room bleached with light. No hiding there. Incredulous, I voiced protests that turned slowly from "I could never . . . " to "How would I ever . . . ?"

My mother has come to visit, and now she is leaving. The *when could I possibly . . . ?* is at hand. I have put it off until the last minute, knowing that any discussion or negotiation would be more than I could handle. I am unsure of my ground. Worse, I am jumping off a cliff. That morning the front elevator is out of order, and she and I stand crushed together in the small vestibule of the service entrance, filled with my neighbor's and our garbage cans. I am afraid of hedging and ultimately being misunderstood. My words spill out, clumsy, flat out, and brutal. In that moment I paint myself into a black-and-white corner. The rickety elevator takes forever. She is in shock, uncomprehending. In my mind, she pleads: *What do you mean? What have I done?* And I hammer back: *This is what I need. You have done nothing.* Until the elevator finally comes and she falls silent in deference to the man who picks up her suitcase. Is she crying? I don't dare look. Do I say good-bye? Probably. I am in shock, too.

There was a lot of back-and-forth. Not between us, but between her and Clem. She called him often. He liked my mother and objected to the way I had gone about it. But when it came to my need to separate from her, Clem, who years before had cut himself off from most of his family, stepped back. He was kind and reassuring with my mother. She also called Sy. I don't know how she fared there.

I felt relief. I also felt remorse, much more than that word can convey. Some days I felt that I had murdered her. Some days I felt that I had put

down a burden. When I explained the overall situation to Sarah, making it clear that this would in no way change her and her father's time with Grandma, my all-knowing girl, said, "How would you feel if I did that to you?" My heart broke. The guilt spilled out.

Clem and Sarah continued to enjoy their visits to the Cape, where my mother catered to their every whim. Clem would sit on the porch at his typewriter, my mother hovering, waiting on him, each doing what they did best: shopping sprees with Sarah, restaurants, family swims in the afternoons. My mother had always liked the idea that she was only seven years older than Clem. He once told me that in her later years she would sometimes pass through the upstairs hall in her nightgown, just as he would be coming up to bed. My mother never did change her flirty ways.

In time, the distance between us eased. We occasionally talked on the phone; she visited New York on her annual drives with a friend to Florida. But we were both tentative, guarded. She, that she might overstep. I, that I might open the door too wide. Neither of us could take anything for granted anymore. We touched, we kissed self-consciously. Following a pattern established a lifetime ago, we didn't know how to "have it out." And therefore didn't know how to rebuild the bridge. In time, my relief and remorse folded themselves into my thoughts and dreams of my mother. And I held Clem and Sarah closer to me and I immersed myself even more in the work I loved.

One night we were invited to one of Mary Lasker's parties in her all-white house, this time a dinner party, and I was seated next to Truman Capote. Why I had been singled out for that honor, I'd never know. My admiration runneth over. He had just published *In Cold Blood*. What to say, what to say? Somehow we soon stumbled onto common ground— diet pills. I had decided to be very, very thin. Not that I was fat to begin with, but this was the time of miniskirts and bikinis; emaciation was in. There was a doctor on Fifth Avenue, known as The Rainbow Doctor, who was all the rage. For several months I and the entire female population of Upper Manhattan, and evidently Truman, had been beelining it to his office to get a compartmentalized pillbox filled with our multicolored fix

for the week. Of course, I never dreamed of asking what was in them, but they had to have been primarily speed, along with diuretics, laxatives, and God knows what.

The Rainbow guy had determined that my goal should be 125 pounds. I was gung-ho; at five-foot-eleven, I would put Twiggy to shame. The weight poured off. Why not? Food never passed my lips. That night, Capote and I, twittering maniacally and building sand castles out of our food and telling each other every other minute how divine we looked, had a high old time. But the next week, as the scale sank to 126, my dance with speed came to an almost heart-stopping end. Breathless, with palpitations, my body and brain froze in the middle of Third Avenue. I couldn't speak, think, or move. Fortunately, I was with Jimmy, who got me into a taxi and took me home. The rainbow disappeared, as they do. And so did the doctor, who was arrested to much fanfare and hauled off to jail. It must have been one hell of a body-altering fix I'd been dosed with, because most of the weight never did come back.

The off-off-Broadway momentum was shifting more and more to ensemble productions. That was where the new heat, the action, was. And the high priest of it all was a director from Poland who had never been to the United States: Jerzy Grotowski. The bible, supplanting Stanislavski's *An Actor Prepares*, was his book, *Towards a Poor Theatre*. Peter Brook was his leading disciple, joined in this country by proselytes Joe Chaikin, Richard Schechner, and every other ensemble director of the day. The key to Grotowski's work was the word *poor*, as in minimal, divested of external artifice or reference. For the actor it meant the sacrifice of self; it meant becoming a pure vessel, a conduit of unobstructed sound and movement. For the text, it meant paring it down to a core concept that would be revealed to the audience. For the audience, it meant stripping away preconceptions and becoming participants. For ten years Grotowski had worked with a dedicated group of actors on several pieces. By the time he and his Polish Laboratory Theatre arrived with their first production, *Akropolis*, plus two others, New York was champing at the bit to see what all the brouhaha was about.

The event, in Washington Square Church, was a hot ticket. How could it not have been? Grotowski had limited the audience to one hundred per

performance. As we entered, we were handed a small strip of paper that welcomed the PLT "out of a passionate conviction that religion and art must take risks in the pursuit of truth. Let this meeting . . . be another bridge spanning the gulf separating man and man, actor and audience, nation and nation." We were jammed into benches on four sides of a small raised acting space, as if we were in a pit. What an audience we were, from Jackie Kennedy and her sister, Princess Lee Radziwell, to Barbra Streisand to me, all cheek to jowl, appropriately humbled. The actors wore covering of some sort but, in effect, were naked.

The Polish text, in process for six years in a town not far from Auschwitz, followed a group of concentration camp inmates who enacted Bible stories as they built a wall of a crematorium. From the moment I walked into that "poor" theater, I became one with the actors; I was inside them, moving as they moved, feeling as they felt, their language my language. I had never merged so profoundly with a theatrical experience.

Like his predecessors Stanislavski and Brecht, so much a product of their times, Grotowski was in step with the politics and revolution of his place and time. No matter how bountiful the reverence paid to him by the theater community, his extreme work process precluded replication. Nonetheless, his techniques and productions set off reverberations that would affect all theater, small or mainstream. The most memorable examples: *Marat/Sade*, *Oh, Calcutta*, and *Hair*. Years later, in 1974, I was front and center at a performance of the patently commercial Peter Shaffer play *Equus*. At the climactic moment when the naked, bone-thin young man, played by Peter Firth, came downstage for his monologue, the sounds he made were coming from the darkest and most ecstatic depths of him. My eyes were drawn to his vibrating feet and, as I watched, I saw the raw sound of him emanating from them. A pure Grotowski moment. As it is with most things, theater absorbed what it could use of Grotowski and forgot the rest. Soon, his influence was there, but not so you would notice, unless you looked hard. And by the eighties, his name had dropped off the theatrical road map.

Hot on the heels of *Akropolis* had come Judith Malina and Julian Beck's Living Theatre event *Paradise Now*—one a searingly disciplined piece of theater, the other an anarchistic tornado of an experience. Kissing

cousins at best, but still cousins. *Paradise* was the product of an ensemble commune, created in Europe by the Beck-Malina team and committed to political, sexual, and individual liberation—a call to arms. In '68, their mythology having preceded them, they were back in New York. Another jam-packed event, this time in the huge relic, the Academy of Music, on East Fourteenth Street, this time without the uptown voyeurs. This was street theater.

Thirty or so hands-on performers provoked the audience to rise against the oppression of the establishment. A be-in where everyone there was high, the air thick with the sweet clouds of grass buoyed by the chi of LSD, and lord knows what. Revolution. The climax reached, the ensemble, by now naked, formed an entwined pyramid as the audience joined in, until the stage was a primal sea of bodies undulating in the harmony of paradise. Slowly the groundswell of the divine power of *om* raised the roof, the ultimate union. I, too, joined in and swayed and cried with that fervent family of revolution and peace.

So it was that by 1968 I was ready to immerse myself in ensemble theater. I leaped into the first group that came my way, a fledgling company led by a dark, quiveringly intense man named Tony Serpio who, in his hubris, usurped Grotowski's name and dubbed his ensemble the Poor Theater. We worked in the annex of a church on Twenty-seventh Street and Ninth Avenue. Barren and echoing, it throbbed with our screams of agony and ecstasy, mostly agony, as Tony pummeled us through the rigors of Grotowski's method. The goal: to create a parable that would be a play within a play, chronicling the actors as they journeyed through hell on earth in search of . . . All par for the course for OOB in those days.

After a month, drained by the relentless excursions into agony, I pleaded the case for joy. Tony, burning with the zeal and scar tissue of a Catholic boyhood, sneered at the notion: "Joy is in the pain." Feeling shallow and pathetically Presbyterian, I resumed the exercises of self-flagellation while chanting "Kyrie Eleison." So much for "paradise now"; I had stumbled into the dark side, and with blind trust bought the line that through pain would come redemption, maybe.

In any event, I wouldn't be staying around long enough for the redemption part. After I had been with the group a few months, things went

sour while we were doing a "trust" exercise. I stood on a high table from which I was to fall backward into the group's arms. I couldn't. They cajoled, they taunted, they spat on me, and finally they disowned me. The shunning continued for the rest of the evening. When I got home, I was disoriented and disconnected from my "self." Instinctively, I went into Sarah's room and lay next to the healing power of my sleeping girl.

It was at this juncture that I ran afoul of the Machiavellian underbelly of Tony. My dear Jimmy—who I had been seeing for two years—had recently returned from a three-month theater tour, and I made the mistake of bringing him into the group. I thought that his presence would shield me in this place where I now felt so unsafe. I should mention an odd bit of serendipity. From the onset, one of the members had looked disconcertingly familiar. Turned out she was Iris, the twin sister of Ruth Kligman, the "other woman" in the drama of Jackson's final days. I also discovered that, besides her appearance, Iris shared her twin's flair for the dramatic. Jimmy hadn't been with the group long when Iris cornered me and, honeyed with concern for my well-being, told me that I should dump him because he wasn't good enough for me.

As it turned out, the feeding frenzy over Jimmy, which included Iris, had already begun. I stood by helplessly as Tony manipulated the situation from the sidelines. It didn't take long for him to suck Jimmy into the group's seductive communal vortex. I knew that power all too well and soon left. The pain ran deep; I had lost my dear friend, my playmate, my astonishing lover, the only man other than Clem who I had ever truly loved. As for the group, it was as close an encounter with a brainwashing cult as I would ever have.

I was wearing pale peach toweling fabric, a meager shift, midthigh, meticulously frayed and fretted by the costumer for me, Eve. My hair, tawny and very long, flowed down my back. I was still bone skinny from the Rainbow Doctor. I was radiant, soaring on the power of knowing I was beautiful and that I was about to sing for the first time to a large audience. I launched into "Here in Eden," the opening song from the Jerry Bock/Sheldon Harnick musical *The Apple Tree*. When I hit the line ". . . I was meant to rejoice in the round vibrant sound of my own

voice," like Peter Firth in *Equus*, my toes twitched, the hair on the back of my neck tingled. With the final note I sent myself beyond the walls of the Woodstock Playhouse.

It was the summer of 1969 and I was in Woodstock, Vermont, the posh horse-country town where I was coproducing a season of summer stock. Once again, a friend had opened the door to an irresistible opportunity. Carol Rosenfeld, from my HB Studio days, had introduced me to Lynn Guerra, a producer-director, who was already committed to the project, contingent on finding someone to share the work and financing, estimated at a total of $5,000. My enthusiasm crumpled. But Clem's response was, as usual, "If we can we afford it," which in effect meant, *Go for it*!

Woodstock would be a potent antidote to the soul-dredging Poor Theater. Crassly commercial entertainment to lure the tourist trade was our goal when we chose our plays and two musicals: *The Star-Spangled Girl*, *The Apple Tree*, *You Know I Can't Hear You When the Water's Running*, *Pal Joey*, and *Two for the Seesaw*. Albert Takazauckas and Lynn cast the company and hired the technical staff. A local theater enthusiast gave us the use of a furnished farmhouse big enough for all, and for $200 I picked up a dilapidated van and station wagon for transportation to the theater.

From day one, Lynn dropped the ball as coproducer and I found myself hurdling obstacles minute by minute. One such was the eleventh-hour defection of our cook, miraculously remedied by my histrionic appeal on an early-morning radio show, which netted us a Mother Earth/Julia Child clone who proved to be the glue of us all. The June death of Judy Garland, which so rocked the sanity of our set designer/costumer that he showed up teary and wan two weeks late, though he managed to pull rabbits out of hats financially and artistically the rest of the season. A misanthropic lighting designer who, though addicted to comic books, somehow bestirred himself to re-engineer the archaic light board and, with a paltry number of kliegs, created magic. A stage manager whose charm and swagger got him the gig but who turned out to be a novice who needed help at every turn. (I still cringe when I hear, "No problem," a sure signal for disaster.) The threatened defection of the company who

wanted to attend that milestone of the sixties in the other Woodstock, which was averted in the last minute by my rallying appeal to their show-must-go-on conscience. (I'm sure that, like me, they're still kicking themselves for missing the "party of the century.") The outrage of the media and denunciation from the pulpit against *Can't Hear You* for "offensive material"—perhaps its mention of premarital sex or birth control. Our box office soared.

Further testament to the conservative white-bread politics of the community presented itself when I approached David Rockefeller—what he didn't own in the town, he controlled—for advice and help in getting the season off to a good start. He brushed me off with down-home smarm that thinly masked his condescension and disapproval of our rag-tag intrusion on his pristine turf; his agenda to turn back the clock and freeze-frame Woodstock as the quintessential New England town had already begun. The redneck fringes, so endemic to bastions of conservatism, regularly threatened our own hippie fringes with beatings and haircuts. All topped off with the unforgettable visit, disconcertingly soon after my visit with Rockefeller, from Sheriff Goode (this was a Dickensian town where names and occupations were ironically or literally wedded—Mr. Blood ran the funeral parlor, Mr. Flower, the nursery . . .), who walked into my bedroom at 3:00 AM and, with a torchlight in my face, hissed a warning that there had been complaints about drug use and that I should pass the word or there would be consequences.

It was a frightening hit of the us-versus-them abuse of power that was part of the Nixon years. The years of violence and national upheaval following the Kennedys' and King's assassinations had numbed me. Life in New York had numbed me. But I had not expected to encounter it firsthand in this sleepy, picture-book town where even the cows posed prettily in the fields.

Of course there were drugs at the farmhouse, but I had a penchant for not seeing what I didn't want, or need, to see. Although it wasn't my thing yet, in the theater world I took drug use for granted, like drinking. But I did pass the word. I suggested the company lay off the stuff, especially around the theater, lock the doors at night, and stick together if they hung out in town. And "Whoever is getting it on with the police sergeant's

daughter, you might want to think twice." We laughed about it, we were angry about it. Nothing made sense. While I had been singing Eve's song, ". . . and I am more than simply worried that things are getting out of hand," *Apollo 11* landed and we strolled on the moon. But we couldn't walk comfortably down the streets of Woodstock, Vermont.

Notwithstanding the obstacles, those three months were the happiest, most fulfilling time I had ever known. I awoke every day at dawn, ready to leap at the day. From public relations to overseeing the front of the house to keeping the company on track, to performing at night while rehearsing the next show most of the day, the more I did, the more I could do. I learned there were no limits to what I could achieve. That summer I blew my mother's "economy" credo to bits. She who had never filled a day with bliss, or anything much at all, who had never run if she could walk. I had even found time to take up with Mark Turnbull, our hapless but adorable nineteen-year-old stage manager.

Toward the end of the season, we were all outside fooling around, laughing after our usual early dinner. My body, my feelings, were strung so tight I thought I would burst. I had to have distance. I walked to the top of the hill behind the house, wondering if I was losing my mind, or maybe just burning out. I looked back at the people below and realized, no, it was just that such happiness, such pleasure in using myself to the utmost, were utterly foreign to me. And more than that, the months in the farmhouse, in the theater, all the wonderful work we had done, all the friendships that had formed, I had made all those things possible, not just for myself but for everyone. On that soft end-of-summer evening, I was not just soaring—I was proud.

That summer was also the cause of my deepest regret. Sarah was six, and there was no way I could have undertaken what lay ahead if she had come with me. I don't remember what Clem's plans were that had precluded her being with him, but I decided the only solution was to enroll her in a nearby summer camp. After seeing a film of the camp and meeting with the woman in charge, Sarah warmed to the idea. I had hoped for the best, but it was a terrible mistake. She was the youngest camper. Notwithstanding assurances from the counselors that she was adjusting and doing okay, I knew it was wrong. I visited twice, Clem

also, and we talked often on the phone, but nothing would make it right. Though I cried when she cried, I let it happen. My stalwart Sarah, she managed, but she never forgot nor forgave. Nor would I forgive myself. It was the first, and I vowed it would be the last, misstep that would mar our togetherness.

Reentry into my New York routine was jolting. I missed having Sy to help smooth the transition as I picked up my home life with Sarah and Clem. I did a few plays, but without classes to attend, my days felt bland. Juggling our social life with my work, once so invigorating, now became arduous, and the effort diminished both. Often, anxious about thoughts of the future, I felt as if a clock were ticking. If my momentum stopped, would the summer's high evaporate? Had my ability to use myself fully been linked to being on my own for the first time, away from the security of Clem and home? Had the years of schizoid shifting between Clem's world and mine kept me from making a full-out commitment to work and to myself, kept me from taking risks?

These questions were too big, too ominous, and I backed off, looking instead for a more immediate solution to my unease. And I found it, filed in my mind under "unfinished business." Perhaps as a backlash after my romp into the mainstream commerce of Woodstock, I was drawn back to the possibilities inherent in Grotowski's work. I had often wondered if it would be possible to apply his methods to a given text, rather than to an ensemble-created piece. Also whether his stringent techniques could be adapted to suit the work process of New York theater. Maybe this was the challenge I was looking for. I would have to find a suitable play. I would need a workspace and actors. I had never directed before . . .

During the fall of 1969, I mulled over possible scenarios for the project. The pictures in my mind excited me, as the plans shifted incrementally in the direction of a permanent workspace, rather than a rehearsal hall, and from there they took the leap to a space where Sarah and I could also live. I was startled by the audacity of the idea. I never envisioned it as an exchange, one place for another. I saw the space as being an adjunct to 275. Clem and I would be together, but separate. Was such a notion feasible? How would it work?

As energized as I was by thoughts of a new venture, I was also fearful.

I could be putting fifteen years with Clem on the line. As much as I tried to see the step as an expansion that would reconfigure our marriage—as our sexual openness had—I feared that it could just as easily damage, even nullify, our connection. As I talked with friends about my scenarios, I painted them with bright colors and free brushstrokes, and they bought it. But much would depend on Clem, and I knew better than to try to predict his reactions. As a teenager I had never learned how to discuss and negotiate; in those days, when I encountered an obstacle, I would shrug and walk away from what I wanted as if I didn't care. No, discussing with Clem a plan in its early stages was not my way.

And so I weighed my plan, and the more I did, I understood that it was not as precipitous as it had felt originally, that it was the result of a sequence of events that had started nine years earlier, with the death of our baby and the years of analysis that followed, and that had slowly awakened me to the possibilities of a life beyond Clem. Even as my interest shifted toward the theater and we both became romantically involved with others, Clem and I remained emotionally and sexually close as we brushed against each other day to day. And always, we were doubly bonded through Sarah. Clem was my touchstone, and I had always believed that it was our bond that enabled me to move forward and take chances. Now, I was about to take a step toward independence that would stretch that bond. No, my leave-taking was not impulsive or precipitate, nor was it inevitable or unavoidable. It was a choice, made with my fingers crossed.

And, my fingers still crossed, I talked to Clem. I called the plan "an experiment" involving a project and a place to do it in. Downplaying the possibility of living there, I compared it to an artist's renting a loft. I would cap the cost at $150 a month. If money ran low, we could always hand off another painting to an art dealer to sell—by that time, that was beginning to be our way of life.

As I write about this, I want to take my decision back, to say, "I came close to leaving, but at the last minute I couldn't do it." I want to write about the different life that would have played out if I had stayed. But there my imagination falters; I see only obstacles and walls without doors. I exaggerate. More realistically, I envision a rather frivolous

continuation of careers, each less committed to than the last, a rather frivolous succession of lovers, until the intricate dance steps of romance no longer seemed worth the effort, and a succession of analysts, until I despaired of hearing anything new. I see my steps through life as becoming increasingly small and tentative, my spirit doggedly resigned to maintaining a status quo.

As I play with the past, it is only my past. Clem's path was a throughline unaffected by my choice. It fulfilled the promise of the career line in his palm that was so deep and long and unbroken, that line that so clearly proclaimed a life devoted to the steadfast pursuit of learning and the achievement of his goals. I had not been so blessed. I always felt unformed, had always searched for answers. Goals, even fantasies, evaded me. But Woodstock had demonstrated to me a simple truth: I needed, wanted, to use myself completely. For the first time, I had touched my own power. No wonder I wanted to open the door and see what was around the next corner. And no wonder I still wanted to cry out, *Stay! You can discover all that at home. Stay where your life will be so much easier.*

The Seventies

WHEN I TIPTOED out of the Central Park West apartment, the door didn't click behind me. It wasn't even ajar. It was more like a revolving door. I took nothing at first. Then, over the next weeks and months, I took some clothes, books, records, which I threw into the back of the car. All the chattels passed down through the matriarchies of my family, all the things Clem and I had accumulated over time, most of my clothes and "stuff," all that stayed in situ, where it belonged.

No drama, no fanfare. I moved out so slowly and quietly that Clem never noticed I had gone. So I would tell the story for years, usually getting a fond chuckle over Clem's obliviousness. But fact is, it was true, and it wasn't funny. I still tremble at my brashness. One of those people who seem to have all the answers once said to me, "Only if you shut a door completely can you open the next." How tidy. Tidy as I always was in the way of washing dishes and making my bed, I never could shut doors. I saw my life as a long, drafty corridor, lengthening as I moved from room to room, the doors behind me creaking to and fro in the breeze. A habit no doubt etched on the slate of me when my parents slammed their doors on each other with a ferocity that must have awakened me with a cry from my innocence. No, my doors with Clem would always be open.

Through a painter friend, I had found a loft at 500 Broadway, between Spring and Prince Streets, for $150 a month. Originally industrial space, the nineteenth-century cast-iron building was now mostly vacant. The top floor, four thousand square feet of raw space with a small living area enclosed at the far end, was like a football field, with banks of windows at both ends. Big enough to stage an opera, big enough for Sarah to ride her bike, learn to roller-skate, and shoot hoops, and big enough to share. With us were my friend Mark and Robert Liebowitz, who had

been costumer/actor/general factotum at Woodstock. They brought the fun and spirit of the summer with them and, in return for a place to live, would help put the loft into shape.

They built two more bedrooms, spray-painted the place white, and sanded and stained the floors. On the Lower East Side, for next to nothing, I picked up some beautiful old oak furniture and an artist crafted a red lacquered bunk bed for Sarah, red being her color of the moment. My bed, more mundane, was from Bloomingdale's, and, thanks to André Emmerich's designer discount, I bought two Eames chairs, caramel colored, not white like the Kootzes'. In the open space, we put the old upright piano an actor friend had given us, strung up a big hammock, and installed a stereo and enough speakers to fill up the emptiness with Jimi Hendrix and Jefferson Airplane. Within a few months, everything as ready as it would ever be, Sarah and I took up residence in our virtual playground.

Our new area—one couldn't call it a neighborhood—was best described as "below Houston." There were artists sprinkled here and there, with more creeping in all the time, but mostly it was still home to small industry. Our loft may have been a playground, but nothing came easily—no garbage pickup, an elevator that worked when it felt like it, and no market, drugstore, or restaurants for tens of blocks in any direction. After six o'clock, the streets emptied out, dark and desolate. It was then that I knew we were living on the edge.

My new routine was framed by driving Sarah to her school on Ninety-sixth Street and Fifth and fetching her at the end of the day. While I continued singing lessons with Graham Bernard, I no longer went to the Actors Studio. I missed working with a group, yet didn't search out a new one. All my focus and energy went into planning my own project.

I picked Strindberg's *Dream Plays* to work on because of its amorphous structure, which lent itself to interpretation and adaptation by a large ensemble. Casting was difficult because, unlike the usual month of rehearsals and flexible hours, I was asking for at least two months and long hours. Add to that no money and no more than three weekends of showcases at the end.

The biggest stumbling block for many I auditioned was the sound and

movement group work. I certainly understood actors liked parts, preferably large parts, and scenes they could get their teeth into. Ensemble work was a hard sell. It defeated the whole point of doing a workshop you could invite a potential agent to. The final group, after the usual first-week dropouts, came to ten. Not bad, except that none had worked in ensembles before, much less were familiar with Grotowski's method, and three of them were non-actors. Not to mention that this was my first time out as a director. But I plotted the exercises, and we dove in. What went right was the willingness of the actors to open themselves to each other and to the exploration of themselves emotionally and physically. I had counted on that, knowing that was what actors love to do. Fortunately, the group gelled and we all learned as we went forward.

The problem, from first to last, was the play. It was too abstract, too highfalutin, too earnest and heavy-handed, and more and more I let the text go and encouraged the group to personalize it.

And then we were ready. Mark and Robert did the lights and marked out the space. There were no costumes, per se, but we went wild with hair and makeup. Though I had originally thought blankets and people sitting on the floor would be good, I finally caved in to renting chairs. To cover all our asses, I presented it as a work in progress. After each performance, everyone, audience and actors, partied hard. I have no idea what people thought, but I'm sure most dismissed it as just one more "happening" sort of exercise. I knew Clem was disappointed; he couldn't find the play he had come to see. For me, the success was in the personal journeys the actors took. I had watched their faces and bodies change in those months as they shed their facades. I had taken that trip when I was with Tony's group and knew the bravery and power of it. Yes, the choice of play was wrong. My leadership wavered—sometimes too strong, sometimes too hesitant. But what disappointed me most was that my experiment had failed; I had been unable to adapt Grotowski's method to a standard text in a restricted amount of time. I accepted it and would never attempt it again. His work was part of me; that would have to be enough.

After *Dream Plays*, I continued to perform in a few plays with Albert and also started to audition more earnestly for mainstream productions.

There, I ran headlong into rejection for the first time. I could understand when the part wasn't right or the chemistry was off or I had screwed up the audition. More difficult to deal with was when I would be called back repeatedly, only to lose out in the end.

I also started auditioning for musicals and was thrilled when I was offered the part of Sarah in a revival of *Guys and Dolls*. I still soar at the memory of the "I'll Know" duet. But the thrill was as short lived as the funding, which dwindled away. A particular heartbreaker was when I sang "Why Was I Born?" for Al Carmine, the theatrical guru of Judson Church, for a new musical he was staging. I could feel the heat in my body as I sang full out, opening myself to the breadth and joy of the sound. We talked a bit, but then he said, no, he had nothing for me. To give my all, the best that I could give, and not have it be enough, how wounding that was. And the idea of putting my whole self on the line again? Fuck it! And for a while, I pretty much did.

But there were good times in the loft. I learned that I could be casual, that I could live in a place where the door was always open. Friends, new people, there was always someone around. Thank God, because when the place was empty, it gave me the shivers. As for Mark and me, we were certainly an odd couple. But we genuinely liked each other, and I was drawn to his spontaneity and readiness to have fun, and of course I adored that he adored me. And I loved that he was great pals with Sarah, sometimes surprising me with how intuitive and protective he could be with her. I knew that people assumed our relationship was based on fantastic, older woman–hippie boy-toy sex, or some such. Fact was, the sex was terrible and I put an end to it early on. So, in that sense, I guess we were an odder couple than people even imagined. Our ties were simple: casual, yet close and caring. No surprise, "our song" was Rod Stewart's "Maggie May."

Besides friends and gatherings, it was important to me that the space was used for theater, and several groups rehearsed there. The high point was when Charles Ludlam—the farouche impresario of the Ridiculous Theatrical Company, the Orson Welles of high camp—virtually moved in to rehearse his extravaganza *Eunuchs of the Forbidden City*. Charles, simultaneously profound and fey, so slight, so huge eyed, so astonishingly

imaginative, so vastly knowledgeable—to know him was to adore him. For the months he and his company were there, life was a circus. To Sarah's delight, they built their costumes there—oh, the kimonos and headdresses and wigs. And the group, all of them so damn nice: Charles, a vegetarian, giving me recipes in hopes I would clean up my nutritional act; the guys doing magic and acrobatics for us. And I still see the divine Black-Eyed Susan guiding Sarah as she tried to walk in Susan's foot-high platform shoes. And the immensely zaftig Lola Pashalinski dressing up the cats.

Yes, we now had two cats. Dick, an abandoned kitten who had adopted Sarah while we had been in West Shokan, New York, the previous summer. And Berry, an all-black Himalayan that Mark, an animal maven, found for us to keep Dick company. Sarah adored them, and they would reward her by living until they were nineteen.

Over the next few years, Charles and I stayed in touch, meeting for brown rice and tofu at his vegetarian hangouts in the East Village. His company flourished; he would become a legend. So much achieved in so little time. Only forty-four, he would die of AIDS in 1987.

Soon it was Sarah's turn to join the theatrics when Albert directed *Troilus and Cressida* as a Super Bowl face-off. I was Cressida, head cheerleader, Troilus was a clearly gay quarterback, Helen was homecoming queen . . . and Sarah was a mini-cheerleader who opened and closed the play as Pandarus's page, a part Albert created for her. Leave it to Albert, at the height of the Vietnam frenzy, to turn a tragic war play into an antic farce. The audience, not to mention the actors, were bewildered.

There were marvelous trips to Coney Island with Sarah and Mark, where I discovered that my six-year-old was actually a daredevil in disguise. Only the scariest, most topsy-turvy, fastest rides would satisfy her, while I cowered below. I, who had grown up with Rye's Playland in my backyard, threw up after being bullied onto the mildest of the roller coasters. Coney Island, so deliciously scuzzy and redolent of past glories. Just my thing. I would often seek out the grand Victorian beach hotels of my childhood that smelled of the mildew and must of the sea, where I could still hear the accordion's refrain of "Goodnight, Ladies" wafting through the corridors at night. And, too, the rococo movie palaces of

the thirties, the vestiges of their gilt and frescoes marking time until the wrecking ball. Such was the decaying charm of Coney Island for me.

There was a brief affair with Buddhism and with the come-hither actor who I met in Chekov's *Platanov*. The Buddhism lasted longer than the man, but not by much. And there was a strange encounter with two waifs and a sick dog. Kids in their late teens, a boy and a girl, filthy, destitute strangers to the city. Mark had befriended them in Times Square and brought them to the loft. We washed them, disinfected them, fed them—all three of them—and put them to bed in Robert's room. He was away, and Sarah was with Clem. I washed their clothes and dug up new ones for them. Disillusioned flower children abandoning the promise of Haight-Ashbury—now bearing the more prosaic label of "vagrants"— they were now hitching around the country, searching for the next Eden. Question was, what to do for them?

The next day, they answered the question themselves. We all got in the car to take the dog to a clinic. On the way, they became hostile, called us capitalist pigs, doling out charity, who the fuck did we think we were . . . At the next light they got out, and I drove off before they could change their minds. I understood the backlash—maybe I would have felt the same—but I wasn't about to take them on. We felt bad about the dog, though.

During the slow times, I took on a new project: researching early American drama. Bypassing melodrama and musical revues, I worked in libraries to ferret out the roots of homegrown realism. I had to believe American drama hadn't begun with Eugene O'Neill. Then I hit on the groundbreaker James A. Herne, a heralded playwright/actor/company manager who in 1892 wrote a simple play, *Shore Acres*, about a lighthouse keeper. Eschewing artifice throughout, the play ends as the old man, alone onstage, prepares for the night. The scene is long, silent, and intensely private. He goes about his mundane tasks, then extinguishes the gas lamps, until, the room illuminated only by the glow of the wood stove, he slowly exits.

Audiences must have been startled by these first steps into such naturalism: minimal footlights, no declaiming; instead, they became voyeurs into the life of an old man. Perhaps *too* startled, because the play was

never as successful as Herne's melodramatic productions. I like to think of *Shore Acres* as the first American drama. Fact was, though, it wouldn't be until the 1930s that tastemakers acknowledged that an American could write an important play. Light entertainment and musicals, yes. But not drama.

The scenario was certainly familiar to me. After all, until the 1950s, it had been inconceivable that America could produce great art, much less become the center of the art world. I continued to explore the theater's past, but as fascinated as I was by the material and its history, the solitude made me restless. I didn't want to read about theater—I wanted to do theater.

And, yes, there were drugs. Everyone I knew smoked grass and hash. Many dropped acid now and then. The heavier stuff was too expensive and harder to come by; it hadn't become mainstream yet. I was considered a dinosaur because, when pressed, I would admit that I preferred vodka. To much laughter. Although I joined in around the hookah or passing the joint, I never really took to it. Except for the acid. I don't know how many trips I took with friends, but there were quite a few during those loft years, and they were all good. For the first time I really heard music, saw color, saw a tree, and felt a lightness of being.

Besides doing a couple more good plays, *The Cherry Orchard* and *The Skin of Our Teeth*, I dipped a toe into TV. I got a three-day bit in *The Nurses*, a soap opera. All day to say a line or two, oh so boring once the fun of being plastered with makeup and being on camera wore off. But that was nothing compared with the agony of being an extra on a movie shoot at city hall. I showed up at dawn and by midafternoon was still loitering on the streets. When we were told we had to wait on the bus until we were called, I fled to the nearest subway, and that was that. Movie stardom would have to wait.

Rejections were one thing, but the lowest blow landed when I got fired. Once again, I had been pounced on by a gung-ho director, who thought he had discovered his perfect Eurydice for his production of Cocteau's *Orphée*. Problem was, he had an existing company of actors who from the outset resented the intruder. Who could blame them? Difficulties were compounded by the director's high-concept staging on a

cantilevered trampoline-type structure. Tempers flared as we attempted to be suitably tragic while striving to stay upright. The final straw for the cast was when the *Times* came to do a story before the opening and, instead of running a group shot, chose to run a close-up of me. A good picture—too good, I guess, because it must have led to all-out mutiny. The morning after opening night, the feckless director called and fired me. As miserable as I'd been, dodging bullets from the cast and balancing on that damn trampoline, that was a killer punch.

And then my two-year lease was up. The area, now hot enough to justify its own name, SoHo, was now hot enough to justify the landlord's doubling the rent. Too rich for our blood. Part of me was relieved, part not. I certainly would have preferred to leave what had been my first step toward an independent lifestyle on a higher, lighter, note. As it was, I could feel the shadow of depression over my shoulder.

Though I considered going back to 275, I knew that, feeling as discouraged and unfocused as I did, it would be a bad idea. Instead, sending Mark and Bob off on their way, Sarah and I moved back into the middle-class milieu of a two-bedroom floor-through in a Chelsea brownstone. Circumstances had been spiraling in the wrong direction for some time. Now I felt downsized in every way; my furniture was too big, I was too big. Everyone said, "How charming" and, "Imagine, two fireplaces." I wanted to scream.

Soon, all that didn't matter much. I felt pain in my abdomen and was diagnosed with a fibroid tumor in my uterus and scheduled for a hysterectomy. I curled up, feeling old and withered. I whimpered. I was thirty-eight. It wasn't fair. Hysterectomies were for crones. I thought about the children, the other beautiful Sarahs, I would never have. I mourned the choice I would never have. And wondered if I would die.

While waiting, I spent long days at 275 with Clem. I felt safe with him, wanted to sponge up his calm perspective. But he was also uncharacteristically unnerved by the thought of the operation. When Clem was sixteen, his mother had died, and he had always blamed his father. Forget the mastoid infection and blood poisoning that killed her—his father hadn't made her happy enough. No wonder he had agreed with Cyril Connolly,

who once said to him that you could always tell a man's character by the health of his wife.

Me, I reverted to my mother's less convoluted, but even more misguided, mindset about actions and consequences: The cyst was retribution for my having been too happy, too free. And all that sex. What if I had never . . . ? I sat in Clem's office, the air thick with our misgivings and cigarettes, while Clem worked on "Can Taste Be Objective?" and I blanketed my brain with C. P. Snow novels in an attempt to rekindle our high times in England. And still wondered if I would die.

Then we were back at Doctors Hospital, that familiar site of previous tragedy and bliss. It was St. Patrick's Day. The big parade was nearby. I was a few blocks east. Emptied out. Scraped of my core. Cut open by men who had scooped out every reproductive organ in sight as if they were at an all-you-could-eat buffet, and hungry. I was not I. I was a slab of meat on a table. Now rendered genderless. By the time the parade was over, the sated butcher looked down at me and told me I had had a "radical hysterectomy." He listed the many parts of me that were now garbage.

"Though the cyst was benign, it was the best way to proceed. You wouldn't want to have more problems down the road, now would you, young lady?" Terrified at the thought of a replay, I agreed, as he handed me a prescription for Premarin "to keep me shipshape."

Clem was there day after day, pouring out his feelings and theories of self-blame, shouldering ownership of it all. His purification rite. After a while, part of me believed him, wanted to unburden myself of the thought that I had brought it on myself. *Yes, I give it all to you. Yes, it was all your fault.* But I couldn't. To do that would have left me nothing but the sour dregs of blame and resentment toward him. So on and on he talked his way through his pain, while I looked at the sky sheltering the East River and Queens and the planes slicing through it as they flew in and out of LaGuardia at exact six-minute intervals. I grabbed on to my physical pain as if it were a lifeline. At least it was real. Each throb and thrust told me I had not died. Now I wondered if I would ever walk upright again.

Three months later, Sarah, Albert, and I were on our way to Hamilton,

New York, home of Colgate University. We had been invited by a group of recent graduates to put on a summer production in a 1890s opera house in nearby Earlville. Earlville, home to a few hundred people, consisted of one streetlight and two blocks of abandoned buildings, one of which was the opera house. The Colgate group, having been gifted the property, had set up a nonprofit company to ensure the old theater's restoration and survival. They were looking to us to provide an event that would raise both money and awareness.

Our house for the summer would be a tiny tract house: paintings on velvet of matadors and señoritas, furniture cocooned in plastic covers, mustard shag rugs, and gold-flecked linoleum. It was all so perfectly what it was, a museum piece of American 1950s kitsch. Our first morning completed the picture when we awakened to a roar and shudder; the house abutted the end of the runway of the local airport.

To enter the opera house, we climbed a dubious staircase to a small entryway, then through a door to the theater itself. As if I had stumbled into King Tut's tomb, I swooned with the beauty of it. Yes, the red plush upholstery and stage curtains were rotted. Yes, the paint was peeling. Yes, the place smelled of God knows what. But what I saw was the hand-carved artistry of the proscenium, the balcony, and the exquisite boxes that framed the stage. I saw the colors, the reds, umbers, and greens. No gilt, no crystal here. This was true elegance, the honest elegance of gifted craftsmen. What I breathed was the gaslight from the original panel of footlights, the greasepaint in the tiny dressing rooms backstage that lingered from the traveling shows when this theater had been "on the circuit." It was dying, but it wasn't dead.

Having been miraculously spared fire and demolition, it was the only extant nineteenth-century opera house in the state. I stood on the stage and envisioned a production of Herne's *Shore Acres*. It was as if I had been handed the opportunity to re-create it in a place where it might well have been staged by Herne's touring company. Hadn't the play opened in 1892, the very year the opera house had opened? However, as director, Albert had first dibs, and his choice was Victor Hugo's 1830 swashbuckler, *Hernani*.

Albert cast *Hernani* as I set to work editing the script and learning

lines. The first read-through went well. And then, before the project had really begun, it was over. It was as if that derelict, leaking ark of a theater had awakened from her slumbers and said, *Not now. It's all too much, too soon.* She may have been a grand old diva, but she was sensible. Her structural needs took precedence over her artistic appetites.

The Colgate contingent was apologetic about pulling the plug and agreed to cover our expenses through August. One of the group, John Schoonmaker, a film enthusiast, suggested we make a movie. He and Albert sketched the plot of a horror movie, which they preferred to think of as a film noir. Sarah and I would be in it, along with a hunky young local boy. Horror or noir, I was grateful to be doing it. However, still emotionally raw from the operation, I would drift too often out to the swing set in the dry, weedy backyard, my thoughts dark as I listened for the next plane to rev up.

The simple plot: Mother and daughter in suburban tract house; mother becomes obsessed with young, muscle-bound bagger at the supermarket; various town and rural scenes as relationship sparks; mother rejected for younger girl, sets up meeting, and fatally stabs hunk under a full moon. Albert directing and John on camera got off on the blood and gore of it. Me, it took a bite out of my shaky self-esteem. Here I was, damaged goods, over the hill, rejected, no happy ending, reduced to turning in a cheesy portrayal of a demented Medea/Phaedra.

I had made another short movie for a guy at the NYU film school, who I had met at the Actors Studio. Shot one midnight in an Upper West Side tenement, dressed in a clingy silk slip Grandmother Ruby had given me for my sixteenth birthday, I gazed across the rooftops and water towers and droned dreary monologues. Backlit, I'm sure I was virtually naked as I moved onto the fire escape, droned and gazed some more until it became clear that hurling myself into the trash cans below was the only way the movie was ever going to put an end to itself. I never did see either movie. I think my instinct told me that ignorance and amnesia were the only ways to play it.

Time hung heavy that summer, and, with Sarah, I checked out houses for sale in the area. An old habit. For a couple of years before she married Harry, my mother sold real estate to give us "a few extras," as she

put it, although I was sure the situation was closer to the bone. A gutsy move for someone who had never had a job before. Neither tough nor good with numbers, she didn't have much success, but for the first time, I noticed, she was proud of herself. Sometimes she would take me along to explore empty houses. Fun, but excruciating, because I was convinced we would never live in a real house again. This time, in upstate New York, the looking would be just for fun, or so I told myself.

Back in New York, the one-year lease in Chelsea would be up in January. I put the furniture in storage, and Sarah and I moved back to 275. This time I didn't hesitate. Unsure about what to do next, I was at a crossroad. I figured there could be a theater life for me after Earlville, but I was tired and my creative engines had slowed down. In March, when a Norwich realtor called about a house he thought I would like, though the impulse had faded, I drove up for a look.

On a good day, Norwich is about five hours with a pit stop from the city. It lies between Binghamton and Utica in the Chenango Valley. On that first drive up Route 12 to Hamilton with Sarah and Albert, the very name Chenango had enchanted me—something about the scale of those gentle hills that embraced, rather than imposed themselves on, the broad valleys, hills that allowed just the right proportion between horizon and sky. Dairy country, lush, squeaky clean, and sweet smelling. Broad Street was solid and reassuring, unlike the Main Streets of many upstate New York towns in those years. An Americana dream: the Bon-Ton dress shop, the movie house, the Bluebird Café, the modern library, the county courthouse, the A&P, the Woolworth's, the manicured town square with its requisite gazebo, the new Howard Johnson Inn that looked like a concrete block jail, and a jail that looked like an inn.

Fortunately, or unfortunately, the house the realtor showed me was a good fit for us. Nothing suburban, the house was based on a Frank Lloyd Wright design of a low-budget, utilitarian house for the masses. Wright's master plan had never materialized, but here was an example of it built in the fifties by a student of his. On a sparsely developed strip of Chenango Lake Road, on a hill two miles outside of town, it perched on an escarpment of enormous boulders. The house was modern in the Wright way: varied ceiling heights, slices of surprise windows here and

there, indirect lighting, built-in furniture, radiant-hot-water floor heat-
ing. On three shallow acres, it had only four small rooms, one and a half
baths, an annex for a den and guest bed, a detached garage, and a postage
stamp–size lawn, no landscaping or flowers, stripped-down functional,
zero maintenance. Far too modern and small for a Norwich family, it was
perfect for outlanders like us. Original, yet humble. Price: $35,000.

Clem, once again, took my word for it and asked only if we could
afford it. I said we could put $5,000 down and get a mortgage that the
realtor had assured me would be under $200 a month. Debt. That made
us both shudder. Neither of us had ever owned anything big or ever owed
anything. I was scared. Clem wasn't, but he wondered if we really needed
it, his criterion for most decisions. I told him I didn't know, but I thought
maybe we could give it a try. I was hedging. Of course we didn't need it,
but I was unwilling to admit it.

Money aside, the most glaring disadvantage of the house—the ele-
phant I refused to acknowledge—was its five-hour distance from the
city. Who would use the house? And when? Summers, maybe; certainly
not weekends. Would Clem ever go? Would I? I ducked and dodged the
drawbacks, and Clem didn't bring them up. That was the way it was
between us. We danced around the hard questions. Small wonder that
on the surface we seemed to glide so harmoniously. That seemed to be
our priority, whatever the cost.

During the next month I made a decision that I thought would justify
our risky venture. It was time for the next experiment in living. What if
Sarah and I moved there, at least for a year? Norwich felt like an answer,
though I was unsure what my question was. I did know that nothing was
happening as it was supposed to, either out there in a country mired in
violence and discord, or in my body, or in my head. Why not a change?
Why not ride on the momentum of the sixties and do the bread-baking,
return-to-nature thing? We bought the house. Our local Chemical Bank
laughed at our lack of credit history and turned us down. The Chenango
Bank was more forgiving of our virginity and came through.

Before our experiment could begin, there would be a brief interlude.
Like fairy godparents, Larry Rubin (Bill's brother) and his wife, Liz,
offered us their house in the south of France for July. Yes, thank you.

Sarah's first trip to Europe. We would go to Nice by ship. In August we would take *le train bleu* to Paris. Sarah would travel in the old way, before those ways disappeared. At the last minute, Clem backed out. I hesitated, but only for a moment.

So it was that Sarah and I spent the summer in a sumptuous aerie above Saint-Tropez on the terraced slopes of the vineyards. With a swimming pool, a daily housekeeper, and the Rubins' car, she and I lived in a storybook. By day we lolled and explored and entertained a few visitors. By night we pretended to be grandes dames as we were served delectable dinners on the terrace under the stars, before adjourning to the living room to tackle our confounding jigsaw puzzle of the Eiffel Tower, which we were determined to finish before we left to "do" Paris and visit the real thing. And then, tan and well fed, we flew home.

The hill up to Chenango Lake Road was so long and steep that in the space of two miles the weather and time would change—rain to snow, snow to ice, sunset to night. Darkness fell like a curtain as the road veered toward the lake. The winter of '73–'74, the winter of recession in more ways than one. Oil dried up, and so did jobs and prosperity. Daylight saving time was extended through the winter, along with a fifty-mile-per-hour speed limit to conserve energy, and that was only the beginning.

I bought a wood stove for the annex, just in case, and stacked cords of wood and bags of coal in the garage. I traded in the urban frivolity of our Mustang for a Subaru, a new, exotic name in cars. With its fuel efficiency and front-wheel drive, plus snow tires, shovel, bags of salt and ashes from the fireplace, it would get us up the curved, steep driveway, maybe. Hurricane lamps, stashes of candles and water, a first-aid kit, a wheelbarrow, a rake, a manual mower if spring should ever come, and a chain saw, having failed to gain mastery over the ax. Limits on heating oil, endless lines at the gas pumps, limits on gallons sold, gallon cans in the garage, just in case. In case of what? Mostly the unknown, which for me was country life, and for all of us, the ominous rumblings of the deep recession. In the local paper I read of people hoarding gas and food and taking money out of the banks, and I stopped reading. The whole country was going dark—what more did I need to know?

Sarah was entering fifth grade and her first public school. In the city, she had attended the progressive Manhattan Country School since she was three. Now, she was at a traditional, rural, white-bread school where she experienced a series of firsts: sitting at a regulation desk (kind of fun), standing each morning for the Pledge of Allegiance (never heard it before), raising her hand to go to the bathroom (hard to remember), learning lessons by rote (not so hot), and, of course, having to figure out how to fit in, make new friends, and deconstruct her wardrobe. Enter our new fashion boutique, the Sears catalog. As it was, my concerns about her adjustment came to naught. I should have known. Cheerfulness was in her nature; when something got her down, she bounced back so fast my heart would spin.

I settled happily into my own new wardrobe, overalls. As for nesting, it took two minutes. Our loft furniture, always so at odds in the Chelsea apartment, fit perfectly into the new space. I installed two outdoor spot-lights that played on the trees and boulders with the two large sculptures that graced them as if they were rooted there—a long, low, stainless-steel Caro and a raw-steel piece, an amalgam worked on by Clem, Tony, and Ken. At night in front of the large windows, Sarah and I sat in the two Eames chairs, put on rock and roll and played Sorry, Submarine, and Backgammon, or moved into the annex to watch the flickering TV screen and fall in love with *Happy Days*. That fall it was mostly Sarah and me. Except for a stalwart few, my car-less friends never did hazard the trek to Norwich.

I bungled around on the piano, made bread that smelled luscious but never did taste like much, raked leaves, pruned everything prunable, strung up the loft hammock between two pine trees, tried to make friends with the mice, bats, and snakes, and failed, escaped into Henry James—a step up from my Edith Wharton binge in East Hampton a lifetime ago—looked out the window, and wished there was a view.

But there wasn't. The trees had grown up and taken away what once had been a view "all the way to the Catskills." So our neighbors Al and Doris Velake said. Al, barrel-chested, ham-fisted, with a face as broad and gnarled as a tree, was a retired steel worker on the railroads that had once brought prosperity to the valley, and even to Earlville. Terse and

pragmatic, he lived in the present. I thirsted for the past. Our conversation sputtered and stalled. I explored the ruins of the grand hotel that had once stood on the far side of Chenango Lake, a quarter mile down the road. He said, "You'll get shot doing things like that."

He laughed when I nailed up POSTED signs during hunting season. "People around here shoot where they feel like shooting," and with sly delight showed me his freezers full of venison and lord knows what. Like David Smith, he liked to swagger and shock "the little lady," and, as at David's, I choked on a few mystery pies around their knotty-pine dinette set. Protective and condescending, I appreciated the former when it came to trapping and annihilating the critters that came too close, and put up with the latter. Doris was a bookkeeper at the shoe factory, which was threatening to close. A full-time office worker and a full-time housekeeper. It stirred my feminist hackles, but I knew enough to keep my mouth shut. I kept scratching for common ground and not finding it.

When Clem came up in October, that changed. Doris—shades of my mother—gussied up to welcome the "new man in the neighborhood." And Al and Clem forged a lasting bond. They were of an age, each with a robust curiosity about all and sundry. They both liked booze and cigars and the Bible. The Jew and the Catholic—here was the book they both knew well. They talked, argued, and reread it together. The perfect complement: Al educated Clem on nature and the "how-tos" of the arcane world of washing machines, electric stoves, fuse boxes, et al., and Clem introduced Al to the world of art. Wouldn't you know, Al had a veritable metal junkyard out back and a shed packed with welding equipment. In time the erstwhile philistine who had shaken his head in disapproval ("What will people think?") when I hung a row of Jack Bush prints along the hallway would turn his hand to the making of sculpture. Over time, Al would come to know all the artists who visited Norwich, especially Ken, Jules, Friedel, and so many more.

I wished that Clem had been there with us. But he wasn't. He was a part-timer. There was something about a house that spoke of family to me, a whole family. Living in a New York apartment, I had never thought about it that way. But now the isolation exaggerated our distance and I wanted to be closer to him. I became aware of needing him in a new way.

I began to understand what Clem meant when he would so often say, "I love your presence," a phrase I had always disliked because I saw it as inert, even dismissive. I began to feel the deep resonance of "presence" and what his presence meant to me.

Fortunately, the more time he spent in the house, the more he liked it. His visits became more frequent, especially after he discovered that Norwich Pharmaceuticals—Norwich's economy floated on the bounteous pink seas of Pepto-Bismol—ran a commuter service once a day between LaGuardia and the local mini-airport. And, of course, Sarah and I would drive down occasionally for a hit of the city. But, for all that, Clem wasn't really there.

In November I reached out to Chris Foster, whom I had met during the Earlville summer. She belonged to the Norwich community theater group and suggested I become a member. I exchanged my overalls for a skirt and attended the next meeting of their membership committee. I answered a few questions, and they then asked me to wait in another room while they made their decision. I flashed on the Criminal Club in the sixth grade when, at Nan Ahern's house, after we hung out and scarfed food, they told me to stay downstairs while they met in her bedroom to decide whether I would be allowed to remain in the club or not. The coup de grace: "While you're waiting, wash the dishes." Deep in soapsuds and tears of humiliation, I obeyed. When my "best friends" came downstairs, they told me I was out. The reason? There were now boy-girl parties, and the boys didn't like me.

My flashback was on the button. When Chris emerged from the meeting, she told me that I hadn't been accepted. Later she called and said they had been threatened by "the New Yorker" who would want to take over. I laughed and told her they were probably right. But more seriously, I added, I had counted on it and needed a connection. Chris had a new plan.

I would work with the drama department at the high school as a volunteer coach/assistant director/whatever on their productions. I was grateful. That year I assisted with *The Music Man* and *Bells Are Ringing*, helping the kids develop their characters and doing scene work. I also initiated a small drama club where we did improvisations and worked

on short plays that could be presented at various assemblies and school functions.

Fine, but not enough. I got together with the Colgate group at the Opera House. The architectural department of Cornell was now on board, and at least the roof was patched for the winter. We tossed around ideas about how to use the one small storefront that was habitable. I suggested a crafts store, which might pay the utilities until spring. I visited the big Veterans Administration home just south of Norwich. Every crocheter, knitter, needlepointer, every egg carton artist and bead stringer—I was in awe of them all. My little consignment store would be their Fifty-seventh Street art gallery.

Between Thanksgiving and Christmas, I went for a few hours every day, swaddled in my army surplus jacket that I had lived in at Bennington, and nipped brandy from my flask as I waited for my seductively arrayed treasures to fly off the shelves. A good day was $20; a bad day was $5 out of my pocket for whatever I couldn't live without. A cockamamie idea in a non-town of eight hundred and only the post office across the street to provide "walk-in traffic," the more disgruntled souls muttering, "The best thing would be if the whole block burned to the ground." I didn't care. I knew why I was there. I was paying my respects to the theater I had fallen in love with at first sight.

And then there were the fossil rocks. I didn't know what fossils really were until I literally tripped over them while gathering wildflowers along the back roads. My interest shifted quickly to the rocks and their messages of glacial drift. I looked out at the boulders that our house sat on and saw them for what they were, precious gifts from the receding glaciers. My Piscean nature relished living on the erstwhile bottom of the sea, which had left its imprints for me to discover. Soon I was seeking out the abandoned shale pits in the hills. Beer bottles and condoms told of an active nightlife, but during the day they held the chill and stillness of tombs. In this sedimentary Mecca, I sorted out the gems from the dross. The most common were those with traceries of shells and cones and what might have been insects, or not. The best were the stones with the intact shells themselves. The naming of them interested me little, the millions of years they harbored was all. Each trip I gathered as many

as I could carry and piled them by the garage. Al scoffed; they were "a dime a dozen, a confounded nuisance." I saw power and beauty and had a plan. I would build a low wall of them along the front path. My own Stonehenge.

But the wall would have to wait. Winter closed in one day and would stay to deliver an ice storm on Easter Sunday before it was banished on tax day by a purple crocus outside my kitchen window. In the lowering darkness of a house that was never warm enough, I watched the conclusion of the Watergate saga as the indictments finally fell on Nixon's inner circle of thugs in their smug suits. I watched Nixon deflate like a balloon as impeachment loomed. I watched the last-ditch maneuvers of the Vietnamese as they tried to clean up the mess we had left them with. I watched as if these events were happening on a distant planet.

Closer to home, the toilet acted up. I called a plumber, a genial older man, and made him a cup of coffee and sat on the edge of the tub to chat as he prodded and tinkered. Born in Norwich, he had never gone to New York City and never wanted to go. He told me about his wife, who the last few months had taken to sitting at the kitchen table all day. He would leave in the morning, and when he came home she was still there in her wrapper. He didn't know what to make of it. I did. I could see the kitchen, the dirty dishes, the tick of the wall clock in the shape of a teapot, the old chenille robe, the blankness of her.

Those winter days, that dark place was in me, too. I felt its tug sometimes when my restless energy ebbed at the end of the day. The woman, a still life at her kitchen table, had succumbed. I empathized with the plumber, murmuring the bromides that are, or are not, reassuring, and suggested the basic anodynes: a doctor, a priest, a friend who could break her isolation. I ventured to tell him something I had learned from my own experience, that one didn't have to be isolated to feel isolated.

The toilet was an easy fix. For the rest, who knew? The plumber's wife left me with fantasies of the women's group I would start where we would talk about the problems and solutions of daily life, where we would learn that we had a voice and that we could be heard and know we weren't alone. My own get-real voice always broke in: *Who does that interfering New York bitch think she is, and since when do six*

years of analysis qualify her to be anything but a certifiable nutcase? My consciousness-raising impulses slunk away in defeat.

Sometime during that winter, Broad Street slowly lost heart. It was as if enterprise and prosperity had stolen away in the night, leaving dusty storefronts in their wake. So much for my bright and thriving town. Seems a barracks-like shopping center had popped up a mile north. "Progress," the local paper called it.

And sometime during that winter, the depression I knew I was experiencing deepened. It was different from the way I had felt the years after we had married when, despite my loss of "self," I knew I was at the beginning of my life and somehow, some way, the heaviness would lift. Now, my lights had gone out. I had no sense of a future. For the most part, the feelings were masked. I knew too well how to do that. I didn't get sick or sit at the table all day in my wrapper. I relied on my energy and the beauty around me. But the darkness was there.

I remembered what an interim analyst, whom I'd seen only twice during the end of my loft days, had told me: "There's a spine of depression around which life is organized after the loss of a parent before the age of five." Her words seared my brain as if they were a brand on a carcass of defective meat. In effect she was telling me I was forever scarred because a douche bag daddy couldn't keep his prick in his pants. Who the hell was this Park Avenue bitch with coiffed hair and polished nails?

There I'd been, a thirtysomething hippie living in a loft with her daughter and her eighteen-year-old boyfriend, feeling at the end of one life without another in sight. I did the only thing I knew how to do—I slammed the door on the messenger and buried the message. It would have helped if I had also known what would become common knowledge, that the traumatic loss of hormones following a hysterectomy, especially a radical hysterectomy, can cause clinical depression. No one had even told me that, despite the Premarin, I would experience symptoms of menopause, a word barely spoken at the time.

Spring brought the mud and my ardent affair with my chain saw. I took to walking through the patch of woods below the boulders. Annoyed by the dense underbrush, I decided to clear it out. Starting with loppers, I quickly graduated to the chain saw. I loved the noise, the efficient speed

of it, the power it gave me. Master of my domain, I was soon cutting down saplings, anything in my path. The debris piled up. Al, muttering his disapproval, gave me some old oil drums that would do for burning and long hoses that extended from the house to the cans. Just in case. Some days, from the time I dropped Sarah at the bus stop until it was time to pick her up, I would be "working." I was cleaning that small bit of land as if I were vacuuming the living room. I liked the mindlessness, the physical labor, a new way to use myself up and see the results each day. But of course there were no results. Every day I cleared, and every night nature outpaced me. Until the day the usually sanguine Sarah came home from school, looked down at her chain saw–wielding mother stoking her fires, and said, "When are you going to stop?" As I always did with Sarah, I listened.

One day after my drama club, I was summoned to the principal's office for a "word" concerning my "fraternization" with students. Apparently someone had reported seeing student cars parked outside my house. The principal, a nice man, was uncomfortable about mentioning it. I was wide-eyed with innocence and "regrets for any misunderstandings." We parted amicably. But I wondered if the accusation would have been leveled at me if I'd had a husband in residence. For the mysterious informant, I must have become the femme fatale with the "strange" marriage. As absurd as I thought the incident, I was creeped out. Shades of the rednecks in Woodstock. I also felt I had been slapped down again, as I had been by the community theater.

But soon there were graver concerns. The town was simmering with the disappearance of a sixteen-year-old high-school student, Wendy Cooper. As days, weeks, passed, murder was in the air. Investigations narrowed, and five seniors, one of whom I knew and liked, were questioned. Steve was the boyfriend of Roberta, who was in my drama group. She and I had become friendly during the year, and as her feelings for Steve deepened and her relationship with her parents deteriorated, I became a confidante. It was the time-old Romeo and Juliet imbroglio engendered by a stern, inflexible father who forbade any contact between them, and a mother who was sympathetic but ineffectual. One place they managed to meet was in the drama group. I got to know them both, and they were

wonderful together. Of course, Steve's being questioned by the police certainly didn't improve their prospects. But we were confident it would blow over. Surely Wendy had simply run off and would come back. It happened all the time.

When Clem called to chat one afternoon in early June, I heard myself say, "I'm coming back. I want to get a job, a real job, and earn money." I heard my clarity. No days of pondering, no weighing of pros and cons. At that moment, I simply knew: It was time. Clem wasn't surprised. As much as he had come to like the house, he had never thought my experiment in living would last. I asked Clem if he knew anyone who might help. Anyone, that is, outside the art world. For a moment he was stymied, then he said that he had met "a man in commerce" recently. I loved Clem's "in commerce," always the precise word at the ready. And it was true; he really didn't have occasion to know many businesspeople. He said he would invite the man around for a drink so that I could meet him. We continued to talk of other things, all so casual, but I had to sit down because my world had just shifted.

Almost immediately, I felt a weight lift from me. Sarah's reaction was mixed. I was surprised. I had assumed she would be happy to be going "home," but I had underestimated how much she had settled in. We talked it through during the next weeks, and I knew it would be all right. But I realized how much easier it made my life to believe that she felt as I felt. I knew better, but I fell into that parental trap too often and vowed not to make that mistake again. Once again, Sarah was a good teacher. I returned the oil drums to Al, and, as if on cue, my chain saw "disappeared" from the garage. I was certain a handyman who had recently done a few odd jobs had helped himself to it. I considered confronting him, but when I thought of his tumbledown house in town, stuffed with children, I wished him well instead.

The following week, Clem did pull the man of commerce out of his hat, and I did go down to meet him. Charles Mandel, by name, he sat on our couch, drink in hand, and asked what I would like to do. I said, "Anything at all. I think I would be a good waitress." Unabashed, he suggested I come to his office at a media company—whatever that was—and we would talk about what I might do there. Saying I would come by in

a few weeks after Sarah's school let out, I took his card and rushed off to the theater. It was as if the details didn't matter. The decision to move on was all—the rest would follow.

When I did call him, Charlie told me the media company had folded and he was currently renting an office in an advertising agency and selling space—again, whatever that meant—and he had nothing to offer me. As if I hadn't heard him, I said I would drop by when I was next in the city.

Clem happily settled into the Norwich house for the summer with his portable typewriter, his seersucker short-sleeved shirts and old khakis, his Dopp kit smelling of neat's-foot oil, his sable shaving brush and wooden bowl of English shaving soap that smelled of the forest, and the OED and sundry books. Clem didn't have a lot of props, but those he had were choice. In time, he would come to use the place often, staying for longer and longer stretches. It was clear why Norwich worked for him and not for me. He brought his world with him wherever he went. In addition to his props, his work and coterie of attentive and persistent friends were sure to follow. More fundamentally, Clem was complete unto himself. He, like Sarah, was at home in the world—that innate quality that he prized so highly. I was not so fortunate. Too often, I felt like a stranger in a new place, starting from scratch and pasting together a life that would suit me.

Now I was about to do it again. During that early summer, I had one foot in Norwich and the other in New York. I would drop by Charlie's "office": one room, one desk, two chairs, and one secretary outside the door. He would dredge up tasks for me, mostly related to half-hour television shows he was putting together for a friend who owned a cable station on Long Island. My most ambitious effort was a kids' game show I dreamed up, based on charades, called *Be a Where*. In a week I put together a format, hired two actor friends to emcee, taped some catchy music, "borrowed" a bunch of ten-year-old summer-school kids, bused them to the studio, fed them at McDonald's, and taped the "show." It was tatty, but who would've thought—I actually did it. The basics of TV, like the basics of being an electrician and carpenter in the loft, were just common sense. And so another bastion of the arcane hit the dust. But

the next day when Charlie asked, "What do you know about harness racing?" I said, "Forget it."

After about a month of this hopscotch, one day Charlie told me about the only thing he still owned, the rights to the name *Madison Avenue* magazine. "I'll be the publisher, you'll be the editor," he said as he scurried off to Penn Station. The next day he gave me a crumpled piece of paper that spelled out the premise: a monthly editorial magazine that targeted advertisers, each issue focusing on a different industry. There would be profiles of CEOs, a day in the life of an agency VIP, a magazine review board of agency creative stars to critique the industry's advertising . . . The first industry: airlines. It was all there. All I had to do was fulfill it. And—oh, yes—the first issue would be in October.

He also gave me three other indispensables: a cubicle of my own, an assistant, and an art director. I hired Kathy Bernard, the young daughter of my singing teacher, Graham, and Charlie hired Nicolai Canetti, a young émigré via Israel and Kenya. What a trio—Kathy and I knew nothing about advertising or magazines, and Nicki had never pasted up a galley. We shared ignorance and enthusiasm, and that would have to do, given our zero budget.

Charlie knew what I didn't: Because I was a novice, I wouldn't question his preposterous time frame for the first issue. And, most important, because I wasn't the usual advertising hack, I stood a better chance of getting to the people he wanted represented in the magazine. He had picked up on my lack of awe of people and just about everything else, the quality that Clem always gave me high marks for, and it would pay off at the magazine that catered to a world that thought very highly of itself.

He also gave me a modus operandi I've never forgotten: Don't mess with middlemen or public-relations people—go directly to the top. My own MO was to be myself, as a person and as a writer, and to trust my instincts, especially in terms of the look and feel of the magazine. Bottom line, I was guileless. These power guys had nothing to fear from me, this WASPy, well-mannered "girl" with blond highlights in her long hair, who wore silk skirts and blouses from Cacharel, Ferragamo shoes, and tinted aviator glasses, and who, after every issue closed, sent them a copy along with a handwritten note thanking them for their "participation."

No agendas, no jargon. I wouldn't have known a hard question if it fell on me. Homey chats, a photographer who took flattering pictures . . . a good time was had by all. I let someone else do the sidebars with the marketing statistics.

One sidebar of my own, money. During the summer, my salary consisted of the few bucks Charlie would pull out of his pocket now and then. By September, when I was working full-time on the magazine, there were murmurs of a part-ownership down the road. My friends told me I was nuts; the guy was a loser, I was being exploited, I'd never see a dime, I should have a contract . . . What could I say except, "Yeah, but I'm having the time of my life"? I didn't say, "Besides, I think I'm falling for the 'loser.'"

The airline issue came out on time, all thirty-six pages of it. I had laid it out, titled the features, edited it, and written most of it. I loved my eight-to-seven days and beating my ignorance back with a stick at every turn. I loved the adrenaline throb and the surprises, as when Charlie would pop in and drag me off to some potential advertiser's office—mostly magazine publishers—where he would schmooze about golf while I lent credibility to his pie in the sky. He always got the ad.

I learned fast that publishers came in several flavors. Most of these high-and-mighties looked and behaved just as I would have expected: bankerish and tailored from Paul Stuart, shiny and fragrant from the barbershop, purring of Ivy League, photos of blond wives and children posed on immaculate suburban lawns. And then there was the publisher of *Esquire*. Gritty, thigh-slapping loud, somewhere between the dirty jokes and latest coup on the eighteenth hole, I heard him say, "I had his tits in the ringer." I blushed. The guys roared; I blushed redder. Once again, Charlie got the ad.

I also depended on Charlie, who, when I would get buried in overwhelm, would make me laugh and always remind me, "If it isn't fun, it isn't worth doing." I loved my new title of editor in chief, which he had conferred on me in honor of the first issue, along with an honest-to-God paycheck of $100 or so. Hodgepodge as the airline issue was, I was proud of it. Charlie was, too. Like Johnny Appleseed, he would take an armful of magazines whenever he went out and would sprinkle them at

newsstands and offices all over Midtown. The master "space" man now had a new product to sell—this time, his own.

Not to say I didn't fall on my face, hard and often, especially with the early issues. I even had a nasty habit of wanting to spell *advertising* with a *z*. But, as usual, Charlie said the right thing: "Hey, no one actually reads the thing. They just want to be in it." I wasn't so sure, but he was right insofar as no one ever threw my mistakes back at me. Except for Clem. A master editor, by propensity and for years by trade, he bore down on words and usage with the same intense scrutiny that he brought to art. It was what made his prose zing with simplicity and precision. But even there he was hard on himself and would sometimes grumble to me about how much he wished he could ease off and write more conversationally. As for *Madison Avenue*, every month he would grab it up, and the next morning it would be on the hall table. No judgment, no comments, just line-by-line red pencil. I would rifle through the pages in dismay. But I never dwelt on it, just as I never read the magazine once it was out. How could I? By that time I would be up to my eyeballs in the next issue.

I hadn't brought much of Norwich with me when I had come back to 275, except for some of the fossil rocks, which I stood along the back of my closet shelf. But, as single-focused on the magazine as I was, my thoughts were drawn back when a distraught Roberta called at the end of September to tell me that Steve had been arrested for the murder of Wendy Cooper. Her body had been discovered by a woman walking her dog in the woods near a shale quarry, the same quarry I had haunted during my fossil-scrabbling days. She had lain there for three months. After five hours of questioning, at two in the morning, Steve had confessed. It couldn't be true. I envisioned him, terrified, no lawyer, coercion, brutality. Those things happened. But for Roberta and me, the unspeakable thought was that if he had done it, how had he managed to lie and carry on as usual during the summer?

During his months in the jailhouse on the town green, I visited him twice with Roberta and brought him pizzas and talked about everything but what was. Feeling helpless, I talked to his lawyer on one visit and offered to pay for an independent lie-detector test. A sympathetic man who seemed to care about Steve, he explained that it wouldn't help;

there were facts revealed in Steve's confession that confirmed evidence not previously revealed by the police. I heard what he told me, but my heart refused to accept it.

As for the rest, the process played itself out over the next four months while the lawyers wrangled over the charges and Steve bungled a suicide attempt. In March he was found guilty of first-degree manslaughter and "murder in the furtherance of a felony," i.e., attempted rape. It was the latter charge that had been at the heart of the wrangling and would result in the devastating sentence. Steve's confession claimed the sexual preliminaries were consensual, but that he had been unable to consummate the act. Wendy had threatened to tell everyone what he had tried to do, and he had hit her to scare her. The jury deliberated fifteen days before convicting him on both charges. The sentence: twenty-five years in Attica. On leaving the courtroom, Steve tried to lunge through a window. To freedom? To his death? More likely simply out of despair.

In the newspaper photos of him being led away after the trial, he was in bell-bottoms and a jacket too small, bone thin, his lank, straight hair below his shoulders. So diminished, so young. He had just turned twenty. Gone was the handsome boy, cocky and lovesick for his Roberta, who I remembered. I wished I could comfort him, protect him from what was to come.

If I had any lingering doubts about leaving Norwich, they were laid to rest. I had bought into the clichés of rural living: good air, good people, a simpler life. All true, but I had also experienced narrow-mindedness, loss of privacy, and a stultifying homogeneity. I was glad to return to the anonymity and unpredictability of a city where I couldn't understand most of what people said, much less what language they were saying it in, and where murders didn't even rate the first section of the *Times*. In a small town, small things became big things, and big things became catastrophic, and everything else festered in secrecy behind closed doors. Being a "fretter," as Clem too often assured me I was, I had been unsuited for small-town life.

The magazine grew, in pages and in depth, and Charlie came through on his promises. In addition to a burgeoning paycheck, I now had a one-third ownership, along with Charlie and a golf buddy silent partner.

The magazine moved to its own offices at 750 Third Avenue, where a new salesman, a writer, and a receptionist joined the "staff." No more mom-and-pop store.

When I was sure this would be my life for some time to come, Sarah and I moved two blocks south to 257 Central Park West, close to Clem and Sarah's school. The building, originally a hotel, had recently been converted to apartments. Though awkward and haphazard, as most conversions were, its smallish five rooms were bright and had a modern flair, thanks to the ceramic Spanish tile the previous tenant had installed in the open kitchen and long hallway. As always, decor was a snap: I simply papered the walls with large paintings. Sarah and I would both grow up there. During the next seven years, Sarah would go from Manhattan Country School to the Lenox School to Trinity to Vassar, and I would become an accomplished "woman of business."

As the months passed, I quickly mastered the how-tos of getting a magazine out, but it never got easier. The fatter it got, the more editorial it required and the faster I had to run. Added to the frenzy was the attraction between Charlie and me. He was coming on strong, and I found his high energy and appetite for fun irresistible. Flirtation eventually moved to the inevitable. But there was a twist that was new to me that would prove to be no fun at all: Charlie was a devoted suburban husband with two children. As with magazine editing, here was another challenge, but the guidelines kept shifting under my feet, and the guide, even more inept than I, quickly became the problem. Worse, this was a skill I wasn't at all sure I wanted to learn.

But, like it or not, too soon I was in the middle of a traditional marriage and, therefore, in the middle of a traditional "affair" with all the trimmings. Hush, hush, "she" must never know. It had been ten years since my marriage had moved into "open" territory, and since then, whatever our choices, Clem and I had made them freely and with forthright communication. No wonder I wasn't prepared for the fallout.

On a whirlwind trip to Los Angeles—our first and last out-of-town junket—Charlie laid it on thick with the Beverly Wilshire Hotel, limo, et al. Two days jammed with business calls, sandwiched between visiting old friends and haunts. Spur of the moment, he added on a weekend in

Las Vegas. On the way to the airport, he told the driver to first take us to Disneyland, another of his favorite places. We dashed from ride to ride. He knew the drill; it was as if the seas parted and the place was a private playground. Yes, it was all fun, but it was also as if Charlie were putting on a high-speed, this-is-my-life show and I was the audience of one, clapping on cue. By the time we were on the plane, I was played out.

In Las Vegas Charlie made for the craps table, and that was that. I wandered around, played some blackjack, and soon went to bed. In the early hours, I woke up and went down to see how Charlie was doing. He was easy to spot. Alone at a table, pale, his eyes glassy, he rolled the dice like an automaton, the chips pushed to him or raked away from him, mostly away. I had never seen gambling like that; as an addiction, it made alcoholism smell like a rose. I knew it was time for me to go. When I got his attention, the exchange was simple: I told him I was heading home, he told me he was going to play poker off the strip and asked me to lend him money, as the hotel had cut off his credit. That was easy. I took my AmEx card to the cashier. I went upstairs and made a reservation for the early-morning flight to LaGuardia. Later, when the phone rang, I picked it up, figuring at that hour it was probably the airline or Charlie. It was Charlie's wife. We were both startled. The conversation was short. I wrote Charlie a note telling him about the call and left for the airport.

On the plane I felt a surge of release. I was out of it. They would figure things out. If I felt anxious or guilty, in my usual way, I buried it. After all, we were all grown-ups. I slept until the wheels smacked the tarmac. For the will-the-plane-fall-out-of-the-sky fretter, another first.

From then on, it was farce. She: the raging wife, screaming betrayal, threatening dire ultimatums, throwing his things out of the house. He: guilt-ridden, suicidal, falling-down drunk (Charlie rarely drank). Me: feeling woefully miscast as a femme fatale mired in the ugly mess. All feeling like victims.

Farce aside, I felt cannibalized by them, chewed up as dinner-table fodder as they played out their marital push-pull rituals. I had nightmares of family meals deteriorating into mayhem and chaos and carving knives and ravaged food. Fanning the flames, Charlie would insist on a daily blow-by-blow of the latest he-said-she-said. I, who had always recoiled

from confrontation, did my best to close my ears and closet myself in work.

In time, things simmered down. Perspective was restored. And insights, dripping with hindsight, flooded in. Right at the top, I vowed never again to get involved with a "hush-hush" married man. Far too high-maintenance. I also recognized that beyond the magazine, which had triggered a powerful bond, Charlie and I had little in common. *Madison Avenue* was like a favored child that we got a kick out of, and that bond would continue. But we didn't really think alike or care about the same things.

Just as in the past I had never considered leaving or divorcing Clem to be with anyone else, I never considered doing so now. I think my relationship with Charlie had initially reminded me of the theater, where the sheer thrill and proximity of the production would lead to a liaison—short-term, long-term, whatever—where the parameters were always clear, and casual. Not to have picked up on the differences in an office relationship with a married man and the potential damage to all was short-sighted, to say the least. Overall I reconfirmed the simple homilies: Sneaky behavior is sneaky behavior, and why lie, when the truth feels better?

Whatever the drama and insights, my work came first. And the pace accelerated when Charlie made a deal with WNEW, Channel 5, in New York, for *Madison Avenue on TV*. The series of shows would be aired on Sunday nights at eleven o'clock, the "dead zone." Co-hosted by Charlie and me, the shows mirrored the magazine by highlighting an industry's advertising, followed by a discussion by marketing and creative pros. All I had to do was get the bodies in the chairs, compose a bunch of questions, and keep things lively. Easy, except for the lively part. But what about makeup, clothes, hair? I was more nervous than I had ever been on a stage. I could hear Strasberg sneer when I blew the opening and we had to do three takes.

When Charlie again reassured, "Don't worry, nobody will watch it," this time I believed him. Who would possibly be interested in the making of commercials, much less in the middle of the night? But Charlie had a nifty new sales toy. We did four shows: airlines, soft drinks, corporate

advertising, and, my favorite, advertising to women. As with the magazines I never read, I never did look at the shows, so I had no idea whether I sweated through my silk or whether my fake eyelashes were fabulous or ludicrous.

Also in the course of that first year, *Madison Avenue* took to the road with regional issues. Every three months, photographer in hand, I headed to a different major market. I would interview the leading advertisers and media directors, gather agency heads for a give-and-take market assessment, and then write my personal take of the city. In interviews I never used a tape recorder; it took too much time to filter out the chaff from the grain. With my trusty speedwriting notes, I often wrote up an interview in the taxi on the way to the next, or long into the night.

Early on I recognized that industry leaders were not just money men; most were passionate and creative. Top of my list was Charles Tandy of Tandy/RadioShack, entrepreneur extraordinaire. I talked to "Chuck" in the back room of a storefront in Fort Worth, home base of his billion-dollar corporation. Scruffy, feet up, people in and out, whiskey, beer, and cigars all around. He may have looked like he was kicking back, but he sparked with energy, for conversation, ideas, and "the dream." His credo: low overhead, hard work, focus on the product, grow big and then bigger, but stick with what you know. From selling leather crafts to being poised on the cusp of the microchip revolution to becoming a retail household name, he was always a gambler—he called it "betting on the future." A puckish jokester surrounded by geegaws: the rubber tit on his desk to summon another round of drinks, the witch's mask with the "pull me" string that drenched me with water, the ubiquitous fart cushions. His CB handle? Mr. Lucky. He might have used a touch of suave, but I never forgot him, and I was sad when, a year later, his luck ran out and he died of a heart attack at sixty.

One of my most discomfiting encounters was with Hugh Hefner. Not because of my budding, if late-blooming, feminism. On the contrary, the "girls" I chatted with around the pool at the Mansion or while munching superb hamburgers around the big dining-room table were smart and straightforward. Just like Hefner, who was, in addition, generous with

his time and invitations to this movie or that party whenever I was in town.

I went several times, once in the late seventies, to a New Year's Eve party with Sarah. For all the hype about Hefner, this event, like the others I attended, was quite tame. Even with the mandated attire of "sleepwear," the diaphanous baby-doll creations were more PG than titillating. I am sure there was snorting and sniffing going on, but not so one would notice. Hefner was fiercely antidrugs; his addictions were Pepsi and sex. And even when Sarah and I cruised the infamous "grotto," we saw nothing we hadn't seen on the beaches of Saint-Tropez.

Hefner's largesse was prompted not by my interviewing him—he couldn't have cared less—but by my being his son's boss. David Gunn, twenty-one, was Hefner's younger child and my photographer, the best the magazine ever had. He lived in Chicago near his delightful mother, Millie, and would travel with me often. Handsome and fun, he was also unsure of himself, but never more so than when we were at the Mansion. At dinner, around the table filled with regulars, Hefner gratuitously belittled David. I tried to deflect the attack with talk of David's remarkable work for the magazine, but his father would not let go until he had reduced him to tears. The unacknowledged son, the golden-girl daughter, Christie. Publicly, even privately, it was as if David didn't exist. But it was the face-to-face father-to-son cruelty that appalled me. And David continued to go back for more.

After my interview with Hefner, I broached the subject of David's need of his father's approval, but I touched no chord. I had stepped over the line. I was very fond of David and admired his father, but didn't like him.

Three years slipped by. Not in a blur, not at all—the images were indelible. And from day one, my wish had been realized; once again, I was using myself up fully and happily every day. With pride I watched the magazines piling up on the shelf, each one thicker than the last, proof of a job well done.

Along the way, in 1976, I picked up a powerful ally, a new analyst. The impetus was my first, and only, panic attack. On Madison Avenue,

steps from my office, I found I could barely breathe or swallow. Kathy took me to the emergency room at Lenox Hill. Even as I waited for the shot of whatever to do its thing, I wondered where I could find a good analyst. I asked Joe Smith, a marketing guru and mentor/friend who knew all things, and he referred me to David Rubinfine, a member of that elite coterie, the New York Psychoanalytic Institute.

It was clear from the start that though David was a Freudian MD, he was a maverick at heart. The first session was remarkable. I dutifully reeled off my life scenario. He, without taking the usual meaningful pause, said, "You're an orphan." With that word, the floodgates were finally released. I cried until the session was over. Defying protocol, he walked me to the door, patted my shoulder, and, alakazam, instant transference. It saved a hell of a lot of time and money.

David was a great analyst. I was a great patient. With his help, my day-to-day empowerment remained intact. With his support, in 1977, I took a step that startled me: I told Clem that I would like a divorce. Clem was startled, too.

Clem is on the love seat in the living room, where he always sits. I am next to him, where I rarely sit. It is midafternoon on a fall weekend. It is warm. The windows are open. He is angry, the only time he has ever been angry with me. Not loud or full-out in any way. Worse, the anger is in the restraint of it. In his face, in his voice, I can see and hear the effort it takes to hold the anger back. All I can say is, "I want to know what it would be like to be single." He calls it "a meaningless gesture." I agree on some level; it does seem out of nowhere and frivolous. But it isn't meaningless.

"What's wrong with the way we are now?"

"Nothing. It's just something I need to do." Which brings us back to "meaningless gesture." We repeat the circle a few times and then sit in silence. In my mind I start second-guessing. I know the time is right, but the words feel hollow. I feel strong, but I am unsure how long that feeling will last. Most of all, I find I am unable to talk definitively about a separation. I am afraid.

Clem's anger subsides. We go to the kitchen for another drink. It is there that he asks if my reason is another man. I say there is no one. He repeats one of his life axioms: "To leave one person for another doesn't speak well for one's character." I am reminded how much I believe that. Only two years ago, Charlie asked one day whether, if he left his marriage, my door would be open. My response, an emphatic no. "If you leave, you leave for yourself, not for me."

Once again in the living room, Clem becomes practical and says, "As long as it is all done through one lawyer." Given that neither of us has ever had a lawyer, much less known one, that seems a good idea. Then he adds, "And it should be no one's fault." Makes sense. And then he says, "And as long as nothing changes." That's when I know all will be right in our world. We talk about Sarah, who we suspect won't even notice the difference. And then we move on to the more mundane: the magazine, what bills have come in, did the maid show up on Tuesday . . . And when I leave, we kiss.

I found Jack Strauss, the perfect lawyer, through a magazine friend who had recently divorced. We met with Jack, a rare lawyer who had creativity and imagination, only once. The final divorce paper was three pages long, reduced from its original length, when Clem said it was overly complicated. He particularly took issue with the phrase *irreconcilable differences*, but agreed to it after the lawyer read off the menu of alternatives. Typically, after the final decree arrived, Clem edited it and struck out that paragraph. The pieces of paper with a blue cover went into the metal box in his office that held our very few "important documents."

In today's climate of adversarial divorce, I look at the decades-old document and am struck by its civility and simplicity, and the degree to which it reflects mutual esteem and trust. Two portions are particularly telling. Regarding *joint custody* (another phrase that grated on Clem) of Sarah, age thirteen:

> " . . . they agree that being an intelligent young girl, she may reside or be with either of her parents as she, from time to time, may decide."

And the final paragraph:

> "That this document, limited as it is, was arrived at solely between the parties themselves without the aid of an attorney . . . the only part played by him—pursuant to their wishes— was to reduce their agreement to writing . . . and because of their amiable relationship, their agreement has been limited to the provisions contained herein as the only provisions they feel necessary to be included and which they chose to consider."

I don't know if I thought about it at the time, but Clem had another life axiom that would have pertained; "Never marry someone you can't imagine divorcing." He was so right. If I had been married to anyone else, my "gesture" could easily have escalated into a nightmare. And kudos again to our lawyer, who understood his quirky clients and made it the non-event it was meant to be. Now, when I ask Sarah about it, she agrees. "I suppose I knew about it. But it wasn't important."

A few months later, in June, my mother called to say she was going into the Falmouth Hospital to have an operation. With her usual vagueness she added, "Nothing serious. I just haven't been feeling quite right." I called her doctor, who supplied the chilling adjectives *exploratory operation* and *possible pancreatic cancer* and added, "No, she doesn't know. No need to upset her."

The hospital, airy and bright, more like a country hotel. Her room looked out over a stretch of gardens and trees. How pretty she looked, eyes bright, her hennaed hair shining against the white of the pillow. I had never seen my mother sick or stretched out on a bed, much less a hospital bed. I had come up immediately; Norden flew in the next day. She was so happy we were there, together. Such a small family; such a lousy excuse for a reunion. We put on quite a show. He and I kidded around, unwrapped the old family jokes. Hours passed as we leaped over the elephant. Secrets, always secrets.

The hospital room was easy. Later, back at the house, would be more difficult. Over the last three years, thanks to my sessions with David, my wounds with my mother had begun to heal as I had slowly sopped up

the anger and guilt that had festered so long. But Norden. All it took was two drinks, and the resentments—old, new, real, and alleged—streamed out of me. He didn't react. Much like our father, he had a passivity that almost precluded reaction. He also had an unshakable belief that he was always in the right. Both traits drove me to a fury and to an early end to a long day.

The following afternoon, Norden and I learned the crushing facts about pancreatic cancer: It was swift, relatively painless, and the cancer the doctor would choose for himself. Or did he say that to all his patients? They had opened her up and closed her up. Nothing to be done. How different from protocols today—no Internet searches, alternative treatments, life-prolonging procedures. And no "full disclosure." We all agreed that she need not know. Never had I heard my mother say the word *cancer*. If pressed, she would whisper, "the Big C." She had a particular fear of breast cancer and was convinced that if her breasts were ever bruised, she would die of it. Odd, in view of the fact that no one in her family had ever died of breast cancer, or any cancer.

Those were the facts of it. But that was by no means all of it for me. After hearing the doctor's report, I collapsed into a chair. I refused to believe it. She couldn't die. It was impossible. I couldn't listen, all I could do was moan and sob, "No." Over and over. By the time she was returned to the room, my cheerful face was glued back in place and I was ready to paint pretty pictures for her, just as she had always done for me as she tucked me in at night. She devoutly believed in good thoughts, that everything would be better tomorrow. I thought of the three exquisitely carved ivory monkeys that had always sat on her Chinese desk. Gifts from her father, they had taught her well. Buffeted by whatever travails befell her, and now by the cancer that trespassed inside her, she saw, heard, and spoke of them not at all.

Late that night at her house, the phone awakened me. A moment's hesitation; then a man said, "Is Norden there?" Three words, yet I knew it was my father. Numb, I called upstairs to Norden. He picked up the extension and I hung up. My father's voice. I hadn't heard it in twenty-three years, but I knew it. A bland voice, unweighted by emotion,

bordering on indifference. A not-unpleasant voice delivering, in effect, a harsh message: *I have nothing to say to you.* And his brief hesitation told me that he hadn't even considered the possibility that I, too, might be in my mother's house that night. Yes, indifference. I had already cried too much that day. I watched my hurt, my anger, wash through me. They would find no foothold, at least not then.

Over the next two months, I went to the Cape most weekends and called often. The real angel in the family was my stepsister, Judy, who had always maintained a close relationship with my mother. During those last weeks at home, Judy stayed with her as the disease progressed, bringing jaundice and rashes. More and more, my mother stayed in a hospital bed set up by the window in the living room. Thankfully, the doctor had been right. Her pain was minimal, the bottle of Demerol barely touched. And then, beyond even the ministrations of the angel, she was back in the hospital.

She declined daily. Yet each morning I was taken aback, as if I thought there should be a plateau where she could rest awhile, where we could hang out, have a chat, do what mothers and daughters are supposed to do. But there never was a plateau. Too soon, she retreated into herself, and when she did connect, she was terse and demanding. That mother, who I had never met before, crescendoed one morning when her sister, Elfrida, came to visit and she lashed out, "I don't want you here. Get out." I wanted to raise a flag. Finally, "Poor Lolly" had stood up for herself in the love-hate sisterhood that had teetered on half-truths for a lifetime. She had finally told it like it was.

Then she, who had never taken an aspirin, was given IV drugs and she went further away. One afternoon, drifting on her drugs, she was rapturously happy. I asked her why. "I am dancing," she said, "dancing with my David." I could see my parents in their late teens: he the boy next door, she with the secret crush, both so beautiful, dancing on the cusp of love.

And then the day was there. It was very early, the Thursday before Labor Day. I kissed her on that narrow bed, her face a dark yellow and raised slightly as if to drink in the light she couldn't see, her shrunken

body barely there beneath the sheet. Quiet, alone. I held her hand and told her I was sorry for the pain I had caused her. I told her I loved her. My sweet, loving, soft mommy. I told her all would be well. I searched for her inside the face I didn't know. Was she still there? It didn't matter. Did she hear? It didn't matter. I hoped she was happy.

The epilogue of her life was written over the next four days. Norden and I composed the obituary, arranged the funeral, buried her, and had a small gathering at the house. We packed up her life in boxes color-coded to my brother, to me, to sell, to a yard sale, to trash. We spoke to the lawyer about her will, to her cousin who lived nearby to oversee the sale of the house, and to a used-furniture dealer. Throughout, I was hot, I was cold, my eyes ran, my nose ran, until I didn't know if I was distraught or sick.

Seven rooms, an attic, and a basement. So much stuff. And nothing came easily. Norden and I had not been brought up to share. No need to, when the boy is entitled and the other is just a girl. I had lost my mother, and now I lost my equilibrium. I was a successful forty-four-year-old woman. I was a hardscrabble kid desperate to grab her marbles. Nothing would erase the sordid scavenging, the chill dampness of the basement, the heat of the attic, the musty excavation of closets and drawers that hadn't been opened in years. All as the clock ticked. Endings should fade away at their own pace, but I didn't know that then. So that was not the way it was. After all, Norden and I had lives.

Overwhelming events have a way of piling up, or so it seemed in the wake of my mother's death. That winter, almost three years into my analysis, David had a heart attack and decided to move to Los Angeles. The timing couldn't have been worse. He was the most insightful, effective analyst I could have hoped for, and I had become increasingly dependent on him for guidance. Who would I talk to about things like the phone call I got at the office a few weeks after Ma died?

Midmorning, while I was knee deep in the magazine, Elfrida called me. Always one to have the last word, she wasted no time: "You killed your mother." There were a few other words, but that was the message. I don't know what I said, if anything, or who hung up first, and it doesn't matter. But I heard the message. Guilt, rage, hatred, self-pity, and more

guilt. Nothing new, except the messenger. I went back to editing my magazine.

The loss of David even more difficult to bear. And then, within a few months, another loss. Charlie abruptly left the magazine. Restless Charlie—the monthly routine had slowly ground him down. He had always said that if it wasn't fun, it wasn't worth doing. And, true to his word, just like that, he was gone. After four years of partnership, I was flying solo.

Well, not exactly solo. The silent partner, Walter Wiedenbaum, who until then I had met only in passing, stepped out of the shadows and became publisher. Tall, patrician, he ran a tight ship. Gone was the spontaneous informality of the office. Walter ruled from the top down with a steady stream of memos that replaced discussion and any semblance of autonomy. Worse, from the onset we were oil and water. As a boss, he had an icy authority that brought out my own icy defensiveness. I began to notice that whenever our paths crossed his jaw muscles would clench, a sure sign that this wasn't just dislike, this was barely concealed anger. This was someone who would have liked to take a swing at me. I kept my distance.

Compounding the personal differences, I realized that I had been stretched too thin for some time. The magazine had grown from 34 pages to 142. As thrilled as I was by its success, in some respects, I hadn't grown with it. Although the staff had increased commensurately, I had never learned how to delegate and still ran the magazine as the small operation it had once been. I was convinced that my hands-on attention to the day-to-day minutiae was vital to maintaining the style and tone that set the magazine apart from other trade publications. But how could I motivate the staff if I didn't trust them? I was tired.

I knew I was seriously off track when I experienced a meltdown during a trip to Kansas City to do a Midwest-markets issue. The trip proceeded smoothly: good interviews, VIP treatment from Hallmark, an enthusiastic panel of agency people, superb hotel, and my regular sidekick, David Gunn, with me. But my second night there, I started crying and pacing. I couldn't quiet my mind or body. I had never felt so lost. I called Clem. No answer. I called David in Los Angeles, my now ex-analyst. He was

there, but not in the way I needed him. He was almost indifferent to my state of mind. He had switched hats. He talked not as an analyst but as a friend, more than a friend.

About a year into my analysis I had begun to feel that David was coming on to me. I well understood the power of the patient-analyst attachment, and, like a good patient, I had shared those feelings. He had said that my perception was a natural part of my transference. However, shortly after that, he had initiated a conversation about countertransference. Oh, the jargon of it all. It seemed my feelings had been spot on, and indeed he had feelings for me that went beyond the patient-analyst boundaries. I hated what I heard, while at the same time I felt relief that I hadn't been imagining it. I was also scared that it was one of those "things will never be the same again" moments. But, as I have said, David was a good analyst and the incident was smoothed over.

In Kansas City, what I thought had been smoothed over had merely been sidelined. I asked him if I was having a panic attack. I knew that I was. Instead of advice, he suggested we meet somewhere, perhaps a resort. Or he would come to New York for a visit. Could he stay with me? I told him I didn't need a lover, I needed an analyst, and hung up.

Technically, there was no unethical behavior on David's part; the analysis had been terminated. To my way of thinking, that still didn't make it right. But I needed him, and, after several subsequent phone calls over the next few months, we began a sporadic sexual relationship. Two or three times he stayed with me in New York, and I with him in Los Angeles. The problem was, I did not find him attractive and did not want to have sex with him, yet I continued the relationship. That was a first, and I was angry at him and at myself. And ashamed. I couldn't ascribe my complicity to the thrall of analysis. That was gone. Though I often thought that perhaps there was no time limit on transference. Sadly, the person who could have helped me sort out my feelings was the cause of them. And I didn't feel free to talk to others about the situation. The abuse of power analysts wielded over their patients was still a taboo subject and protected by secrecy. That would soon change, and experiences such as mine would become almost commonplace. But meanwhile, I kept my story to myself and tried to focus on how grateful

I was to him for understanding what it had felt like to be "orphaned." And for shepherding me through my years at the magazine and through my reconciliation with my mother.

By the time I returned from Kansas City I knew my departure from *Madison Avenue* was imminent. Walter had methodically chipped away at my editorial standards. There would be no meeting of the minds, and grinding out perfunctory fodder to feed the bottom line was not my idea of fun. I lasted a year under the new regime, and in May of '79 I left. During my final weeks, Walter revealed a hearty geniality. I preferred his anger; at least it was sincere. With the help of a lawyer, I reached a satisfactory buyout of my shares. For five years the magazine had been my world, and I left with pride and self-confidence.

So many changes, so fast. I had no plan, only vague ideas of what I might do next. I would write. But what? I would have the time to fall in love. With whom? Instead, I took intensive French at the Alliance Française—that refuge for women at loose ends—read a book a day, scrubbed and polished, tackled Julia Child when the spirit moved, succumbed to TV dinners when it didn't, and obsessed. I basked in Sarah, teeming with vitality and the pleasures of her final years at Trinity. I liked to think she didn't notice my aimlessness. But Clem did, and we spent more time together than we had in recent years.

As with sex and drugs, I was also a late bloomer when it came to the women's movement. I now had time to catch up on what other women had been reading—Germaine Greer, Gloria Steinem, Betty Friedan, Simone de Beauvoir—and to rally around congresswoman Bela Abzug and the ERA. Previously, I had remained on the sidelines, a sympathetic witness of women's inequality and the demands for change.

Hell, I was an old hand at men's worlds. I had almost suffocated in the art world. But I was on the fringes, and had come to take it for granted. It was different for women artists in the fifties, when those who were taken seriously by the guys could be counted on one hand. By the seventies, the situation had moderately improved, but . . . As for the boy's club of the advertising agency world, that had remained as immutable as Stonehenge.

At the magazine I had watched the momentum effect change as national

advertisers, like Rip Van Winkle, slowly awakened to the alien notion that women bought cars as well as detergents. In our first issue, I had run an article about the stewardesses' protests against Eastern Airlines' sexually suggestive "Fly me" campaign. Their union was also demanding that their designation be changed to *flight attendant*.

I had interviewed Pat Carbine, publisher and cofounder, with Steinem, of *Ms.* Stepping over toddlers and toys in that magazine's homey office, I wondered what Charlie would make of a playpen at *Madison Avenue*. Carbine was homespun and motherly, my projection. Fact was, she was a pioneering, smart businesswoman who had the guts to publish the first women's magazine that wasn't about fashion. She was a singular figure in the man's world of publishing. At Madison Avenue I had been accepted because I supplied publicity, a service men could use. But I had never met a fellow woman editor in chief, except a few, again at the women's magazines. Nor a Pat Carbine, a woman publisher I could hug and who hugged me back.

And then there had been the conference-room incident. At the beginning of my first review board panel, Charlie, after greeting everyone, put his hand on my shoulder as he left. Later, the only agency woman on the panel—women creative stars were in short supply—drew me aside to alert me to what she described as Charlie's "condescending behavior in the workplace." *Harassment* had yet to become a buzzword; my first thought was that she had sniffed out our incipient affair. My second was relief that she was referring only to his apparent lack of respect for my position. I assured her Charlie and I had an equitable working relationship and made a note to invite her again, but not too soon.

While still at the magazine, I had had another close encounter with feminism. This time with Ti-Grace Sharpless, a core member of the movement and a woman I knew socially as part of the art-world circuit. One of those has-everything women: beauty, brains, ease in the world, and money. On a late afternoon, she and I were in the living room at 275. Clem was expected soon, and we were having our first and only tête-à-tête. She spoke at length about the National Organization for Women, and the consciousness-raising groups that I might be interested in. Ashamed by my ignorance about the movement, my mind clapped

shut. I felt judged, defensive. My life was perfect, thank you very much. Besides, wasn't she having a casual, now-and-then fling with Clem? Yes, for all the openness of our marriage, my proprietary bells still jangled on occasion, especially when the femme was "too good to be true" and had a mischievous streak to boot. The message may have been fine, but she sure as hell was the wrong messenger.

All to say, that while I had grasped the import of the women's movement, I had failed to see its relevance to my own life. But everything in its own time. Soon after leaving the magazine, I did find my way to NOW and became part of one of its small, satellite, consciousness-raising groups. Provided with a briefing by a moderator and an agenda of issues for discussions, we spun off on our own. Pledged to sisterhood and no bullshit, we met once a month for two years and probed and challenged everything from our most intimate secrets to our role in improving women's equality. And when we completed the agenda, we devised a new one. Those friendships would be lasting.

Norden called in late 1980 to tell me that our father had colon cancer. The surgery had not stemmed its course, and the prognosis was bad. *Here I go again*, I thought, but I knew this journey would be very different. Though I had rejected my mother, well before her death I had begun to heal the wounds with her. But way beyond that, I *knew* my mother. No matter what, she was in me, part of my heart and bones; her eyes looked back at me in the mirror. But who was this father, this stranger I resembled: Nordic, tall as I was, to whom I felt no kinship? Unforthcoming, unaffectionate, preternaturally passive, he had never invited me in, and then without a blink he had disowned me because he hated Jews. That he felt strongly about anything had been a surprise. That he was a bigot was less so, being, as he was, a conservative whose national hero in the fifties had been Joe McCarthy. All so long ago. Twenty-five years had elapsed with no overtures, no acknowledgment of Sarah's birth, nothing. I had never considered making the first move. It had taken so little to tear the fabric that tied us, and once torn, it was far too fragile to be mended.

But dying. Dying says, *Now or never*. I didn't think hard or long. I decided to have a look at this eighty-year-old cipher of a father. At my

request, Norden agreed to join me, and we set a time to meet in Tampa, where David and Marge had lived since he retired. I set off with curiosity and a cold heart.

He was straight and tall, backlit by the tropical sun, his silver hair abundant, arrayed in apricot slacks and yellow polo shirt, for all the world as if he were headed for the first tee. Marge, the Nurse, was at his side, thick, stolid, arms crossed. I still saw her as the woman who had plucked my father from his marital nest. Her purple fetish had run amok with age. From mauve to deep plum, from toilet paper to carpets, not an inch had been spared her decorating palette.

We sat stiffly in the glass-enclosed terrace, or "Florida room," as Marge called it, looking out at palm trees, plastic flamingos, and a man-made pond. He puffed oxygen; he had advanced emphysema. She smoked. We all drank martinis. So much was the same. So much had changed. His pallor was ashen, the eyes cloudy. He was so thin I saw his bones, his skin so translucent I could see the map of his blood. It was as if he were turning inside out. The Nurse now had a full-time job; her patient was losing ground. He made small whistling sounds as he breathed. He spoke little. When he did, it was an effort. The rest of us compensated with chatter. No one except me looked into the twenty-five-year abyss between us.

Amazingly, we went to a restaurant that night. That was when, toward the end of the meal, I lost it. Anger poured out of me: "Is anyone going to ask me about my life, where I live, what I do? Is anyone going to ask me about Sarah, what she's like, what she's interested in? Here, here's a picture. This is Sarah, your granddaughter. She's seventeen; she's beautiful and smart and happy." Silence.

I may have unburdened my heart, but I felt defeated. I had been impelled by an urgency to shake them out of their complacency: *Look at me. I exist.* But to what end? No one did look at me. No one said anything. I had only made the abyss deeper. Marge complained of palpitations, and we fled the restaurant. At the condo she had to be helped up the stairs. The next morning the prickly barricades were back in place, and I soon left for the airport.

But I was undeterred. Over the next months I went back three times.

The next visit was coordinated with Norden and Pieter, my sweet boy of a half-brother whom I had known and loved so briefly before the abyss. That visit was more about rediscovering my thirty-nine-year-old brother than about saying good-bye to the father we shared. It culminated when Norden, Pieter, and I took off for a few hours in our father's big boat of a Buick. He had always prized his Buicks. We were like teenagers ready for a Tampa adventure. Three oversize Van Hornes in the front seat, me in the middle. A sister and her two brothers. Pieter put his arm across my shoulder. I put my hand on Norden's knee. Skin to skin. Everything was funny; we laughed until we hurt. I was in heaven. This was the way it should have always been.

Another month passed before I returned, this time with Sarah. She didn't want to come, but I appealed to her curiosity about the grandfather she had never met. Though just a quick overnight, the visit was a mistake. David was even frailer. Even in his prime, he had had nothing to say to me. Why did I imagine that now, when he was a shell of a shell, he would have any interest in her? She took away nothing from that desultory, sad day. Much later, when I asked her about it, she said, "I don't remember him. Are you sure I went with you?"

And then the last call. "If you want to see him again . . . " This time it was just me. This time I wanted a moment alone with him. In the late afternoon, I asked the Gorgon at the Gate if she would leave us alone, just for a few minutes. With dark eyes, she retreated.

He and I sit across from each other in the Florida room. I am soft and gentle. I ask him, "Did you ever think about me in all those years?" And then a few other questions like that, short questions, short answers, all very simple. He says all the right things. Even "I'm sorry." I tell him, "What a terrible waste." He nods. And I am in his lap. Then I ask him the question in the hearts of all abandoned children.

"Did you love me?"

"Yes."

"Did you love my mother?"

"Vera was my first love. I have always loved her."

They haven't seen each other for forty years. Is he just responding

to the plea in his daughter's blue eyes, so like Vera's, as she sits in his cancer-ridden lap? "Such a waste," I say again, thinking how easily those two threw people away. I tell him that before she died, Vera said she was "dancing with my dear David." He holds me tight. He is so strong. I am so little. I call him Daddy for the first time. And why not? It is the first father-daughter conversation we have ever had.

Later, Marge asks if I want to say goodnight to him. He lies so flat in his tight envelope of sheets. Drained, he fades into the whiteness of them. His lips are cold and dry. I kiss them good-bye.

What a pair they were, my parents. For my mother, the theme of her marriage with my father had always been the victim of true love, betrayed. And for him? I don't know. I suspect that he did not often think of the past. Conditioned to inertia, he preferred to live in the sway of others. I never thought of him as either happy or unhappy, presenting, as he did, an emotional blank slate. Their deathbed messages to each other and the actions they had taken so long ago did not mesh. They had casually slipped those lovelorn messages into a bottle to be delivered in Never Never Land, with me as the messenger.

Over the years, my mother had perfected her romantic illusion of true love. While at one time I had sniggered at her romanticism, I had by no means escaped unscathed. I too had my illusion, that my father would someday come through for me. Of course, he couldn't and didn't. And I had also succumbed to another abandoned-child syndrome: the myth of reunion. Over time, the myth lingered, like sludge in my arteries, as I pondered their last words about each other, so blithe, so innocently open to the "what might have beens."

One early summer day in 1981, Clem suggested I come back and live with him. Sarah would be leaving in the fall for Vassar, and I was coming to grips with the degree to which my life would be emptying out. Since I had left the magazine, there had been a bit of drama, a few sexual skirmishes, workshops, a few trips. All fillers. And there had been loss. Now I also faced the degree to which Sarah had been insulating me from the aimlessness of the last two years. That hit me hard. I knew better; that shouldn't have been her job. Here was Clem, suggesting a plan. Sarah's

going away would be a big transition for all of us, and consolidation made sense. It would be a bridge. I wondered why the thought had never occurred to me. I took it to heart, pleased and comforted.

"Come live with me." Somewhere in that line—beyond "and be my love"—I heard, "as long as everything stays the same." The last five years we had been living two blocks from each other, talking almost daily, seeing each other often. I still ran the household, paid the bills, cut his hair, all the usual tasks I had assumed when I had moved into 90 Bank Street twenty-five years before. Well and good. But Clem was still awash with women. Though none were particularly long term, and those whom I'd met I rather liked, still . . .

For the first time since our "openness" had become a reality, I felt that I would need more from Clem. Unsettled as I was, returning home to set up day-to-day housekeeping for the long haul while everything stayed the same was something I couldn't picture myself doing. Though Clem had made the suggestion at the right time, the timing was off for me.

I knew well the power of choices, and I considered them. I could stay where I was, I could move home with Clem, and, before the summer was over, there was a third choice: I could move to Los Angeles to live with someone I had met there, and liked, the previous year. And that is what I decided to do. As had been the case with our other life changes, little was said between Clem and me. It was simply understood that we would continue as before—separate yet together.

THE EIGHTIES

I EXITED LAX, blasted by the yellow light, the heat that carried the memory of desert and the air I could taste. Russ stowed me and my stuff in his '67 green MGB. We drove up La Cienega, past the oil derricks, the wind in my hair. I thought of Lena Horne's "Lady Is a Tramp," except I hated the wind in my hair. Whether I was a tramp or not, I wasn't so sure. If moving across the country to live with a man I barely know . . . well, maybe I was. I wrapped a scarf around my head and hoped I didn't look frumpy.

I had always had a good time in L.A.—from my first trip with Clem, in 1960, to the whirl with Charlie to all the subsequent trips for business and fun. A good-time town, as far from New York as one could get and yet still feel in the mainstream. A heterogeneous soup of colors and languages. The only city I had ever imagined living in other than New York, and this was the time for some imagination. Besides, in the summer of 1980, through my old theater buddy Beverly Magid, I had met a man I could imagine living with here.

I was upstairs in the bedroom I would share with Russ, in his white colonial house with a picket fence that looked more like Rye than Hollywood. It was a house that teetered on the edge of a long, drawn-out divorce. Its future was the contentious centerpiece of a marriage that had died years before. I couldn't breathe. Dizzy, I sat on the yellow comforter. I felt cosseted, a word I'd never used. Sounded so similar to *closeted*—closeted in coupledom. It was a strange new feeling, dizzying but nice.

I was four blocks up the hill from Hollywood Boulevard and Musso and Franks, my favorite restaurant, where I could indulge in my favorite dinner—a martini, jellied consommé, and creamed spinach—and five blocks from Judy Garland's footprints at Grauman's Chinese Theatre.

I looked out the windows, open wide to the hum of Hollywood and the scent of jasmine. Three banks of windows, each with its own slice of hills and sky, palm trees, and crimson splotches of bougainvillea. A Technicolor world. I looked at my azure blue canvas duffel draped across a chair. I had bought it at Bloomingdale's early in my magazine days. I loved its adventurous color at first sight, its buttery leather straps, and its magical ability to shrink and expand at will. I had a few special things that I treasured; the blue duffel was one of them. The rest were just things. Russ was downstairs. Suddenly, music filled the house. "Welcome to the Hotel California . . . " All was well.

Awaiting me were the promises of a new life: a playmate eager to introduce me to the secrets of the city he loved and knew so well; the light, airy house; new people, and a few old friends, including Debby Katz, from my Bennington days, and her husband, Norman, who had been with me the night I had met Clem, and, of course, Beverly. And, front and center, sweet Charlie, Russ's black cockapoo, the first dog I ever bonded with.

Mostly, we were on the go. Museums, art galleries, architectural wonders, beaches—we hit them all. Restaurants, bars, movies, lots of movies. And when we had canvassed the home front, we made side trips, from Santa Barbara to San Diego and its zoo at twilight. We went to Palm Springs and discovered "our place," Two Bunch Palms, where I became addicted to massages. We played Scrabble in the sun, by the fire, and in bed. We went to parties and gave parties.

Then one day we went to the supermarket together for the first time. It was an outing I had only fantasized about during my life with Clem. Here I was with someone who pushed a grocery cart with me. By the time we reached the produce department, my fantasies bit the dust. Seems I hadn't a clue about how to choose a tomato or a peach, much less thump a melon. Everything I chose went back on the shelf. Never before having had to account for anything to anyone, I hadn't mastered the art of collaboration and saw everything as criticism. I fumed and kicked the cart, and thanked God for having bestowed on me the precious gift of Clem's indifference to such things. At my advanced age, I had butted heads with a tough lesson—to live in a true partnership means not always assuming

you're right. And so, to protect my thin skin from future criticism, I soloed in supermarkets and ducked duets in the kitchen, that breeding ground of resentments.

That said, the getting-to-know-you skirmishes were few, considering we were two people in our forties who were set in our ways and used to being in control. Besides, they were far outweighed by the good stuff. I marveled at Russ's boundless energy and creativity. A currently unemployed art director for movies and TV, he had a passion for painting, music, and theater and was a formidable tap dancer. And who could resist a man who took such pleasure in making room for me in his closet, bureaus, medicine cabinet, and his life? I was so happy to join, for once, a ready-made domesticity, all the tchotchkes already in place. Best of all, we liked and loved each other.

As much as I enjoyed our playtime, I intermittently began to feel the familiar tug of aimlessness that I had felt after I left the magazine. The flip side of the ready-made house and a domestically adept partner was that it was a house that didn't need me. At forty-six, I knew from experience that if I wanted to give myself and our 24/7 relationship a chance, I needed not only to excise the aimlessness, but also to outwit the lure of losing myself in a man. That cozy exclusivity—how seductive to feel like gods on the wings of love and expectations. From there, I knew how easy it was to slip into petty dissatisfaction and eroding self-esteem.

I made a plan. I would stake out the time in a day and space in the house that I could call my own. What I would do in that time and space, I had no idea. I hadn't been able to commit to such a plan after leaving the magazine. Now, not only did I have motivation, but I had a witness. There would be a person on the other side of the closed door while I was doing lord knows what, a person who would welcome me when I opened the door, who might even be proud of my industry.

My solution may have been simple and obvious, but the fact was, I had never learned how to bring balance to the man-woman push-pull. What began with the closed-door plan was as close as I would ever get. Russ made it possible. He was supportive and helped set me up. The room was large, with a day bed, a chair, a hooked rug, and a big library table placed next to windows that opened into the branches of an apple tree

and an empty lot beyond, both rarities in L.A. I opened up the typewriter that I had optimistically packed in the trunk I had shipped out from New York and closed the door. I decided I would write.

But what? Poetry? That's where I had started, with all those passionately innocent poems that had gushed out of me the first fall at Bennington. Poems that had become increasingly tight-assed over the next four years, until they were second-guessed stutterings squeezed dry by critical methodology and unabashed emulation of William Carlos Williams, Auden, Macniece, et al. In the past months I had written some poems for Russ about L.A., our house, our life. They had heart, an innocence reclaimed. As glad as I was to have tapped back into my poet self, that was my private voice, much like the journal writing that had been part of me for years. Besides, poems were too small, just as novels were too big. I had no appetite for the vast scale. I wanted something I could metaphorically hold in my hand. Short stories? I didn't like reading them—well, except for Henry James, with whom nothing came up short—so why would I want to write them? But what about plays? I had come to believe that life had a way of recycling experience. Playwriting might be just the thing. And so, with years of theater improvisation in mind, I jumped in. It went something like this:

Kitchen. A phone rings, a woman rushes in through one of several French doors, dumping packages on a long butcher-block table downstage. Phone stops as she picks up. She puts away groceries. Phone rings again. She grabs it, angry.

She: What! [*Pause.*] I can't hear you! [*Pause.*] Oh my God, Willy?

Seems "She" has just arrived from N.Y. to live in L.A. with someone she barely knows, when her bad-news brother, Willy, shows up needing a place to crash, and so on, right up to "Lights fade to black."

The best I could say about it was that it had a beginning, middle, and end, and that it had taken only a week of my life. Beyond that, it sat there, misshapen and leaden as cold oatmeal. Fortunately, I knew that *First Play*, for so I dubbed it, belonged in the back of my closet, where no one would ever see it. I also knew what to do with the next one: ease back, lighten up, and listen to the voices rather than some so-called "plot."

Over the years I would stay in L.A., the plays would get better: more

intricate, the needs and dilemmas sharper, the moments funny or angry, usually both. Words—to play with them, their resonance, the rhythms; that would always be my fun. A place, a line, a face, an object—plays would bloom in my mind in wondrous ways, and always I would be led by the voices of women. Some of the lines and images still call to me:

Will You See Me When I Wave?
A long-married couple on a porch. A hot, late summer evening.
She: I wish . . .
He: Got up to ninety-two today.
She: [*Beat.*] More, I would have thought.
He: No. Ninety-two.
(He watches as a fly alights on his arm. He lifts his arm, looks at the fly, and gently lowers his arm. Until indicated, He doesn't move that arm.)
She: You won't forget to . . .
He: Every Thursday night.
And so on . . .

Fine Line
A party is in progress beyond the closed door of a designer Upper East Side bedroom. A fight is in progress between two thirty-ish knockouts, who face off across a large bed heaped with fur coats.
Dody: You do! You think I'm a victim!
Zee: [*Incredulous.*] Victim!
Dody: A doormat!
Zee: Look, you're a victim, I'm a victim . . .
Dody: All these years, and now you call me . . .
Zee: . . . everyone's a victim!
Dody: And I thought you cared . . .
Zee: . . . At least females. Men, on the other hand . . .
Dody: [*Lunging at her.*] Damn it, Zee! You're my best friend!
And so on . . .

Keepers

Grace: [*Offstage.*] Cheese balls. If there's anything I hate more than cheese balls!

Grace, a flamboyant, rain-drenched, sixty-ish woman, bursts through the door, followed by her restrained, voice-of-reason sister. Crouching unseen on the stairway is the virago's forty-ish daughter, a sullen heap of damaged goods.

And so on . . .

Within a few months after shelving *First Play*, I finished *12 Chatham Road*, a marginally improved, full-length play. Soon after, at a party, I met a young actress who belonged to the Ensemble Studio Theater, a branch of EST in New York. The large group of actors, writers, and directors worked out of a theater space in downtown L.A. The actress took my play, and someone must have thought it passable, because I got a call to join the group. By that time, with Russ's sage guidance, I had bought a Volvo. Not quite the pizzazz of a Mustang, but it was sure and steady. I was ready to open the sun roof and hit the freeways.

The Ensemble was unlike *Madison Avenue*, where beneath the joy of meeting a challenge there had always lurked the quicksand of my ignorance. Now, I was a one-play playwright—a ho-hum play at that—but I knew theater. The high energy, the infighting, the fellowship, the power plays were all mother's milk to me. I had lived it all in my theater days. All I had to do was keep writing. Hell, the plays couldn't get worse.

That fall of 1982, the Ensemble scheduled a ten-minute-play festival. Everyone jumped in the pool; actors, directors, writers all competed for the twelve spots. I wrote *Will You See Me When I Wave?* over a weekend. Though a transparent paean to Pinter, it was dead-on. Here was a play I could hold in my hand, all the economy of a poem and the immediacy of theater. I had stumbled on a short form I would often return to, with pleasure and success.

One noon-to-night Saturday, everyone who had signed up read their playlets for the jury and the full-membership. The actor in me paid off; I had timed it and rehearsed it. The play was chosen. The icing was that John Randolph and Sarah Cunningham signed on to do it. Long-married,

well-established actors, they were also the co-founders of the Ensemble. Not so sweet, I also learned that they were old-school actors, pragmatic, and stubborn. They wanted the sentences completed, what did this and that mean, and the silences, that would not do. I was the new kid, and the director knew where his bread was buttered; nonetheless, I stood firm. Of course, smiling all the way, they did exactly as they pleased. In the name of "honoring the text," they "picked up the pace," and effectively turned my filigree into a chunk of metal. But they were charming, and the play was enjoyed and was featured in the *Los Angeles Times* review, picture and all.

Because my plays would continue to be driven by the rhythms and patterns of the characters' voices, I would invariably run into hassles with directors and actors. I understood the seduction of going for "real," rather than style, but I also hoped they would have the faith to at least try to achieve both. Thinking that clear signposts might help, starting with my next play, *Legacy*, a full-length with a cast of eight, I incorporated slashes into the dialogue to indicate when the next actor should begin speaking her line. Sadly, actors are courteous people, programmed not to "step on" someone else's line. I explained that half of most sentences, onstage and off, were throwaways. But the audience, they wailed, they won't get the point. They'll understand exactly as much as they need to, I assured. *And they'll hear the music*, I didn't say, because I knew that would be a hard sell. I also knew that actors—not the best—are driven by two things: not to make fools of themselves, and to make their characters likable—two things antipathetic to playwrights. And oh, the joy on those occasions when during a performance I would hear two trios or quartets simultaneously ride the wave to a crescendo.

By the beginning of 1983, Russ's acrimonious divorce was finalized and we downsized to Broadlawn Terrace in the hills overlooking the Valley and spitting distance above Universal Studios. A small house with a small pool, a cottage coziness. Russ set up his studio in the one-car garage, and I worked upstairs in a room just big enough for me and my table.

Russ was now working at Universal as art director of the new series *Knight Rider*. Our togetherness shifted dramatically into "see you when I see you" mode. His long hours, stress, and drinking to "unwind" strained

our relationship at times. In the whirl of my feelings for Russ and my excitement about a new start, I had glossed over the impact his drinking might have. With insouciance, I had assumed I could handle it, and I did. I never considered leaving; I wanted to be with Russ and I wanted to be where I was. In any case, it was soon clear that our good times would outnumber the difficult times. It took diligence not to get swept up into the whirlpool of the drinker, but I was motivated. So it was that on the "bad days" I would dust off the drill learned as a teenager: sidestep, disengage, and, most important, keep a firm grip on my own life.

My cornerstone was EST's weekly writers' workshop. Through one of my new friends, I also started going to a monthly workshop, the Writers Bloc. A large group, it served all genres, from screenwriters to novelists, and was more formal. One signed up in advance to have a reading by group members, many of whom were actor-writers. Criticism was fast and furious—everyone had to have their say, which ranged from gratu-itously harsh to insightful—and I learned to take what was useful and toss the rest. I also honed my ear and taste by listening and critiquing the work of others.

Soon, without a whisper of self-doubt, I slipped into thinking of myself as a playwright. To be a playwright in Hollywood sounded like an oxy-moron, but there was a plethora of small theaters that presented original work and attracted enthusiastic audiences. Fortuitously, I had taken up the right trade in the right place. In L.A. I could experiment and get my work produced, precisely because it was a movie town and theater was treated as an impoverished, but charming, cousin. In New York, theater was God and the turf inviolable.

Engrossed as I was in my work, I continued to make frequent trips to New York, where I would stay for several weeks. In 1983, on one of these trips, I sealed my commitment to my life in L.A. by selling the apartment at 257 Central Park West. It had gone co-op a few years after Sarah and I moved in, and, to my amazement, we now lucked into a siz-able profit. I merged our two Central Park West apartments and, keeping the best of both, took the opportunity to refurbish 275, which was, and still is, a rental. Clem, as usual, barely noticed, except for the wall-to-wall carpeting. He never wore shoes at home, and, as I knew he would,

he luxuriated in the deep-pile softness underfoot. I would continue my regular visits to New York to see Clem and Sarah; the only difference, now I would be staying at 275. Clem was content. I was content. I had tidied up my life.

Well, not quite. There would be one more bit of domestic tidying up when, in 1988, we sold the Norwich house. Clem not only took it in stride; he seemed relieved. I think that increasingly he had spent long periods of time at the house simply because it was there. The last time Clem and I would be at the house together was for Al Velake's funeral. A fitting time to leave. I scattered the fossil rocks around the property to be discovered by the next wide-eyed voyager into the past. I sold the cars and put mementos and the oak furniture from the loft into a storage unit. I found I was still unwilling to relinquish those symbols of my first foray into an independent life. Otherwise, nothing went to New York that wouldn't fit in our rental car, and the rest went to whoever wanted it. No financial bonanza from that sale. We sold it for what we had bought it for. Even after fifteen years, it was still a house too small and too offbeat for most.

In January 1984, I got a call from Billy Hopkins, who was production manager at the Ensemble Studio Theater in New York. The L.A. playwrights had been encouraged to send plays to their Marathon, a highly esteemed and well-attended annual festival of one-act plays. I sent *Fine Line*, the first play I had submitted anywhere. When Billy called, I screamed. He was delighted; so refreshing, he said, after the usual blasé responses he got from most writers. Not that it was a shoo-in, but I had made it to the final cut.

A few weeks later I was on the second floor of the Ensemble, listening to Christine Lahti and Judith Ivey give life to my Doty and Zee as they tried to unravel the age-old dilemma of how to leave a man. It was the first time I had experienced the joy of hearing my words channeled through actors of such sensibility and experience. I still see Lahti casually stroking a scarf she had put on the table—such a simple gesture, but one that brought the bedroom and the furs to life. Billy had done my play proud. Watching were Curt Dempster, the über-meister founder/director of the theater and a committee of judges. Afterward, I was so high I

walked all the way uptown. I stopped at a florist and called Billy for the actors' addresses and enclosed gushy notes. They had changed my life. I knew, somehow I had known from its conception, that *Fine Line* was a winner. And I was right; the play would be produced in the Marathon.

Again, thanks to Billy, I was gifted Harris Yulin to direct and Roxanne Hart and Jill Eikenberry to star. The rehearsals were intense for me as I learned when to battle, when to cave. The designers, the music and sound, the costumes, with Billy masterminding down to the last detail, the Marathon was first-class all the way. The experience surpassed the thrill I had felt as an actor. Now, I had created this piece and was part of the team that was devoting their talent and skills to make *Fine Line* the best it could be. A thrill that would never grow stale.

The opening, the laughter, the absorbed audience; afterward, the long table at the restaurant on the corner of Tenth Avenue and Fifty-second, jammed with my old theater cronies—so like those days, only better. I didn't miss a performance. There were some good reviews, followed by an offer from Samuel French, the primo play publisher, to publish *Fine Line* under its own cover, an honor for a one-act. The play was also selected with two others as the Best of the Marathon, to be performed at the SUNY play festival that summer. I also received a request from CBS to see more of my plays with an eye to TV work. That one I passed on. I had to—I had no "body of work" to show them.

I had gotten off to a remarkable start, from finding a home base at EST/L.A. to having my first two short plays produced. I had known from the first lines I had written that playwriting was right for me. The quick validation was the gravy. What had started as a plan to secure my sense of self while I nurtured my relationship with Russ had now blossomed into a vocation. Who would've thought? And as the plays multiplied, I started mailing them out to regional theaters. I had done my job; now I sent them out into the world to do theirs. Being a playwright, I had all the fun, none of the angst—no auditions, no stewing about whether I was too old or too tall, no having to shave my legs or put on a happy face.

Soon, thanks to another writer friend, Shirl Hendryx, I became a member of a third writer's workshop, the Actors Studio in L.A. It matched its

New York mother ship in intensity and tough standards of the work and criticism. It also perpetuated the cliquey-ness and elitism that ensured its edginess. However, I missed the intimacy and fellowship that was possible in New York. In typical L.A. fashion, everyone drove up alone for a session and drove off alone afterward. There was no Jimmy Ray's or Joe Allen around the corner to hang out in. It was a daunting venue to work in, but once I had sorted out the objective folks from the die-hard misanthropes, I was able to keep my focus on presenting my work. Just as my acting life had snowballed in the sixties, one thing led quickly to the next. Once again, I was feeling that exhilaration of using myself completely.

I was always on the prowl to hitch up with a particular director or nucleus of performers, as so many other playwrights did. I kept thinking, *Maybe this time I will find the perfect mesh of actors and director who not only will hear what I hear in the plays but will astonish me with their own artistic insights.* To that end, I came as close as I would get with Pamela Gordon, who directed a quirky play, *Three at Squam Lake*, about the slippery shifts of power between two men and a woman. It was workshopped twice at the Actors Studio and then staged at the Wilton Theater with Bill Pullman. That perfect mesh was there. At its nadir, there was *Provenance*, so lavishly produced on the large main stage at EST. The set, the skeletal frame of a nineteenth-century Cape Cod beach house, conveyed both beauty and foreboding and illuminated the play perfectly. Sadly, the lead actors, querulous and egocentric, abetted by a limp director, jettisoned the delicate play about love and the fear of change. But oh, that set.

And in between the two I think of *Keepers*, the play that might have been but never was. For me, it was the most achieved of my "musical" plays. The harmonies, the duets, the quartets, the arias, were music to me. It had a highly polished staged reading with Salome Jens and Kevin McCarthy at the Actors Studio. It came close. There followed another reading of *Keepers* at the Skirball Theater, where dream casting came through, almost. Nancy Marchand, set to play the lead as the tyrannical curator of her past and everyone else's, had to drop out two days before

the reading, when her friend with whom she was staying in L.A. died. Always a bridesmaid, *Keepers*, as admired as it was, would be optioned twice but never produced.

Closest to my heart among the productions was *By Sections*, a play for an unlimited number of actresses in eighteen "sections." It was inspired by a vision I'd had of a group of women, all ages and colors, seated as if on the rim of a half-moon across the stage. The playlets—some monologues, some for two, some for more, some comic, some sad, some strident, some soft—flowed with all the voices of all my women. The director, Dan Hamilton, through lighting and projection, carved out the sections while making the whole cohesive, as he brought the actors to a transcendent place. When it was done in New York, the director chose not to use the ensemble on stage and though the pieces worked on their own, the impact was lost.

By Sections was a later play, and by then I had accepted that once a play was out in the world, it was a win some–lose some game and each play would have to take its chances. The lesson was hammered home one rainy night when some friends and I went deep into the Valley to see a production of *Fine Line*. By that time, the play had had many incarnations, few of which I had seen. That night I saw a different setting and different opening lines. I had to double-check the program. The young actresses sprinkled the play with *you know* and *like*, dropped lines, and added others. A Valley girl romp. We snuck away, went to a bar next door, and laughed until we cried into our double martinis.

When I had first moved to L.A., I had established a connection with Russ's internist. I went to see him for annual checkups and minor things over the years. In 1986 I had a virulent and persistent bronchial infection, and the doctor suggested I go to the Barlow pulmonary clinic in Pasadena to be evaluated. I was at the clinic all day. First, my history: family health, childhood scarlet fever and severe whooping cough, walking pneumonia, and, of course, smoking history. Then the testing: blood work, X-rays, breathing into tubes and inside space capsules, sitting, standing, running. The result, "mild emphysema."

As I drove home, I saw myself suffocating as my father had. What had the bastard bequeathed me! Mainly I cursed myself for years of smoking.

I had started in college, stopped during my pregnancies, picked it up again for eight years, quit again for ten years after the hysterectomy, then started again after moving to L.A. I had never had any trouble quitting, but then, almost whimsically, circumstances would shift and lighting up would seem like a fun thing to do.

As I sat stalled in rush hour traffic, I thought of a house on Beacon Hill in Boston in 1952, I a bridesmaid at my ex-roommate Sandy's wedding, twiddling a glass of sherry, wearing a spectacular red velvet gown, and yearning for a cigarette, which was verboten in that house. Sandy's father, Dr. Little, a handsome, authoritative man in tails, stood at the center of the wedding party as we waited for the ceremony to begin. He told us of the research he had recently spearheaded that proved without question the devastating effects of smoking. "Cigarettes kill," he summed up. "The government knows; it is only a matter of time before the public will know." I imagined his frustration as the decades passed and the government sat on its hands and the public puffed itself to death. How awful to think that I had heard him, had never forgotten hearing him, but hadn't listened. That day at Barlow, I listened. I never smoked another cigarette. When I got home, Russ held me for a long time. I was scared.

But I had my usual antidote: work. Sick of my own bitching and moaning over the years about inadequate directors—and perhaps feeling a need to take control after my health scare—I decided to take a shot at directing one of my short pieces, *Security System*, at the Actors Studio. Casting it with Richard Behmer, Pamela Gordon, and Barry Stattles, I figured it would be easy for four old Studio pros like us to plumb the depths of the material. We presented the piece and it fell flat. The audience clobbered me, the actors, and the play. Mostly me. That failure gave me new respect for directors. We had all plumbed beautifully, mined glorious nuggets of nuance, but my inattention to the overall shape of the piece and my inability to clearly communicate the play's intention, to either the actors or the audience, had reduced it to shambles. Lesson learned.

I finally accepted that though I had created the characters and endowed them with my personal voices, to expect others to hear them and what lay beneath them shouldn't be necessary. If the frame of the play was solid, it should serve as a vessel for any amount of interpretation and

experimentation. Too often I had underestimated the mystery that is at the heart of theater. How else to explain how a scene can work one night and fail the next? Oh, I still fretted about not having things my way, but unless there was a shipwreck I might avert, more and more, I put my feet up and trusted the mystery.

However, all was not the world of make-believe. Real life stumbled along and sometimes took a fall. By 1988 we had moved once again, this time triggered by the financial lure of cashing in on the real-estate boom. Selling our cozy Broadlawn nest, we moved farther up the hill to Mulholland Drive, to a jerry-built house that was ugly inside and out. But it had a major selling point for us: a back yard with large pool and Jacuzzi, palm trees, masses of bougainvillea, lush vine-covered walls. A tropical paradise. Perhaps we could overlook the small nonfunctional rooms, the low ceilings, the darkness. The place was cold, unwelcoming. Indeed, as we arrived, the overhead entry light exploded.

We did our best. I took a room on the second floor as my workspace; Russ opted for a cramped basement room as a studio. For the rest, it even defied Russ, an inspired nester. But the coup de grace soon struck. We were surrounded by gated properties—even we had a flimsy excuse for one—that were patrolled by guard dogs. Night and day the six Dobermans barked at anything that moved, and when the world fell quiet, they howled at the moon. We tried all the help lines, we taped, we photographed, we tried city mediation. To no avail. Sleeplessness, stress—Russ was ready to resort to poison. The problem eventually escalated into an ultimate neighbor nightmare. A vengeful dog owner lit a fire near our bedroom window, awakening us to smoke, fear, and fury. We had eked out almost two years there; it was time to flee.

But first I had a personal decision to sort out: I had thought for some time that Clem and I should remarry. Not a pressing thought, it was just there. Maybe it was the next step in my need to tidy up my life that had started with the sale of the Norwich house and then the co-op. Maybe it was sharing the experience of Al Velake's death and then seeing Clem's first sign of vulnerability after he had a hernia operation in 1988. Clem, who was so proud of his constitution, who had never even had a doctor, had been shaken by that. Maybe it was simply that I needed to feel closer

to him. Being single had clearly proven to be just what Clem had termed it, one of Jenny's "gestures." Though both of our lives had moved on, our connection had not changed.

I discussed these thoughts with Russ, and, just as he had always understood and accepted the rather irregular family he had become a part of, he understood and accepted this. On my next visit to 275, I suggested the idea to Clem. Given that he had never considered us "divorced"—indeed, had never stopped introducing me as "my wife, Jenny"—he agreed, stipulating only that there be no fuss or bother. And so in June of 1989, accompanied by Sarah and her longtime boyfriend, Nabil, we were remarried at city hall. Afterward, we headed to the River Club for a lobster dinner. Next to all things deli and Chinese, Clem loved lobster. Like our divorce, as simple as could be.

That fall, as we put the Mulholland house on the market, I found myself hesitating for the first time about where I belonged. Maybe it was time to return to New York. Was that what my urge to remarry was about, a paving of the way? But what about Russ, what about my theater life? As if to lighten up and remind myself of all that was fun and quirky about L.A., I compiled an "only in L.A." list. Where else would I have had my aura cleansed (twice), have been counseled by a psychic nutritionist in the art of dangling a crystal over an avocado in the supermarket to test its toxicity to my energy flow, have traveled afar to attend clandestine channeling sessions, have consulted a mantric healer, have been advised by a psychic astrologist, have had my chakras cleared, have been Rolfed, have been treated regularly by acupuncturists and herbalists, and have been massaged every way to Sunday and back? I should mention that my more esoteric excursions were made in the company of a friend who was researching a book on the subject. The only thing I sidestepped was colonics, although I fasted occasionally and drank wheatgrass to the edge of nausea. And where else could Russ and I have so effortlessly maintained a macrobiotic regime for five years? How could I leave such an abundant confluence of health and lunacy? On a more serious note, how could I leave my loving partner, and did I have faith that my career and well-being would survive the transplant to New York?

Once again, Russ and I had started looking at houses. We saw only

one place we liked, a small cottage on a grassy corner of Pacific Street in Santa Monica. Four blocks above the beach, it was as far as one could get from gates and mansions and Dobermans and, wouldn't you know, it had a white picket fence. Still, I hesitated.

But there was a time pressure. It was imperative that I come to a decision about whether to move back to New York and live at 275 with Clem. To delay further would have been to mislead Russ. Russ and I were in transition, and I needed to make myself clear to him about the options I was weighing. That night I talked to him, and it turned out I had worried needlessly about his reaction. Unlike me, as a communicator, Russ never equivocated. Whether about feelings or what he thought of my new shoes, he told it like it was. That was the Eagle Scout in him. Thanks to him, we talked easily about the pros and cons, and my dilemma melted away. Our openness had a revitalizing effect on our relationship. Then, rather quickly, the Mulholland house sold, to someone who had the sensible plan of tearing it down and building a real house. And the little white cottage? Russ and I drove to Santa Monica one night and knocked on the door. The owner told us yes, it was still for sale. We bought it the next day.

The mist in the morning, the coolness, the thrall of the ocean—Santa Monica was a breath of fresh air. With each move Russ and I had been creeping toward the sea; now we were as close as we could get without swimming to Catalina. It was good to be back in a nest of a house. I took over the second floor, a pint-size converted attic, and pushed my table under the eaves.

I shouldn't have been surprised at my waffling about where I was meant to be next. There was a quality about our life in L.A. that had kept me off balance: our "Hotel California" house in Hollywood, teetering on the brink of a divorce; Russ's job cycles, which jumped from twelve- to sixteen-hour days to his being home 24/7; my swinging back and forth to New York like a metronome; Russ's drinking, which see-sawed between sober and out of control; flipping from house to house three times. Hell, what was an earthquake or two? I tried to put down roots, perhaps a silly notion in a city that was built on sand and prided itself on *not* having roots, in living for the now, and the next best thing.

And what about Santa Monica, that self-advertised paradise by the sea? To a suburb-phobic like me, it was a challenge. Even the zip code confirmed that I was no longer in L.A. And with the suburb came the commute, the brain-numbing hours in the Volvo as I sucked in the fumes of every other car inching its way from somewhere to somewhere else and imagined my lungs shriveling with emphysema. But the alternative was unthinkable, and I refused to adjust my routine of workshops, rehearsals, singing class . . . Often, I would drive in early and go to a hotel lobby, where, like a hooker, I would loiter for an hour or so, nursing a vodka tonic, and there I would write. My choice spot was the new downtown Sheraton, with its atrium, discreet piano player, lush chairs, and macadamia nuts. Early on I had discovered the joy of writing in public, buoyed by the energy of strangers in pursuit of their lives. Now it was a welcome counterpoint to the solitude under my eaves and a reminder that I was still in the land of the living.

In 1991, while in that alcove and deep into my play *Chiaroscuro*, about an aging woman artist, I got a call from Betsy Wilkinson. She and her husband, Bob, an astrologer friend of Russ's, lived in Austin. Though I had met her only once, I had liked her on sight. Now, on the phone, she told me she was a grief counselor and was organizing a national march in Washington, D.C., that would focus on the needs of families who had experienced the death of infants through miscarriage or at birth. Their goal was to draw attention to the emotional damage caused by these traumas and urge lawmakers to provide funding for the education of medical professionals and the counseling of patients. She herself had suffered through multiple miscarriages and had heard from Bob, who had done my chart, about the death of our baby and the lack of empathetic care.

My knee-jerk reaction was to feel that my privacy had been invaded and shut the conversation down. Instead, touched by her warmth and concern, I found myself saying, "Yes. Yes, I will be there." She filled me in on the details and told me about the quilts they were making, comprised of squares from those who had experienced loss. The quilts would be spread across the Capitol steps.

There is a time for everything. Before I had even hung up the receiver,

my lost child was on my left shoulder. I picked up my pen and on a fresh page of my legal pad these lines wrote themselves:

> Empty armed,
> Anger disowned
> Disnamed you. Unheld,
> Unburied, ungrieved.
> Thrown away . . .
> Then.
>
> My child
> Let me back
> Forgive me
> I name you Emily
> I hold you
> In love.
> Welcome my spirit
> In joy
> Now
> Always.

She had a name. Oh, what would Clem think? A name with no ballast, too gentile, he would say. But I wasn't listening. Emily and I were in the car on our way to the fabric store, where she helped me pick the colors for our squares for the quilt. There would be two: a red one for the "Then," a white one for the "Now." And flannel, because she was my baby and I would wrap her and rock her in flannel. We cut the squares according to the specifications Betsy had given me, and we penciled in the lines of the two stanzas. That night we embroidered the words, white thread on red, red thread on white. Then we sewed the two together and the next day mailed them to Austin, where they would be stitched together by grieving women into the quilts that would be arrayed, with purpose and in protest, on the steps of Congress.

A few months later on a Saturday in early spring, I flew to Washington. I went to the hotel, where a welcoming reception was under way. I

signed in, pinned on my name tag, which had Emily's name on it, too, and for a moment had second thoughts about what I was doing there. It was all too public. My loss was mine. My feelings were still so new; to share them would shatter them. I spotted a table of T-shirts with the word REMEMBER on them. Well, I could at least buy a T-shirt. But what color? Then I remembered I wasn't alone, Emily would know. And she did: blue. The simple truth became so clear to me. She had always been with me. I was the one who had been missing. I put on the T-shirt over my blouse. Soon after, Betsy and I found each other. She was all I had imagined. My angel.

The next day our group, having mushroomed to several hundred, was bused across the Potomac to Arlington, where we visited the grave of John Kennedy and Patrick, the son who had died shortly after his birth, in 1963. John and Jackie's first child, a daughter, had been stillborn in 1956. We then walked to a site near the river, where we planted a tree in memory of lost infants. People said a few words, but mostly we stood in silence circling that tree, our hands joined, deep in remembrance and prayer. We watered it with our tears. Before we left I took a leaf that had fallen and pressed it in my journal.

The buses left us at the top of the Mall. What had started as a gray, drizzly day now changed dramatically. The sun shimmered on the cherry trees and the Reflecting Pool. As we neared the Capitol, each now carrying a balloon honoring our children, we could see our quilts spread out on the broad steps, beckoning us. And there, even at some distance, I saw our squares. How could I not? Amid all the pastels, there was my bright red plea for forgiveness.

We sat on chairs and on the steps. There were speakers, some formal, some testifying from the heart of personal experience. I remember little. Through it all, I sobbed as I had never sobbed before. Before we dispersed, we held each other in prayer and then let our balloons go, each with their message, REMEMBER. That was hard for me. I knew I would remember, but I wasn't sure I was ready to let her go. But I did. I was still overflowing with tears as some of us gathered for an early dinner, and then another leave taking, again so difficult.

On the train to New York and to Clem, I knew that before that day,

I had known only that our baby had died, but not that she had lived. Now we knew each other. I knew she forgave me for not letting her into me, just as I had forgiven her for leaving me. Our anger was gone. She was at peace. I was at peace.

Clem and I sat, drinks in hand, in the living room. I hadn't wanted to join him in his office, where a book was always too close at hand. I turned on only one lamp; I wasn't ready for more. I told him about my experience, much of the time with tears in my voice. The telling didn't take long. So much compressed into so little. He was uneasy but attentive as I revealed what had happened to me, but not in a psychological or pragmatic way, the parlance we usually used. My feelings were raw and deep and went beyond neuroses and their effects on behavior and relationships. I held his hand as I talked of acceptance, catharsis, and healing. There was little conversation. When I had finished, we sat for a while. Then I told him our daughter's name, kissed him, and went to bed.

I had whispered her name to Clem. It felt so private. A name is a powerful thing. At her birth I had recoiled at the very thought of naming her and thereby acknowledging her existence. In the late seventies I had run across a 1962 document confirming the cremation of Baby Greenberg. Clem had never mentioned the arrangement, just as I had never asked about what had happened to her. The letter had ended up in a carton of miscellaneous correspondence that Clem, along with the rest of his correspondence, donated over the years to the Smithsonian Archives of American Art. They had returned that particular document, along with a pile of other letters, citing its "personal nature." As I read it, my body went cold. When the shock had passed, I soothed myself with the thought: *She has a name. It's Emily.*

I hated that Clem and I had never been able to find a way to talk about our loss. My tears and words had frozen in time. But I had seen his tears, more abundant than my own, when our baby died. They would have to be enough for both of us. As for words, we had been unable to speak about such unspeakable things. I had seen his tears before her death and would see them again and again, and I knew how deep they ran. The first year we were together I had seen him cry, usually in front of the mirror as he shaved in the morning. Always about his son, Danny. At

first because of Clem's terrible remorse over their irreparably damaged relationship, and then again in the years following the late sixties, after Danny disappeared and we never heard from him again. Clem cried for his lost children. We often talked about Danny. But about the loss of our daughter? That night after I came home from Washington was as close as we would get.

Back in Santa Monica, our first year there came to a close. Russ had now joined Alcoholics Anonymous. I was happy for him and happy for me. I knew little about twelve-step programs—amazing, considering all the addicts, from my stepfather on, who had passed through or lingered in my life. However, none of them had ever seriously considered joining AA. I watched Russ start the process. Sometimes he faltered, most often he did not, and sometimes it was like watching grass grow. Sometimes it was painful; the grim, jackhammer determination that occasionally burst into anger at daily minutiae, or at the world, but mostly at himself.

During those months, I was moved by his courage and by the immensity of the undertaking. Life-changing. I couldn't begin to imagine what that must have felt like. I had often changed the circumstances of my life, the people, the geography, but I was witnessing Russ grab on to the steps toward changing himself from the inside out, bringing all his high energy to bear on the process. And once he hit his stride, never did he let go. He taught me that alcoholism is not a hopeless disease.

As Russ's recovery deepened, I was aware that I was experiencing a journey of my own. I felt a lightening, as if I had put down a burden that I hadn't even known I was carrying. I had underestimated the psychic energy it took to maintain my protective detachment from the bingeing. Yes, the shield had been effective, but how could I have not seen its flimsiness? Though tamped down, the tension and vigilance had taken their toll. Now it was as if I had given myself the license to take the next, right step.

As the next year lengthened, what had been an occasional tug toward New York became stronger. I was feeling farther away from Clem and Sarah, too far, and was going to New York more often and staying longer. They were both experiencing difficult transitions. Sarah's relationship

with Nabil had ended badly. They had been together since her senior year at Vassar, but the previous year had been stormy and dramatic. Now it was over. For the most part, Sarah was relieved, but she had also been jolted by the suddenness and finality of the break.

Adding to her pressures were the increasing difficulties she was experiencing in keeping her SoHo art gallery afloat. She had opened Greenberg+Wilson in 1988, and by 1991, with the economy faltering and the money squeeze filtering down to the art market, she had had to close the gallery. As usual, her resilience served her and she soon regrouped, notched up her social life, and enrolled at NYU's Stern School of Business to get her MBA.

As for Clem, I could no longer take his good health for granted. With each visit I noticed a decline in his stamina and increased shortness of breath. He always passed it off as a bit of asthma, a condition he'd had as a child. But I wasn't buying it. Still shaken by my own diagnosis of emphysema and with the wispy voice of my father still in my ears, I dragged a reluctant Clem to a doctor, who listened perfunctorily to Clem's chest and gave him an inhaler to use "as needed." Of course, Clem never for a moment considered cutting back on smoking, any more than he would have considered cutting back on booze. That he was less able to metabolize alcohol now presented a whole new laundry list of "what ifs."

Two years earlier I had considered returning to New York, but, afraid that I would be taking a step back rather than forward, I had pushed the thought aside. Now I was sure. Not only would I be going forward, I would be going where I was needed and where I needed to be. My clarity reassured me. I knew that I had taken important strides: I had opened my heart to Emily and grieved her loss, witnessed Russ's remarkable recovery, acknowledged my need to be closer to Clem and Sarah, and, after a string of important productions, finally come to believe that my work was a portable resource that would thrive wherever I might be.

I had learned years before that knowing when to leave a relationship or a situation was a high art, one I had never mastered. I had a habit of staying too long at the fair. And then, whether it had been a career or a relationship, I would be out like a shot, leaving confusion and hurt

behind. It was no accident that *Fine Line* had spilled out of me about that very thing—that sad, comic little play.

However, there was nothing comic about my situation with Russ. As much as I wanted to leave with a semblance of grace and gentleness, I did it badly. Guilt overwhelmed me for having pushed for our move to Santa Monica and now reneging. The words thick in my mouth, in the early spring of 1992, I talked to Russ about my decision to leave. As usual, he understood, although this time it was, with good reason, an icy understanding layered with anger and resentment. And the timing couldn't have been worse. There would be no pot of gold. With the housing market in a slump, we were fortunate to get out with what we had paid for it.

As best we could, Russ and I retreated to neutral corners for the next months, and in the beginning of August, as soon as the house sold, I left for New York. We would be okay in time, better than okay. We were never out of touch, and, perhaps because we were smart enough to work at leaving the past where it belonged, we would build a loving, enduring friendship.

part four

Our Last Years

HOME AGAIN

IT WAS AFTER EIGHT o'clock when I opened the door and called out, "Hi, it's me." Everything as usual. The front hall dark, as Clem hurried from his office; he never turned on a light until he couldn't see a guest across a room or a word in the book he was reading at his desk. A kiss on the mouth that always took me by surprise with its eager intimacy, a hug, and a determined grab for my suitcase, which he carried, over my protests that it was far too heavy, into "Sarah's room," as we called it. It would now be my room. I bitched and moaned at the mountain of accumulated catalogs and God knows what on the coffee table. As often as I asked him to toss out the junk, Clem could not overcome his reverence for the US Postal Service; if someone bought a stamp and mailed it, if someone else delivered it, it had earned the right to be opened and acknowledged.

Did I want a drink? I most emphatically did. He refilled his own glass and we settled into his office. "You look wonderful," he said, not for the last time that night or for the last time during the days and months to come. No matter what state of ill health, despair, or dishevelment I might be in, for Clem this was an indispensable affirmation that all was well in his world.

Did we talk about the life-altering transition that was staring at us? Probably not. Clem did not noticeably break stride for such things. In any case, it was hardly big news, I had told him of my intentions months ago. Had he had any qualms about my permanent return? After all, twenty-two years. No, not really. His "As long as nothing changes" rang rather hollow at this stage of our journey together, but I had nonetheless assured him it would be so. His daily routine, his social life, would

remain unchanged; far from diminished, his life would now be easier. Mine, too.

Having had a record of rocky transitions, I scrupulously mapped my course this time and took every precaution to cushion my reentry. The plummeting real estate market that had worked against us in Santa Monica turned out to be a godsend in New York. With my share of the proceeds from the house, I was able to buy, on the cheap, a mini–one bedroom at 225 Central Park West, henceforth known as "my office." No valleys of despond this time—I had a plan. I would continue my playwriting. I would join a theater group in the city. Every morning I would go to my office down the street. I would buy the *Times* on the way. I would learn to like coffee and maybe see the point of reading a newspaper.

Within twenty-four hours Clem and I had assumed the comfortable routine of old married folk. Nothing could have been easier; I was ready and willing, and Clem's rituals, from morning to night, had never changed. Not that it was all housewifery. In between the sunny-side-up eggs and charred bacon that stank up the house, trips to the deli for Clem's center-cut tongue and chopped liver, and the broiled lamb chops and mashed potatoes, I was setting up my new office space. I had underestimated the amount of time and labor it would take. And patience.

While waiting, I enlisted Sarah's help to go up to Norwich, where I had left things in storage after the house had sold. Sarah, who was still at NYU, would be leaving shortly for a fall semester at the London Business School, before receiving her MBA in the spring. In Norwich I particularly wanted to reclaim the old oak pieces from the loft to furnish my new place. As for the rest, thanks to Sarah's ruthless practicality, what I hadn't been ready to let go of a few years before, I now disposed of to old neighbors and Goodwill in two days.

But there was one thing I was not able to leave behind: the story of Steve and the young girl dead in the quarry. He was in Attica, still serving his time. I had started a play about the tragedy during my last months in L.A. and planned to resume it as soon as I got back to work. With that in mind, Sarah and I squeezed in a few hours at the Norwich Library,

copying the reports of his trial from the local newspaper. Then, finally, with relief, I left Norwich for the last time.

A few weeks after Labor Day, I was in my office with the morning sun, the trees, and my computer. Through a playwright friend, I had joined a workshop on Forty-second Street. It wasn't as heavyweight as the groups in L.A., but it provided a much-needed outlet for my Norwich play. Creatively I was stymied, hung up between reality and dramatic fiction, and succeeding on neither level. The emotional baggage I was bringing to my experience of Steve and his story had bogged me down. But at least I was working.

And I was singing, having been recommended to a vocal coach a few blocks away. Once a week, with her inspired help, I explored a new range to my voice. The quiet child inside me who had lived in the secret village of her mind, and the woman who had spent the last months in L.A. keeping her mouth shut now took flight. Once again, as in Woodstock, I experienced the freefall exhilaration that only the fullness of sound could make me feel. My daily abundance filled me up. I was doing what I loved best—juggling a new life.

At the beginning of October, Clem and I went to the Pollock house in Springs, where he had been asked to talk about Jackson and Lee. The director, Helen Harrison, sent a car; we would spend the night in the house and be driven home the next day. I was surprised that Clem had agreed, knowing how reluctant he had always been to speak personally about the Pollocks, but he had specified that he would be talking only about their work and the art of their time. We hadn't been to East Hampton in three decades. Though I was curious, part of me would have preferred to keep that chapter closed.

Late that Saturday afternoon we were in the small living room jammed with people, many of them grad students from Stony Brook University, which oversaw the operation of the old farmhouse. From where I sat, off to the side of Clem, I found myself watching the audience watching him. There were the expected, familiar faces from the city, but it was the young faces that I was drawn to. What did they make of this old man who was talking about Jackson, this survivor among the depleted ranks

of the "first generation"? He wasn't spouting the hackneyed spiel that filled the myriad books and articles by people who had never known Pollock or who should have known better than to write the firsthand treacle and/or vitriol that they had.

If the students had hoped to hear about the iconic antihero of American art's golden years, or a rehashing of all the myths about the bad-boy trailblazer, they would have been disappointed. After placing the painter in the context of the art and artists that had preceded him, Clem talked about Jackson as a workaday man; as a painter who had good days and plenty of bad days, who painted great pictures and failures, and who, contrary to myth, never painted when he was drinking; and as a good friend. I was pleased that Clem finally let his guard down and talked of Jackson's struggles—creative, financial, and with alcohol—and of his relationships with his contemporaries.

The students could not have known how unusual it was to hear Clem speak so intimately. After finishing his short talk, Clem moved easily into a free-flow give-and-take, the part of public speaking he preferred. Maybe it was being in that house, maybe it was the informality of the occasion and that his audience was mainly students. Whatever the reason, Clem was having a good time.

The house was a disappointment. A shrine, everything sanitized and barren, even the studio and grounds. What had I expected after so many years? I wondered at the power of this place that, even though I had known it for only a short time, had scarred my memory so indelibly. And, like a child opening a creepy attic door, I looked for what was no longer there: each cigarette burn, stain, coffee-pot dent, each with its tale of drama and discord—the life-and-death urgency that charged the conversation, the threat of imminent conflagration that could, though rarely did, happen. I had never experienced anything like it before or since. I felt again its oppressive effect, and the confines of the shell I had crawled into to escape it.

As for the protagonists, I summon them easily, she more than he. His face slips away, blurred by the countless photos that perpetuate his image: the young, vibrant, achingly handsome Jackson whom I knew not at all. I only smell his beard that, as beards do, tell me the history of his day, at

least the food, drink, and tobacco of his day. And I see his eyes squinting through the smoke, unfocused. But Lee—I'm startled by the clarity and immediacy of her. The bark and bray of her voice, which matches the blunt angularity of her gestures. The mouth, face, suddenly twisting into ugliness, the body never still. Androgynous, imperious, like a cannon she explodes into a room, into a conversation, into my mind.

And I see myself, the girl who drinks, smokes, listens until she stops listening. She seldom utters a word. She looks placid but she's not. She is scared that her life will always be filled with times like these. She has no future, no plans. Worse, she doesn't trust Clem to protect her from such debilitating boredom. How can he? As much as he complains about it, he is incapable of protecting himself from it.

Much later, after Clem's talk and a dinner party at the Harrisons', Clem and I were returned to the farmhouse for the night. I lay on Lee's bed; Clem opted for the guest room. Lord, what a hard, damp slab of a bed. Lee's legacy to me. I was still paying dues, but for what crimes, I would never know. I still wondered what her final rampage at me had *really* been about. I could hear Clem saying to me, "We don't leave this house in anger."

Why not, what better reason? I hadn't said, as I crept up the narrow stairs that night to fume in my sour rage of helplessness.

Oh, yes, Lee, there was always a crisis. But I wasn't angry now. Just cold and sleepless. *Just think, Lee, I'm older than you were then; now it's only my tired body that's unforgiving. I even missed your presence this afternoon, and especially at the rather dull dinner. You would have livened things up. But I do hope to God you didn't die in this bed.*

Daylight and an overdose of coffee warmed my bones and restored the house to its generically benign self. Soon, our old friends Elaine Grove and Dan Christensen came by from their place down the road. Before we left to visit their studios, Elaine took pictures of Clem and me sitting outside at the back of the house. The photo she sent a few weeks later moved me with its simplicity and openness. It reminded me of a photo I had seen of Milton and Sally Avery that I had been drawn to because of their serene oneness. Now I see Clem and me: We look at each other; our hands touch. A tender moment that captures the depth of our

connection. Wary, skeptic that I was, it had taken a lifetime to acknowledge, to fully own, that connection. Clem, who loathed the thought of family pictures on display, didn't protest when I put the framed photo in the living room.

On December 10, Clem and I left for Tokyo, where he had been invited to speak at Musashino University and participate in a seminar at the Metropolitan Museum. A routine jaunt for Clem, who had been to Japan several times, but it was my first visit to the Far East. It was also our first trip together in many years. Although Clem had often asked me if I wanted to accompany him on his many trips abroad, I had always demurred. Perhaps the memories of our earlier travels still flashed uneasy signals. But Clem found an intrepid travel companion in Sarah; starting at age twelve, she had accompanied him to South Africa, Israel, Russia, China, and, of course, Europe. Now, older and maybe wiser, I was sure Japan would be fine. After all, this would be a short trip, a week in Tokyo and then a few days in Kyoto, a special place for Clem and one he wanted to revisit with me.

West meets East. So many surprises, even in those first hours. Though first class, the seats were hard and narrow, at least for a hulking American. I hated to think what coach would have been like. And the interpreter—the pilot spoke for fifteen minutes, the interpreter for fifteen seconds, an imbalance that would continue throughout our stay. As would the gender imbalance; except for me, all the passengers were men. Clem and I didn't sit together; he was in the euphemistically designated smoking section. To my dismay, the dividing line was not front and rear, but right and left. On the plus side were the meals: symphonies of lobster, gray caviar, and morsels of exotic origin. By far the loveliest part of the journey was keeping pace with time. We had left at dusk and never lost the faint rosy glow across the horizon. And there was the inscrutable Arctic, its vast humps of glaciers embraced by the arc of the earth and a sky of pale blue silver. As the passengers slept, whenever I looked back at Clem I saw him reading, haloed in his solitary pinpoint of smoky light.

Eighteen hours or so later, we were finally in our hotel room in Kokubunji, on the far outskirts of Tokyo. Clem slept, I couldn't. I was still

seething. As planned, we had been met at the airport by Teruo Fujieda, our host, and another university professor. The twist was, we would then be taking a train. Any other transport was impossible, they explained, what with traffic, etc. So it was that a short-of-breath, eighty-three-year-old man and an exceedingly pissed middle-aged woman had been force-marched through crowded corridors and tunnels in search of a train they seemed unable to locate.

As I lay in our hotel room, I thought of our friend, the New York painter Kikuo Saito, who had assured me before we left what a fine time we would have: "Clem is a national treasure there." More than once in the coming days I would think of those words, not to mention Japan's renown for respecting its elders. Even the unflappable Clem was taken aback by the cavalier reception. After breakfast, he suggested we call Sarah, who, having just returned to New York from her term in London, had planned to join us for some sightseeing. We told her it didn't look like that kind of trip and she should cancel her reservations.

Late that afternoon we were taken to the university to meet our hosts before a special dinner at a country inn. As we left, Clem tripped on a shallow step and hit his forehead. A deep gash. The blood poured as I did my best to stanch it. He was unsteady, and it took three of us to get him into a taxi to a clinic. There, in a small house on a residential street, I held his hand as they gave him an anesthetic, covered his face with a white cloth, cut a hole in it, and worked through that. Then the stitches, the dressing. So quick, so gentle. To everyone's surprise, and against all reason, Clem insisted on continuing with the dinner plan.

Twelve or more sat around a low rectangular table in a private room. Clem and I were much the worse for wear, but I marveled that, as uncomfortable as he was sitting on the floor, he managed to get through the prolonged ten-course banquet. Though Clem ate little, I was in gastronomic heaven, as delicacy followed delicacy. I blessed Russ for our macrobiotic years and for my proficiency with chopsticks. It was also a feast of academics. I was reminded of an evening at Cambridge with Tony Caro. He had been invited to dinner at one of the schools and had asked if I would accompany him. So similar: the elitist air, the exclusion of women, the spurts of boyish banter and inside jokes, and, of course, the

arcane ceremonies of the table. The big difference: At the inn there was no lively discussion. Girdled by formality, no one engaged Clem, except the university president, who asked a few ho-hum questions. Waves of merriment crested over us now and then from other rooms, but, sadly, none echoed back from ours.

Then, as if there had been a signal, we were told, "It is over," and in a flash, I was hauling Clem to his feet and we were at the exit, putting on our shoes. The interpreter had told me about a special garden, and for just a moment I took a detour. Fires blazing in ceramic pots over a path of moist stones; a pool alive with red-and-white-striped carp; the scent of citrus and spice; a water wheel creating a cascade in harmony with the music of chimes and clapping wood; and, conspiring above, an almost full moon. To the side were the dining rooms, where, outside each sliding paper door, there knelt a traditionally dressed and coiffed serving girl waiting to be summoned. I had found a treasure to take home.

The next day when I changed Clem's bandage, the wound looked fine and he was quite himself. His vaunted healing powers had served him well once again. During the day, which was sprinkled with media interviews, Clem asked Teruo, as he had before, to see the art of the students, something he reveled in and which he assumed would be part of the university visit. Again Teruo put him off: "There's nothing worth seeing." It had become clear that Clem had been invited solely for the pleasure of the faculty. Similarly, when I plaintively asked once again—like Chekhov's Three Sisters, yearning for Moscow—if I might see something of Tokyo, perhaps some theater, I was put off with a vague "perhaps tomorrow," as they firmly ushered Clem off to the hotel's bleak cave of a bar and I headed out to wander the crowded, charmless streets of Kokubunji.

At last, the day of Clem's lecture. He had chosen to speak about morality in art as it related to art's autonomy. Clem had asked earlier what I thought of it, and I had said it was fine, although they were probably hoping to hear about the art scene in New York. As it was, though the interpreter struggled at times, the audience was rapt and the Q & A went on for over an hour. I was drawn to the delicate beauty of the students' faces and their spikes of hair reaching for the sky. And to my amazement, beyond a wall of windows, there was Mount Fuji, with its

lopped crown, as if it had been decapitated by an angry samurai. And on its cusp teetered a crimson sun. Another perfect moment.

Afterward, Clem was rushed by students with books to sign. A rock star. At the reception, we sat surrounded by faculty. Only a few students had been invited, and none was included in the circle. Again Clem asked to meet them; again it was simply not to be. That night, our last night in the outpost, Clem was again corralled into the bar by Teruo et al., this time until 4:00 AM. During our visit I had watched Clem get sucked dry by our hosts, his words swallowed by tape recorders. Teruo would get miles of publishing material from these sessions, as well as, I was sure, miles of conversation about "the nights I spent in the bars with Clem." All the while, I was being sucked into my outrage.

Early the next morning, we were driven to our hotel in downtown Tokyo. Indeed, Teruo had been right; it did take hours. Clem would speak on a panel at the Metropolitan Museum, Tokyo's museum of contemporary art. The next day we would be leaving. We had already canceled plans for Kyoto; Clem was drained, as was I. But for that one day, a weight lifted. I was in a city, and cities were my home. What a strange interlude Kokubunji had been, rather like someone coming to the United States for the first time and being held hostage in Newark. While Clem holed up in the bar with a new band of acolytes, I went off to a museum to see Japan's traditional art.

Later, the symposium went smoothly, Clem in good form despite his late-night debauchery. After a ceremonial tea for the participants, we dashed back to the hotel to meet Susumo Yamamoto, the director of the Fuji Art Gallery. An urbane, delightful antidote to academia, conversation sparkled rather than droned. How it came up, I don't know, but it turned out we shared a birthday—same year, same day. A true shining knight, he took us on a tour of the Ginza and early the next morning sent his car and lovely assistant to take us to the airport. She shepherded us right to the gate. Sayonara.

Nothing like a thirteen-hour flight to reflect on hard lessons. I may not have learned much about Japan in my week there, but I was disturbed about what I had learned about myself. I had been aware that Clem's ability to physically handle alcohol had deteriorated over the years, but

I was confident that I would be able to handle whatever might come. While in New York that was true, however, closeted as we had been in Japan, in a heartbeat I had become a battle ax prison guard, or, as Clem would so often say about other women, I had been "acting like a wife." My codependency, that awful buzzword, had overpowered me; I had shown my need to control Clem in the name of protecting him, my inflexibility and inability to step back. Clem was used to the travel drill. I was out of practice, and the experience opened up feelings I hadn't confronted in decades. I realized the extent of my anger, at Clem's passivity and self-destructiveness and at myself for my lack of detachment. Teruo had become the target of my anger, but in fact he was just one more in a long string of insensitive, exploitive guys who wanted to score points. That, plus our isolation, had pushed Clem and me to our limits, each in our own way.

Back in New York, we restored ourselves. I knew we would be fine, but I also knew that twenty years had passed since we had shared the day-to-day for any length of time, and I had been naive to think that I could pick up the threads and expect them to mesh seamlessly. I resolved to step up my meetings at Al-Anon, a program for family and friends of alcoholics. In November I had gone to my first few meetings and had felt instantly at home. The groups were mostly women. Daughters, wives, grandmothers of addicts—in every story there were pieces of my own. I came to think of this fellowship as one of intimate strangers, loving strangers. The anonymity opened me to a deeper level of self-honesty. Late in the day as it was for me, I wanted to learn how to live with an alcoholic and not lose my self, the self I had worked hard on for decades and didn't want to risk losing now. I had managed to maintain detachment in L.A. with Russ when he drank, but this would be tougher. The weaving between Clem and me was dense and knotted over time.

The first weeks of 1993 slipped by as I settled deeper into my routine: work on my "murder play," frequent workshops, singing lessons, Al-Anon meetings, and domesticity and social life with Clem. I particularly relished the cold early-morning walks along the park to my sanctuary. At my desk, I lost myself in the grays, blacks, and whites of the winter landscape. Never once did I miss the Technicolor of L.A.

However, in mid-February I did return for a staged reading of *Legacy*, one of the earlier plays I had written there. The days passed with rehearsals and seeing friends, the best of times. The reading evoked good response, and two directors interested in productions contacted me. Yet overall I felt out of touch, like the visitor I now was. As it happened, I left earlier than planned. Sarah had called; Clem was having breathing problems.

Two days after my return I took Clem to the Lenox Hill emergency room. He, of the invincible Greenberg constitution, was admitted to the hospital by Robert Kutnick, a pulmonary doctor who had been recommended to us. Clem was put on oxygen, an IV of antibiotics, nebulizer treatments, and prednisone. He had all the tests; his heart was fine, his pulmonary function very low. Amazingly, even his liver was fine. For his age, he was in fine shape except for those damn lungs.

Those few days in the hospital were calm, Clem dozing, reading *The Life of Jesus*. He talked about how scared he had been when he had awakened. "I was suffocating," he said simply, but with an air of incredulity. Since I had known him, he had never been sick enough to take to his bed. Now I felt he was replaying the event in order to make it real. About the book, he called it "a detached view of Jesus' pathetic story," and added, "It always gets to me, disturbs me." It clung to him for weeks. And why not? He'd had a brush with mortality. As for me, I fluttered like a novice nurse trying too hard to do the right thing. At night, we both veered off track. Clem's phone calls were heavy with uncharacteristic fear and anger; I was filled with fear, for him and for me.

And then he was home. The only memento was the intrusion of an oxygen compressor with long tubes to be used before bed and "as needed," and a tall green cylinder of oxygen for emergencies. It stood like an ominous sentinel in the corner of the bedroom, a reminder that all was not as before. The first night home, instead of his usual book and a cigarette, he sat on the edge of the bed, breathing the oxygen, his hands folded. He said he just wanted "to savor feeling better." He remarked on how "feeble" he felt, a new word that would come up often, and how he blamed the smoking and drinking. Sounding like a repentant gangster in a thirties movie, he said, "I thought I could play fast and loose with my body."

In turn, I gratefully seized those thoughts. They meant we would be on the same team. I reminded him of his favorite Bee Gees song, "Stayin' Alive." We could do it.

During those posthospital weeks, we continued to do a lot of talking. He was dreaming a lot. Particularly vivid were the ones of Sol, his middle brother, whom he always referred to as the "good son," the one who had given the most and gotten the least. He had contracted polio as a child, and it had affected the use of his right arm. Clem had always berated himself for not protecting Sol from his father's dismissive treatment of him as the "damaged" son. Sol had died in 1987 of lung cancer, "the first to go."

And we were doing a lot of hugging. We had always been huggers, but these were long, clinging hugs. Another first: I felt needed by Clem. Not just as the passive "presence" he had always loved in his life, nor as the current slavey of health and hearth, but with an urgency, as a hands-on presence.

Surprisingly soon, the familiar reasserted itself. No more medications, except for the "as needed" oxygen and the inhaler, albuterol, for episodes of shortness of breath. We both puffed away on our inhalers—I was now on two that I used daily—as we picked up our routines. For Clem, that meant smoking and drinking. I went to more Al-Anon meetings in hopes of controlling my outbursts of anger, which increasingly fractured my focus on my own life. Every day I stumbled over the Step One tenet that I was "helpless over alcoholism." As many times as I said it, my subtext was *Yes, but . . . Maybe if I . . .* And I kept going back to meetings. After all, I was smart, I could learn, and I was motivated. Things had to get better, didn't they?

Late morning on March 29, I was at my desk, trying yet again to breathe fire into the tepid dialogue of Steve's interrogation by the Norwich police, straining to hear the voices and let them lead me to their truth on the page. The phone rang. I picked it up, grateful for a respite. And our lives changed.

A woman's voice. "Janice Greenberg?" The name Janice always set off my official-business alarm. "The District Attorney's office." "Arrested." "James Powers." "Fraud." I heard her, but I absorbed little. "No, that's

impossible. There must be some mistake." I said all the things people say when something is unthinkable. Besides, her voice was too young, too innocent, to deliver such a dark message. *Who is this girl who goes on and on?* But my body heard. The blood boiled in my head; my skin quaked with cold. Slowly I pieced together what I didn't want to hear: The funds we had given 5 5 5 to invest two years earlier were gone. We had been embezzled. Sarah had been victimized as well. We were to meet with the "girl," an assistant DA, the next morning.

Within seconds I had my folder of monthly statements from Powers, the lists of investments, so orderly: numbers, percentages, totals, and profits, not too big, not too small. Fake, all of them. A fantasy contrived to satisfy a gullible victim by a vicious con man with an oily, optimistic veneer. No, it couldn't be. Trembling, I called one of the companies listed on the statement, then another. Dead ends. I had no proof of ownership; they had no record of my name or of Powers. Finally, one company tentatively acknowledged my name and asked for my mother's maiden name. She said the name "Norden" was incorrect. I screamed at her; she disconnected.

My body was still shaking, but I could feel the iciness of shock start to subside. And I could focus. It had taken such a short time, maybe half an hour, for the truth to sink in. The money was gone. The money from the last painting we had given to Emmerich to sell, the profit from my apartment sale. We had found ourselves with more money than we had ever had at one time, and I had thought it was time we invested it, tried to hold on to it. Instead, all of it was gone. I had been mugged once on a dark street in the West Village. It was like that. Quick. One minute you have something, the next minute, nothing. I turned off the computer and called Sarah. She had already heard. She was angry, so angry. Drawing resolve from her anger, I told her that I couldn't just sit there, that I was heading down to Powers's office. I had to see for myself.

At the Graybar building at Lexington and Forty-second Street, I ran through the labyrinthine corridors to his office, two rooms, seedy and dark. His assistant, Joanne, his only employee, was there. I was taken aback; she was the knowledgeable one, the competent one whom I had been dealing with by phone for two years. Why wasn't she in jail? I kept

saying that I wanted my papers, my records. She was a wall. In an alcove I saw file cabinets and started pulling out drawers, files, but I was too hysterical to know where to look.

I went into Powers's office. I had been there only once, early on. A room that, with its low-overhead prudence, must have impressed me, but that now revealed itself for what it was: pathetic, shabby, with grimy windows that faced an air shaft. I searched his battered desk—nothing. I stared at his chair and saw him sitting there, a pudgy, middle-aged mama's boy, his face shiny as egg whites, with a languid confidence, not too much confidence, not too little. Oh, he knew the value of staying in the invisible gray middle ground. Had I liked him? Not really. But then, I didn't think I needed to. Trusted him? I must have. I had heard about him from my old theater buddy Jim Leverett, who had invested with him for a long time and had always had good results. Thinking it had been time to have someone smarter than I was handle our money, I had asked Jim to put me in touch with him. My fault. All my fault. There was a list of numbers on the phone. I dialed them. A car service, a dry cleaner, nothing. A fat man in a uniform came through the door. As he came toward me, he said if I didn't leave he'd call the cops. I pushed past him, yelling at Joanne, "Why aren't you in jail?"

Downstairs I went into Chase Bank, where I supposedly had an account, and was amazed to find that I actually did, if only in the amount of $21.47. I told the teller to close the account. She said she couldn't do that without the cosigner's signature. Guess who. I asked for the manager. All I could say was, "I want my money." Louder and louder. He gave me the money. Did I imagine that it might be the only money we would ever recover? No. My brain had not yet dared to venture into the future.

The cab ride home seemed to take hours. I was bent double with shame, guilt. The incessant reel in my head that would replay for months had begun. *How could I have ever . . . ? Why did I not see . . . ? Did I honestly think he . . . ?*

With Clem, at last the tears and fears spilled over. He was calm. He was more dismayed by my reaction than by what had happened. Yes, Powers was a thief. Yes, he was a scumbag. "But it's only money," Clem said. His clarity and detachment soothed yet dismayed me. Would I have

to fight alone? I needed a warrior. Yet Clem made me feel safe, loved. Later, Sarah came over. She brought her pragmatism, her strength. As always, I listened to her and would learn from her.

The next day Sarah and I went through our first metal detector and went upstairs to wait in the corridors of the ADA's offices. Grim, musty, a place of function, a place that smelled of troubled, anxious people. The halls of justice may not have been stately, but they quieted me. I belonged there. I wouldn't mind working there. After all, I would need a job. No, I was too old, too damaged.

A young woman in a black dress—all the women wore skirts—stormed by, a soldier carrying an armload of files, her heels hammering on the worn wood floor. Mid-stride she stopped, turned, and approached us. This was Valerie Arvin. In her cubicle she filled us in on what we could expect. Powers would be arraigned, perhaps that day, and would undoubtedly plead not guilty. In ten days or so we would testify at a grand-jury hearing. If all proceeded as planned, indictment would follow and he would be sent to Rikers Island to await trial. There were ten victims and multiple counts of grand larceny. We heard the phrase *Ponzi scheme* for the first time. I laughed. Such a silly word. Sounded more like a kid's game than a devastating crime. Valerie said these cases took time to sort through and the felon usually pled out. That was all about him. What about us? Would we get any money back? Where did the money go? Wasn't there anything we could do? She shuffled papers, hedged. Money trails were hard to track. Her job was to gather evidence to prosecute Powers. As for restitution, well . . . That day there were no answers. Maybe a glimmer of justice, but no answers.

There was little time to assimilate what had happened, to weigh the effect, and certainly there was no time to heal. Each day I hit the ground scurrying for solutions. The absurdity of that was soon clear, as the ramifications of the damage spread. My accountant told me that no taxes had been filed for us by Powers in the last two years. Yes, I had even turned over the preparation of our taxes to him. Sarah had as well. Again the waves of shame and guilt, the stupidity. I was told it was only a matter of time before the IRS would impose liens on what we had left: about $8,000 at Merrill Lynch and $3,000 at Chemical Bank. The accountant

would try to intercede on our behalf, but until Powers was indicted, until the DA's office supplied paperwork . . . All a catch-22. Soon I wasn't scurrying for solutions, only Band-Aids. What could we hock or sell? How soon could I sell my office, Sarah her condo?

As Valerie had outlined, Powers was arraigned, denied bail, and sent to Rikers. So far, so good. Let him fester, rot in hell. But part of me was envious. No scurrying for him. His job was done. Ours had just begun. Within a week the victims of Powers found each other and met for the first time around my accountant's opulent conference table. There were indeed ten of us, plus a few spouses and relatives. Not, of course, Clem. He had really meant it that day before we were married when he had handed me the checkbook and stepped back from all things financial. Sarah and I knew only our friend Jim Leverett.

We were all in various stages of shock, anger, and disbelief. Quickly, we had a leader, the senior alpha male of the group. The agenda was clear: track the money trail, recoup what we could, put the bastard away for life. Short term, hire a lawyer and a private investigator. We agreed to share all information and work as a team. Then we each told our story. Most of us were theater connected: actors, directors, writers; one of us was a star, and, who would've thought, one of us was a producer for *Law and Order*. Sarah and I were the most recent suckers to be caught in the web, while some had been with Powers for many years, even decades, and had welcomed him into their homes. The amounts of loss ranged from the low six figures to $1 million–plus. Jointly, Sarah and I were in the low to mid-range. But the bottom line was that we had all lost everything. *Everything* was a great equalizer. Some had jobs, some didn't. We all had some assets at hand. We agreed to meet regularly, and, on a lighter note, before we disbanded we dubbed ourselves the VIPs, Victims of Powers. At that first meeting, the group galvanized me. I finally opened up to my anger. I may have been victimized, but, thanks to the solidarity, I knew I could be strong.

Two weeks later, we all testified at the grand-jury hearing. Before we made our appearance, we had a private meeting with District Attorney Robert Morgenthau. The legendary DA was open and informal, well apprised of the devastating nature of the crime, and listened to our

concerns about full disclosure between the ADA and our group. Overall, more form than content, but it did make us feel that our case was special and that at least the guy at the top was watching.

For the actress in me, the witness chair at the hearing was a stage I didn't want to be on. The questions were straightforward, but my voice was a foggy quaver. It wasn't that I didn't know the answers; it was just that in some way I felt that I was the one on trial and I had better get the answers right, or else. Worse, when the jury started asking questions, it hit me: *My God, what if they don't believe me? Powers could walk out a free man.*

I needn't have worried. He was indicted on thirty counts of grand larceny and held over for trial. As a result of the meeting with Morgenthau and the hearing, the media woke up to us. I cringed. I was afraid of being judged, of being thought incomprehensibly stupid. But again, I needn't have worried. Unlike some of the others in our group, Sarah and I were hardly Page Six material, as a few of the others were, and in the small piece the *Times* ran, we were an afterthought: " . . . and a woman and her daughter."

I had lost money and I had also lost trust. I viewed people as the enemy and clung to my safe places: home with Clem and Sarah, Al-Anon, my closest friends—those who listened and cared, not those who spouted outrage and advice—and crowds. I was on a jammed Lexington Avenue subway coming home from the grand-jury hearing when I first noticed that sitting there flesh to flesh between strangers, I felt peaceful, almost euphoric. I was just me. Nothing expected of me. I breathed my air, took up my space. My secrets my own.

At every VIP meeting new accounts of damage poured onto the table: property taxes not paid, IRAs liquidated, documents forged, even a voice impersonated to gain access to private assets. We were sure there had to have been collusion at Chase, Powers's bank, where he had opened the token accounts in our names and through which he kited checks. But who would take on that behemoth? We were impatient with the DA's office. Why thirty counts? Why not fifty, a hundred? And always the driving question: What had Powers done with the money? We each coughed up $2,000 to hire a lawyer and PI. We needed input from some

pros. We knew the process would be long and tedious, but some action was better than none. Like all Ponzi schemes, Powers's had imploded. The market had gone down, clients had withdrawn funds rather than "invested," and the river had run dry. On March 29, one investor had wanted to cash out, hit a wall, and called the cops. Child's play, all a game. But wreaking such havoc.

By the end of April, Sarah had sublet her pretty condo on Christopher Street and I helped her move out. The things she wanted to keep went into storage until the winds of fortune changed. She would live at my office temporarily, until I could empty and sublet it. The wheels of co-ops move more slowly. When I returned home that day, my L.A. friend Beverly called to tell me she had gone to see my play *Wedding* before it closed. She told me how funny it was and how much the audience had enjoyed it. I had forgotten all about the three-week production. I felt as it I were living in a movie that had been edited out of context.

The phone rang again. It was Jennifer Gordon, to say she was going into the hospital the next day for a double mastectomy. I told her I would be there. She was in her eighties, the cancer well advanced, the prognosis poor. This from the beautiful hostess of the party where I had met Clem, a friend of almost forty years. A stubborn thorn of a woman. Of course I would be there.

What I chose not to attend was a talk Clem had been invited to give at Yale. Sarah went. I knew the drill all too well. The talk, the Q & A, the smug academic audience, the cheap shots, the clever self-aggrandizing questions, all aimed at taking the old man down a few pegs. Jargon called it "deconstruction." Yet another phrase to give academics a platform from which to produce very, very fat books that hammered the same nails over and over. All that they might be granted tenure and, if they were very, very lucky, a brief mention in the footnote of art history.

Clem, as usual, would not rise to the bait, answering each question in his earnest, straight-arrow way. During the evening he might say: *Bear down, look hard at art, not the theory; develop your own taste; dare to have an aesthetic judgment.* He might talk about art manufactured to shock, to be "new," and use the word *decadence*, a word he was using more often of late. He might say: *Art can transport us; it can startle us*

and stir our minds; it can please our eyes. He would surely say, "That's
the fun of it."

Art academics were only one of the targets for my newly unleashed
anger. They popped up like ducks in an arcade. How easy it was to let
the embezzlement set up house in my brain. I stewed about the loss of
human values and spiritual beliefs, the deification of greed, chaos, geno-
cide, the epidemic of chewing gum and dog shit on the sidewalks . . . The
spiral drained me of all perspective. The only antidotes that provided me
respite were Al-Anon's "one day at a time" (or in my case, one minute at
a time), "take the next right step," and my mantra, the Serenity Prayer.
All to the good, but too often by the end of the day my thoughts would
succumb to the wreckage of my future.

One evening at a crowded meeting, I looked up and saw a well-known
director across the room. We had never met, but she had a play of mine
that a mutual friend had given her. Uninterested, I looked away. I real-
ized I had no sense of who I was anymore. I had redefined myself as an
angry, stupid old woman who had ruined her family.

Since his hospitalization in February, Clem had been managing well.
His schedule was much as it had been before, and Yale had been an easy
jaunt for him. But a trip to Paris was coming up in June. *Cahiers d'Art*
was sponsoring a three-day symposium at the Pompidou in his honor.
There was no way of knowing if he would be up to it. Clem was no help;
in his usual noncommittal way he would shrug and say, "Why not?"
even as I, in my fretful way and with thoughts of Japan still raw in my
mind, checked the logistics of Medicare abroad and portable oxygen. But
I really hoped we could go; this was Paris, and it had been thirty-four
years since we had been there together. Clem finally made his decision
when, in the eleventh hour, the arduous schedule of panels and talks went
head to head with his inertia, and inertia won out. Clem's appearance
would have to be via tape. *Cahiers d'Art* sent an interviewer and cameras
while Clem sat comfortably in the living room, talking for hours about
what he loved best.

Days passed, taken up mostly with VIP business. We divided into teams
and interviewed lawyers and PIs. The legalese confounded me: contin-
gencies, half-contingencies, no contingency; governance, attachments,

Rico, depositions . . . The lawyer's fees averaged $350 an hour plus $200 for an assistant, the PI's, $200 an hour and $100 for an assistant. Even though we squeezed out a few partial contingencies, the numbers were way beyond our means. We hired them anyway. That done, we spent hours trying to sort out the money trail. So much unraveling, so much that couldn't be unraveled. Whose money went where; had my office been bought with Cecil's money, had Michael's SUV been bought with mine? Kafka-esque. Powers's records were not available to us, though we had finally been able to get statements from the DA's office concerning losses—vital information for the accountants of those of us who were in hock to the IRS. One lawyer told us we were lucky to get them. Lucky! Many a day I wanted to cry, scream, or both.

As for our professionals, it was all to no avail. The PI interviewed Joanne, Powers's assistant, and the man Powers lived with in Virginia and pursued contacts at Chase, but anyone who might have known something wasn't talking. As for the lawyer, he served no purpose I could see, except for making a condescending appearance now and again and providing a small room for our meetings and a copier as needed by me, the secretary of the group. In all, we learned what we already knew. The DA had told us that the only apparent assets were a few low-end properties that were heavily entailed and of little value.

By the beginning of June, my office was rented for enough to cover the small mortgage and maintenance, plus $200 to add to our home stash. Thanks to Jim and Ann Walsh, and Steve Achimore from Syracuse, who gathered a truck and two other guys—all painters, all good friends—the move was more of a party than a wake. In blistering heat, we sweated and laughed and drank beer and emptied that space that I had treasured so briefly. This time the wonderful oak furniture was sold, and after the painters took a few things they liked, we trucked the rest a few blocks north to 275. By the end of the day we were all sprawled out in my new crammed bedroom/office, the AC at full throttle, drinking, eating Chinese food, Clem front and center. Before they left, I remembered a bunch of T-shirts in my closet that had accumulated over the years from Tony Caro's annual artists' workshop, Triangle. I gave them to the guys so they could smell as sweet as they were on their trip home.

On that day that I had dreaded, I was happy for the first time in two months. I had learned a new lesson: I could accept help when it was offered, and, who knew, soon I might even be able to ask for help. My mother had lived in isolation with her secrets, never daring to open up to "outsiders" about anything, much less when in need. A bit late in the day, I began to shed my own misguided thinking. It was a day of shedding. No wonder I felt so good. I was all in one place for the first time in decades. I was down to basics, ready to take on whatever lay ahead. No more one foot out the door. No more just-in-case escape hatches. I had wanted to come home. Well, now I was. As for Sarah, she was floating. She had just completed her MBA, was bunking with friends, and was taking odd jobs until she found something better. Hard times, but I had faith that she would regain her ground in her own good time.

And then, a step back. The following week Clem had a particularly rough breathing night and I had to call 911. Against all my pleas, the ambulance took him to Roosevelt Hospital. A new ER, a new doctor, a superior staff, and a new wing that was spacious and bright. Once the crisis eased, Clem was angry at being there. I was drained after a long, placating day with him. Early the next morning, a nurse called to say he was checking himself out. I stifled my anger and picked him up. In the taxi, we returned home in silence. On my lap was a portable nebulizer, a loaner from the concerned young doctor to help Clem get through the nights to come. The upside was, we weren't in Paris.

At home Clem was closed off. As always, he opened the mail, read, seemed calm, but there was a fire inside him. Willfulness, anger, stubbornness—whatever it was, it was new. The day was hot, his office windows open to gusty wind that rattled papers, everything in its path. He drank more than usual. Lit up a cigarette, and another, and another. This was not the Clem who had come home from Lenox Hill a few months before grateful to be alive. He was at war. Unfortunately, it wasn't the sort of defiance that would help him fight his disease. This defiance was saying, *Take me, damn it. Get it over with.* I prepared the nebulizer for him. At first he was reluctant, but then he rather liked it. I told him to think of it as sucking on a cigarette. Eventually he fell asleep.

What a grim day. I felt abandoned. He had given up, walled himself

up behind booze and cigarettes. What would the night bring? Would I have to call 911 again? Or would I not make that call? *He wants to go, let him go.* And on the heels of anger came the guilt.

Waiting for sleep, I was six years old, hearing my father steal away in the night. How fearful I must have been of what would happen to me. After all, I must have done something, though I didn't know what. And I must have clung to my mother, who, distraught with anger and grief, was not a good port in a storm. Oh, how that house must have shaken on its foundations that night. And soon my recurring nightmares began: a rhythmic circle of animals marching slowly in unison, faster and faster until they collided in a deafening chaos that awakened me, screaming unstoppable screams. My Freudian Sy said it was sexual; I called it a cry for a life jacket in a sinking house. So went my dark scenarios as I waited for Clem's call in the night: "Jenny!"

At the root of my foreboding was that I knew these were early days. I might not have settled into the illness drill, but it was becoming clear that the only thing I could count on was that every day would be different. In comparison, the embezzlement seemed like a breeze. It happened once—slam bam, the deed was done. The rest was mopping up the mess. This would be recurring shocks as I lived in wariness, waiting one minute at a time for the next tremor.

Not even a month passed after Clem's return from Roosevelt when we were back at Lenox Hill. That morning he had been very weak, unable to eat. I knew that if I was to get him there in a cab, we would have to go immediately. This time he stayed for six days as they dosed him with antibiotics, prednisone, oxygen, a nebulizer, a nicotine patch, and Haldol to keep him sedated. As before, the days were calm, but at night, after I left, the calls would come. "Where am I? Why am I here?" The nurses called it "sundowning."

I could imagine the panic when the safety net of the hospital's daytime routine fell away and, abetted by disorienting drugs, one went into free-fall. I thought of Friedel that long-ago summer in East Hampton, calling us in the night as he waited for kidney stones to pass, so sure he was in a prison camp and would not live to see the dawn. Finally I took Clem

home with Dr. Kutnick's prognosis as a souvenir: "Each episode will be more severe and last longer." I didn't need to hear that.

Clem, thin and ashen, sat on the bed. "I don't know what to do with myself." This was yet another Clem. I trusted his mood would be as transitory as the deep purple blotches on his arms from the IVs and prednisone. But I would have preferred my insouciant Clem, who, instead of saying, "You," when I asked him what he wanted, would have said, "A drink."

I had barely settled Clem when Merrill Lynch called. The IRS had imposed a lien for unpaid taxes on the money market account I had always kept separate from Powers to cover immediate expenses. I called Chemical Bank. No surprise—the gate had closed there, too. The accountant had said it would be only a matter of time; nonetheless, it felt like a knife in the back. I hadn't been on the lookout; my thoughts had been elsewhere. Such an outrage, first a victim of Powers, now of the IRS. And always a one-two punch: What happened to us happened to Sarah. But it could have been worse. Early on I had removed about $3,000 from Merrill and stashed it in our new "bank," a pale gray envelope behind the A–L volume of the OED on Clem's bookshelf. From now on I would be paying bills with money orders and I would cash any incoming checks at a storefront on Amsterdam Avenue. It would be hard to remember that the liens would be lifted when the facts were documented by the court. Mostly, I felt that I had been raped twice.

That evening, after lamb chops and a hit of *Seinfeld* with Clem, I knew it was time to get down to the business of financial wherewithal. I thanked God for Social Security, Medicare, and AARP. My own insurance premiums were high, but they covered Clem's medications. I made a list of our essential expenses, and another, woefully short list of our anticipated income from royalties and reprint fees. There would be no more lecture fees. To our "bank" I added five gold coins that my grandmother had given me over the years and my mother's diamond bracelet, rarely worn in recent years. The last time I had hocked it, I had been twenty-four. I and the times might have changed, but the Century Pawnshop was there. I wondered if it would still support us for a month or two.

So much for my treasure trove—what about my real asset, me? I would get a job. Surely someone would hire me. Another list. From audacious to hallucinatory, it ranged from Alex Liberman, head of publications at Condé Nast, to Nan Ahern Talese, the much-heralded editor with whom I had gone to grammar school.

Alex and I had shared art-world space for decades. Knowing how much he enjoyed the flirting game, I had never taken personally the twinkle in his eye and his warm hands. But now I thought, what the hell, the worst he could do was turn off the twinkle and freeze me out. As for Nan, the possibility that she would remember me after fifty years was indeed hallucinatory. Although both married to writers, we had moved in separate orbits, as we had even as children. She had been the class "star," I one of the "others." Of course I remembered her—the sixth grader whose sled the boys would pull up the hill, with her on it. "I hate her," I had written in my diary at the time, even as I adored her.

And there was the art. As watered-down as the collection had become over time, it was our major asset. No more Newman, Hofmann, or Gottlieb; they and their kin had been turned over to dealers or Christie's in order to house, feed, clothe, and school the family since the art-market bonanza had ignited in the sixties. But there were still a few paper works from the all-stars, a slew of predominantly second-generation pieces, and an abundance of sculpture and representational art. What to do? I called three dealers for their advice.

Larry Rubin, now director of Knoedler, came by to talk to us. We had known him and his family for years, but that morning there was no small talk. He was grim. The outlook of the market, especially for the art that we had, was not good. His suggestion: We should borrow money and sit out the slump. And, poof, he was gone. *Borrow?* The word was anathema to Clem and me. The idea of owing someone money was out of the question. I had learned from Clem on day one that when a bill arrived it was to be paid immediately. Nor did Clem lend money; when approached, he would give it as a gift and forget about it.

André Emmerich stopped by next. He was more optimistic. He thought we would do well at auction, preferably with a group of the

most "desirable" pieces, offered as being "from the Greenberg collection." It sounded risky to me to put our primo art out there all in one shot and hope for the best. It wasn't going to happen. However, we appreciated his advice, his warmth, and his offer to be of help in any way he could. I also appreciated the reminder of how valuable the Greenberg provenance was.

Bill Acquavella was the next to visit. We knew him, but not as well. He was genial and to the point. In effect, he said, "Whatever you do, don't cherry-pick what you have, sell nothing, keep the collection together as the Greenberg Collection, and avoid auction. It would be better to offer it to an institution." After he left, I knew immediately that was the way to go. Clem agreed. How it would happen, or when, I had no idea, but it was the right solution for the long term. Short term, we would simply have to get by. At least now I had a direction.

Those were the good days, when I felt no situation was so bad it couldn't be fixed. But sometimes my mind and body would shake and Clem would say his usual, "It's only money." Once, he asked, "Do we have enough to cover everything we need?" My answer was, "Yes." And I explained that his Social Security covered the $800 rent and there was enough behind the OED for food, etc. Subject closed. Clem, my endearing, enduring socialist. He soothed me with his commonsensical ways, at least until the next time I would hurtle through the "what ifs" and "what thens." Especially as I waited for sleep and the daylight, which would bring the palliative chores that would keep us healthy that day.

July was a time of relative normalcy for us. Clem, though short of breath, was able to go out when the spirit moved. Most of the time he sat at his desk, handled his endless correspondence, and read. He ate, drank, and smoked. He talked on the phone and people came by, though he never took the initiative. As for me, life had become simpler. Stripped of all the worldly busy-ness that free time and money afforded, I lived on a short leash and chose my activities carefully. I undertook what I hoped would be my last curatorial job and began the process of making a detailed inventory of the art. I would then need to label the photos and have new ones taken of the others. It was good to be back at the

computer. When it was done, I would get a few appraisals and we could start thinking about a price. But that was all in the future. Meanwhile, the activity of just working on a plan gave me a more balanced perspective of our financial problems.

Then the respite was over. On August 3, I took Clem back to the Lenox Hill ER. Weak, breathless, nothing else for it. This time there was no bed available, and I spent the rest of the afternoon shuttling between a stool by his gurney in a hallway and what had to be the smallest, dreariest waiting room in the city. Eventually, they stowed him in an alcove of the ER for the night. When I returned in the morning he was in a small room with three other patients. Sedated and on the usual regime of oxygen and IVs, he seemed all right. He would be discharged the next day.

I went to keep a Plaza lunch date with Jennifer, a celebration of her recovery from her double mastectomy. She had come through so beautifully and was cheerfully making plans for reconstructive surgery. While with her, I checked our answering machine. Dr. Kutnick had left a message: Clem, wanting to check himself out, had tried to get dressed and had fallen. When I got there I was told that he had fractured his pelvis and that there would be no surgery. Instead, they would put a pin in his leg and he would be in traction for approximately three weeks. Yes, eventually he would be able to walk.

Those were the facts. I had no time to absorb it all. Clem, who had the highest pain threshold known to man, was now in severe pain. I asked for medication. I screamed for medication. The nurses were stones. Evidently no orders had been left. I demanded to see a resident. At last a white coat turned up and authorized something. Still raging, I went to admissions, explained the circumstances, and demanded that Clem be moved out of the ward. Something must have clicked, because he was transferred to a palatial private room overlooking Park Avenue, replete with plush chairs, real food, china, stemware . . . at least for two days. Then it was back to the trenches.

That first night Clem was in traction, strung up like a chicken, leg in the air. They assured me the pin didn't hurt. How could it not? The sight of him broke me; I kept ducking into the bathroom to cry. I was

afraid that if they saw me, they would clap me into the psycho ward. I finally went home.

The next morning I arrived to find him calmer, but tied to the bed rails. I untied him. Once again I was screaming. Full-out war. A resident explained that he had tried to get out of the apparatus—well, who wouldn't have?—and he was now on a small dose of morphine. But all day his restlessness was only a millimeter below the surface, like my hysteria. Clem desperately wanted to sit, but the weights kept pulling him down. Over and over he called for me to lift him, but all too soon he was down again. Finally, a nurse said that with the traction they should have installed a trapeze to pull himself up with. Followed by those now-familiar words "You'll have to have an order." The comedy continued, and it was evening before the thing was finally hooked up. Clem was too weak to use it on his own, but together we managed to keep him vaguely upright. A helpful night nurse suggested a bed pad that would keep him from sliding. No, no order necessary. I had learned that it would take a village to solve a simple problem. That was day two.

Soon we settled into our quarters, where, I assumed, we would be for the duration of Clem's healing. Fretter that I was, to my surprise I never doubted that there would be a healing. Perhaps I used up my fretting quotient during the day-to-day skirmishes or at night when, sleepless at 4:00 AM, I would slip into the abyss of dark thoughts and bad dreams.

We were in a dim, approximately seven-by-eight-foot cubicle separated by a curtain from Mr. Beckman, his starched, chatty private RN, his often visiting, coiffed and buffed wife, and his window. In a matter of a few days we had been shunted from loading dock to steerage to first class to third class. I say *we*, but Clem noticed little. And I soon got used to it. The days were long, sometimes from ten to eight, with Sarah spelling me when she could. I put out the word, but it was August in New York, the city a desert, the friend pool in short supply.

When people did come, I was always shaken by the initial dismay on their faces. To see Clem through their eyes distorted my reality, which was that whether I was in that cubicle or in my bed at night, I was one with Clem. I was partnered with him through erratic test results and bodily functions, with him on the uncertain ground that in an hour would shift

from one step forward to two steps back: changes in his eyes, from clear to cloudy to deranged; in his skin, from chalky to yellow to pink; and in his mind, from coherent to distressed to angry to delusional to comatose. I lived in the minutiae of him, while others could see only the barbaric nature of traction—and indeed it was barbaric—and that the man they had known was lost, probably forever. Some came only once. The most stalwart came regularly and came to accept what was. They were my lifesavers, who seemed to understand that Clem was there, somewhere— he was just on a long trip.

The ultimate nonbeliever was Dr. Kutnick's backup. Following a crisis caused by dehydration—why had that been allowed to happen?—he said to me flat out, "He won't last another week on that traction," and turned on his heel. I reported the Harbinger of Doom to Kutnick and steered clear of further encounters. As much as I hated to admit it, like my stepmother guarding my father, I, too, had become a Gorgon at the Gate.

The weeks passed. Those hours by his bedside, both of us bathed in fluorescent light that turned us into mud-green creatures of bad dreams. I read, I wrote in my journal—the dumping ground of my anguish—and I made endless lists of questions that I would hurl at any doctor who passed by: Would his "good" leg atrophy, shouldn't he have a circulation machine, why wouldn't the bedsores heal, couldn't the traction be reduced from forty pounds, would his mind ever . . . ? There were few answers, and, caught in the abstruse machinery of the hospital, I continued to run in circles of ignorance. However, I did come to accept the necessity of restraints, which were used during the bad nights, when he would rip out his tubes and even his catheter. I blamed everything on the constant fiddling with drugs: up this, lower that, changing combinations of Percocet, Ativan, Haldol, Restoril . . . I tried to chart it, but gave up. No matter what, it was never right. I often prayed for the courage to trust the doctor, but failed and continued my vigil. And each time Clem would call out, "Jenny!" as if I weren't right there, it was a stabbing reminder that, as much as I believed he would come through, for now he was lost to me.

In fact, Clem had three states of being. Sometimes, for a moment in the morning, he was "there," and I might even read him a bit of the *Times*. At the other extreme, he was "out." Most often he was in the middle ground,

suffused with the spell of whatever was dripping into him. It was then, bored with my own thoughts, that I took to chronicling my storyteller's long narratives, which had two central themes: war and travel. He talked of being a casualty "because I am the only man and there is a war."

"Where?" I asked.

"Inside."

He was often in an airport (he loathed airports) going to L.A. (he wasn't so keen on L.A., either) or at Bennington (he liked Bennington). The snippets: "We weren't told we were going abroad . . . That man has a baby pack on his back . . . We're on the wrong airline." Or, "Get into the kitchen. Get a weapon . . . How did they get hold of us? Do they have Sarah, too? What do they want? Do they have the picture? They should know it's only art. We're in the Northwest . . . this is prison." One day it was funerals: "My grandmother Eva, my father's mother, I am sixteen [the age Clem was when his mother died suddenly of a mastoid infection] . . . It'll be my funeral when the death rattle starts . . . It's inappropriate for me to be laid out in a bed . . . It takes something away from Bill [Rubin] for me to be buried at the same time . . . At Bill's funeral we drank ourselves cockeyed [Bill would die in 2006, at seventy-eight]." Of his "lost" son, Danny: "He's been abducted into a cult. He can't get out." Or he was dying, most often on a train to Baltimore: "But I push it away."

August 22, Clem veered abruptly into pneumonia. Different floor, traction off. He had been coughing a bit, his white-blood-cell count went up, and within an hour, breathing was difficult, and that was that. Sarah and I were there, later joined by Annie and Jim Walsh and Sarah's best friend, Ruthie Mayer. Clem was comatose, the bed raised, his breath labored, antibiotics pouring into him. We waited through the night. It was so sudden. I was dazed. *This can't be happening, he had a broken pelvis, he was healing, we were supposed to be going home.* The hospital corridor was alive, TVs blaring, lights on, the nurses loud, alternately peremptory and boisterous, trolleys rattling like freight cars. Jarring my cold insides. An old woman, white hair down her back, her open gown floating behind her, sang tunelessly as she wandered up and down the hall, clacking her gold mules. A Times Square of infirm insomniacs. Did they sense death on the floor, or was it the norm?

By morning, Clem rallied. And why not, we laughed. This was Clem. He was alert and for a moment even knew where he was. I wondered if the last weeks had been a dream. Dr. Kutnick dispelled any such thought. Clem had responded well to the antibiotics, but next time that might not be the case. Right out, he told us that he had thought Clem would die the night before; however, he had been "salvageable." This time he would be "dischargeable" from the hospital. I was appalled by the jargon and all the "this times." Hell, I had always known that, hospital or home, this was a time of no guarantees. What I now knew for sure was that Clem hadn't stopped fighting.

The next day the "salvageable" patient was awarded a window bed. Lighter in every way. Out of traction, even Clem's tales were less dire; he was a traveling man again. He was enthralled by the brick wall adjacent to the window: "This architecture has been with me the whole way." That wall transported him to Dallas, where he waited for the two o'clock train to New York and complained, "I can't get a damn drink because it's Sunday." Or often to San Francisco, a location that seemed to soothe him, perhaps because that was where he had met his first wife, when he was twenty-five, and for a short time had been so happy. Once again, there was a Vlaminck reproduction across from the bed: "Those pictures are all over the place now." But mostly Clem was on the go: "I yearn to see the inside of the edifices we pass by as we move across Canada [we had traveled by train from Toronto to Vancouver in 1962]." As if on cue, the wanderer in her gold mules tottered in with an I LOVE NEW YORK plastic bag: "Can I leave this here till the train comes in?"

As Clem regained a semblance of normalcy, a heat wave hit and turned our apartment into an oven. That night I woke in a sweat of night fears—tightness in my chest (surely a heart attack), shortness of breath (surely respiratory failure). It was as if I had said, *It's my turn. Just for this moment, let me be weak.* Restored by light of day, I understood that my symptoms were also sympathy pains for what Clem had just been through. I wondered at their power as I grabbed a fistful of cash from behind the OED and went to get money orders to pay the overdue bills. Then on to the hospital, the air still oppressive, now called an "ozone alert," a phrase I had not heard before, as the temperature topped a

hundred degrees.

That afternoon, the world intruded. The hospital phone rang. A man said he was writing a piece for the *Observer* and asked to speak to "Clem," an informality that immediately alerted me. I said no. To his questions about his condition, I responded grudgingly, with a word or two. Then he abruptly switched course: money, James Powers . . . In a fury, I hung up. When the article appeared, it was so preposterously malignant that I could only shake my head. The gist: Clem, who had supposedly scammed artists of art and money in return for favorable reviews, had now been scammed by an embezzler. His hospitalization? That was just icing on the cake for the media buzzard.

Two nights later there was another intrusion, this one with a comedic touch. In the morning when I arrived at the hospital, I was startled to see that the all-too-familiar Vlaminck had been replaced by a small, dun-colored abstract painting. On the back it was inscribed to Clem and signed by the artist. Not one of Clem's more alert mornings; he hadn't noticed the switch. Evidently the audacious artist, a longtime Greenberg groupie, had come before the close of visiting hours and while Clem slept had left her mark. Unfortunately, the picture wasn't as interesting as the act itself. I reinstated the Vlaminck.

Then the day came when Clem was able to sit in a chair. He lasted only a short time and was chilled and short of breath, but what a victory. From then on, the steps toward home were incremental: physical therapy, a walker . . . But progress was slow and arduous, and Clem had no patience for it. As if reflecting his opposition, Clem's meanderings led him back to the Civil War and the Battle of the Wilderness: "Everyone is dead . . . It's the end . . . They prepare us to move out, but we're lying on the ground . . . It doesn't look good . . . I think it's all for nothing."

Early one evening we sat quietly and watched as the last of the sun turned our brick wall a glowing pink. There was one of those lulls that occurred inexplicably, as if the hospital had stopped to exhale. I asked, "What would you like to talk about?"

"Your life after me," he said. "What will it be like?"

Having expected another war story, I was taken aback. I could only say, "I don't know. How do you see it?"

"You'll have a new ascent," he said.

And that was that. So brief, yet it was an exchange unlike any other. Future talk had never been our way. Our way was, "How are you feeling?" "I had a dream last night about . . . " "Did the mail come yet?" I pocketed his words of promise as I would a talisman that I could touch that day and in days to come.

Soon after, we got our week's notice for release and my attention turned to Medicare, aides, transportation home, equipment rental, visiting nurses, PT . . . How much paid for, how much out of pocket, the duration of the help . . . ? I was amazed at how much Medicare would cover: all the equipment, two weeks of home care, and visiting services for as long as Clem needed. I cleaned the house as if royalty were about to descend and tried to mute my thoughts: *Will Clem make it home okay, will the bed be delivered in time, will I be happy?*

Clem was weaned off the Haldol and Ativan, but the attempts to get him off the catheter failed. Like the oxygen, it was just part of him now. Without the drugs, Clem was restless and irritable, and I often yearned for the drifting Clem. He missed it, too. After all his time travels, he looked at his life and found it dull. "I don't care much whether the Rundles come by. For the life of me, I can't remember her name." Val and her husband stopped by: "Something empty in what they had to say." And about an old girlfriend: "She doesn't have enough genuine interest to afford interest to others." And he summarized: "If this is what life has to offer, I'm ready to expire."

September 8, moving day, we received an unexpected benediction. The Doctor of Doom sidled in. Now all smiles, he dubbed Clem the Miracle Patient. Clem shrugged. "What did you expect?" Doom had the good grace not to tell the smug miracle boy that he had buried him a month ago. And then we were ready to hit the road. On our backs were the bedpan, the cane, the linens, diapers, elastic stockings, gowns, bed pads—all the accoutrements we would have gladly left behind. For all the world we looked like fugitives from the Dust Bowl of the thirties as they headed west, hoping for a better life.

DEATH

THE FIRST DAY HOME was the best of days and the worst of days. Clem had survived his ordeal. Now he could heal in the peace and comfort of the place he most longed to be. But the celebration was short-lived. Clem was breathing hard. My work and my questions started. Was the home oxygen equipment less efficient than that at the hospital? The nebulizer, too, seemed less effective. What else should I be doing? I realized I knew nothing. And Vilma, the home-care aide, knew even less than I did. She was unmotivated and roused herself to help only when asked and directed. As soon as I would leave the room, Clem would call me. "I am dying," he said too often that first day.

The visiting nurse arrived. She was pleasant and reassuring about Clem's condition. She checked his vitals and the formidable array of medications on the bureau, to be taken once, twice, or four times a day. I had made a schedule and knew that several would soon be phased out and that others were only necessary "as needed"—a phrase I hoped I would be wise enough to assess. Though the nurse's visit seemed more about Medicare paperwork and getting forms signed than about Clem's condition, I was grateful for her presence.

The doorbell rang. A forty-ish woman in running shoes introduced herself as Ms. Kashlinski as she flashed an IRS badge. Even as a chill ran through me, all I could see were those running shoes. The badge said *danger*, the shoes said *nice girl*, and I let her in. She asked to see Mr. Greenberg. I took her down the short hallway to the door of the bedroom. She saw an old man in a hospital bed, a tube in his nose, the half-full catheter, a woman taking his pulse, and, in the background, a bland-faced black woman on a love seat.

I babbled about hospitals, embezzlement . . . She only nodded. I said

she should leave, and I gave her our accountant's phone number. At the door she said, "We should suspend collection." Shaking, I shut the door. *Suspend collection*? Had they been ready to strip us of our possessions? Was the marshal waiting in a truck? Could a young woman in running shoes be a decision-maker? I called the accountant, who talked me down. "She knows all about the embezzlement. It's all part of the routine. It will be fine."

The nurse left, Vilma went out for a break—from what, I didn't know—and, with the scenarios still whirling, I sat by Clem's hospital bed and held his hand, as cold as mine, as he dozed. When Sarah arrived an hour later, she said Vilma was sitting downstairs in the lobby, eating Doritos, and had told her, "Your father had a bowel movement." Ah, the news flash of the day.

A few nights later, I patched myself together to go to an opening at the Gagosian Gallery of Alex Liberman's work. My first foray in months into high life and fancy shoes. The invitation had beckoned to me, so I grabbed the moment while I had the luxury of an aide to stay with Clem. I left Vilma a bloated list of do's and don'ts and phone numbers, more for my benefit than hers, because I was sure she wouldn't give them a second glance. Then Sarah and I were off, with the lilt of Clem's "be happy"—his signature way of saying good-bye—in our ears.

The opening was heavy going, a *who are all these people?* occasion, as if I had just gotten off a boat from nowhere. Those days, if it didn't tie into health, dying, or financial survival, it wasn't real. I cruised the rooms in a blur of déjà vu. This was the space, much reconfigured, where thirty years earlier French & Company had created a contemporary gallery of unprecedented size and beauty and engaged Clem, who, as their advisor, had filled it with his hit parade of Newman, Smith, Gottlieb, Louis, Noland . . . Now most were dead and those shows legendary.

At last I spotted a familiar band of art brothers: Alex Liberman, of the twinkling eyes, André Emmerich, of the charm and polish, and Si Newhouse, buttoned and glacial. At least some things never changed. I allowed myself a wry smile at the thought of Alex's having been at the top of my "audacious" list of job angels. A photographer snapped a

shot of Alex and me, and seconds later, as Richard Avedon approached, I was jostled out of the inner circle by a flurry of cameras hungry for a tastier target.

People asked about Clem. I nodded. "Yes, quite an ordeal." "Yes, home now, recovering well." "Yes, amazing, so strong." Somewhere along the way I had lost the knack of chat. I passed by Frank Stella, but we only nodded. I thought of Princeton 1959, when we had first met, Clem giving the Gauss Seminar, Frank a grad student. Their thrust and parry, Clem's favorite pastime. The occasional dinners over the years, always lively. Even as they disagreed, an affinity. Clem, loathing his dependency on dentures, teasing Frank about not filling the gap in his front teeth. I wondered, as I had about so many others I had enjoyed moments with, *What happens to memories? Does Frank remember as I do?*

Later, Sarah and I walked to Gagosian's townhouse for a postopening dinner. More a spa than a home; we gaped at the lap pool, Jacuzzi, sauna ... For dinner I settled down next to Louise Reinhardt Smith, an outgoing, opinionated octogenarian whom I barely knew. We talked about the vigor of the old days and the predictable inanity of the new days. As we picked at course after course of overly produced nouvelle cuisine, she spoke about her first steps toward amassing her renowned art collection, and about the spits and spats of being on the MoMA board, and about how she had always had a thing for Clem. And I told her I had always had a thing for octogenarians.

Talking to her invigorated me. I looked around at the smattering of fashion glitterati perched like emaciated magpies on a couch: Diane von Furstenberg, Tina Brown, Anna Wintour, and Grace Mirabella. They didn't seem invigorated. As the party broke up, Jasper Johns came over to wish us well and tell me how important Clem was to him. I was reminded of what a nice man he was and always had been. Francine du Plessix Gray, Alex's stepdaughter, waved: "Lunch . . . lunch." Another woman, nameless now, joined the chorus, which now swept the room: "Lunch . . . lunch." As I bade farewell to my dinner companion, she said, "We must have lunch at Daniel . . . dutch." And so the rich get richer.

Sarah and I hit the street with a disorienting thud and ran for the

Madison Avenue bus. Before sleep, all the lunacy of Alice's tea party danced in my head. As I drifted, a poem wrote itself. I turned on the light and jotted:

From despair
To Medicare
To IRS
To billionaire
And decadence.

I might well have added, "And from there, where?"

After a week, Clem and I were on our own. Vilma was history, the physical therapist came once, never to return after Clem refused to cooperate, and the visiting nurse would show up on a monthly basis, as would Jerry, the male RN who changed Clem's catheter. Our routine was simple and revolved around food—a good thing, considering that over the summer Clem's weight had diminished to 125 pounds—medications, the toilet, grooming, and all my domestic puttering and pothering. Clem became increasingly resilient and resourceful. He mastered the despised walker, accepted the fact that where he went the catheter had better follow, and, though he wouldn't do any exercises, managed to get a bit of a walk, thanks to his insistence on eating in the kitchen.

I should add that there was also a daily ration of frustration and anger, all on my part, and all of which Clem chose to staunchly ignore. I knew he was on the road back when he said one day, "If I had a cigarette with my drink, I'd feel better." The cigarette never happened, but I meted out a couple of drinks a day. He was never overly insistent, and even when he eventually figured out how to carry a drink while managing the walker, he usually found it to be more effort than it was worth.

For the most part, Clem's world was his hospital bed. It suited him, with its unforgiving mattress just the way he liked it, and high enough to get in and out of easily, and low enough for him to set his feet on the carpet as he read at his typewriter table that I had appropriated from his office. I often sat near him on a small "boudoir chair" that I had

bought from a graduating student at Bennington for $5. It had followed me ever since.

Now that the drugs had cleared his body, Clem read almost every waking hour. In addition to the usual history and philosophy, the *Times*, and the *London Review of Books,* he was now rereading Dickens and *Gulliver's Travels*. Novels, never his usual fare, now absorbed him with their language and stories. Every now and then he would look up over his glasses and say, "Damn, he's good." I became addicted to mysteries; they swept through my mind and out again, inspiring and demanding nothing. I loved being in our bedroom, bigger than any I had ever imagined. Thirty-five years had filled that room with beds that had grown from double to queen to king, never seeming to be big enough to support the weight of two people needing ever more space. And now Clem floated, weightless on that narrow loaner bed.

As it always did after Labor Day, the city stirred to life and the phone rang more often. Some called with timid voices, as if fearing to hear the worst. Others showered me with dire tales based on their experiences or gave me lists of things I should and shouldn't do. One woman ventured to tell me I was "in denial." As for the chirpy "everything will be fine" and "take care, now" people, I froze them out. As for Clem, even when it was an old friend, he wouldn't speak to them.

But one day Friedel called. His hold on reality had been slipping away, and I figured, *Now or never*, and handed Clem the phone. I listened in on the frail voices talking past each other and tried to assure Friedel that, yes, he was really talking to Clem. Then I hung up and left them to it. I heard the echoes of those two friends, who had bickered and made up for fifty years. Clem, the bully: "Stop fooling around and get to work"; Friedel, good-natured, putting up with it, even liking it. That was when I had first met Friedel, fondly referred to as "the painter who didn't paint." But age had now brought the "boys" to an unbridgeable impasse. Eventually, Clem gave up trying to penetrate Friedel's fog. "Fuck him," he said as he handed me the receiver and picked up his book.

The VIPs had continued to meet intermittently throughout the summer and fall. Our agenda focused almost exclusively on an eventual civil suit

to attach Powers's assets. To that end, we set about drafting an agreement concerning the eventual dispersal of the assets vis-à-vis the amounts of individual losses. "Assets? What assets?" I ventured to say, reminding them of the negligible findings of the DA's office and our investigator. But no one wanted to believe that, and I shut up. Most discouraging for me was that the tenor of the meetings, which had initially been so "one for all, all for one" now became divisive. We spent hours wrangling over the wording and terms that delineated who would be entitled to get what percentage of the putative assets. The document also included a pledge that any suit against Powers would be a group action. In the event, the agreement would prove to be irrelevant.

As the year drew to a close, the group splintered as two people moved away, another chose to close the door on the whole sorry mess, and a few others were distanced by the vicissitudes of work and illness. Though I knew that I didn't have the will or the wherewithal to take any future legal action, as a support group the VIPs had been invaluable to me, and I continued to attend meetings, if only to remember that I was not alone.

That was the ongoing status of the embezzlement aftermath. Emotionally, especially at the end of the day, it was another matter. Many nights during the months following the imposition of the tax liens, I would pull out that A–L volume of the OED and extract the gray envelope behind it. I would dim the light, close the blinds—not that anyone could be looking in, but one never knew. With a mix of trepidation and a need for reassurance, I would check and recheck the contents. I despised myself for those secret, craven indulgences, but I was unable to stop.

The weeks passed and Clem, when motivated, was able to stand long enough in the bathroom to wash and shave. He also became more amenable to having visitors, and even when he wasn't, I would often invite those who called to come by. I divided them between bedroom people— our "family" friends—and living-room people, who were everyone else. The latter involved a good deal of preparation. Though I had finally made friends with the catheter and found easier ways of dressing Clem without endangering the apparatus, I was still leery of strapping the bag to his oh-so-skinny leg because of the possible effect on his circulation.

After I had hooked him up to the oxygen tubing that would stretch to the living room, he would make his grand entrance on his walker. However, these efforts meant an expenditure of precious air, and most days motivation went on hiatus. On one such afternoon, our painter friend Jeanne Wilkinson dropped by. Clem lolled on the bed. We drew up chairs and chatted. Jeanne asked Clem if he would mind if she did a sketch of him. As a lifelong charcoal sketcher himself, he was pleased. As she took out her pad, Clem matter-of-factly asked, "Do you want me nude?" After much mirth, not shared by Clem, he kept his nightshirt on.

A far less pleasant visit was that of a Harvard professor and his graduate students. Seduced by his fancy titles, the polite formality of our preliminary exchanges, his solicitude in regard to Clem's health, and of course the aegis of Harvard, we agreed to a two-hour "field trip." Clem had no objections—after all, art talk, students, just his thing. The group arrived, a bit larger than I had anticipated, but everything seemed in order.

Assuming all would go well, I went off for an hour or so to an Al-Anon meeting. I returned to a scene out of *Animal House*: all the lights on, overflowing ashtrays in every room, everyone boozing, and in the smoke-filled bedroom, Clem, bleary on Scotch, surrounded by students, sucking oxygen. Outraged, I ordered them to open every window, put the glasses, bottles, and ashtrays in the kitchen, replace the furniture where it had been, and get the hell out.

Yes, this sort of thing was run of the mill. Yes, I behaved once again "like a wife." But this was an indignity on a scale that was incomprehensible to me. As for the students, I was sure they had much to chortle about. And the smarmy professor? I was sure he would slither his way to the heights of academe.

During the fall, Clem had routinely put off speaking requests, but there was one engagement that had been on the calendar for some time and that he was reluctant to cancel. The New York Public Library had a special series of appearances by "distinguished authors." The venue was compelling; for Clem, as for all aspiring New York intellectuals, the Forty-second Street Library was where he had been nourished. Joining the ever-resilient *Art and Culture*, the last of Clem's four volumes of

collected essays and criticism had been published in 1993. Now his life's work was available to all and he would be honored, not only as an art writer in an art context, but as an author. But, as with Paris—though now because of more stringent health problems—it was not to be.

For the most part we inched forward, the waters uncharted. We had never been so encapsulated, our life together having always been such a crowded place. The only other occasions had been those dread driving trips, especially the three-month European odyssey closeted in the mini-Simca, as Clem searched for art gold and came up empty and I searched for togetherness and found loneliness.

Now, we had taken on the coloration of an old married couple. As he had done since the day he had been fired from *Commentary*, Clem continued to do only what he wanted to do. In recent years, when people had asked about his writing, he would say, "I suffer from inertia." Now, should someone ask, he would just shrug. But no one really asked. As for me, I tended to his needs, anticipated disasters, and fretted about every coughing spell and wheeze. And, like any tired, old married woman, I continued to get grumpy and nag when he forgot to take the pills I put out or he got tangled in the catheter tube. Then, like any old, long-suffering husband, he would take the high road of forbearance, leaving me to bite the dust in shame. Only once, when I had raged long and loud, did he raise his voice: "Don't yell at me!" And I shut up, relieved to know there was a limit to what he could bear.

At night we sat on the love seat in the TV room, watching sitcoms, and I thought about when our love was new and we would lie on the bed at night in our deplorable lingerie-puce bedroom on Bank Street and watch boxing and Sid Caesar and Jack Paar. Now I introduced Clem to the vast menu of TV, and he quickly espoused PBS and the History Channel. In fact, any documentary would do, preferably one about nature. But his favorite was *Frasier*. The runner-up was *Seinfeld*. Always the critic, he would mutter, "Too Jewish" and, "They push too hard for a laugh." I also introduced him to the wonder of the remote control, which I came to regret. Congenitally incapable of operating anything with buttons or knobs, his plaintive "Jenny" calls notched up as he fell into TV limbo. One morning he reported that he'd found a porn site but then had been

unable to find it again. Unfortunately, I couldn't help him there. And a few minutes later he mused, "All those years, all those girls . . . I would have been better off masturbating."

One night, as we watched a PBS show about birds, Clem mentioned the nightingale and that he had never heard its song. As if I had heard a clarion call, I sprang into action. Surely, here was something special I could do for him. The bird of poets and fairy tales and even my mother. She who had lived in perpetual innocence and had sent me into my dreams and nightmares with her ramblings of buttercups and nightingales. I had found buttercups, but, like Clem, I never had heard a nightingale. Had she? Had Keats, Yeats, Eliot, or Matthew Arnold? Or did its mystique lie in its elusiveness, a bird that sings in the dark and never sings the same song twice, as if to tantalize and confound?

I headed to the Colony Record store, that mecca of all things musical, where as a singer in the sixties I had combed the racks for the moony torch songs of sad ladies of the twenties and thirties, the more obscure, the better. My songs. Just as two decades later, still in their thrall, those songbirds would become the gritty core of my bittersweet comedic plays. At the Colony, the clerks were intrigued with my quest for the nightingale. They scoured their storeroom, computer records, sourcebooks. The store became an aviary as we listened to records and tapes, just to be sure the elusive diva was not hiding among the sparrows. But all in vain. Until the maturity of the Internet, its mystique would remain intact.

Soon after, I noticed Clem, uncharacteristically without a book, without pen or paper, lying still on his bed. I asked him if he wanted anything. He said, "No, I'm reviewing my life." I wondered if, in his reverie, he was thinking of the young intellectual who had yearned to be a poet. Was that his link with the nightingale? The poet he had never become, the song he had never heard. Yeats, the poet we both loved, and the bird that sat " . . . upon a golden bough to sing / to lords and ladies of Byzantium / of what is past, or passing, or to come."

During the night I would check on Clem. Was the room too hot, too cold? I would adjust the blanket and touch him. Sometimes he would remember in the morning and be pleased. Though I liked hearing that, I preferred being unobserved. Deep down I was afraid that he would

expect more and more tender care and I would either fall short or be eaten alive. I say *deep down* because I knew well the sad, entangled roots of that thought. And also knew that nothing of that sort would ever happen with Clem. He expected nothing of a practical nature from others, and therefore had lived a life free of disappointment and free to enjoy the gifts of the unexpected.

My own expectations in regard to my work went through a sea change at this time. There was a flurry of interest in my plays from directors who submitted them to the McCarter Theater, the Manhattan Theater Club, and the Skirball Theater; they were all rejected. I watched myself open the letters and trash them with indifference. In only a year, my joy of writing had evaporated. The reason was only too clear: The cold hand of reality had left no room in me for the "let's pretend" world of theater.

One afternoon, when two women painter friends of Clem's asked to come by, I once again grabbed the opportunity and joined an out-of-town friend on a jaunt to the Cloisters. Believing as I always had in the gentleness of women, I felt that Clem would be in good hands. I readied him in the living room and, tethered to his tubes, I left him to a few hours of art chat. At the Cloisters I was drawn to a small wood-paneled painting of Jesus, *The Man of Sorrows*. The tears of blood, the suffering. And the Woman of Sorrows, where was she? Who stood for the widows, the mothers of dead children? The Madonna, of course, but she was only in evidence serenely suckling her babe. Alas, the Cloisters may have given me a change of scene, but it was hardly the best feel-good choice at that time.

When I came home, it was a replay of Harvard—the place reeking of cigarettes, all three woozy on Scotch—and I lost it. I threw the Harpies out, opened the windows, and got Clem back to bed. I despised the women, who purportedly loved and esteemed Clem, for their stupidity, and Clem for his complicity, and myself for fighting battles that drained me and bored me and that I knew I could never win. I wouldn't make that mistake again. But those were the moments when another part of me wanted to throw in the towel and move on to the sorrowing widow scenario.

December was a good month for us. Clem's condition remained steady,

enough so, that several times his friends suggested a wheelchair tour of the Met on a day when the museum was closed to the public. Clem would always say yes and then, at the last moment, say no. Even for art, Clem would not be lured from home.

And then it was celebration time. As we always did, Sarah and I staged a bang-up Christmas: a huge tree, proclaimed, as always, "the most magnificent ever," mounds of presents, and a gathering of friends for Chinese food, Clem's favorite. Clem tottered around on his cane, pleased with the glitz of it all. And after months of interim jobs, Sarah was celebrating her directorship of the new gallery Black+Greenberg on Grand Street. She would be living in an apartment in the back. And more good news: Our tax liens were finally lifted. No more money orders, no more fear of marshals at the door. We could have a bank account and I could trash the worn gray envelope. The OED could rest in peace.

The only sadness was Jennifer's death. She had fought her breast cancer with every fiber in her, but no amount of courage would save her. She had been housebound the last months, seen to by a series of live-in aides who never lasted long, given that they received the brunt of her fierce rage against what was happening to her. I could understand that rage, and would listen and nod. But she barely knew I was there, so completely had she crusted over and moved inside herself. It wasn't long before she was rushed to the hospital. When I arrived there later that morning, there was only an empty bed. I was told she was in the morgue. The word made me shiver, as did the knowledge that she had died alone.

The next day I met her brother and a sister, a nun, whom she had never mentioned. Sister Violet was as short and stout and round-faced as Jennifer was tall and lean, with her fine-boned blondness. I watched Violet put on Jennifer's white Givenchy winter coat with a white fur collar and gracefully scalloped hem. She preened at the mirror, thinking herself very fine. "Perfect for Nebraska," she said.

I had understood Jennifer's rage, but I was disconcerted by Clem's listless acceptance of what was happening to him. No anger, no highs, no lows. His emotional spirals had flattened out since he had been weaned from the hospital medications. At home he was the Clem he had always been, except more subdued. His even disposition that I had

always treasured now oppressed me. When he would say he wanted "to talk," he really just wanted my presence. He had reached a plateau in his recovery and evinced no interest in furthering his progress or talking about it. While I, as I tended to his daily care, needed to believe that his condition was improving. I was incapable of joining him on his high road of acceptance. A lonely time of things not said. He never spoke of death. Only once did I ask him whether he thought about it. He said he did, but seldom, and when he did, he "numbed at the thought of it." I envied him.

On January 16, Sarah and I threw an eighty-fifth birthday party for Clem. Since his seventieth, we had arranged a big celebration every five years, always in friends' lofts, always a dancing party. This year, the gathering would be smaller, and I filled the apartment with close friends and family: his brother Marty, so long estranged, and his wife, Paula Fox; their half-sister, Natalie, whom I had met only once; and Leatrice Rose, his brother Sol's ex-wife. Reconnecting with Clem's family meant more to me than to Clem, who appeared to be unmoved by their presence. The Greenbergs, who cared so little for maintaining family ties, would have been surprised to know that they had become my virtual family after I had been stripped of my own forty years before. Now I felt the lack of family more strongly, and, though I knew they cared little about Clem and certainly not at all about me, I wanted to see them and touch them. The party was a success. I kept everyone moving and talking to people they didn't know, as I had learned to do years before. Clem sat where he sat. After the group winnowed down, we put on the Bee Gees, and when "Stayin' Alive" came on, Clem couldn't resist. With his cane and a steadying hand, he stood and danced.

As if to keep the celebratory mood going, a few nights later, leaving Clem with Sarah, I went to a party at my artist friend Yvonne Thomas's. There I ran into my "starter affair" and felt the flutter of being young and in love. Later, on the Fourteenth Street subway platform, three beautiful African American women were singing in a cappella harmony, "I believe in yesterday . . . " When, at Columbus Circle, I switched to the C train, it was to the strains of an aging hippie on a sax playing, "Smile though your heart is breaking . . . " I cracked up. How many nostalgic messages

did I need to tell me that my flirtiness had just been my own half-baked way of "feelin' alive"? And the coda? It told me that my world was Clem, and though we were dancing on thin ice, we were alive. I smiled all the way home.

And then winter closed in. It started off on a frightening note. During the past months there had been occasional alarms with the catheter when the urine had turned cloudy or bloody. Each time I was advised to wait and see, and each time it had cleared. But in late January the flow stopped and Clem was in pain. It was 3:00 AM. I wrapped him up, stowed him in the lobby, scoured the deserted streets for a taxi, and once again took him to the ER. They cleared the blockage, gave him antibiotics, steadied his breathing, and discharged him the next afternoon. Clem, as usual, was unfazed, while I found it an unsettling reminder of how fragile our status quo was.

I scrubbed and vacuumed, emptied closets and drawers, and then began again. My way of numbing. I would sleep heavily, as if it were a burden, only to awaken suddenly when I would hear Clem call. But often they were phantom calls. No matter—I would go and check and then check again, and then be unable to sleep. I had a strong need to talk to friends, but I was unable to listen. I felt that my sadness was contagious and that people were keeping their distance. As Clem suffocated, I suffocated. "Sympathetic dying," I quipped to my friend Carol. She understood my panic and simply said, "Clem is alive."

I endured all the caretaker clichés: I had no appetite, cried at odd times, couldn't concentrate on a book, was struck suddenly by physical pains that then disappeared. Even as I recognized these things as clichés, they were no less real for that. On the emptiest of days I watched myself watch television. Shadows of Bank Street in my twenties: I watched myself losing my self. I slipped into a monotone. More shadows remembering when, after our baby's death, my analyst Sy had said I was choking on inexpressible emotions: rage and guilt and fear. I felt them all. I was submerged in a tank of water, navigating by fear, dodging electric currents. Rage itched under my skin to get out. And it leached out, mainly at Clem over the trivial frustrations of caretaking. My anger had always been part of me, but never before had I met it head-on and been forced

to acknowledge it and admit my helplessness in the face of it. Then, suffused with guilt, I would beg forgiveness, even as I knew I didn't deserve it. And the price of a good hour, a good day, a party? More guilt, piggybacking on my anger about having to pay a toll for feeling good. Oh, the long tentacles of guilt.

These feelings had been cumulative, and eventually I had the sense to know that I needed help. Marge Iseman, Helen Frankenthaler's sister and always a cornucopia of advice, recommended the Jewish Board of Family and Children's Services. There, at a cost adjusted to what one could afford, I was folded into a therapy group that met one evening a week under the guidance of Ruth Kreitzman, a skilled and compassionate therapist. I found, in the occasional confrontations and bickering of the group, a chance to vent some of my emotional steam in a safe place. It provided a good counterbalance to the gentleness of Al-Anon's dynamic. I hadn't known I needed both until I experienced them.

As winter drew to a close, so did the one-year anniversary of the day we had heard of the embezzlement. My fellow VIPs were indifferent to my reminder, and I felt let down. Not that I wanted to celebrate or have a weep-fest, but I wanted a simple affirmation: "Yes, a terrible thing happened to us." And: "Yes, we remember." I was sure no one had forgotten, but the hand-holding days had passed.

The IRS had certainly not forgotten. As tax time approached, we faced a final reckoning regarding the taxes that Powers had never filed. The liens had been lifted, but the amount the IRS had deducted for unpaid taxes, plus interest, left us with much less available cash than I had expected. The IRS was holding out for penalties as well, which the accountant hoped to negotiate. Two weeks later, we received the final IRS sign-off letter, so important in case credit problems cropped up down the line. We were no longer criminals in the government's eyes.

Fortuitously, that very week, on April 28, as if to show that what goes out can also come in, there was an opening at the Wadsworth Atheneum in Hartford of a group show honoring the work of Noland, Olitski, and Caro, a show that also honored Clem. The three artists, family to us for so many years, attended the opening and dinner that followed, as did Sarah, who represented her father. She called late that night to tell us

of their extraordinary generosity: The artists had gifted their honoraria to Clem.

The final convocation of the VIPs was on April 29, for the sentencing of James Powers. Two weeks earlier he had pleaded out, as Valerie Arvin had predicted when Sarah and I had first met her. It seemed that years had passed since then. I awoke, stomach clenched, fearful yet eager for my day in court. Sarah was still in Hartford, but our friend Annie Walsh offered to come with me. The group congregated, swelled by family and friends. I could feel the uneasiness in the air.

Grim and guarded, we were impatient for the proceedings to begin. Powers was finally brought in. He looked pasty, diminished, his demeanor sullen and listless; he looked like the loser felon he was and had always been, although he had concealed it well. Only five of us took the stand to speak. The crime was the same, but each spoke from the depths of his or her experience and the gist of each differed. From trust and betrayal to "His life in jail will be more assured than my own" to "He should pay" to the invasion of our lives to "I cooked food for him." This speaker was the only one who, when she finished, approached Powers, pinned him eye to eye, and said, "Shame on you." I felt a chill. She might as well have put a bullet in his head.

I told our story, Clem's, Sarah's, and mine. From the initial shock and my retrieval of $21.47 from the Chase account—"the only return on our investments I would ever hold in my hand"—through all the ensuing shocks of destitution, taxes, liens, and Clem's health. My gist: "The numbers and facts are known, but I will never be able to calculate the damage Powers did to our family. This was a crime of violence." Inwardly the emotions of a year flooded through me, and when I mentioned Clem, I cried but the flow of my words never faltered. Strasberg might have finally said, "Well done." And I was proud; I had said what I had to say. One of our group leaned over and said, "You were earth and fire, Joan of Arc." Annie held my hand.

The judge had been moved by us all. He passed a sentence of eight years, the maximum under the plea agreement. He spoke of the magnitude of the crime and recommended that the defendant serve his full term. I liked to think he would have been happy to sentence Powers to

fifty years. Valerie told us it was highly unusual for a judge to put such a recommendation on the record.

The group adjourned for lunch nearby. Our spirits were light, our mood softened. Oh, there were a few grumblings about the length of the sentence. After all, eight years added up to less than a year per victim, a short term for a crime that had altered the course of our lives. And it would take almost that long for our credit ratings to be cleared of liens. But at least the bastard was in jail. We bantered, drank, and toasted the future. We had come a long way since our first meeting, when the air had been filled with panic, fear, anger, and so many questions with no answers. We still didn't know all the answers, and never would, but we had all found strength, perspective, and purpose within the group. We were bonded, although I realized how little I knew of their personal lives. On the street when we parted, I knew that we would probably not see each other again. None of us would need or want to be reminded of the past year. And then it was over, and I headed for the subway.

Over the next two days, Clem's breathing became more labored. He used the nebulizer more frequently and he was back on prednisone. This time, however, it soon became clear that the miracle drug had lost its healing powers. On Monday, May 2, in the late afternoon, Clem's breathing worsened and he complained of pain in his left leg. I called 911. The drill was the same, but this time, as we waited for the ambulance, Clem broke out in a cold sweat and started shivering. For once, the paramedics didn't waste time with the usual arguments against going to the East Side, and in record time we were in the Lenox Hill ER. Clem was started on an IV, they eased his breathing, tests were under way. It was still unclear whether he would be admitted. Sarah joined me for the long vigil in that disheartening waiting room we knew all too well. Late that night, he was admitted.

The next morning Clem was much improved, downright chipper. He even shaved himself. Doctor Kutnick said that his lungs were clearing, and although there was a blood clot in his thigh, it should respond to medication. If all went well, he could be released as early as Thursday. I had brought books and we settled in to Room 434.

After lunch, Clem mentioned the morning we had gone to get married.

"We were sitting in the back of that taxi, and I knew that marrying you was too good to be true." I understood what had stirred the memory—the next day was our anniversary. It was a day we never forgot to mark; nothing fancy, just a word to say, *I remember*. But that he should refer to the taxi made me laugh. I told him how vividly I, too, remembered, except that I had been worried about my golf dress and if it was spiffy enough and wishing I had a corsage to make me look more like a bride. "Do you remember stopping the cab and running into a florist for an orchid? It was as if you had read my mind." He shrugged. "Maybe I did." But I knew he didn't remember the flower.

When I told him it was thirty-eight years—we never did subtract for the "divorce"—he said, as he did every year, "That long? You don't look old enough." Good to hear, especially since I had recently turned sixty. A little later, drowsy, eyes heavy, he said, "I never gave you enough. I'm sorry." His words came from a place seldom unlocked. I knew he wasn't referring to flowers and "stuff," he meant enough of *himself*. I told him that his words surprised me, that I had always thought of myself as being the withholding one. He simply said, "No, not you." But I was sure it had taken two. I thought of the many things that lay between us, said and mostly unsaid, as we had protected each other or, more often and more likely, protected ourselves.

There was a gentleness in the room that day. It was reflected in his thoughts and his voice. I had noticed that in recent weeks his intonation had become softer, the hard edges of consonants more cushioned. It was as if his boyhood Southernness had reasserted itself.

Late that night he was possessed once again by the drug demons. He called me. He was locked up in a hotel. They refused to give him a wake-up call . . . My helplessness, the doubts, my anxiety kicked in. He had been so fine all day. What if he fell again? I should have taken him home. They were just making him worse.

The next day, our special May 4, was as bleak as the previous day had been sweet. Clem was still raving when I arrived. Valium, Ativan, nothing would calm him. The doctor said the clotting was worse. There was now numbness. They would operate that day to "evacuate the clot."

The waiting was interminable. Hours passed. We heard nothing. By

late afternoon, Clem was finally calm. We sat silently on the edge of the bed, holding hands. There was something childlike in the way we sat facing the door, as if we were waiting for a grown-up to come and tell us what to do. After a while, so matter-of-factly that he might have been telling me the time of day, he said, "This must be what it feels like to be dying." I murmured reassurances, but I knew nothing. All I could do was arm myself with questions as we waited for the surgeon.

It was evening when the surgeon finally showed up. He was in no mood for questions. With icy precision, Dr. Ahmed spelled out that he would "evacuate or bypass." There was a fifty-fifty chance of removal. The leg was probably gangrenous. No general anesthesia, and the operation would take about an hour. And he was gone. He had barely looked at Clem, not to mention at me or Sarah, who was now with us. Stunned, all I could think was, *Gangrene? Fifty-fifty chance of what? Amputation? Death?* I held on to Sarah. I held on to Clem.

More waiting. It was dark before Clem was wheeled out. We followed and sat in an empty waiting room nearby. One hour, two, almost three, and we heard nothing. Then I saw Ahmed coming down the hall in street clothes. He seemed taken aback that we were still there and simply said, "There were more clots than anticipated." As I sputtered with questions, he said I should speak to Dr. Kutnick and left. Thanks to Sarah, physical violence was averted.

Early the next morning, Dr. Kutnick told me that they had removed as many clots as possible. It was now a matter of waiting to see if what remained could be dissolved. He prescribed a pain pill, "as needed." Compared with the emotional storms on both our parts the day before, this would be an easier day. Clem rested, deep in his thoughts, picking up a book now and then, putting it down, picking up another. I felt weepy all day. No tears, an inner weepiness. Clem summed it up when, toward evening, he said, "Dying is boring." Humor and horror. To laugh or to cry? I laughed and told him he hadn't lost his gift for telling it like it was in the fewest words possible. I also told him I had never known him to be bored. He said, "All things being equal, which of course is never the case, I never have been bored before." His favorite caveat, "all things being equal," in this case meant, "with the exception of boring

people." I went home that night reassured and convinced he would come through this.

The following morning, everything seemed much the same. But not to Dr. Kutnick. He told me Clem's kidneys were now impaired. He wanted to hold off on giving him anything stronger, but said if Clem experienced more pain I should call him. *Impaired, pain*—this was not going to be a calm day. But Clem managed well on the pills and he dozed on and off. An Upper East Side matronly supervisor of something or other stopped by to talk. Her kind words hovered in the stale air. Nothing sank in, until an hour later it did. "My God, that motherly bitch was death's messenger!" I had stopped processing information. I needed help.

I called Sarah, my steady center. I called Annie and Jim Walsh, who said they would come the next day. When Alexandra Truitt, our friend Anne's daughter, called to ask how Clem was, I asked her, too, to come by. Somewhere in the course of that day I finally understood that a corner had been turned. Medical attention was no longer focused on how to restore him but had now shifted to how to "make him comfortable." That euphemism for *imminent death*. As with so much in life, the clues were there long before the mind was willing to grasp their significance.

That night when the phone rang, it wasn't Clem; it was Dr. Kutnick. My breath caught. Through a tunnel I heard him talking about Clem's kidneys and other organs and time to start on morphine . . . The rest was lost to me. I threw the receiver to the floor and remember nothing except the howls that must have been mine. How long I was "gone," I don't know, but when I returned I saw the phone and picked it up. The doctor was still there. He talked me down; no need to come to the hospital tonight, Clem was sleeping, the morning, come in the morning . . . I called Sarah and told her what I knew, by now the tears silently streaming.

At five o'clock I was in the lobby of the hospital, fighting with a guard who wouldn't let me through to the elevator. I reasoned, I railed, I threatened. I had found a target for my rage: that nameless man in a uniform buttoned up with rules and regulations. He didn't stand a chance. I physically shoved my way past him. Upstairs, outside "our room," a nurse tried to bar me from entering, but, mercifully, another nurse intervened and drew her aside.

I had slain the dragons at the gate, and there was my prize. Clem rested peacefully. The oxygen, the tubes, the drip of IV fluids, all as usual. I took my place by his side and held his hand, his beautiful, treasured hand, surprisingly warm. I thought, *This is good. Kutnick read it wrong, he underestimated Clem's healing powers, he has come through the worst, the clots are dissolving, it may take time but we've done this before, we'll do it again, and we'll go home.* Did I speak these words or think them? I know I talked to him of this and that and of going home, the words sprinkled with love. Occasionally his eyes flickered; he knew I was there. And Sarah was soon there, too. A perfect room of our own, the other bed empty, the morning light blooming in the window.

Later, when Dr. Kutnick came in, he told us that Clem would experience more discomfort and that they would be increasing the morphine dosage throughout the day. Again that shock, the cold clench of fear. The truth hammering at the door. But this time, no howling.

As the morning lengthened, a reassuring ordinariness settled over the room. Our small family of friends gathered. As we talked and gossiped, we tacitly included Clem in everything we said. For all the world, he might as well have been reading a book as we moved around him. But each time a doctor stepped in or a nurse adjusted the IV, I was shocked again, slip-sliding out of the ordinariness of the routine, the surety that all was as it should be, just another day in the hospital. I shut the door to the room. But that did not stop the uniforms from coming.

And so the hours crept by. We did the *Times* crossword. Clem could have helped us out, but we agreed that he never would have. He loathed games, tests, puzzles of any kind. He couldn't see the fun of it. A sad day when I, a games addict, learned I hadn't married someone I could play with. I told them what Clem had said the day after Jackson died: "What matters most is what you mean to your nearest and dearest." Clem's way of cutting through all the hoopla and bullshit that had followed Jackson's death. Poor Jackson, he hadn't fared well in the nearest-and-dearest department. But Clem was speaking of himself, too. Even before he had gotten sick, he would say that he wanted to die at home with us at his bedside. Well, he'd gotten it half right. And in our way, we had all spent the day making the room feel like home. All our chat and movement

tuned to the steady cadence of Clem's breaths. Like music. Lulled, we shared his soporific calm. Our breath, his breath.

At four o'clock a nurse came in and asked if we would step out while she "made him more comfortable." A couple of us went to the cafeteria. Why, I don't know. It was a place I had always avoided. Dismal, ill lit, filled with refugees like me passing through, seeking respite, so many alone, staring, eating they cared not what, none of us where we wanted to be. How long were we there? Ten, fifteen minutes? Enough to drain my soul. Afraid, I ran back to 424.

Clem was there, but he was different. What had they done to him? They had stolen his Clem-ness. He looked like an old man in bed, a supplicant at death's door. Meek and mild. Sanitized, starched, and trussed. Posed for death. Why hadn't they let him be? Rumpled, frowsy, his head arched back, the easier to reach for breath. *Make him more comfortable, my ass*! They had stolen his will when I wasn't looking. If only I had never gone to that damn cafeteria, he might have been himself for another hour, another minute, long enough to astonish us one more time, to say, "I'm glad you're here. Be happy."

The spell we had cast on that room throughout the day had been swept away. We now sit hushed. We hold him. His breaths are few and fragile. I feel my sadness creep through me. Does he know, does he sense, we haven't been there? He knows he isn't at home, but does he know we left him alone? The thoughts jump out at me from behind the doors of my sadness. They tighten the screws of my guilt. Even as I bury my face in Clem's hand, I wonder if I can ever appease the ferocious appetite of my guilt.

No more intrusions. The door stays closed. Twenty minutes, forty-five . . . Then the final shock. His last breath.

AND AFTER

THERE WAS NOTHING soft and easy about widowhood. The process, rote and impersonal, began the moment Clem's body was wheeled away to the elevator and someone asked if I wanted an autopsy. Startled, I cried, "No!" and fled Lenox Hill forever. In the days and months that followed, the regimen ground on, from the funeral director—there would be no funeral—to the lawyer to the endless forms and procedures. And time always seemed to be of the essence. Those things went against every inclination in my body, which wanted to sink into the utter stillness that had descended on 275, as if the winds of a terrible storm had swept through and moved on. In that vacuum I wanted to contemplate the enormity of what had just happened and absorb the impact in small doses, and at a tolerable pace. But the machinery of death's aftermath would not be stopped.

The obituary in the *Times* brought the world in with calls of condolence tinged with concern about the announcement's many sloppy, silly errors. The callers were not amused. I was. Evidently, to die on a Saturday when no one over twelve was minding the store was not prudent. In any event, by the end of the week the *Times* regulars weighed in at great length with their thoughts on Clem's role in the history of American art.

At Sarah's urging, a party was organized, and before a week had passed the apartment was crowded with friends. I swam underwater and for once didn't work the party. Well, except for an inspired moment when, after an orgy of toasts, I told the story of Clem, at twenty-four, going across the country selling neckties wholesale for his father. And how, over the years, when he would talk about developing one's "eye," he would say, "Bear down hard when you look at each piece of art, as hard as you

357

look when you're choosing a necktie." I led them to the tie racks in his closet, where they deliberated at great length over which of his prodigious number of ties would be their memento of Clem. Two days later, I fell onto my bed one late afternoon and slept eighteen hours.

A few days later, Sarah and I sat in Clem's office, staring at the heavy, maroon vinyl container of his ashes. What should we do with them? Scatter them, we supposed. But where? There was no favorite mountain, or beach, and certainly no dolphins in the vicinity. The Frick and Met, though dearly loved, were unlikely venues. And Ken's Gulley was now the aggrandized compound of Norman Lear. The more we looked at the humble vessel, the more we realized how much Clem would have approved of the honest color and practicality of the vinyl, and that his office was where he was meant to be. He would be surrounded by what he enjoyed most: his old Remington and the walls of books. Not a fancy library, but an eclectic, every-word-read and annotated library. At one time, when *Town & Country* had asked him to write a short piece about his favorite view, he had begun, though never finished, a piece about the view from his desk of the reservoir, the birdlife, and the mansard roofs of the Stanford White building across the way.

Of course he should stay here, and I knew where: among the poets the young Clem had revered and whose ranks he had hoped to join someday. We cleared a niche and slid him next to Wordsworth. The box looked like a hefty tome with a curious title: "No. 33663, remains of Clement Greenberg, cremated May 10, 1994, Babylon, NY."

After staying with me for two weeks, Sarah left to resume her gallery life. I was alone for the first time in my life. Never was my aloneness as palpable as when, laden with the bustle and dust of the city, I would open the door to my silent rooms and call out, "Hi, it's me." And in my heart I would hear his soft, quickening voice answer, *I'm here.* And there was a different Clem voice that would awaken me in the night: *Jenny,* stretched to two strong syllables. Reflexively, I would jump up, then stop. Silence. I had heard, but not heard, caught in that hypnagogic moment between dream and reality. His calls that had been so much a part of our last year lingered for months, a bittersweet tie that I wasn't ready to relinquish.

I slowly slipped into sadness and depression and turned to my support systems: Al-Anon, and group and now private therapy at the clinic. At their urging, I tried a bereavement group at the YMHA, where I had once begun my journey into the theater, but this time I had less success. A group of twenty or so women and one man met in a preschool room. As we squatted on tiny chairs, everyone told their stories: brief glimpses into the vast nature of coupledom. At one extreme, glued-at-the-hip unity. In the middle ground, the many variations of glued-at-the-hip unity. And at the other extreme, our free-floating separate/togetherness.

One woman had lost her husband a year before. She had tried a bereavement group but had been unable to go in because she was paralyzed by the idea that it was the first time she had been anywhere without an escort. *Escort*—I was moved by her use of the quaint word. But overall I felt like an alien amid those widows of "normal marriages," who were mourning losses of things that had never been at the core of my own. More than that, I felt that what Clem and I had had was illegitimate and that, in comparison, I wasn't entitled to mourn my loss. I didn't go to session two.

Sometimes over the next months I would think sympathetically about the "escort-less woman." She and her story were emblematic for me. So many times over the years I had been torn between envy for such a conjoined couple and revulsion for the crippling consequences of such bondage.

During the summer, the regimen of widowhood continued as I moved back into the bedroom, moved my computer into Clem's office, and began the ritual of sorting his clothes. Just as he bought clothes reluctantly, he was reluctant to ever throw any away. Clothes were still there that had been in his closet at the beginning of our marriage, and they had grown old along with us. The things I chose to keep would carry the provenance of my love for the man I had chosen to live with. No wonder I remembered in such detail the occasions when we had bought those skinny wool ties and treasured felt hats in London, and those brown suede shoes in Calgary. I let most of his things go, except for the mantles from his various honorary degrees—no sentiment there, but they were

pretty—and his suede and wool "bagel jacket" that hailed from our Bank Street days. And those wonderful hats that still grace the hat racks in the hall closet. I don't notice them much, but they are there.

While I was still in the crucible of the clinic, it was suggested that I try antidepressants. Why not? I would be a new Jenny who wasn't fretful, who didn't totter along the rim of depression, dipping a toe and a leg in now and then. Hell, I wouldn't have to experience widowhood at all. I said none of this. I liked my group therapy, I liked my therapist, and, after dutifully reeling off my sixty-year history to an in-house psycho-pharmacologist, I took a Prozac. Within a few hours, I began to shake, sweat, and feel a band tighten around my head, and I figured I would be joining Clem any minute. I was switched to Paxil. I slept twelve hours a night, and now and again a lightbulb would explode in my brain and hurl slivers of glass that flashed behind my eyes. My report of these "short circuits" was greeted with skepticism. I stuck with Paxil for six months. But during the weaning process I experienced full-blown depression for the first time. Palpable, like thick, scratchy blankets were being stuffed into my head. The good news: It was temporary. The best news: I finally knew what real depression felt like, and I knew that that wasn't me. No more pills. Good times, down times—I might dip my toe in, but I now knew I would never drown. Besides, widowhood was an experience I didn't want to miss.

That fall I got a call from Tod Catlin, who suggested that the University of North Carolina might be interested in buying the art collection. We had met Tod on our "honeymoon" trip to the Walker Art Center in 1956 and had stayed in touch. His call touched off a surge of renewed energy. I realized how much I needed to be at work, and here was the opportunity. I reopened the computer and began to finalize the detailed inventory of over 150 items that I had begun the previous year. I had it appraised, and Tod moved forward. Thanks to my ignorance, I assumed all would go well and was ready for whatever came next.

The Getty Research Institute in Los Angeles had written to me about the acquisition of Clem's papers. Most of his vast correspondence through the mid-eighties had been donated to the Archives of American Art. Now I searched through Clem's casual filing system and set to work

meticulously cataloging manuscripts, drafts, lecture notes, travel diaries, journals, daybooks, correspondence, everything that said *papers* to me. The clerical nature of the work, the burrowing, head-down, get-each-detail-right aspect of it, was like a warm bath to me. And the bonus: For the first time, I immersed myself in Clem's thoughts and the arc of his oeuvre, and marveled at the breadth of it.

As if on cue, I received an inquiry from agent Andrew Wylie concerning the handling of Clem's literary estate. Just as Clem had never had a lawyer or a doctor, he had never had the need for an agent. But this was a new day, and I knew I would need help with this deal and others in the future. I also knew that, since the embezzlement, it would require a huge leap of faith for me to trust others with our affairs. Fortunately, good sense prevailed and that winter, Sarah at my side and the archive inventory and Getty letter in hand, we met Andrew Wylie. He was everything an agent should be: businesslike, shrewd, and imaginative. At our second meeting, Andrew told us what we could expect from the Getty and we discussed the sale's terms, the most important item being that the estate would retain all copyrights on the material.

Over the next year Andrew's associate Sarah Chalfant was the negotiator. I was in awe of her steely resolve, which kept the process on point and kept me out of counterproductive pettiness and impatience. The end result was a full-price contract that covered every imaginable contingency. After years of carrying guilt and shame for having put our family's finances in James Powers's hands, I felt a weight lift from me. Most important, under the superb guardianship of the Getty, Clem's papers would be preserved in perpetuity and available to all.

On Thanksgiving of 1994, at Alexandra Truitt's house in South Salem, Connecticut, Sarah met Matthew Morse, the man she would marry. The circles of life, linking as they do as one ages, had intersected yet again. Matthew had been brought to the gathering by Sam Truitt, Anne and Jim Truitt's son. This was Sam, the baby who had "slept in his crib upstairs" during that homey Camelot dinner party in Georgetown when Anne had taught me how to make salad dressing. Now, in Connecticut, a perfect day: a houseful of young beautiful people, Trivial Pursuit, and an invitation to take a walk with the handsome, charming Matthew, who told me

he was thirty-two, a poet, had spent a year traveling around the world after college, and as a teenager had bicycled across the country. What more did a mother need to know? On the train home I asked Sarah what she thought of Matthew. She shrugged. By July they were engaged, and in November I gave the bride away.

On the one-year anniversary of Clem's death, we held a memorial at the Century Club. For me, the soaring moment was Sarah, who had prepared a poem-like remembrance of being her father's daughter, the refrain being "Lucky me." But for the most part I felt oppressed by the solemnity in the room. Not that I had expected a cabaret, but I wasn't surprised when, after the designated speakers had had their say, only a hesitant few came forward to spontaneously share their memories. Later, some of us gathered at the Algonquin Hotel around the corner. Predictably, the mood lightened, and predictably, the men drifted off from the lounge to the adjacent bar to salute Clem with single malt and cigars.

In the years since, I have gone to many memorials, so many that I call them "the weddings for my generation." Some, multimedia events and dinners, so elaborate that the star attraction was drowned out. Some, simple occasions at home. Most, on the heels of death and others, like Clem's, so delayed that the emotional impetus was lost. Whatever the choice, I never did come to understand what was meant by *closure*. Probably because I never sought it or felt the need of it.

That summer, the University of North Carolina's interest in buying the collection was officially withdrawn, having collapsed under the weight of the divisive factions of a large, diverse university. It had taken them a year to agree that they would never agree. Over the next years there would be three more flurries of interest, until finally, in 2000, the right suitor came along: the Portland Art Museum in Oregon. The museum had almost no contemporary art, but it did have a determined director, John Buchanan, and curator, Bruce Guenther, who had the foresight to know that the collection would not only attract national attention, but also act as a magnet for future donations and acquisitions.

Once again, the push-pull took what seemed to be the requisite year. At last, in July 2001, our family, now including four-year-old Clementine and six-week-old Roxanna, boarded the plane to Portland for the

opening of "The Greenberg Collection." For the first time we saw all of the art gathered together and saw each piece as it was meant to be seen: beautifully installed and in a blaze of light. The catalog—an award winner for its design—exceeded all my expectations and was a testament to the artists, to their work, and to Clem. For three days we were pampered and feted by the museum and the art lovers of Portland. People asked me if I would miss the art. In one way, yes—I had been the caretaker. As familiar to me as old friends, the paintings and sculptures were the "furniture" of my life. But I had never thought about them in terms of ownership; I always knew that they were just passing through.

While I was inventorying Clem's archive for the Getty, three publishing projects had clearly presented themselves. The first was a series of nine seminars on aesthetics that Clem had presented at Bennington College in 1971. For years he had been thinking about writing a book on the subject, and he'd seen the seminars as an opportunity to formulate and argue his theses in front of an audience. Though he had reworked the seminar texts and published them in art magazines over the next years, he never had written his book on aesthetics. As editor, I structured the book in three parts: the finalized pieces, published as a unit for the first time; the original texts, as delivered at Bennington; and a transcript of the Q & A sessions that had followed each seminar. The book would show Clem's work process as he brought the pieces from concept to verbatim discussions to final edit. Collaborating was Peggy Noland, Ken's ex-wife, who coincidentally was transcribing the seminars for her master's thesis. It was her transcript that I edited for the book. *Homemade Esthetics*— Clem's title and spelling—was published by Oxford University Press and was named a 1999 *New York Times* Notable Book.

My next project was inspired by a carton of over four hundred handwritten letters Clem had written to his best college friend, Harold Lazarus, between 1928 and 1943. The letters began when they were juniors at Syracuse University and ended after Clem's discharge from the army. As I transcribed and edited them, the young Clem spoke to me each day of his goals and feelings as he detailed his personal and intellectual journey against the backdrop of the Great Depression. The intimacy of the story his letters tell, the nearness of him, swept me away, and when the book

was published in 2000 by Counterpoint Press, I went everywhere I could to do readings.

There was one more Clem project. I wanted to complete the four volumes of his collected works that had already been published by the University of Chicago. The fifth volume would cover 1970–1986, with additional interviews up to 1994. Unlike *Homemade Esthetics* and *The Harold Letters*, this volume required the straightforward gathering of pieces and the writing of an introduction. The art historian Robert Morgan had approached me about doing such a book, and I gladly passed the editorial task on to him. *The Late Writings* was published by Wisconsin University Press in 2003.

Those years were not all about editorial work, Clem, and my computer. In 1997, a few months after the Getty sale, Sarah, Matthew and I took out a map of New York State, drew a circle, highlighted a few towns, and set a price limit. The goal: a country retreat less than an hour's drive from the city, whose pleasures and expenses we would share. This wouldn't be another Norwich, whose location had made it useless to everyone but Clem.

Soon after, a realtor took us up a dead-end road in Putnam Valley, onto a driveway that crossed a little wooden bridge over a babbling brook, to a fifties saltbox house on a rise. Matthew, who, like Clem, is precise with words, deemed the house "graceless," and indeed it was small and boxy. But the grounds: lawns, spectacular trees, a beautiful pool where one could swim naked and only the deer would know. I imagined children running across the grass, sailing high on the old wooden swing, paddling in the pool, sledding down the hill, catching frogs in the brook. We bought the house that night. And soon all my visions came true, after Clementine and Roxanna were born.

In the late nineties, my brother came for a visit with his new partner, Brenda. My sister-in-law and good friend, Lou, had died in 1992. Norden suggested we drive to Rye and revisit the places of our childhood. Our first stop was the faux Tudor mansion in Green Haven that our grandfather had built for Vera and David in 1925. As Brenda took our picture on the grounds, the current owners emerged and invited us in. The trappings were different, but the bones were the same. I felt again

the vast gloom, the hollowness a small girl would feel. There was the stairwell where I had told my first lie, that I had brushed my teeth, and the amazement, and sly pleasure, that I had been believed. Framed in the glow of the orange pongee drapes, I could see the grand piano and my mother as she stretches out her silken legs to place her open-toed, high-heeled shoes upon the pedals. She straightens her back, breathes a long, perfumey sigh and begins "The Missouri Waltz" so fast that her clickity red nails blurred into the ivory keys. I smelled her closet and walked in her magic gold party sandals.

In the garage I rode on the back of my brother's bicycle on a rainy day, a rare moment of touching and oneness while Mother was honeymoon-ing with the Con Man after Daddy had flown the coop for the Nurse. I saw my bed under the eaves and, next to it, my home within my home, my dollhouse with its tiny lights that almost kept the dragons at bay. The bed where I kept long vigils at night as I listened for the sound of our car and the rake of headlights across the ceiling as it turned up the drive and brought her home to me. She leans across my bed; I smell the intoxicating elixir of perfume, cigarettes, and booze as her dark curls tickle my nose.

In the backyard I could see the miniature log cabin and swing that floated too far from the mother ship for the comfort of the girl who had been told those ominous words: "Go outside and play." In the bathroom I felt the warm flow on my feet as I tried to pee like my brother peed.

Later, at lunch in Rye, Norden revealed two memories. He, who had never revealed anything "inner" to me before, told me about the eleven-year-old who had stood on the upper landing of that staircase, the Con Man in the hall below. A stand-off. The man in a fury, demanding repeat-edly that he be called Father; the boy above, mute, his knuckles clenched white with hate around the mahogany railing. And he told me about the boy in his midteens who had slapped his mother hard across the face when she had said something about a girl he was dating. For the first time I saw the boy in my brother—not the pampered, cocksure golden child who took life in stride, but the hurting child who, as he grew up, had simply become more skillful than I in shutting the lid on the past. I finally believed that we really had grown up in the same house. And by

the time we finished the rounds of our haunts, I had folded my brother into my heart with an unconditional love.

Perhaps still on the wings of my experience with Norden, a few years later I sought and finally found a lasting peace with my mother. I had made a rare visit to Cape Cod to spend a week with my friend Edith Kurtzweil in Wellfleet. On my way back to the city, I was overcome with a desire to visit my mother's grave, which I hadn't seen since she died. After much searching, I found her under a tree, a few yards away from her sister, Elfrida. By then the sun had turned to clouds, the air cold and damp. I sat, my back against the tree, by the simple granite headstone and talked to her as I never had talked to her before, about the small daily stuff and the big changes, about past feelings and feelings at that moment, about Sarah and Clem, about her great-grandchildren, about widowhood, about my fears and confusions. I crisscrossed twenty-five years. And I heard what she had to say to me. I settled in. There was no rush.

As a light drizzle stirred the leaves above, I sang "The Donkey Serenade," her favorite song. Once again, I saw her tears when I came to the part when the girl becomes a nun and kneels to pray as her lover sadly rides away. I ate a tuna sandwich, took a pee behind the tree, cried a lot. I asked her forgiveness for the pain I had caused her, and began to forgive myself. Maybe that's what a meander is about: It takes as long as it takes. The rest is just detours.

The past has a funny way of reasserting itself. In 2002 I was at the Whitney Museum, and there, in a dimly lit room of its own, was a replica of our living room as it was in 1964 when it had been photographed for *Vogue*. The installation, "Empire," by a young artist, Paul Sietsema, was like an oversized dollhouse. The shock of recognition. Transfixed, I peered down into my living room across forty years. Everything in its place, from the smallest bibelots to the tattered brown foam couch from Altman's to the chattels of all the matriarchs who had preceded me. And the art: from the smallest sculptures to the largest pictures, all exquisitely reproduced to scale and in breathtaking detail. The only flaw, the color in Noland's glorious six-foot chevron, *Sarah's Reach*. But then, Noland's palette was a gift from God and therefore inimitable. The time

and industry Sietsema had expended! As for his agenda, whatever it may
have been—and it was no doubt highly political, rather than aesthetic, as
most art is these days—it didn't interest me. I revisited the exhibit with
my five-year-old granddaughter, Clementine, and we played a game—
how many things do you see that are in Gramma's living room? I felt he
had created the room for our delight.

I had always thought of the art world as the family I had married into.
Of course, as with any in-laws, our relationship had been rocky. But I
had changed, the times had changed. I would be hard put to call today's
art world a "family." Nonetheless, endangered though the old-timers
may be, in the years after Clem died, there would still be a few family
reunions where my past and present could collide.

In 2001 I saw a screening of the movie *Pollock*, followed by a Q & A
session with Ed Harris and the cast. All proceeded predictably until the
final question. A man asked whether in the closing images Harris had
intended to suggest that Jackson had committed suicide. Harris, as I can
best recall, said that that was a question that could never be answered.
There was a bit of back-and-forth, and I was getting ready to leave, when
I heard Harris say the word *murder* in relation to Jackson's role in Edith
Metzger's death. I let out a whoop of surprise, startling the people around
me. Of course, Harris was not suggesting willful intent; he was speaking
of Jackson's ultimate responsibility. My surprise was that it was the first
time in over forty years that I had heard anyone other than Clem use
that word in connection with the tragedy.

A few months after I had seen *Pollock*, I found myself sitting across
from three women on a Madison Avenue bus. They had just come from
the movie, and I listened to them commiserating with "that poor Lee,"
who, as it were, had laid down her brushes and her life for "that man."
"Why did she put up with him?" They used the word *suffocated*. Oh,
they were identifying, all right. What woman hasn't thought at one time
or another that her life has been consumed and detoured by a man? I was
itching to interrupt them: *No, you don't get it. Not only did she choose
that life, she had been on the prowl for years, and when she found him,
she got him in her sights and bagged him.*

If the women and I had stayed on that bus all the way to Washington

Heights, I might have told them about Lee's early days at the Hofmann School in the thirties. About the three sirens, Lee, Elaine, and Mercedes. All good painters. All savvy to the near impossibility of a woman's getting recognition in those years. It wouldn't have been enough for our trio to hook up with any artist; he had to be a genius who one day would be the greatest painter in New York. Mercy, the raving beauty, would undoubtedly be deemed the also-ran when she married Herbert Matter, a fine photographer and graphic designer. The race between Lee and Elaine, who snagged de Kooning, would be hotly contested over the next decades. Bill would be the popular favorite, with his more accessible art and personality. He would have won the Most Likely to Succeed and Mr. Congeniality awards if the art press and his peers had been judging. Despite the odds, Lee's genius pulled ahead in the final lap and she found herself in the winners' circle.

I could well understand that this take on Lee would be unacceptable to all women, whose knee-jerk response after seeing the movie would be to identify with Lee as the victim. In fact, they probably would have asked me, *What about all those painful years in between? The sacrifice?* I would have said, *Again, you're missing the point. She loved her life. She knew that with every Pollock that got painted, her faith in him was reaffirmed. And for every Krasner that didn't get painted, Lee had a moment of glory as Jackson's wife and then widow. She hugged her life to her chest and never let go. Well, only for a moment that summer of 1956, and look what happened when she did.*

What did I think about the movie? I thought Harris was extraordinary, right on target. I couldn't say the same for the actor who played Clem. He delivered a caricature, from posture to delivery: the art critic who leans back, looks down his nose with a condescending sneer, and pontificates. Very un-Clem. As for Lee, I couldn't find the Lee I knew in the movie. Marcia Gay Harden, by choosing to deliver a softened Lee, reduced the story to the overbearing man and the beaten-down woman. As I had never personally seen the soft underbelly of Lee, most of that would have ended up on my cutting-room floor. In my movie I would have portrayed a perfectly matched, toe-to-toe marriage. A win-win, lose-lose kind of marriage. As for Harden, she picked up an Oscar. Harris got

passed over. The movie became Lee's. But Best *Supporting* Actress? Lee would have hated that.

For the most part, the time I write of was before all the mythologizing about the first-generation artists. To me, they were just the guys in Clem's life. But Jackson, from the time he was dubbed Jack the Dribbler to the notoriety of the "death car," had become the juiciest target for the myth-spinners. And then it got personal: Jackson the roaring drunk, who slugged this one and that, who ripped doors off hinges and pissed in fireplaces. Fortunately for them, once upon a time he did piss in Peggy Guggenheim's fireplace. Sadly, for posterity, those are the myths that stick—like gum in your hair—and then get embellished. And what about the five-hundred-pound biography by "the two boys of the street," as Clem called them—they, too, lived on Central Park West—who went so far as to try to make a case for Jackson's being gay? It reminded me of the absurdity of watching Neil Armstrong and Buzz Aldrin plant that little American flag on the moon. All I know is, Jackson, as the subject of so much speculation, is a stranger to me. I imagine how he would have hung his head even lower and retreated even more deeply inside himself. And, of course, it isn't just Jackson, but all of the superstar artists. Myth-making explodes the truth and guts out of people. And to have known them in the day-to-day of our lives and then watch them be stretched this way and that sickens me.

I shared an intimate evening with the past the night I was invited to a screening of a documentary of Hans Hofmann. In the small, dimly lit theater I saw rows of faces, aging faces, turn toward us. A few nodded as we found seats. I knew none of the faces by name, yet from the moment I walked into the room, I knew I was "home." Soon, the film began and I was twenty-four, feasting on Hans's world: Provincetown, Miz, the magical house of colors, his square feet in those sandals, his thick voice, his heat and intensity, the heft of him. As we all straggled out of the past and out of the theater, a few people greeted me. As always, I was surprised they knew my name. As I searched my mind for theirs, I hugged them close and realized the names didn't matter.

I think of a small birthday dinner given some years ago by my friend Edith Kurtzweil for her husband, William Phillips. It was there that I

once again crossed paths with Roger Straus, renowned publisher and forever renowned in my mind as my first job interviewer. After dinner, I harnessed his attention—at his advanced age, quite an easy task, as he never left his chair. In a breezy, anecdotal way, I at last unburdened myself of the story of our early, brief encounter and the significance it had held for me. It was clear he didn't comprehend much of what I said, but he was still as sartorially splendid and, with his abundant crown of white hair, as handsome and charming as ever. He took the cue from my delivery and nodded and laughed heartily at my story, before looking away desperately in search of rescue and another lemon tart. Both of which were soon supplied by his beautiful wife, Joanna, and I said my good-byes. He died soon after, at age eighty-seven. I was surprised. I had imagined him gracefully sauntering into his hundreds. But I smiled to think that he had been only thirty-eight when he had dismissed me with such finesse and sent me out of publishing and on into my life.

I think of André Emmerich's eightieth birthday party, a large, elegant event. This time I knew many people, but perhaps because of the formality, I found that I had suddenly reached the end of my thread of small talk. Had I really been saying the same things to the same people for fifty years? We had never moved on to new colors and textures. Had it been me? Or them? There would be no answer, but that evening, my words wadded up in my mouth and tasted bad. As for those I knew less well, we were like actors in a play with no plot and lots of loose ends. My attention was transfixed by the tiny bejeweled purses on the tables and the heavily veined, bejeweled manicured hands lying across them. *Ah*, I thought, *the collectors*. With some, we try to sort ourselves out as we smile and move on, but we are stymied by our inability to match the face with a name, and we wonder if we know each other at all. And how could it have been otherwise? We had only had the polite latticework of small talk that had obscured the stuff of what might have been real conversation. I didn't sleep much that night. Often, after these reunions, I don't sleep much. Too many dreams of other nights and times.

I think of one of Helen's openings at Knoedler. In the crush, Gifford and Joanne Phillips greeted me. Their names floated to mind easily; they were like magnets bringing with them all the memories of our many times

together. They were also outstanding collectors. We talked about Helen's art—we liked that picture, that one not so much—the way people used to talk about art when qualitative judgments were still kosher. As we parted, Joanne said how fondly she remembered buying me "the little silver cup at Tiffany's." A moment of confusion, before I realized she thought I was Sarah.

Just then, a young man with blond spiked hair said, "Jenny!" and grinned at me in passing. Who on earth . . . ? What a comedy it all was. As I left, I waved at Helen, seated in front of a long line of admirers waiting for her attention. As usual she mouthed, "Lunch. Call me." It was the last time I saw her without a wheelchair. And there would be no more lunches.

And I learned how proprietary I was about my art family when my real family and I were recently invited to Barbara and Ernie Kafka's for Thanksgiving dinner. During the wonderful meal, conversation at the adult end of the table turned to the artists we had known in common— in particular, David Smith, Bob Motherwell, and Ken Noland. Their talk was not just idle gossip, but strong criticism of everything from lifestyles—all the girls and sex—to the management of families, careers, finances, and wills. As surprised as I was by their vehemence after so many years, I was more surprised by how defensive I became. As if I had a stake, as if I hadn't plenty of my own reservations about those artists. But damn it, they were my family and no one could . . . As quickly and easily as that, I was overwhelmed by a groundswell of feelings for them that I had never acknowledged before. They might be out of my life, or long dead, but they were mine.

Over the last decade I have often felt as if I were living in a kaleidoscope of art people. It seemed that every time I looked around, they had shifted from friend to acquaintance to a memory. Nothing mysterious— simply the drift of changing lives, old age, and death. I have come to accept it, just as I accept that, now and then, when I am with one of my "family," I simply know that this will be the last time I will see him, or talk to her. As with Friedel Dzubas at a gathering after a small retrospective of his work. His voice soft, we huddled close on the couch to hear and be heard, his cold hand holding mine so tight, talking of Clem and

the painting he needed to finish. As with Jules Olitski at a party at the Willard Boepples, at war with cancer, eager to retravel the roads of our past, not with nostalgia, but with warmth. His voice was weak, but we laughed long and loud. And there were too many others who had slipped so far away over the years that there would be no last word or touch.

There was a different sort of good-bye when I went to my fiftieth reunion at Bennington. Rightfully, the place and I had outgrown each other. But the women of 1955, we would be sisters forever.

And there was my last afternoon with my dear friend, the painter Yvonne Thomas, sitting on her black art-deco chair in her loft, the sun playing in her hair, so beautiful in her mid-nineties, still weaving stories for me across the rumor mill of seventy years. That day, my questions led her the Hofmann School during the summer of 1938, " . . . and of course Mercy was having a mad affair with Hans."

"Really?"

"Oh, yes, he had quite an eye for all the girls."

"Did Miz know?"

Yvonne shrugged in her French way. "How could she not? But things were different then, more comme il faut." Ah, what a pretty way of saying *open marriage*. I felt again the force of the Hofmanns' harmony and the harmony between Clem and me, and how, if one cared enough to go the distance, an open marriage could be an open door to any togetherness one chose. I adored the urgency and gusto of Yvonne's repartee, as if the events had happened at a party last night, as if the people were not dead or past caring. And as the sun faded in her hair, I watched her devour her favorite coffee ice cream and chocolate cookies, so angry that she had outlived her time.

Like any self-respecting relationship archeologist, I believe that embedded in the moments of Clem's and my first year together—Jennifer's party, Delaney's bar, René Bouché's studio, Bank Street, East Hampton—were all the clues of what lay ahead for us. My life with Clem introduced me to love, honesty, and trust. My life with Clem brought me swift and total submersion into the art world—a world of men, a world not of my making or choice—and it taught me to swim. It brought me our beloved daughter. It brought me an open marriage that allowed me to

love Clem for a lifetime without resentment or anger. An open marriage that afforded me the chance to explore other worlds of my own that I might never have experienced otherwise. Clem loved me completely for who I was, not for what I did or might become. It was in his gaze that first night we met—not the love, not yet. But his wholehearted interest in me was there. His eyes into mine. I was caught, caught up.

Acknowledgments

I want to thank those who gave me the keys to unlock this book.

Francine du Plessix Gray for introducing me to Carolyn Heilbrun's astonishing book, *Writing a Woman's Life*, before I even knew I was ready to read it.

The friend who led me to the International Women Writers Guild and Susan Tiberghien's seminar on memoir before I knew the time had come for me to write one. And thanks to the IWWG summer workshops at Skidmore College. Writing in the company of hundreds of women, I formed lasting bonds with Eunice Scarfe, Lynne Barrett, Marsha McGregor, Kathleen O'Shea, Linda Durnbaugh, Mira Shapiro, Judith Searle, and Kay Raheja. By example, they never let me forget that writing is an inside job where there are no rules and all things are possible. Thanks as well to our writers' workshop in New York for inspiring me with their insights over the years: Veronica Picone, Anne Hollyday, Darlynne Devenny, Lenora Odeku, and Regina Kolbe.

And to the early readers of the book: Sarah and Clementine Morse, Stephanie Noland, Ruth Mayer Bacon, Jim and Annie Walsh, and Amy Mintzer—thank you all. Your responses made me feel that my long journey had been worth every minute of it. And thanks to the incomparable Trish Hoard who, when I fretted that the book might be too long, in effect, said, "It's your life story, it will be as long as it needs to be."

My thanks to all the photographers who documented our lives and provided us with a treasured archive. I am grateful to them—and their estates—for granting me permission to reprint their work. (Photographs without credits are from our personal collection.) I also thank Robert S. Warshaw, trustee of the Renate, Hans and Maria Hofmann Trust, for allowing me to reproduce the letters Hans wrote to Clem in 1961.

I thank Jack Shoemaker at Counterpoint Press, a publisher who honors the books he chooses to print and the authors who write them. My gratitude to Kelly Winton, Laura Mazer, and Jodi Hammerwold for their help, and copy editor Annie Tucker for her thorough and thoughtful contributions.

Closer to home, a special thank you to my daughter Sarah Greenberg Morse for her emotional and practical guidance every step of the way. And I thank my invaluable assistant, Emily Hoenig.

At the Wylie Agency, my thanks to Jin Auh for her enthusiastic support of my project. And special thanks to her teammate Jacqueline Ko for being my infallible advisor through the process. I will always think of their belief in my book as a great gift.

INDEX

377